SOCIETY OF ILLUSTRATORS
52ND ANNUAL OF AMERICAN ILLUSTRATION

SOCIETY OF ILLUSTRATORS
52ND ANNUAL OF AMERICAN ILLUSTRATION

SI
52

FROM THE EXHIBITION HELD IN THE GALLERIES OF THE
MUSEUM OF AMERICAN ILLUSTRATION AT THE SOCIETY OF ILLUSTRATORS
128 EAST 63RD STREET, NEW YORK CITY
JANUARY 6 — MARCH 20, 2010

PUBLISHED BY SOCIETY OF ILLUSTRATORS AND COLLINS DESIGN

COLLINS DESIGN
An Imprint of HarperCollinsPublishers

ILLUSTRATORS 52

Society of Illustrators, Inc.
128 East 63rd Street, New York, NY 10065-7392
www.societyillustrators.org

Copyright © 2011 by Society of Illustrators
All rights reserved. No part of this book may be used or reproduced in any manner whatsoever
without written permission except in the case of brief quotations embodied in critical articles and
reviews. For information, address Collins Design, 10 East 53rd Street, New York, NY 10022.

HarperCollins books may be purchased for educational, business, or sales promotional use.
For information, please write: Special Markets Department, HarperCollins Publishers Inc.,
10 East 53rd Street, New York, NY 10022.

FIRST EDITION

No part of this book may be reproduced, stored in a retrieval system or transmitted in any
other form, or by any means, electronic, mechanical, photocopying, recording or otherwise,
without prior permission of the publishers.

While the Society of Illustrators makes every effort possible to publish full and correct credits
for each work included in this volume, sometimes errors of omission or commission may
occur. For this the Society is most regretful, but hereby must disclaim any liability.

As this book is printed in four-color process, a few of the illustrations reproduced here may
appear to be slightly different than in their original reproduction.

PUBLISHED BY:
Collins Design
An imprint of HarperCollins Publishers
10 East 53rd Street
New York, NY 10022
Tel:(212) 207-7000
Fax:(212) 207-7654
collinsdesign@harpercollins.com
www.harpercollins.com

Library of Congress control Number: 2006922270
ISBN: 978-0-06-200460-4

DISTRIBUTED THROUGHOUT THE WORLD BY:
HarperCollins Publishers
10 East 53rd Street
New York, NY 10022
Fax: (212) 207-7654

EDITOR, Jill Bossert
BOOK AND JACKET DESIGN BY Erin Mayes and Simon Renwick, EmDash
JACKET COVER ILLUSTRATIONS BY Marc Burckhardt (front), John Krause (back)

PHOTO CREDITS: Jury photos by Jessica Yeomans

PRINTED IN CHINA
First printing 2010

S152
TABLE OF CONTENTS

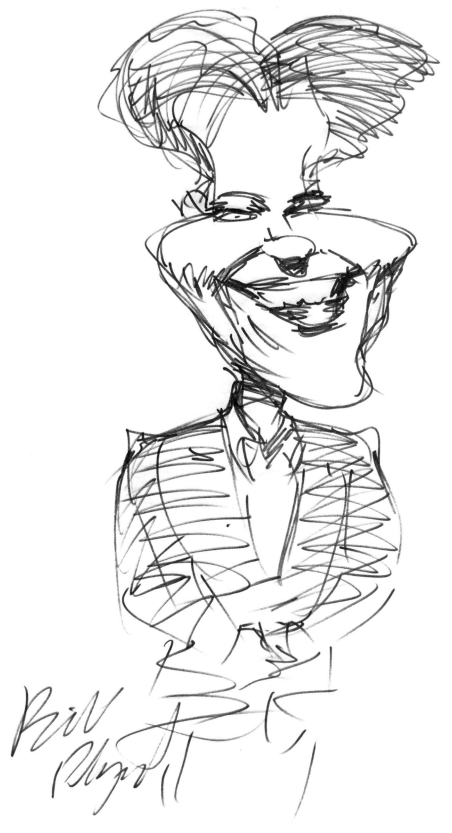

President's Message
Dennis Dittrich

Anyone who hasn't seen the annual show in a very long time might think: "Hmm … different than I remember." Many things are smaller. Lots of prints. There's an arrangement of little rubber stamp men not far from where Birney Lettick's three-foot oil painting for a Moose Head beer label used to hang. What changed? We can only guess.

Drawings might be smaller because budgets are, or because they have to fit on a scanner. A larger volume of digital work might reflect a changing aesthetic, or technology catching up with artists' preferences. More conceptual content might be here because that's what's being assigned.

Is anything the same as it used to be? Yes. This show represents, as it always has, the results of a dedicated jury choosing the best of the American illustration market from the previous year. For the 52nd time, the Society offers the annual as an interpretive record of our culture through the vision of contemporary illustrators. In these pages you will recognize work from brilliant veteran artists whom you have known for years. You will also discover exciting, fresh images by names that are new to you, and you may notice that some of your favorites are conspicuous by their absence.

Sports Illustrated's Richard Gangel said it best some 30 years ago, "Illustration must understand the change and create a place for itself." If the work in this volume is any gauge, illustration is doing just that, and we offer this year's annual for your judgment.

My thanks go to our annual chair, Nora Krug, to co-chair Edel Rodriguez, and to our jurors for their tireless efforts, which made this show possible. To our director, Anelle Miller, who did all the heavy lifting so the rest of us could have fun, and to the SI staff, who worked very hard to make the logistics seem to magically happen. To our member volunteers, who generously gave their time to hang the exhibits, making sure each of the shows looked great on the walls, and, finally, to you, the illustration community, for your continued participation and support.

Facing page: Portrait by Bill Plympton.

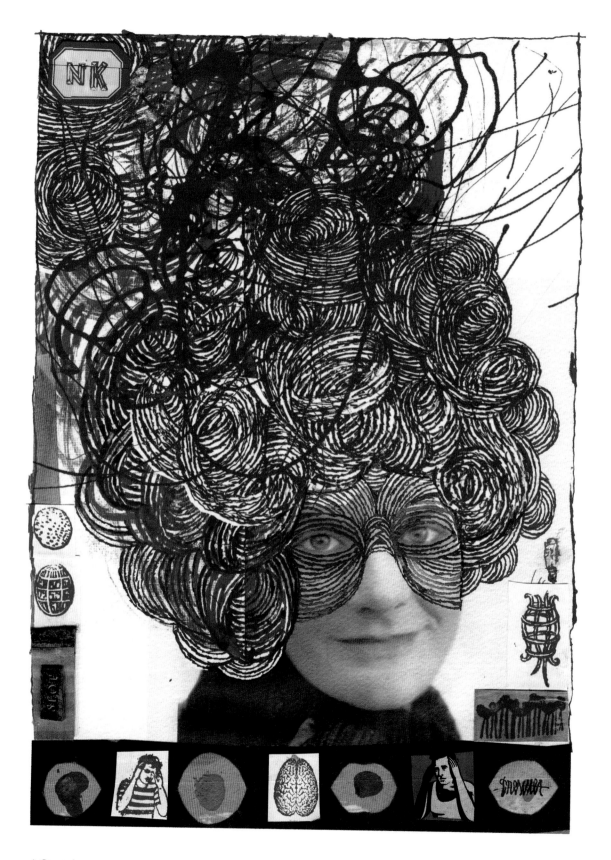

CHAIR'S MESSAGE
NORA KRUG

The power of the illustrated image is often underestimated today, and, on the part of the general public, there seems to be little understanding of what it is we do as illustrators, on what levels we contribute to society as visual thinkers, and how our work affects our society. For centuries, illustration has played a crucial role in shaping a society's collective consciousness: illustrators visually documented the working of societies from the very beginning of human civilization. Societies and their visual vocabulary exist in a reciprocal relationship. Illustrations mirror our cultural, religious, and political systems, and at the same time, society is constantly affected and transformed by its visual vocabulary. Illustrators have played a particularly important role in explaining, shaping, and preserving, as well as questioning and deconstructing our understanding of the world. Illustrators throughout history have provoked change in thought and in action—often for better, but sometimes, as in the context of political propaganda, for worse.

The strength of illustration as a medium lies in its ability to reach out to an audience by communicating content on a personal, rather than purely factual, level. Drawing and painting means not only seeing, but recognizing; not only analyzing, but feeling; not only documenting, but interpreting and communicating. How and what we see is subjective. An illustration never claims to be objective. It raises questions instead of trying to provide answers. What's important is what we imagine, and how we decide to reinvent the world through images. Illustration internalizes the outside world and simultaneously makes our own interpretation of that world visible. Illustration blurs the line between the inner and the outer worlds and allows for the audience to pass back and forth between them fluently.

As the world changes, the nature of illustration changes. And as this century has seen print culture decline, contemporary illustrators have invented new platforms to communicate their ideas. Illustrators increasingly consider themselves as visual authors, applying a variety of forms to communicate these ideas, including artist's toys, animation, graphic novels, street art, textile design, or illustrative set design. What's crucial is not the choice of platform or medium, but whether a piece of art speaks to an audience and whether it communicates something intrinsically human.

For over a century, the Society of Illustrators has represented and honored these changes in the field and the various roles illustrators have played in society. This year's exhibition represents a variety of different directions, and the chosen works include illustrations for the editorial, book, advertising, and institutional fields as well as comics, sketchbook art, pieces created for galleries, and 3-dimensional objects.

The poster for this year's Call for Entries was designed by *New York Times Magazine* art director Arem Duplessis, and the illustration was created by Italian artist Lorenzo Mattotti, whose work exists somewhere amongst the worlds of illustration, fine art, and comic art. This year's group of 44 jury members included illustrators, art directors, designers, editors, and critics from the fields of editorial design, children's books, graphic novels, and animation. Some jurors made a pilgrimage to the Society from Europe just for the occasion of the judging.

I want to thank all those who were involved in the year-long process: Society director Anelle Miller and president Dennis Dittrich; co-chair Edel Rodriguez; the past chair committee; the indispensable Tom Stavrinos, Kate Feirtag, Matt Black, and the rest of the Society's staff (who ran the organizational part not only smoothly, but extremely pleasantly); this year's jurors; Arem Duplessis and Lorenzo Mattotti; and Henrik Drescher, who created the portrait of this year's chair.

Thank you to the Society of Illustrators, which has become like my second living room.

Facing page: Portrait by Henrik Drescher.

Hall of Fame 2010

Since 1958, the Society of Illustrators has elected to its Hall of Fame artists
recognized for their distinguished achievement in the art of illustration.
Artists are elected by former presidents of the Society and are chosen based on
their body of work and the impact it has made on the field of illustration.

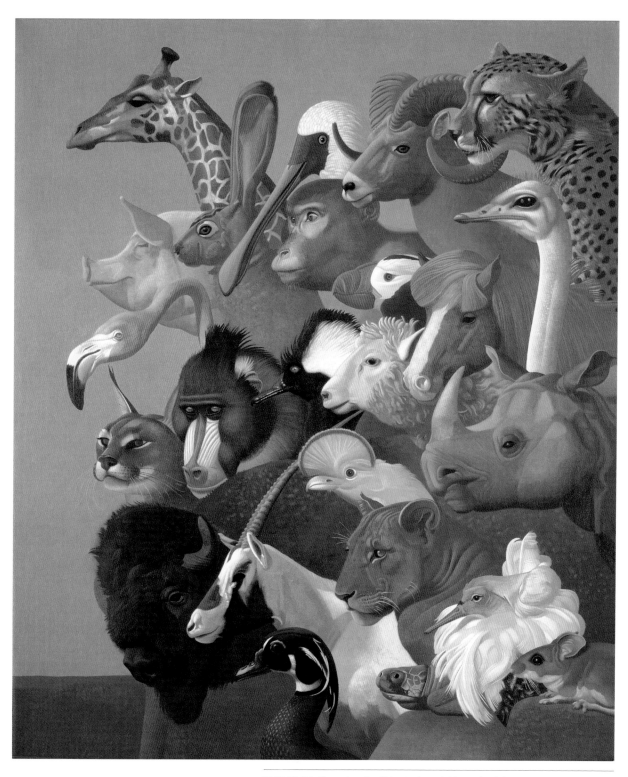

THIS PAGE: Illustration for *If the Earth*, a children's book by Joe Miller for Greenwich Workshop Press, 1998. FACING PAGE: Illustration about surveillance and crime, *Playboy*,1990s. Art director Kerig Pope. Oil on canvas. All images courtesy of the artist.

WILSON MCLEAN

[b. 1937]

Wilson McLean arrived in New York City in 1966. Twenty-eight years old and married with two children, he had come to America to fulfill a childhood dream to become a famous illustrator. He wanted to use his considerable drawing and painting talent—not to show in galleries—but to create illustrations for the many American magazines he had admired back in England. He was in the right place at the right time, when illustration was in wide use and commercial images had real social impact. Art directors at magazines and advertising agencies in the late 1960s and the 1970s were on the lookout for artists who were skilled draftsmen and painters. Discovering new talent was part of the job description, and in McLean they found a fresh vision.

Born in Glasgow, Scotland, McLean moved with his family to a working-class suburb of London after World War II. His exceptional drawing ability was obvious by the time he was 12 years old. Other than an occasional sketch of his mother, he seldom drew from life, instead he copied illustrations—black-and-white line drawings of cowboys and fighter pilots—from *The Boy's Own* adventure annuals and other illustrated books. He was consumed by the process, drawing the images over and over again. At 13, he went to a school that offered art classes, and for the first time he knew what it was to draw from life. Finally receiving real instruction, McLean began to feel that becoming an artist could be a reality. He won the school's top art award for artistic excellence and received *Lives of Great Artists*, a book of black-and-white drawings that included the works of such artists as Rembrandt and Caravaggio.

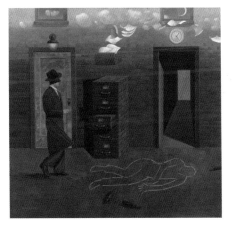

"It was the first time I really saw any art," McLean says. "There were no books in our house and I think I must have been 16, before I ever went to a museum."

Based on his talent and ambition, McLean was offered a scholarship at 15 to attend a professional art school. It was a great opportunity, but his art education would have to wait. His father, a foreman in a dry cleaning factory, was in a car accident that crushed his collarbone and a leg, preventing him from ever holding a fulltime job again.

Of that time McLean says, "I remember the headmaster pleading for me to stay in school. My mother left the decision up to me, but knowing how dire the financial situation at home, I really didn't think I had a choice. I felt I owed it to my mother to get a job, so I went to work in a factory."

But his drive to make art never abated. Weekends were spent copying paintings from any book he could find, and he looked for opportunities to get work that had some meaning for him. His first job was for Phelps Silk Screen Painting, a studio that made silk screens and signs for local businesses, and McLean was hired as messenger, janitor, and general clean-up boy. It wasn't illustration yet, so he kept copying and drawing and painting on the weekends. A year later he got work at a studio on Fleet Street in London. They didn't do illustrations but he was out of the suburbs. He says, "The job was really useful to me. I became the super messenger, running all over London getting to know every news shop that sold magazines with illustrations in them. I found American magazines like *Colliers*, *The Saturday Evening Post*, and *Argosy*, which displayed full-color storytelling images.

"I was very excited by the macho illustrations of unshaven men in combat or on the Texas range. This kind of drama wasn't in English illustration at that time. English illustration was more genteel, more conservative, less flashy. I saw Norman Rockwell's work and admired his skill, but couldn't relate to his world. The adventure illustrations of Fred Ludekins and Harold Von Schmidt seemed more exotic and fed my love of history."

Just when McLean finally landed decent paying work from a newspaper, he turned 18, and mandatory military service began. Sent to Yemen, a British protectorate at the time, he stayed for two years and "drew to keep my sanity and not for pleasure." After the army McLean returned to his messenger job, but started taking evening drawing and painting classes in earnest at Chelsea St. Martins and The Central Art School. There were no illustration classes, so his portfolio featured life drawings and paintings. He applied for a job doing paste-ups and

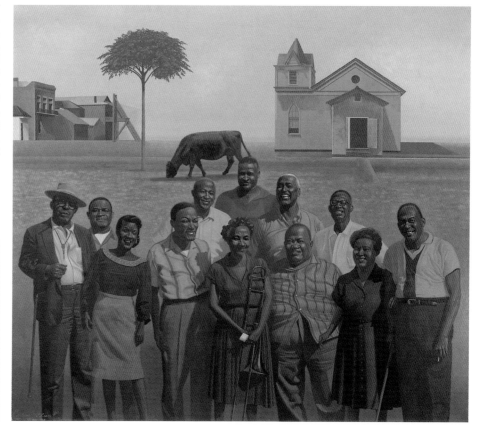

BELOW LEFT: *Manuel Noriega*. *Time* magazine cover, March 7, 1988. Art director Rudy Hoglund. Oil on canvas. RIGHT: *Mississippi Morning*. From a series of works featuring jazz and blues musicians. Oil on canvas. FACING PAGE: *Holland America Line*. Advertising piece done for Chiat Day advertising agency, 1982. Art director Bob Dion. Acrylic on canvas.

mechanicals at *Woman's Own*, a popular British magazine that featured illustration and even reprinted some American work.

Daily, McLean was surrounded by transparencies of illustrations by the big names in American illustration at the time—Joe Bowler, Joe DeMers, and Coby Whitmore. But it was the work of a new illustrator, Bernie Fuchs, that really excited him. "A little too modern for me," was the comment from the magazine's art director, but Fuchs' approach to illustration was to become a major influence on McLean's early work.

"I liked the way he used the camera to design his illustrations. The work was photo-based, of course, but very inventive, and it had a freshness to it that I found missing in Coby Whitmore and Joe Bowler. I set up my own darkroom, bought a lucigraph, and started setting up more complicated photo sessions with models and props."

It worked. *Woman's Own* gave him his first of many assignments. A year later McLean was making a living as a free lance illustrator. In 1968, he met his mentor at the Society of Illustrators in New York. Bernie Fuchs, it turned out was already aware of McLean's work. They were colleagues, finally, and it was a memorable occasion.

"When I first came to America I knew my work looked too much like Bernie's," McLean says, "so I began to reinvent my style. I sold the lucigraph and began to rely more on my drawing ability. I started looking at the work of painters instead of illustrators for inspiration."

The work of Kitjai, an American painter living in London, caught his imagination—the scale distortion and picture geometry was of particular influence—and McLean's work changed dramatically. More line, more ambiguity, and less realism were evident in his work, although his interest and ability to paint realistically remained. Magritte, the Belgian

surrealist said, "One should paint each object in a picture as accurately as possible." McLean developed his own form of surrealism that even today is echoed in both his illustration work and gallery paintings. But, unlike Magritte, whose surreal images have a singular, focused impact, McLean will visually tell two stories, one on top of the other. The first story will feature an image or scene of heightened reality, while the second story, which lies beneath, is more vague, more mysterious.

During the 1970s and 1980s, he was able to bring this approach into his advertising work. A time of great productivity, McLean produced award-winning work for the top creatives in the business, including Milton Glaser; Herb Lubalin; Don Smolen; John DeCesare; Bill Gold; Keith Bright and Bob Dion at Chiat Day; Walter Bernard at *Time*; John Berg at CBS Records; Richard Gangel at *Sports Illustrated*; Arthur Paul, Tom Staebler and Kerig Pop at *Playboy*; Frank Metz at Simon & Schuster; Bennett Robinson at Corporate Graphics; and Terry McCaffrey at the U.S. Postal Service. He has produced commemorative stamps for the Royal Mail; illustrated the children's book, *If the Earth*; and taught in workshops nationwide.

Though he now paints for gallery exhibition, McLean says, "The habit and love of illustration is part of me. I have come to accept the fact that my work started in my childhood drawings. I will continue to explore my own language of realism and ambiguity because that's what interests me. It is a wonderful thing to do and get paid for and I shudder to think what would have happened to me without it. I have accepted the fact that my drawing and painting are rooted in tradition. I don't believe that tradition will die. That's what keeps me young."

MARSHALL ARISMAN
Chair, MFA Illustration as Visual Essay program. School of Visual Arts

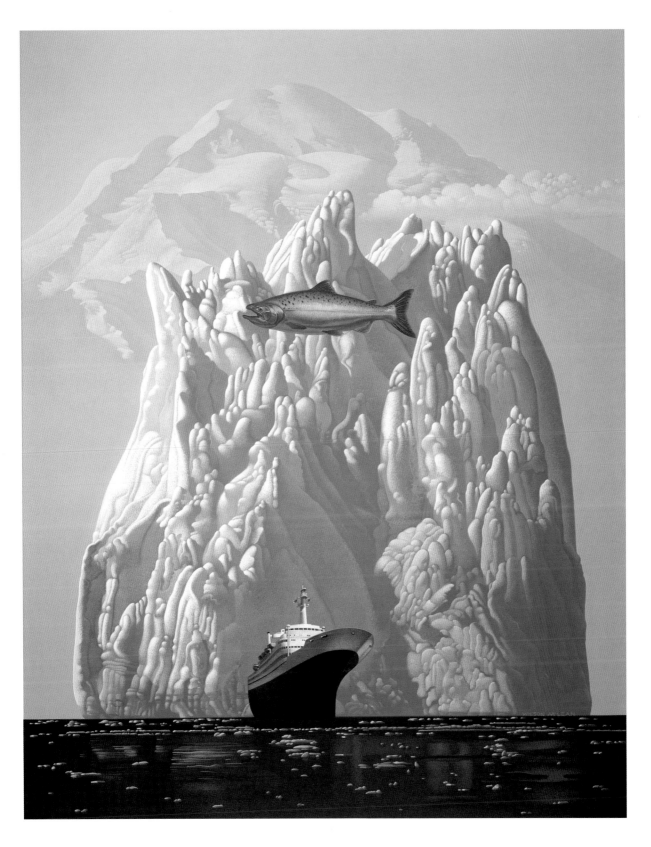

Chris Van Allsburg

[b. 1949]

If Chris Van Allsburg is the fish that got away, then I'm the angler that couldn't tell the difference between a perch and a pike. In the late 1970s, when I was art director of *The New York Times* OpEd page, Chris's wife, Lisa, brought the newly minted portfolio of her husband to my office hoping that I would assign him an illustration. The work was amazing, but it was not illustration. In fact, it was mostly wood sculpture (a bit reminiscent of H.C. Westerman's surrealist wood boxes). Van Allsburg, who had graduated with an MFA degree in sculpture from the Rhode Island School of Design in 1975, had already had a couple of shows at Allen Stone Gallery in Manhattan, but an illustrator he was not. His ironic blend of real and surreal was conceptually perfect for the art world at that time—and, in a weird way, it might have been right for the *Times* OpEd page. But for reasons I cannot recall, I never gave him an assignment. Some time passed and *The Garden of Abdul Gasazi* was published, and the rest is, as they say. . .

So, here is a little history. When Van Allsburg's sculpture career was in full throttle, he amused himself by drawing pictures during the evening in his apartment because the sculpture studio he rented proved too cold to use in the winter after five p.m., when the landlord shut off the heat. He hadn't done much two-dimensional work in college because, he told me, "I didn't study art in high school (I fast-talked my way into art school at the University of Michigan). I felt out-classed and overwhelmed by the drawing talent I saw in classmates around me. Unaware that drawing was to a certain degree a skill one could learn, I assumed I did not possess the innate ability to do it."

As a child, he added, he was a "gifted" builder of model cars and planes, and he thought those skills could be easily applied to making objects. Hence, sculpture became his métier. And the ones I recalled were mostly transportation related: sinking boats, colliding trains, a flying saucer puncturing the domed roof of an observatory.

The drawings Van Allsburg made on those cold winter evenings were the first so-called "picture drawings" he'd ever done. "Up to that point," he noted, "I'd used a pencil only to sketch ideas for sculpture. The pictures I began drawing were pretty simple compositions, with one or two figures, usually engaged in a puzzling activity. They were quite refined with respect to the application of tone, but the figure drawing and compositions were pretty naive."

These early drawings were moody—a result, he claimed, "of conjecturing particular kinds of light"—and had a slightly bizarre narrative quality. These characteristics lent an "illustrative" quality to the images. Consequently, Lisa, an elementary school art teacher, encouraged Van Allsburg to think about doing some book illustration. "To make her case she brought some from her school library, stacks of picture books, which did not provide me with much encouragement or inspiration," Van Allsburg recalled. "They were uniformly sentimental and condescending stories accompanied by art that was the same. If this is what publishers wanted to put into books, then clearly, there could be no interest in the pictures I wanted to make."

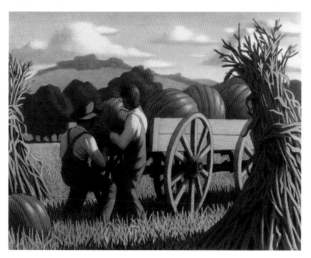

LEFT: From *The Stranger*, 1986. Watercolor and Caran d'Ache. 12 inches x 9 inches. FACING PAGE: From *Jumanji*, 1981. Conté dust and conté pencil. 20 inches x 14 inches. Winner of the Caldecott Medal and the National Book Award. All books published by Houghton Mifflin Harcourt. All images courtesy of the artist.

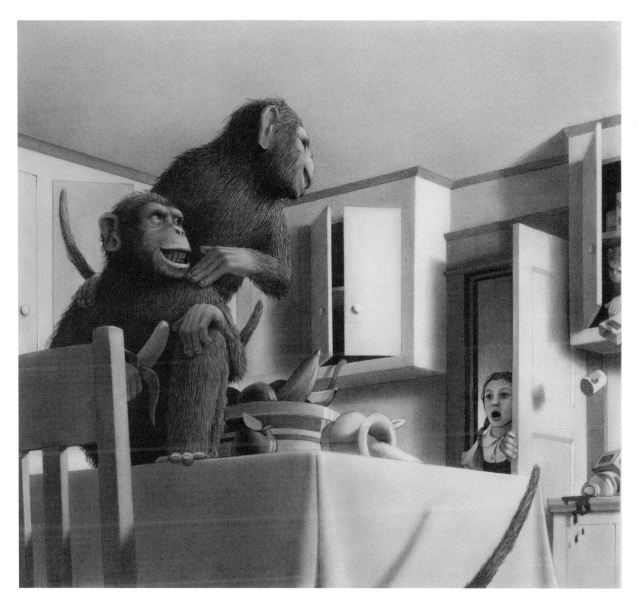

Undaunted, Lisa took a half dozen of Van Allsburg's pictures around to different publishers. Much to his surprise, they reacted favorably. "Unfortunately, the texts they sent to me, with the hope that I might be interested in illustrating them, were very conventional—the kind of story that detailed the challenges of small animals going off to their first day of kindergarten."

He just couldn't see making pictures for theses stories. Then, Walter Lorraine, an editor at Houghton Mifflin, suggested Van Allsburg write his own story. And here's the historical tipping point: "This struck me, initially, as preposterous. I'd never thought about writing, and had never nursed a desire to tell stories to children. But it occurred to me that by writing my own story I could provide myself with picture-making opportunities suitable to my interests and my inclinations." Eureka!

All literature (and especially children's books) are couched in auto-biography, which, Van Allsburg pointed out, does not mean events depicted in the story happened in the life of the storyteller, but it does mean that values and concerns expressed are consistent with those held by the writer. "Consequently, my stories suggest that the world is perilous, that some stories are not resolved, nor can all mysteries be solved."

Van Allsburg is obsessed with themes of loss: the loss of childhood, (*Polar Express*), the loss of imagination, (*Wretched Stone*), the loss of the ability to fly (*Wreck of the Zephyr*), the loss of a comforting recognizable reality (*Bad Day at Riverbend*), and even the loss of the story itself (*Harris Burdick*). According to the artist, "The psychological issues raised in the book generally reflect concerns and interests that are my own." And yet they are everyone's concerns. Those who have read these books themselves or to their children can use them as a substitution for personal articulation. In each of his books, there is a personal (universal) feeling that is expressed, often more eloquently than we—the tongue-tied—can express them to our children (or ourselves). Van Allsburg is our interlocutor and interpreter.

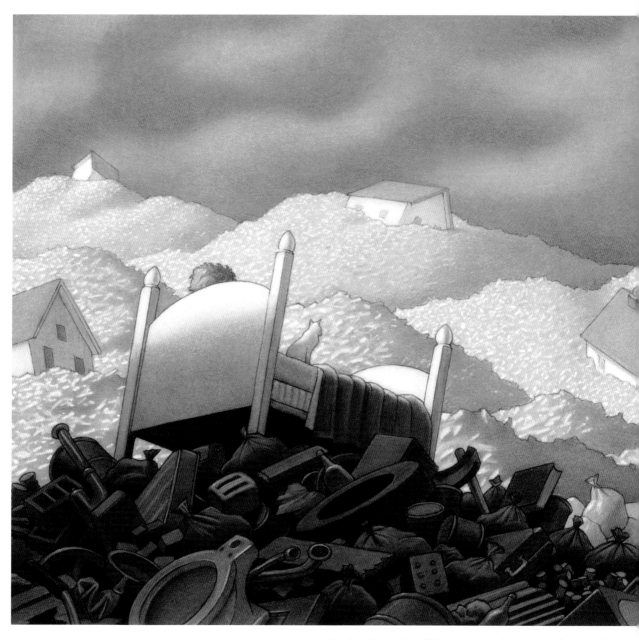

For *Polar Express*, Van Allsburg responded to an image he saw in his mind's eye: "A gasping, old steam engine waiting in a winter woodland setting, with only a few empty cars and a lone figure (a boy in pajamas and a bathrobe) approaching. Where, I wondered, was the train going and who was the boy who hesitantly stepped toward it, each footstep crushing through snow?" In the process of figuring out the "why and where" of the train, and the "who" of the boy, Van Allsburg ended up writing a story about the loss of childhood, "but suggesting it's possible to retain or maybe occasionally reclaim some part of it."

Van Allsburg admitted that when he draws, he is essentially trying to produce on paper what he sees in his imagination. "This is actually fairly tedious. When I am working from models or props, the process is more enjoyable because I am 'communicating' with the subject matter.

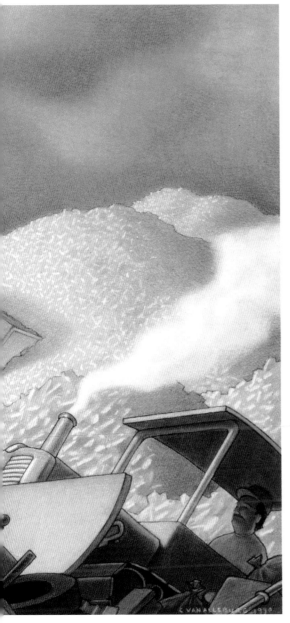

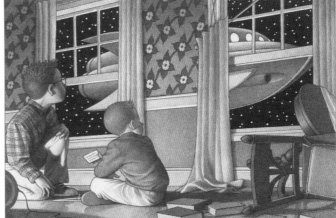

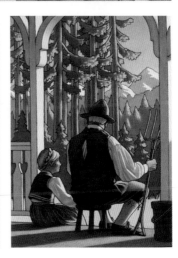

FACING PAGE: *From Just a Dream*, 1990. Pastel, Caran d'Ashe, pen and ink. 18 inches x 14 inches. TOP: From *Zathura*. 2002. Lithographic pencil, pen and ink on cocquille board. 15 inches x 10.5 inches. ABOVE LEFT: *From Two Bad Ants*, 1988. Pen and ink, casein. 7.5 inches x 10 inches. ABOVE RIGHT: From *Swan Lake*, with text by Mark Helprin, 1989. Oil pastel, Caran d'Ache, pen and ink. 12 inches x 16 inches.

Few of the pictures I draw allow me to do this. One of the motivations for doing the book *Z was Zapped*, was the desire to just sit down and actually behold the thing I wanted to draw."

Every literary season I look forward to the work of two or three authors. Van Allsburg is one of them (and for a long while he satisfied that desire with a book a year) because his are not really children's books, although they're suited to a child's needs. He agrees. He said that he doesn't think of his books as being so pigeonholed. Nonetheless, "that does not mean that I am unaware that the largest part of my audience is children, but I do not choose story ideas or draw in a particular style because of that. I'm sensitive to the requirement that a story be told lucidly in language that's not too challenging. I have respect for the youngest members of my audience and as a result do not feel constrained by what some may feel are their limitations."

I wonder today what might have been if I had commissioned illustrations from Van Allsburg for the OpEd. Would this have enhanced or crushed his career as a book author and illustrator? Would he have found his bliss anyway? Would he have conformed to the OpEd approach? Would the sculpture reproduce well? It was around 30 years later that I asked him to illustrate the holiday issue of *The New York Times Book Review*, which he did beautifully. By then, however, there was no gamble that Chris Van Allsburg would make fabulous illustrations—it was as sure a thing as shooting fish in a barrel.

STEVEN HELLER
Co-chair, MFA Design department,
School of Visual Arts, New York

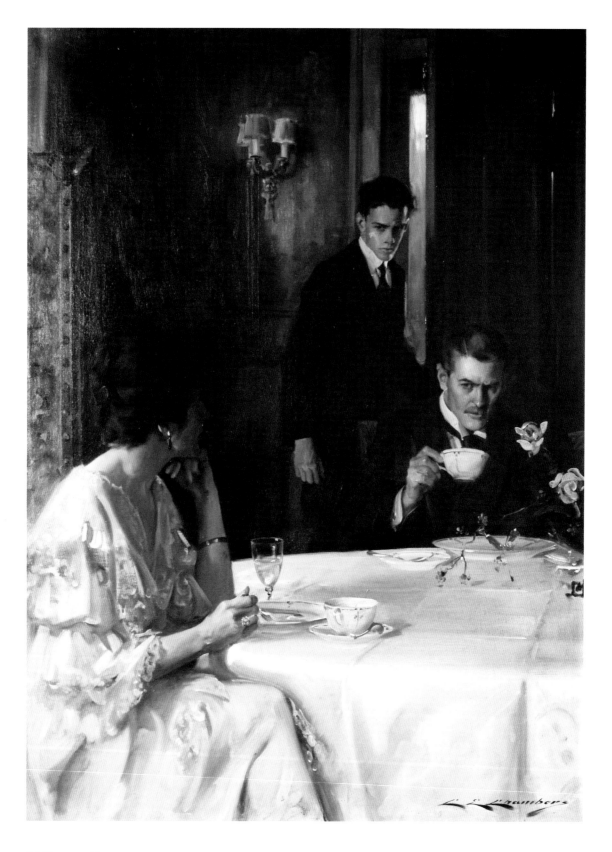

Charles Edward Chambers was a classical painter representative of the old school, his technique was impeccable, anatomy perfect, compositions compelling, and color harmonious. One could infer from his polish that he was a product of the French Academy, with years of classical training.

Yet he was born in Ottumwa, Iowa, in 1883; his training was at the Chicago Institute and in New York at the Art Students League with George Bridgeman. In fact, one of his important teachers was Fanny Munsell, who later became his wife. She was an accomplished illustrator in her own right as a contributor to *Cosmopolitan*, *Woman's Home Companion*, and other national magazines. Chambers clearly modeled his style and technique on hers. Unfortunately, her career was cut short by her early death in 1920, and now sadly almost forgotten.Some of Chambers's early professional illustrations were centered on a series of short stories about a clever con man know as "Get Rich Quick Wallinford," whose antics gave Chambers opportunities to depict events of dramatic action and humor, enhancing the stories and the artist's popularity in the process. A later popular series of stories of rural China by Noble-prize-winning author Pearl Buck was published by *Cosmopolitan* in the 1930s with Chambers's sympathetic interpretation of peasant families caught up in the intrigues of the Chinese Warlords. Chambers worked under exclusive contract for *Cosmopolitan* for several years, and, in addition to Buck, illustrated such authors as Louis Bromfield, Faith Baldwin, and W. Somerset Maugham.

It was Chambers's use of color that was his greatest strength. He had become a regular contributor to *Harper's Monthly* in the 1910s, often with the lead story. His fiction illustration was expanded to include most of the major women's magazines and for their covers as well, including a dramatic series of cover designs for *Redbook*.

In the 1920s Chambers was commissioned by Steinway & Sons to paint portraits of the leading pianists of the day, including Sergei Rachmaninoff, Josef Hoffman, Paderewski, and Alfred Cortot, which were widely reproduced. A parallel popular series of paintings was commissioned by Chesterfield (cigarettes) for billboard advertising among which was cited "one of the most beautiful posters ever painted," as reported by the trade publication *Advertising Outdoors* in 1931.

His billboards for Palmolive Soap also set high standards for the field of outdoor advertising, and another outstanding poster was his painting for the Red Cross in 1933, posed for by Pauline True, his most frequent model and subsequent wife.

Among Chambers's numerous awards was the second Altman Prize at the National Academy of Design exhibition in 1931 for his portrait of watercolorist and fellow-illustrator John Alonzo Williams.

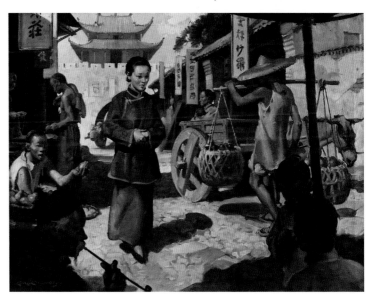

FACING PAGE: *Discussion over Tea*. Oil on canvas. 33 inches x 24 inches. Courtesy of the Museum of American Illustration at the Society of Illustrators. All other images courtesy of Illustration House. RIGHT: Illustration for *Sons*, Pearl Buck's sequel to *The Good Earth*, *Cosmopolitan*. Oil on canvas. Photo of the artist in his studio, *Harper's Bazaar*, 1915.

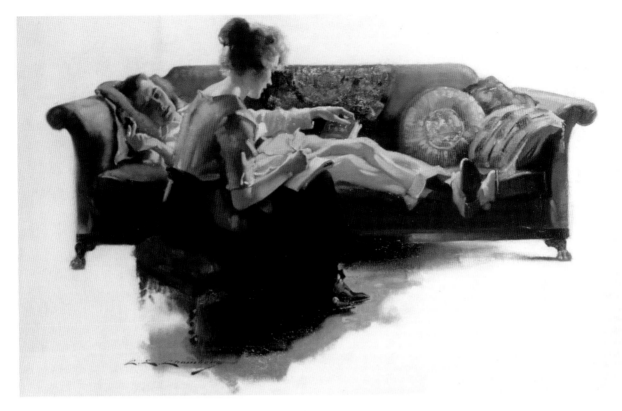

One of the best analysts of Chambers's working methods was the art editor John D. Whiting, whose book, *Practical Illustration: A Guide for Artists*, in 1920, outlined the artist's process:

Probably no living American better typifies the successful illustrator than Charles E. Chambers. How does he do it? The student will find in Chambers's illustrations a good working model of practical illustrative technique. If you have access to any of these paintings, do by all means study them well. If this is impossible you can at least study the prints through a magnifying glass. You will find that there is nothing extraordinary or abnormal about the workmanship. They are remarkable rather for the absence of any particular mannerism, and this is one secret of their successful reproduction.

The original paintings by Mr. Chambers are exceedingly round and soft in treatment. The passages between the different surfaces are seldom hard edges of one plane against the other. They are almost always 'opened up' by an additional value which, however strong the contract, is soft enough in edges to produce an atmospheric effect.

These drawings range from clear white to jet black and therefore print well, whatever the size of the addition. But the transitions are so open and gentle that they often appear to be done in a limited range. When reduced they are clear enough to be intelligible to the literal, and yet soft enough to please the eye of the connoisseur.

While preoccupied with technique and the tastes of the 1920s and 1930s, Whiting's comments are still pertinent to a realistic illustrator. Chambers's originals do stand the test of time and have much to be admired and to inspire a contemporary painter and illustrator.

WALT REED
Illustration House

FACING PAGE: Illustration for *Dare's Gift* by Ellen Glasgow, *Harper's*. Oil on canvas. TOP: *Young Woman Reading to Man on Sofa*. BELOW: *Cover Girl*.

EARL OLIVER HURST

[1895–1958]

"Study Hurst's line carefully," wrote Ernest Watson in a 1942 profile in *American Artist* magazine, "You will see how it fluctuates, now full and lush as it accents some dominant action, now delicate as it defines a subtle bit of expression; but always sensitive, directed by complete knowledge and technical mastery."

Watson goes on to say: "You will never find a deliberately drawn line in a Hurst illustration: only a swift-moving brush will produce that sense of alive-ness which is the essential characteristic of his work."

Earl Oliver Hurst was born in Buffalo, New York, in 1898. After a stint in World War I, he took night classes at the Cleveland School of Art while working days at *The Plain Dealer*, where he drew political cartoons and fashion illustrations. From there he took a job as art director at a direct mail house. It was while in this position that he discovered his covers for booklets were being pirated and used on national magazines. Hurst saw this as patently unfair and on leaving the studio job, set out to make himself visible in broader markets. He reasoned that if he had time to experiment, he could put himself into a nationally prominent position, so he explored his skills in seclusion. But without the discipline of client-imposed deadlines, Hurst's work began to suffer—as did his finances—so he came out of exile. But the artist was unsure of how to pick up where he had left off in his career.

He went to his friend, art director Chester Siebold of General Electric, for advice. Siebold encouraged him to take his efforts to a higher level. He said, "I want you to promise me that in the future you will not make one drawing for each assignment, but three or four, then deliver the best one of the lot." The artist was aghast, but agreed to try it. Following Siebold's advice, Hurst executed five fully realized drawings for one job. Years later he recalled, "As I examined those five drawings, standing against my studio wall, I was really shocked to think that according to former procedure I would have delivered the first one, truly a fumbling performance compared with the subsequent drawings."

The 1942 *American Artist* article detailing his working methods, quotes Hurst as saying, "In every illustration I first put down on paper, in pencil, my impression of the entire situation, no matter how poorly conceived or how far from fact it really is ... I find it saves a great deal of time to make several little thumbnail compositions of a convenient size. I do like to do these note sketches about two or three inches high, and in a few quick strokes of the pencil lay in the basic pattern of the composition."

His compositional control through strong lines and bold colors is, probably more than any other single factor, his enduring legacy. In the case of magazine cover illustrations, Hurst considered "the idea [to be] the first hurdle." Working from the dominant shapes of the compositional sketch, he was able to build his ideas into the framework.

"Not until his conception matures does Hurst take up his brush and begin his final drawings on heavy watercolor paper," Ernest Watson wrote in the *American Artist* profile that was later published in the book *Forty Illustrators and How They Work*. Hurst executed his finishes in black India ink and waterproof colored ink washes. His choice of media kept the work bold while giving him a maximum of flexibility to heighten or lessen details and depth.

"Where the color washes flow over the black lines they soften them. When pure black lines are wanted, perhaps in the foreground, Hurst leaves those lines until the last, drawing them on top of the washes. He never attempts to go over a line to strengthen it; in doing this, he declares, he would lose that which he most prizes—spontaneity," explains the chapter on Hurst in *Forty Illustrators*.

The fact that the colors remained fresh allowed Hurst to keep the utmost confidence in his lines. He wrote in an *American Artist* article from February 1950, "The width of line in the original is important. A fine line can be beautiful, and faithfully reproduced, providing the artist understands just how much diminution in size the art will take.... Generally it is best to work close to the size of reproduction—or as small as is convenient."

Hurst was interviewed for an article in *Great Neck News* (New York) in 1932. Part of the article provides a glimpse at the key element that set Hurst apart from most of his contemporaries:

FACING PAGE: *Blonde Skier Waving*. Magazine cover for *Saturday Home* magazine, King Features Syndicate newspaper insert. Watercolor. 20 inches x 15 inches. Courtesy of the Museum of American Illustration at the Society of Illustrators. Photo of artist courtesy of Taraba Illustration Art.

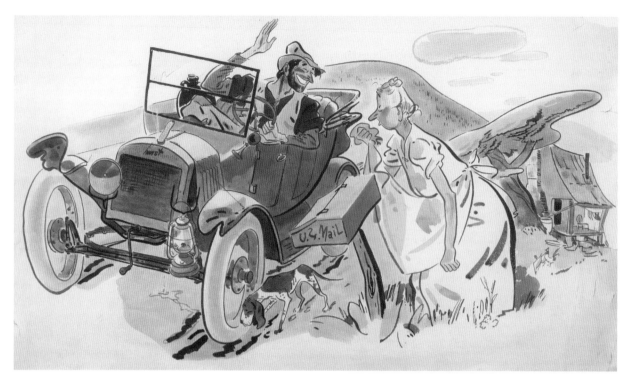

"Mr. Hurst has a theory that his illustrations should be decorative as well as illustrative.... He pays special attention to the lost and found quality of his line and by how it catches and directs that attention to the reader." This came at a time when much of the illustration was becoming more reliant on photo reference. However, Hurst truly believed that "it is part of the artist's job to exaggerate or minimize to bring about a desired impression."

In his 1949 interview with Hurst, art director Joe Lopker points out how little in the way of personal expression there was in American illustration due to the industry's reliance on photography. Hurst replied, "Well, of course, my work is the answer to that.... I've tried photography but find that instead of helping me, it slows me up." He combined the exaggeration of perspective and character with an attraction to the decorative possibilities of general interest illustration to help forge a new type of illustration. His vision was tricky for others to duplicate since many of his characters sprang directly from Hurst's own memory and imagination.

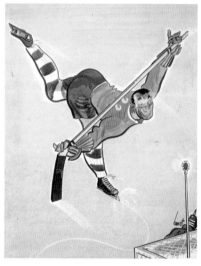

By the late 1930s, Hurst had arrived, with two one-man shows at the Society of Illustrators, one in 1939 and one in 1940. He and his family divided their time between Manhattan and Douglaston, Queens, where they kept a boat. In the summer they would sail to Maine for relaxation.

As his illustration style became more sought after, his efforts continued to improve because he found the busier he got, the more productive he became. Ernest Watson explains, "Hurst says he works best under such pressure, but without efficient organization he could not satisfy his clients." From the early 1940s through the end of his career he employed an assistant to lessen the tiresome elements of his work.

The illustrator combined his talents into a highly successful career, though not without bumps in the road. Among the many magazine for which Hurst did regular commission work were *Collier's*, *American*, *Pictorial Review*, *McCall's*, *Ladies' Home Journal*, and *True*. His advertising clients included Nabisco, Royal Crown Cola, General Electric, Sanka, Jantzen Swim Suits, and Swan Soap.

Beyond the good design apparent in Hurst's work there lies an outlook on life and a sense of humor that is the fuel for the creative engine. The profile in *Forty Illustrators and How they Work* defines the artist's whimsical nature this way: "Hurst's humor is that of character. It springs from a deep understanding of human nature and a feeling of sympathy—albeit mirthful—for those who find themselves victims of predicaments.... Some of his biggest laughs have been at his own expense."

FREDERIC B. TARABA
Founder of Taraba Illustration Art and author of Masters of American Illustration: 41 Illustrators and How They Worked, *from The Illustrated Press.*

ABOVE: "'Pshaw now!' Was Cully's fust words." Illustration for "The Happiest Man in the World" by Frederick H. Brennan. *Collier's*, March 30, 1940. Colored inks, watercolor. Courtesy of the Museum of American Illustration at the Society of Illustrators. BELOW: Cover illustration for *Tab*, 1945. Courtesy of Taraba Illustration Art. FACING PAGE: *Come On You Sunners!* Version of advertisement for Jantzen Swim Suits. Courtesy of Taraba Illustration Art.

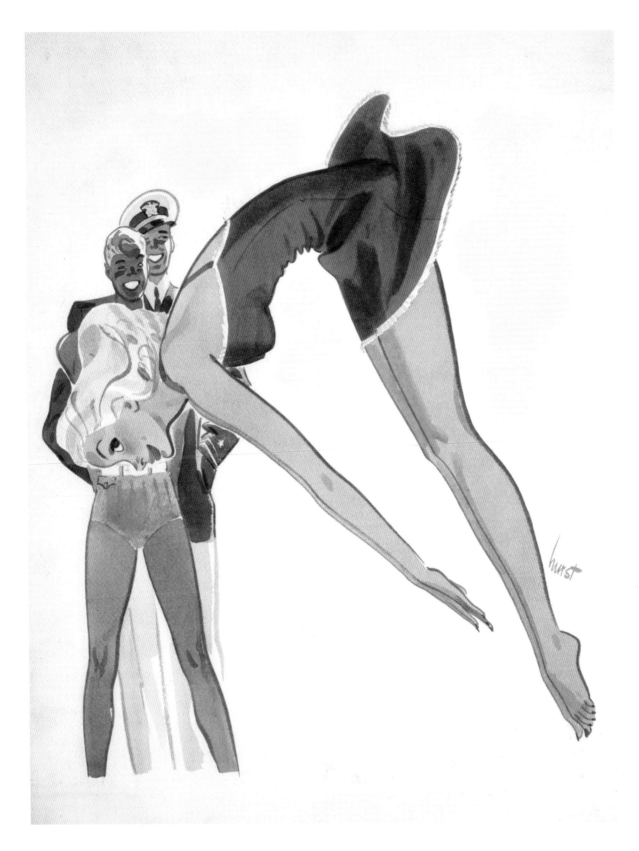

HALL OF FAME 2010
ORSON BYRON LOWELL
[1871–1956]

It was as a social critic and commentator that illustrator Orson Lowell hit his stride. Throughout his career, his body of work shows his love of watching people and their foibles in awkward situations—yet the slings and darts he used on his subjects are meant in fun and are not caustic or mean-spirited.

The artist's good-natured personality kept him active in the illustration field for more than 60 years. As he told an interviewer, "Appearance of good work must show that the artist has had a lot of fun out of it.... When I have several visions of beautiful pictures and ideas in my mind I am restless until I can get them off my chest."

Lowell was born in Wyoming, Iowa, in 1871. From childhood, his illus-

trative efforts had been accepted and embraced on a variety of levels. The artist's father, a landscape painter, encouraged, even pushed him to draw. In 1882, the family moved to Chicago, where Lowell attended public school until 1887, when he began taking classes at the prestigious Art Institute of Chicago. There Lowell studied with J.H. Vanderpoel and Oliver Dennett Grover. Beyond his sense of personal satisfaction, Lowell spread his enthusiasm to others during his last year at the Art Institute, teaching elementary classes. While still in school, he also created pictures for local magazines including *The Spark* and *American Commercial Traveler.*

In November of 1893, Lowell moved to New York City to build his career and reputation in earnest. As the commissions from art directors began rolling in, it was apparent that his style was unique. According to an article in the June 1896 issue of *The Book Buyer* magazine, "Mr. Lowell has the rarest quality of an illustrator. He is original; he has a

way of his own to look at things and a manner thoroughly his own to render what he sees. His scenes, his types, and his imaginative work, are all singularly vivid and graphic."

By 1905 Lowell's work was in high enough demand to allow him to buy a house in New Rochelle while maintaining his studio in New York. New Rochelle came to be an illustrators' community soon after his arrival. Residents there included Norman Rockwell, Edward Penfield, J.C. Leyendecker, Franklin Booth, and Coles Philips.

Lowell's close association with a number of the top magazines of his day not only made him famous, but afforded him the opportunity to befriend generations of other illustrators. His popularity can be summed up by a listing of the magazines for which he illustrated,

ABOVE: Photo of artist in his 22nd Street studio. Courtesy of Taraba Illustration Art. FACING PAGE: *The Jury.* "We, the members of the Jury, find the defendant Not Guilty. On the first ballot the vote was eleven for conviction and one for acquittal." Pen and ink on board. Courtesy of the Museum of American Illustration at the Society of Illustrators.

including *Scribner's*, *Century*, *The Saturday Evening Post*, *McClure's*, *Everybody's*, *Cosmopolitan*, *Metropolitan Life*, *Ladies' Home Journal*, *Judge*, *Woman's Home Journal*, *Leslie's Weekly*, *Puck*, *Vogue*, *Delineator*, *McCall's*, and *Redbook*.

As a humorist focusing on social life in New York, Lowell was not one to stay sequestered in his studio. He joined most of the arts clubs during what was certainly the heyday of club life in New York and held position in many of them. Among these were The Players' Club, the Society of Illustrators (where he was among the first group of non-founding members), The Guild of Free Lance Artists (where he served as president 1924-25), The New Rochelle Art Association, and The New Rochelle Public Library (where he was a trustee from 1930-1944).

Despite his notoriety, the artist took chances in his career and did things many other illustrators of his day wouldn't have done. For instance, in 1911 Lowell put together a traveling exhibition of more than 100 of his original works, mainly from *Life*, which were offered for sale at prices ranging from $10 to $100. The show opened at the Art Institute of Chicago and for the next several years enjoyed great success in every corner of the country. Explaining the contents of his exhibition in a promotional flyer, Lowell wrote, "The subjects are social in character, humorous and satirical, but not acrobatic. They are not comics and there are no political cartoons."

As the magazine world changed, Lowell was always anxious for a new outlet. By the late 1920s his whimsical verses were being published

CLOCKWISE FROM TOP: Illustration for *Life*, c. early 1900s. A married woman with a "young cub." She: "Sh! That sounds like my husband's step." He: "Hang it, he's getting so he leaves us no time to ourselves at all." Pen and ink; *Turkish Pirate Shocks Card Players*. Illustration for *Life*. Pen and ink; A sketch for a pulp fiction illustration in the 1930s. Lowell's note: "The jealous husband or disappointed suitor of this woman has killed his rival and sent his head to her." Sketch for *Collier's* magazine cover. It is unclear whether this was ever executed as a finished version. All images courtesy of Taraba Illustration Art.

by, among others, *House Beautiful*. One of his best, which appears not to have been published, was titled, "Advice to a Young Artist Ambitious to Break into the Game of Illustration," a satire on how to get your work on the cover of *The Saturday Evening Post*—something he never did.

The artist's skills translated well to book illustration, with which he was particularly active early on. He said in an interview for *The Authors Guild Bulletin* of May 1919. "Really, you know, any picture ought, in some way to so closely associate itself with the particular text for which it was made that it won't do for any other. I think most of us try to do this, but we don't always succeed." The artist knew that simply drawing a picture for text did not amount to illustration.

As Lowell noted in the same interview, "The competent illustrator knows—has to know—a lot of things besides drawing and composition. And page decoration, which, after all, is what the best illustration amounts to, for not every picture, no matter how good, can be put on a magazine page to its adornment." Beyond Lowell's artistic abilities, what mattered most in his career was his sense of humor, which was linked inseparably with his sense of himself. The fact that he loved what he did made the occasional disappointment more palatable. As Lowell told *The New Rochelle Pioneer*: "The best illustrations I ever made did not please the author at all, though everyone else liked them. When on delivering another manuscript the editor asked him

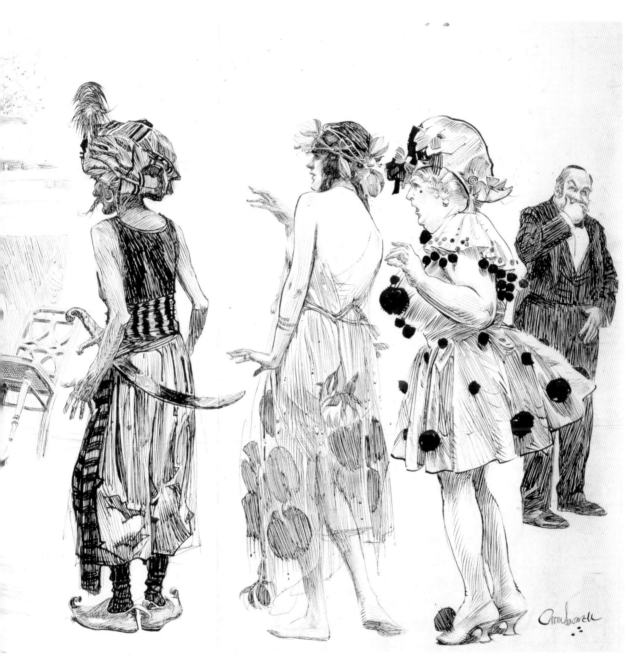

who he'd like to have illustrate it, he said he didn't care so long as I didn't get a hold of it."

Lowell's impact, at least from the 1890s through 1920, is difficult to overstate. Shortly after the artist's death in 1956, *The New York Times* ran an article about the discovery of many of his works from the early 1900s. In the article, the former president of the New Rochelle Art Association, Fell Sharp said, "Mr. Lowell did for American society what Frederick Remington did for the Southwest and Toulouse-Lautrec did for the music halls of Paris. He was an artist with a reporter's nose for a good story."

Today, more than 50 years after his death and a full century after he had established himself as a talented, successful illustrator, a careful inspection of Lowell's originals show a verve and self-assurance rarely seen before or since. In recent decades it seems to have become increasingly tempting to compare him to the mighty Charles Dana Gibson. While Lowell did follow Gibson at *Life*, the depth and appeal of Lowell's work carry far beyond a simplistically-viewed subject matter. Yet, reading the accounts of the time, he had a devoted following and a unique position during his tenure, quite separate from Gibson's impact on the world of popular American art.

FREDERIC B. TARABA
Founder of Taraba Illustration Art and author of Masters of American Illustration: 41 Illustrators and How They Worked, *from The Illustrated Press.*

1958 Norman Rockwell
1959 Dean Cornwell
 Harold Von Schmidt
1960 Fred Cooper
1961 Floyd Davis
1962 Edward Wilson
1963 Walter Biggs
1964 Arthur William Brown
1965 Al Parker
1966 Al Dorne
1967 Robert Fawcett
1968 Peter Helck
1969 Austin Briggs
1970 Rube Goldberg
1971 Stevan Dohanos
1972 Ray Prohaska
1973 Jon Whitcomb
1974 Tom Lovell
 Charles Dana Gibson*
 N.C. Wyeth*
1975 Bernie Fuchs
 Maxfield Parrish*
 Howard Pyle*
1976 John Falter
 Winslow Homer*
 Harvey Dunn*
1977 Robert Peak
 Wallace Morgan*
 J.C. Leyendecker*
1978 Coby Whitmore
 Norman Price*
 Frederic Remington*
1979 Ben Stahl
 Edwin Austin Abbey*
 Lorraine Fox*
1980 Saul Tepper
 Howard Chandler Christy*
 James Montgomery Flagg*

1981 Stan Galli
 Frederic R. Gruger*
 John Gannam*
1982 John Clymer
 Henry P. Raleigh*
 Eric (Carl Erickson)*
1983 Mark English
 Noel Sickles*
 Franklin Booth*
1984 Neysa Moran McMein*
 John LaGatta*
 James Williamson*
1985 Robert Weaver
 Charles Marion Russell*
 Arthur Burdett Frost*
1986 Al Hirschfeld
 Rockwell Kent*
1987 Maurice Sendak
 Haddon Sundblom*
1988 Robert T. McCall
 René Bouché*
 Pruett Carter*
1989 Erté
 John Held Jr.*
 Arthur Ignatius Keller*
1990 Burt Silverman
 Robert Riggs*
 Morton Roberts*
1991 Donald Teague
 Jessie Willcox Smith*
 William A. Smith*

1992 Joe Bowler
 Edwin A. Georgi*
 Dorothy Hood*
1993 Robert McGinnis
 Thomas Nast*
 Coles Phillips*
1994 Harry Anderson
 Elizabeth Shippen Green*
 Ben Shahn*
1995 James Avati
 McClelland Barclay*
 Joseph Clement Coll*
 Frank E. Schoonover*
1996 Herb Tauss
 Anton Otto Fischer*
 Winsor McCay*
 Violet Oakley*
 Mead Schaeffer*
1997 Diane and Leo Dillon
 Frank McCarthy
 Chesley Bonestell*
 Joe DeMers*
 Maynard Dixon*
 Harrison Fisher*
1998 Robert M. Cunningham
 Frank Frazetta
 Boris Artzybasheff*
 Kerr Eby*
 Edward Penfield*
 Martha Sawyers*
1999 Mitchell Hooks
 Stanley Meltzoff
 Andrew Loomis*
 Antonio Lopez*
 Thomas Moran*
 Rose O'Neill*
 Adolph Treidler*

2000 James Bama
 Alice and Martin* Provensen
 Nell Brinkley*
 Charles Livingston Bull*
 David Stone Martin*
 J. Allen St. John*
2001 Howard Brodie
 Franklin McMahon
 John James Audubon*
 William H. Bradley*
 Felix Octavius Carr Darley*
 Charles R. Knight*
2002 Milton Glaser
 Daniel Schwartz
 Elmer Simms Campbell*
 Jean Leon Huens*
2003 Elaine Duillo
 David Levine
 Bill Mauldin*
 Jack Potter*
2004 John Berkey
 Robert Andrew Parker
 John Groth*
 Saul Steinberg*
2005 Jack Davis
 Brad Holland
 Albert Beck Wenzell*
 Herbert Paus*

2006 Keith Ferris
Alvin J. Pimsler
Jack Unruh
Gilbert Bundy*
Bradshaw Crandall*
Hal Foster*
Frank H. Netter, M.D.*
2007 David Grove
Gary Kelley
Edward Windsor Kemble*
Russell Patterson*
George Stavrinos*
2008 Kinuko Y. Craft
Naiad Einsel
Walter Einsel*
Benton Clark*
Matt Clark*
2009 Paul Davis
Arnold Roth
Mario Cooper*
Laurence Fellows*
Herbert Morton Stoops*
2010 Wilson McLean
Chris Van Allsburg
Charles Edward Chambers*
Earl Oliver Hurst*
Orson Lowell*

*Presented posthumously

2010 HAMILTON KING AWARD
AND
RICHARD GANGEL ART DIRECTOR AWARD

The Hamilton King Award, created by Mrs. Hamilton King in memory of her husband through a bequest, is presented annually for the best illustration of the year by a member of the Society. The selection is made by former recipients of this award and may be won only once.

The Richard Gangel Art Director Award was established in 2005 to honor art directors currently working in the field who have supported and advanced the art of illustration. This award is named in honor of Richard Gangel (1918 – 2002), the influential art director at *Sports Illustrated* from 1960 to 1981, whose collaboration with illustrators during that period was exceptional.

JOHN JUDE PALENCAR
[b. 1957]

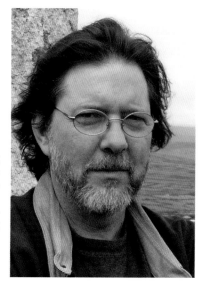

Embers float above the fire pit, mix with curling tobacco smoke, and eventually disappear into the night sky. The tip of his cigarette glows in the dark and you can almost see the flash of a smile. "Every artist should burn his art from time to time," John Jude Palencar says, his eyes flickering as he watches one of his paintings blacken and disappear into ash. "It's quite cathartic."

Lyendecker. Rockwell. Wyeth. English. Peak. McGinnis. Frazetta...

What makes a great illustrator? I would guess that it's some unusual formula, an arcane amalgam of education, focus, style, ambition, empathy, and intuition. What proportions of each ingredient might be necessary to make the transformation occur, I really haven't a clue.

While I may not know precisely what it takes for someone to reach that illusive tipping point, to magically make the leap from "good" to "great"... I know it when I see it.

I first became aware of John Jude Palencar when I saw his paintings for a Byron Preiss "treasure hunt" book, *The Secret*, in 1982. Though John Jude tends to cringe whenever I bring it up—it was one of his earliest professional jobs—I recognized then something special in the work, that there was a unique sensibility on display. I was definitely impressed and I most certainly wanted to see more. Much more.

Born in 1957 in Cleveland, Ohio, John Jude began drawing while watching instructional art programs on PBS with his mother. Headstrong, hyperactive, and precocious in grade school, he ran afoul of the nuns, who repeatedly whacked him with their rulers to force the young southpaw to write and draw (ultimately to their chagrin) right-handed. He began having one-kid art shows in his classes, while selling drawings of naked ladies to the other students on the side. "The black crayon was always my favorite," he remembers with a grin.

John Jude was mentored by his high school art teacher, Frederick C. Graff, and was offered multiple scholarships upon graduation; he chose to attend the Columbus College of Art and Design and graduated with a BFA in 1980. In his senior year, the Society of Illustrators awarded him a scholarship to attend the Illustrators Workshop in Paris; his studies with Mark English, Bernie Fuchs, Bob Peak, and other giants in the field had a profound effect on him and helped determine the course his career would ultimately take.

John Jude plunged headfirst into the freelance world and never looked back. With clients from *Psychology Today* to *National Geographic*, from the Philadelphia Opera to Tor books, he quickly established himself as an artist of significance, someone whose work is affecting and effective. With a muted color palette and characters that exhibit an almost languid beauty (and subtle hint of melancholy), John Jude's art is unlike that of anyone working today. He could become a portraitist or gallery painter in a heartbeat, but chooses to work largely within publishing's fantasy genre for the intellectual challenges it offers. His solutions tend to be the complete opposite of what's expected; through his sophistication he elevates both the subject matter and the field as a whole. John Jude Palencar's art is distinguished—and distinguishable—by both its style *and* its substance.

That he admits to occasionally taking pieces he doesn't like—published or not—to a pit behind his studio and burning them, horrifies listeners, but the practice is a reflection of not only his humility, but his innate desire to never become complacent as an artist.

The Hamilton King Award is often seen (unofficially, anyway) as a mid-career benchmark; when it comes to John Jude I can't help but think of it as another manifestation of his precociousness. I don't see him at a mid-way point in his career; I see him as just now getting up a full head of steam.

Brodner. Deas. De Sève. Kunz. Craft. Heindel. Manchess... Palencar.

I may not know what exactly makes a great illustrator, but as I said, I know one when I see one.

Congratulations, John Jude, on this richly deserved honor.

ARNIE FENNER
Co-Director of Spectrum Fantastic Art LLC
Editor, with Cathy Fenner, Origins: the Art of
John Jude Palencar, *Underwood Books.*

Muse and Reverie for art director Irene Gallo at TOR Books.

RICHARD GANGEL AWARD 2010
DJ STOUT

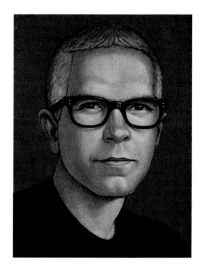

For better than 20 years now, one of the exciting calls an illustrator can get is from a guy in Texas named DJ. Don't believe me? Here's a short list of people who've happily accepted his commissions: Stephen Alcorn, Julian Allen, Marshall Arisman, Gary Baseman, Melinda Beck, Mike Benny, Cathie Bleck, Barry Blitt, Braldt Bralds, Steve Brodner, Joe Ciardiello, Alan E. Cober, John Collier, Brian Cronin, Tom Curry, Paul Davis, Gerard Dubois, Randy Enos, Douglas Fraser, Milton Glaser, Melissa Grimes, Eddie Guy, Richard Hess, Jody Hewgill, Brad Holland, Jason Holley, Gary Kelley, Anita Kunz, Zohar Lazar, Ross MacDonald, Matt Mahurin, James Marsh, Marvin Mattelson, Wendell Minor, Robert Neubecker, Christian Northeast, Steve Pietzsch, Hanoch Piven, Anthony Russo, Jeffrey Smith, Brian Stauffer, Dugald Stermer, Ward Sutton, Mark Ulriksen, and David Wilcox. And that's just the tip of the iceberg.

Starting out in 1981 at Robert A. Wilson Associates, DJ commissioned work from the likes of Gerry Gersten, Geoffrey Moss, and Jack Unruh, and in 1987, when he took over the position of art director at *Texas Monthly* vacated by fellow Richard Gangel award-winner Fred Woodward, he began drawing attention for his award-winning publication design. For the next 13 years, he filled that magazine with stellar art and photography, and in the process garnered ten National Magazine Award nominations for *Texas Monthly*—and won the coveted award three of those times. In January of 2000, DJ was invited to become a partner at Pentagram Design, and in the following ten years has continued that long-standing association, working with both emerging illustrators and top names in the field on a variety of projects, from magazines to packaging and corporate branding. Those images have appeared regularly in the pages of the Society's and other annuals, and have won many awards for the artists involved. Along the way, DJ's design work has become part of permanent collections that include the Cooper-Hewitt, National Design Museum in New York; the Museum of Fine Arts, Houston; the Dallas Museum of Art; the Harry Ransom Center; and the Library of Congress, to name just a few.

However, DJ's enthusiasm for illustration doesn't end with commissioning great art. For the Society of Illustrators 39th annual, for example, he designed the Call for Entries poster, and for the second Illustration Conference in Santa Fe in 2000, he designed the logo, poster, and collateral materials free of charge, even arranging for the contribution of the paper and printing. And in 2005, when the Society was looking for a redesign of the annual, DJ and Pentagram stepped in again, creating the beautiful format for the book you now hold in your hands.

The reason so many giants in our field want to work with DJ Stout is that he genuinely understands the power of what they do, and when they get his call they know the project will suit them perfectly. That's because he is that rare designer who takes the time to see through artists' eyes, and to stand behind that vision in the editorial process. For artists, that means the freedom to do what they do best. It's the mark of a truly trusting and supportive art director, and I can think of no one more deserving of this award than DJ.

MARC BURCKHARDT

Portrait by Marc Burckhardt.

Hamilton King Award

[1965–2010]

1965 Paul Calle	1974 Fred Otnes	1984 Braldt Bralds	1992 Gary Kelley	2002 Peter de Sève
1966 Bernie Fuchs	1975 Carol Anthony	1985 Attila Hejja	1993 Jerry Pinkney	2003 Anita Kunz
1967 Mark English	1976 Judith Jampel	1986 Doug Johnson	1994 John Collier	2004 Michael Deas
1968 Robert Peak	1977 Leo & Diane Dillon	1987 Kinuko Y. Craft	1995 C.F. Payne	2005 Steve Brodner
1969 Alan E. Cober	1978 Daniel Schwartz	1988 James McMullan	1996 Etienne Delessert	2006 John Thompson
1970 Ray Ameijide	1979 William Teason	1989 Guy Billout	1997 Marshall Arisman	2007 Ted Lewin
1971 Miriam Schottland	1980 Wilson McLean	1990 Edward Sorel	1998 Jack Unruh	2008 Donato Giancola
1972 Charles Santore	1981 Gerald McConnell	1991 Brad Holland	1999 Gregory Manchess	2009 Tim O'Brien
1973 Dave Blossom	1982 Robert Heindel		2000 Mark Summers	2010 John Jude Palencar
	1983 Robert M. Cunningham		2001 James Bennett	

Richard Gangel Art Director Award

[2005-2010]

2005 Steven Heller

2006 Fred Woodward

2007 Rita Marshall

2008 Patrick J.B. Flynn

2009 Gail Anderson

2010 DJ Stout

Editorial

GUY BILLOUT
ILLUSTRATOR, AUTHOR

Born in France, Guy moved to New York in 1969 with 14 unpublished drawings as a portfolio, an autobiography illustrating an American ambition by a daydreamer. Milton Glaser published the story in *New York* magazine in August 1969. Guy's very first assignment was commissioned by Bob Ciano, art director at *Redbook*. After that, his best achievements were: illustrating a full page, with editorial freedom, six times a year for 24 years in *The Atlantic Monthly* for art directors Judy Garlan and Mary Parsons; writing and illustrating nine children's books, five of them selected by *The New York Times* for their annual list of 10 best illustrated children's books.

MAXIMILIAN BODE
ART DIRECTOR, *THE NEW YORKER*, ILLUSTRATOR

Maximilian Bode is a New York–based artist and art director for *The New Yorker*. He graduated from Pratt Institute in 2004 with a BA in communication design. His work can be found on clothing, in the pages of magazines and newspapers, and in the galleries of Chelsea. Max has been a guest lecturer at the Society of Illustrators, Parsons, and the School of Visual Arts, and he was on the jury for *American Illustration*'s 28th annual.

LARRY GENDRON
DEAL LLC

Larry Gendron is the founding art and design director for Deal Llc, a multi-media business and financial company. He has over 30 years of experience in design in advertising and publishing, having previously worked for N.W. Ayer, *Sports Illustrated*, *Financial World*, *Corporate Finance*, and Forbes Special Publishing Group. Throughout his career, Larry has worked actively with illustrators. He has won numerous awards for design and commissioned work from *Art Direction*, *Creativity*, *Folio*, and the Society of Illustrators. He lives in New York City and has a studio in Washington, Connecticut, where he works on large abstract paintings. An avid fly fisherman and naturalist, Larry serves on the board of Steep Rock Association.

LUBA LUKOVA
ARTIST, DESIGNER

Luba Lukova is an internationally recognized artist and designer based in New York. Her powerful work uses an economy of line, color, and text to pinpoint essential themes of the human condition. Solo exhibitions include UNESCO, Paris; DDD Gallery, Osaka, Japan; La MaMa, New York; and The Art Institute of Boston. Awards include: Grand Prix Savignac, International Poster Salon, Paris; and Golden Pencil, One Club, New York. She has received commissions from Adobe Systems, Sony Music, Canon, Harvard University, the Cultural Ministry of France, and War Resisters League. Luba's work is represented in the permanent collections of MoMA, New York; The Library of Congress, and Bibliotheque nationale de France. She holds an honorary degree of Doctor of Fine Arts from Lesley University, Cambridge, Massachusetts.

MATT MAHURIN
IMAGE MAKER, EDUCATOR

For over 25 years Matt Mahurin has been an image maker and teacher. He has done political and social illustrations for *Time, Newsweek, Mother Jones, Rolling Stone, Esquire, The London Observer,* and *The New York Times* Op-Ed pages. He has published photographic essays on the homeless, people with AIDS, Texas prison system, abortion clinics, mental hospitals, Nicaragua, Haiti, Belfast, Mexico, Japan, and France, as well as three books of personal fine-art photographs. His photographs are in the permanent collection of the Metropolitan Museum of Art in New York City. He directed music videos for Peter Gabriel, U2, REM, Tracy Chapman, Sting, Bonnie Raitt, Ice-T, Metallica, David Byrne, and Joni Mitchell. He wrote and directed *FEEL,* which premiered on The Sundance Channel in 2010, and his documentary, *I Like Killing Flies,* was chosen for the 2004 Sundance Film Festival. He has received Gold and Silver Medals from the Society of Illustrators.

HANOCH PIVEN
ILLUSTRATOR

Hanoch Piven has been making his distinctive collage caricatures since 1990. They have appeared on the pages of major publications on both sides of the Atlantic, including *Time, Newsweek, The New Yorker, Rolling Stone, The Times* (London), *The Guardian,* and Israel's *Ha'aretz.* His work is in the permanent collection of the Library of Congress in Washington, D.C. A recipient of a Society of Illustrators Gold Medal in 1994, Piven has published six children books in the United States, notably, *What Presidents Are Made Of,* selected by *Time* as one of the Ten Best Children's Books of 2004. Piven has led dozens of creative art workshops all over the world, and has worked with populations ranging from infant cancer patients in hospitals to street kids in Guatemala City to CEOs of companies. His latest endeavors have included TV programs in Israel and Spain, and an iPhone App, Faces iMake.

DJ STOUT
PENTAGRAM

DJ Stout is a fifth generation Texan born in the small West Texas town of Alpine. He received his degree in design communication from Texas Tech University in Lubbock, where he was honored as a distinguished alumnus. Between 1987 and 1999 he was art director of *Texas Monthly,* where he helped guide the magazine to three National Magazine Awards. DJ joined Pentagram's Austin office as a partner in 2000. In 1998 *American Photo* magazine named him one of its "100 Most Important People in Photography," and in 2004 *I.D. (International Design)* magazine selected him for "The *I.D.* Fifty," its annual listing of design innovators. He currently serves on the board of directors of the Austin chapter of American Institute of Graphic Arts (AIGA).

ROBERT ZIMMERMAN
BUG LOGIC

Robert Zimmerman is the creator and day-to-day manager of Drawger.com and illoz.com, as well as other web projects such as Ohger.com (a site devoted to students of illustration) and Tutormill.com (an online mentoring site for students of illustration). Zimmerman's business, Bug Logic, is located in Asheville, North Carolina.

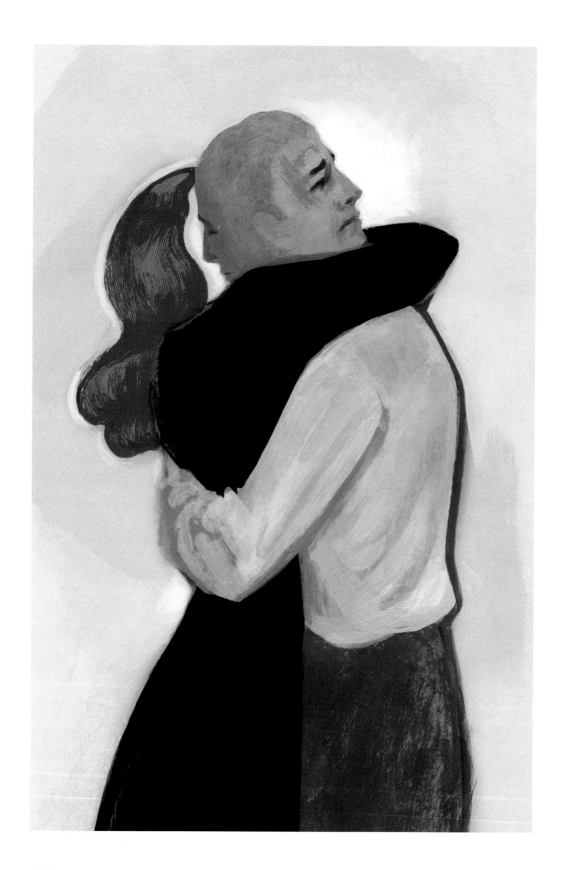

GOLD MEDAL WINNER
JULIA BRECKENREID

Double Life
This image accompanied a personal essay concerning a woman's husband who lied to her about being gay during their twenty-year marriage. There were two variations. One portrayed the husband as you see here and the other showed his feet walking in another direction while embracing the wife. I thought they were both interesting, but felt the viewer may read into and linger a little longer on what became the final image: the dual faces, her arm naturally/unnaturally holding his neck. Luckily for me, art director Faith Cochran thought so as well.

Queens of Swords

I am not really sure if there is a rational explanation behind this silly little drawing. I used to paste these stamps in my sketchbooks and draw over the top of them. I loved the contrast of the beautiful craftsmanship and stoic nature of the stamp and the playful, graffiti-like gesture of absurdity. It makes me smile. You know, that call from the Society about this Medal came at a time when I was going through a lot of hand holding with art directors and way too many revised sketches. The timing was perfect—it brought me back off the edge of the building. Thank you.

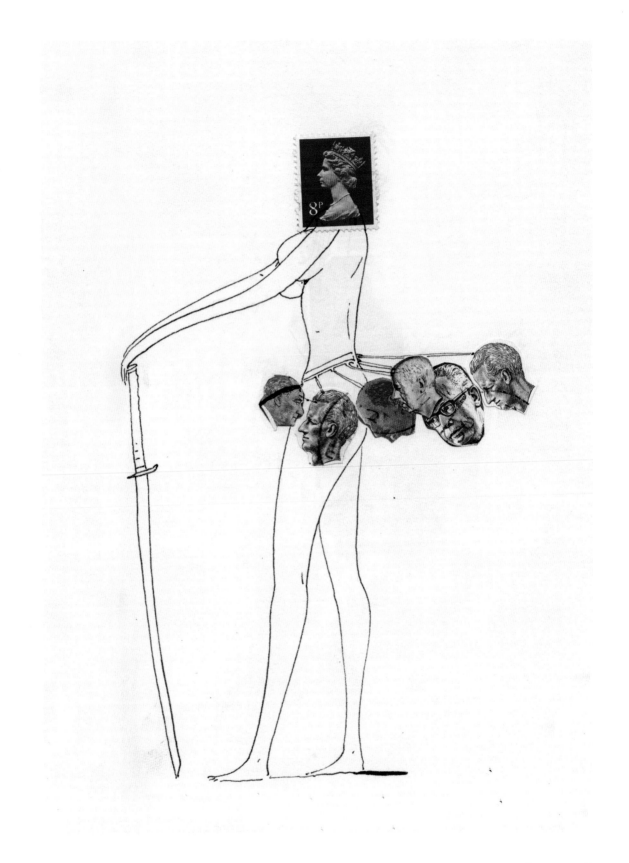

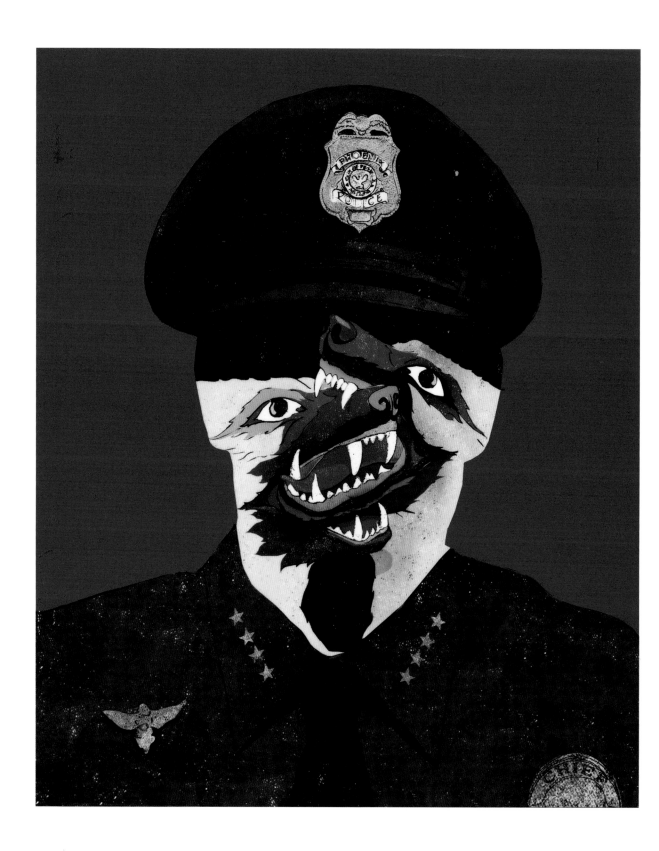

GOLD MEDAL WINNER
BRIAN STAUFFER

Infighting Police
Cover art for a feature about infighting in the Phoenix Police Department over the selection of its next Chief of Police.

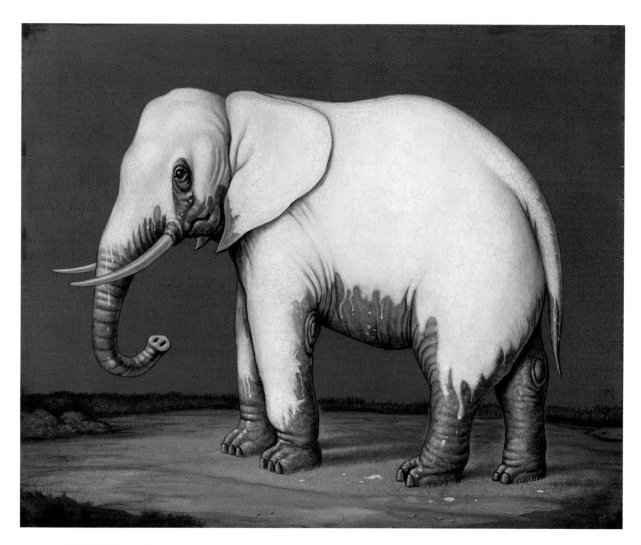

Whitewash
Jason Treat at *Atlantic Monthly* established a "Gallery Section" within the magazine, which features self-generated works on topical subjects. This piece was my visual comment on the Republican Party's attempt at re-invention in the months since George W. Bush left office. I'm tremendously honored by this award, and by the company I find myself in on these pages.

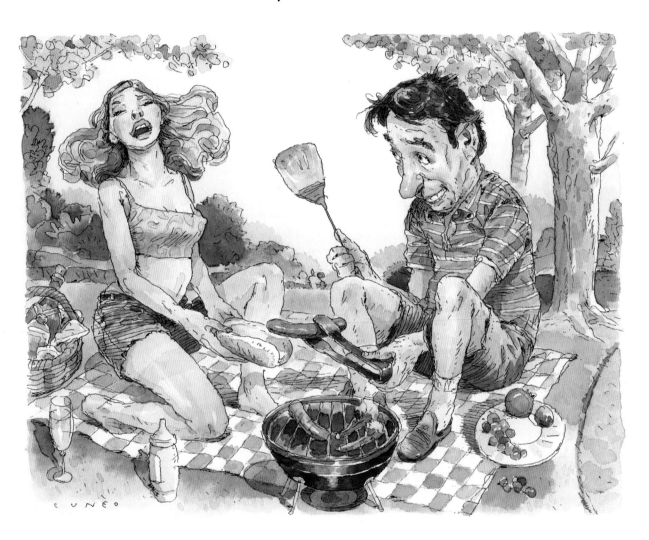

Insertion Technique
A drawing for a sex advice column, about whether or not there is such a thing as a surefire technique—an ideal angle or method—for initiating sexual penetration. After a brief editorial discussion, it was determined that this assignment would be best accomplished through the use of a visual metaphor.

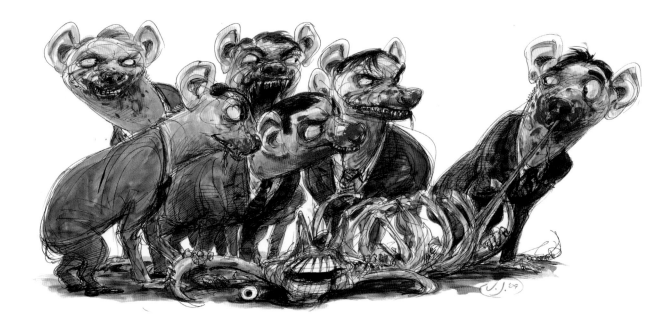

Wall Street's Naked Swindle-Hyenas
This illustration was for the first of an ongoing series of dissections of the recent financial crisis. Written by Matt Taibbi for *Rolling Stone*, the article examines how the very same people who so directly contributed to the disaster became the designated rescuers of the economy. My desire in creating the caricature of Paulson was to portray him as a barnyard animal focused on feeding his overstuffed litter of business types at the expense of many others.

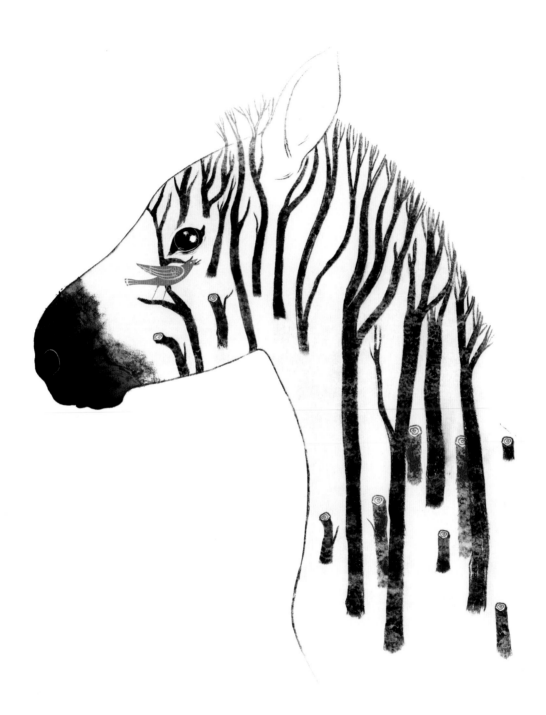

Raquel Aparicio
Zebra
This piece was commissioned by *Viajar* magazine, a Spanish travel publication I work for every month, for an article about the deforestation in Africa and the lack of biodiversity. It was done with ink and digital.

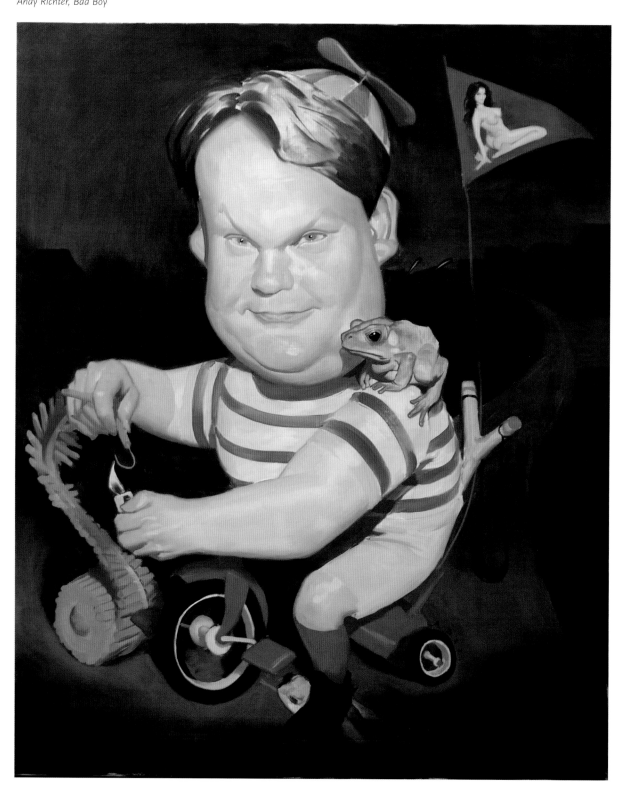

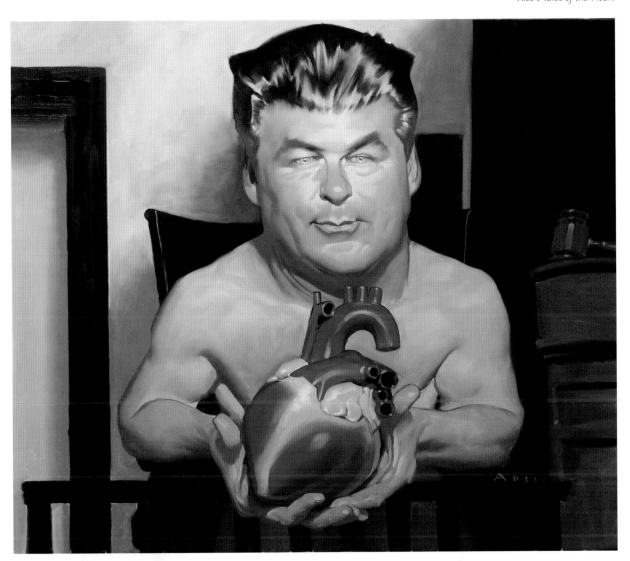

DANIEL ADEL
Harry Potter Discovers Ladies

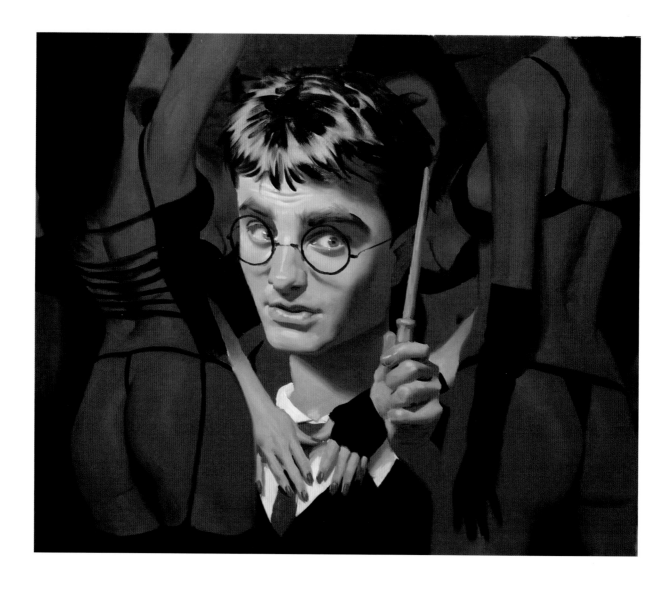

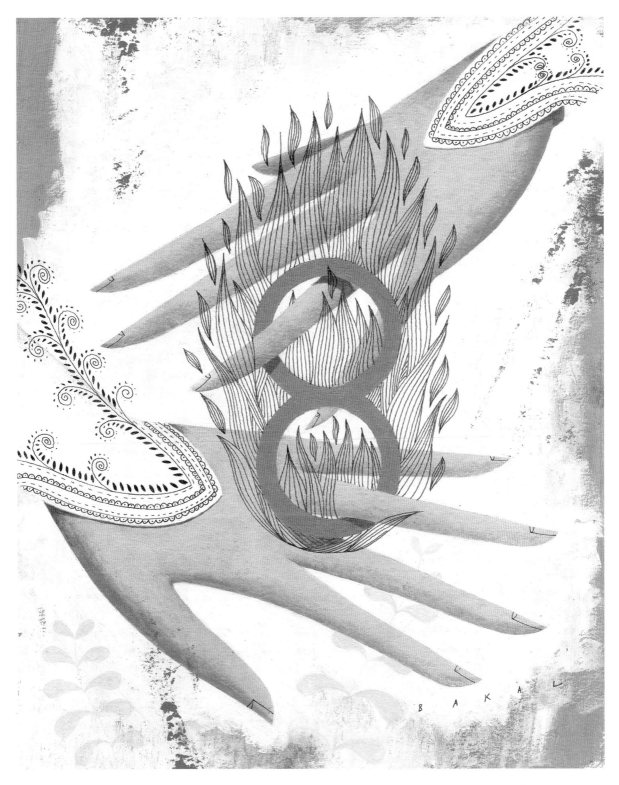

SCOTT BAKAL
Proposition 8

SERGE BLOCH

Old Love

For me, what was important for this piece was the simplicity inherent in putting the elements together, something that is not always easy to get when doing something that must fit to order. I wanted to show time going by and life weaving itself together.

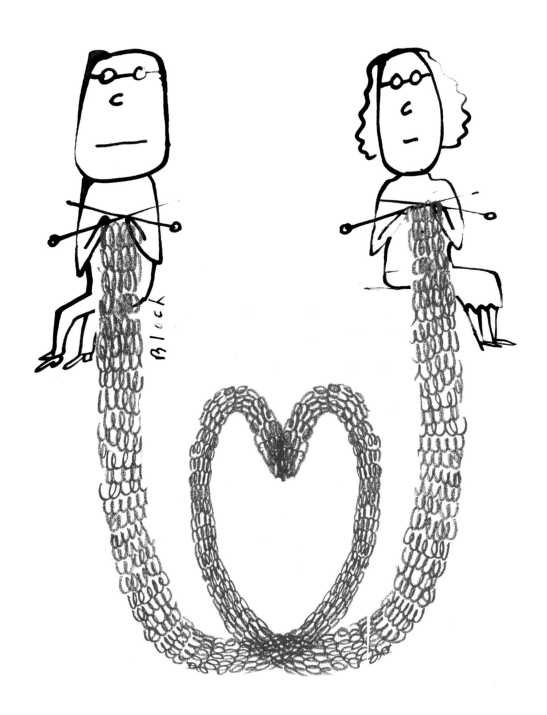

SERGE BLOCH
Green Attitude
For this illustration, the sketch was approved after being enhanced by incorporating plant elements. I like the fact that the spontaneity and freedom of the sketch were successfully preserved.

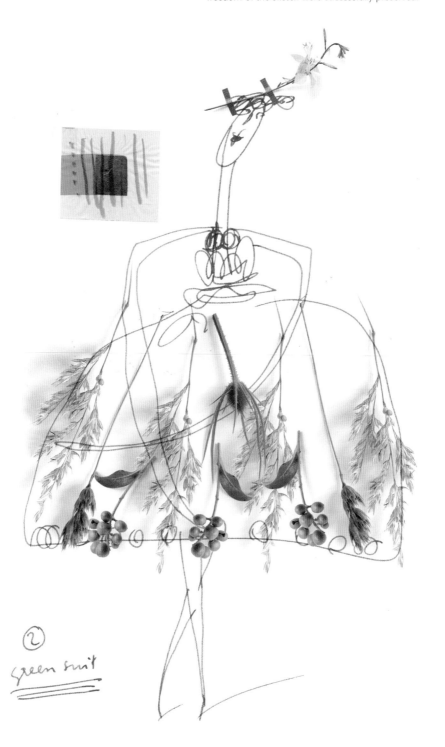

GUY BILLOUT
The Upside of the Downturn

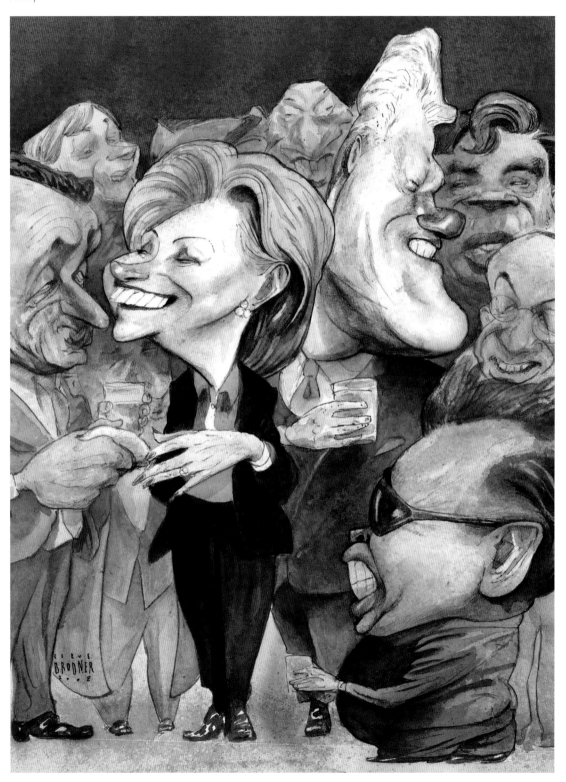

Nigel Buchanan
Bigot

MARC BURCKHARDT

Goldfinch

These are two of three pieces commissioned by the wonderful Joe Kimberling at *Los Angeles* magazine to illustrate an article "The Birds of LA." The idea was to capture the look and feel of historic naturalist images in contemporary urban settings.

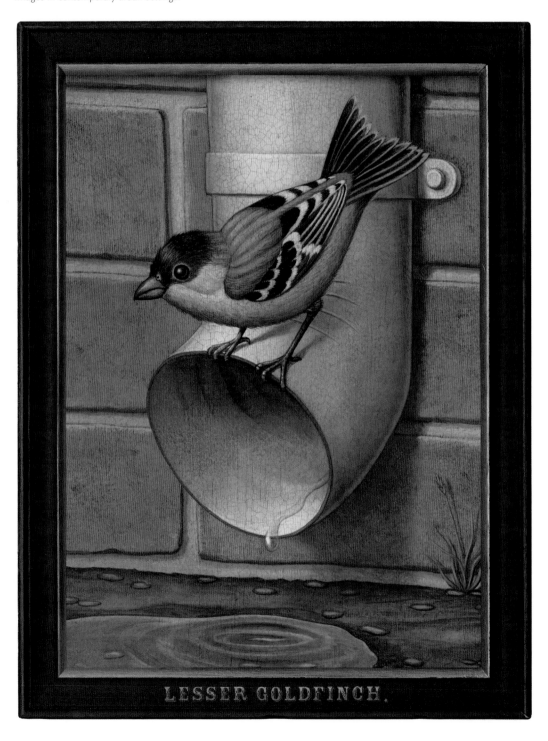

LESSER GOLDFINCH.

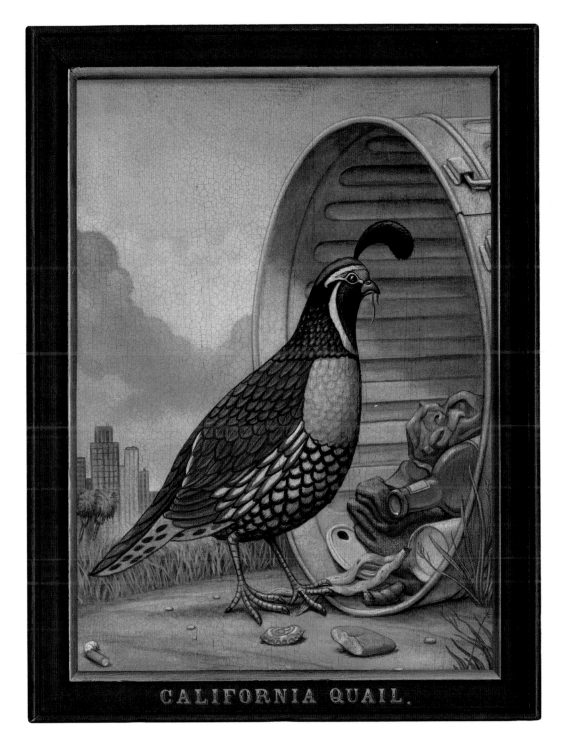

CALIFORNIA QUAIL.

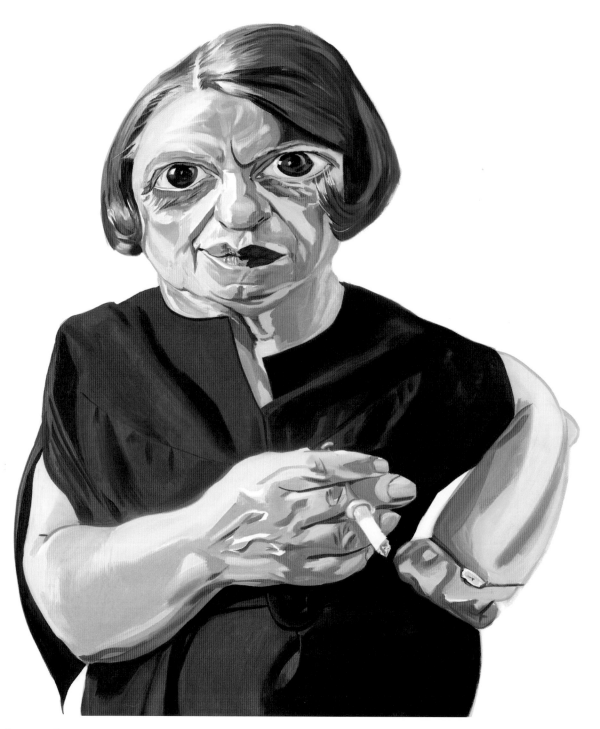

PHILIP BURKE
Ayn Rand

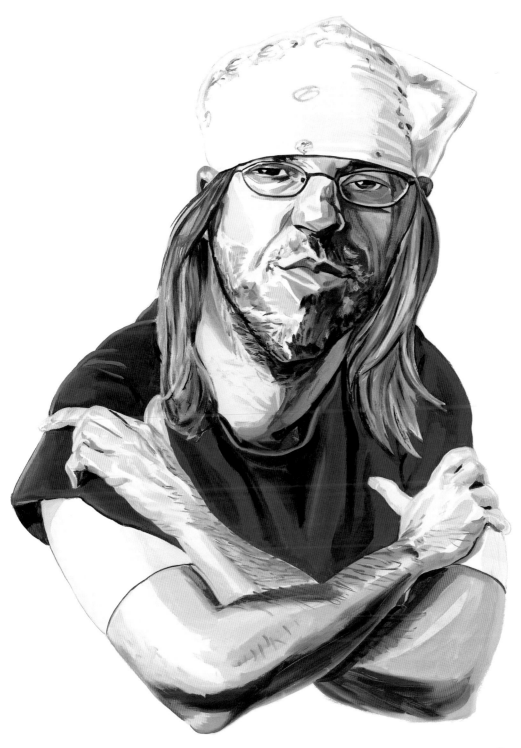

PHILIP BURKE
David Foster Wallace

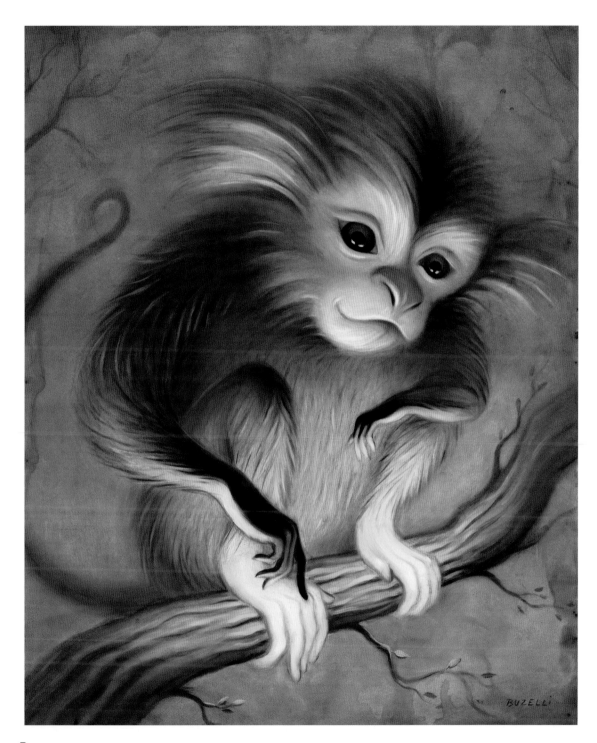

CHRIS BUZELLI
Monkey Glow

Since I was a child, I've always invented and drawn my favorite beasts by combining different animals to create a sort of hybrid creature. This article from MIT's *Technology Review* magazine was a real-life version of my childhood doodles. Recently, researchers in Japan added a jellyfish gene that produces green fluorescent protein to marmoset monkeys. This new trait caused their feet to glow green. The article talks about the medical possibilities of curing diseases and the troubling ethical issues that could occur from this biological breakthrough.

HARRY CAMPBELL

Somalia

This was done for a *Johns Hopkins Magazine*, one of a series of four very interesting articles. This particular piece was about how young men in Somalia, traditionally fishermen, have to choose between fishing and piracy, piracy being very much more lucrative.

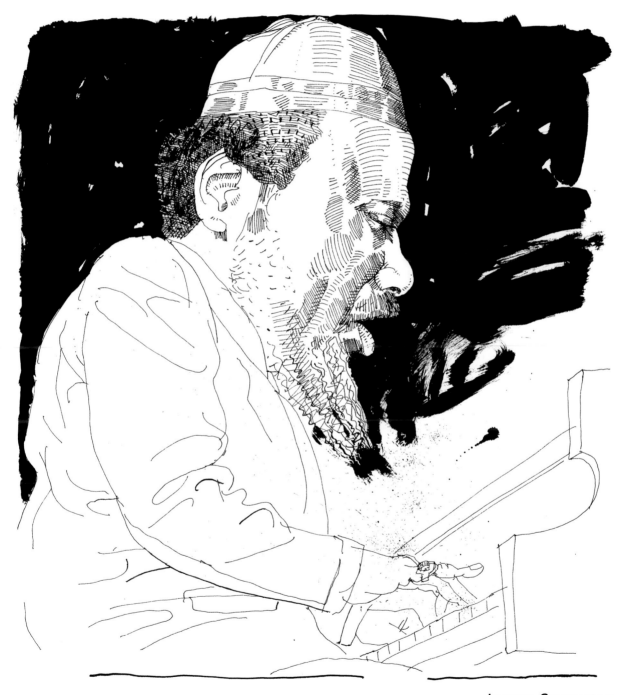

JOSEPH CIARDIELLO
Thelonious Monk

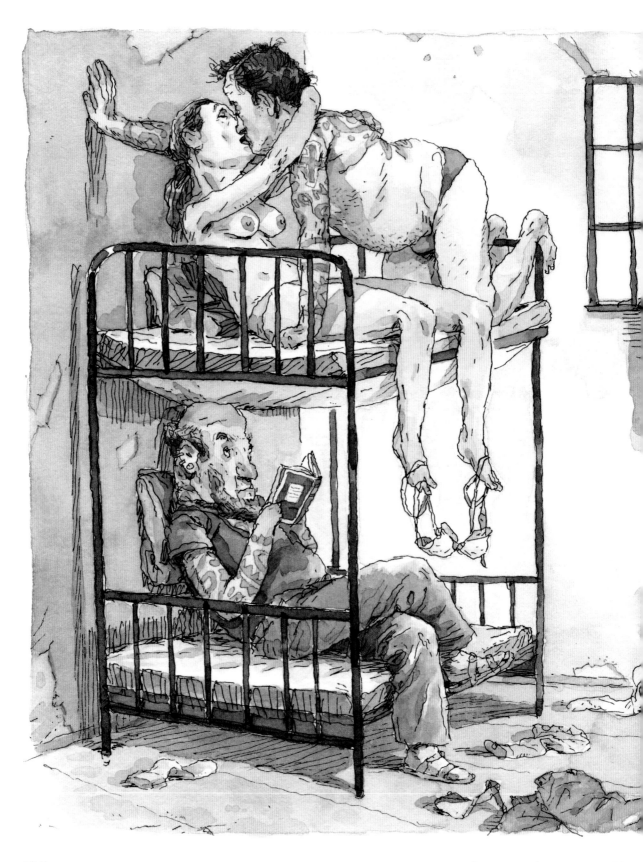

JOHN CUNEO
Conjugal Visit

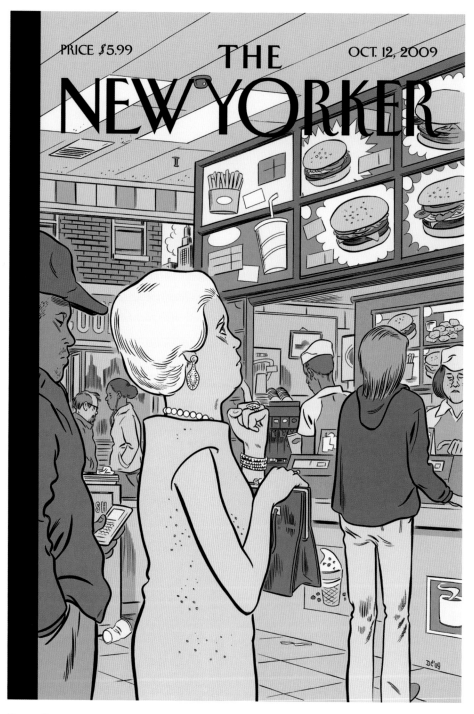

DAN CLOWES
The Food Chain

RICHARD DOWNS
A Hidden Agenda?
A story about hidden elements being revealed in lawsuits. Small plans attacking providers over hidden fees and inadequate disclosure in 401K fees.

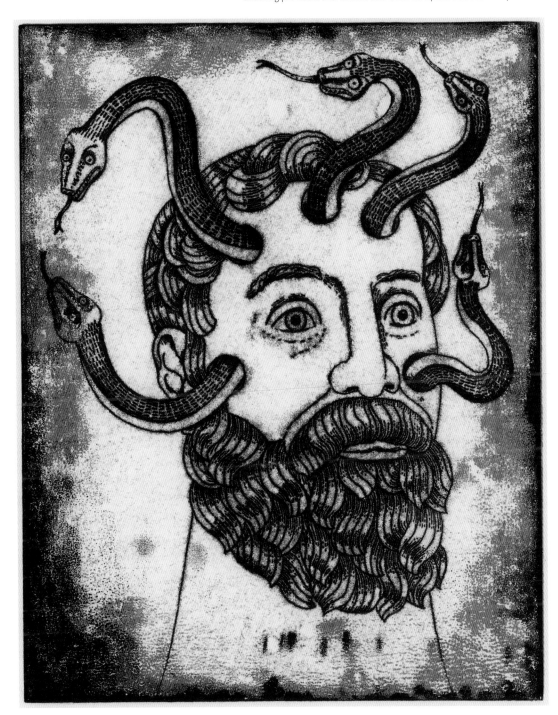

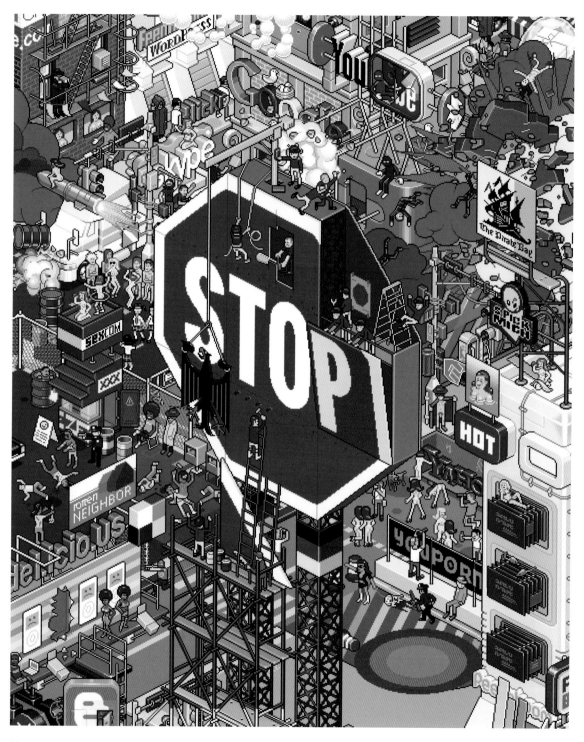

EBOY
Internet Without Rules

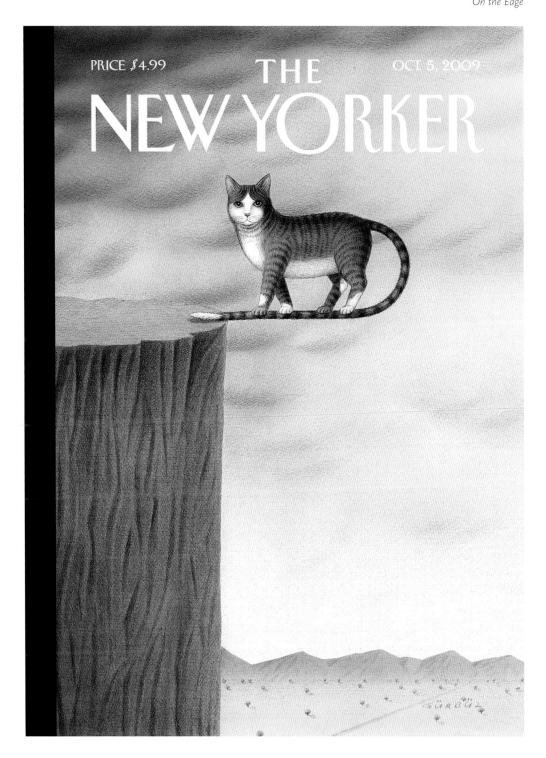

PRICE $4.99

OCT. 5, 2009

THE NEW YORKER

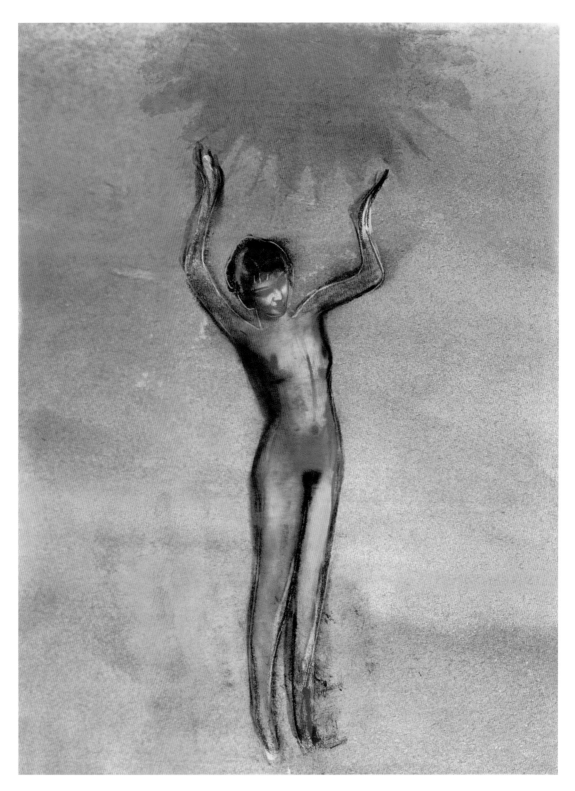

VIVIENNE FLESHER
Sun

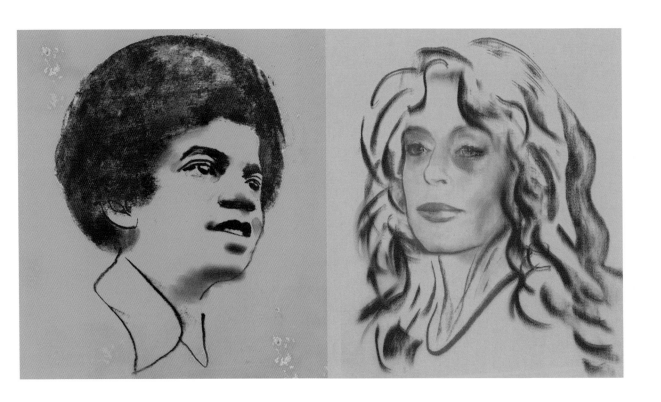

VIVIENNE FLESHER
Michael and Farrah

Alessandro Gottardo

Post Consumerism Society

BEPPE GIACOBBE
Exit Strategy

Jakob Hinrichs

Mount Everest

My technique is related to a German wood printing tradition which I adapted for a digital environment. I like the boldness of the lines and structures and the overlays of the printing procedure. My color scales are usually put together from two to three pure color and mix tones.

Working for Martin Colyer is always a pleasure. He enjoys good ideas and makes really nice use of how the illustration works within the layout and context of the article.

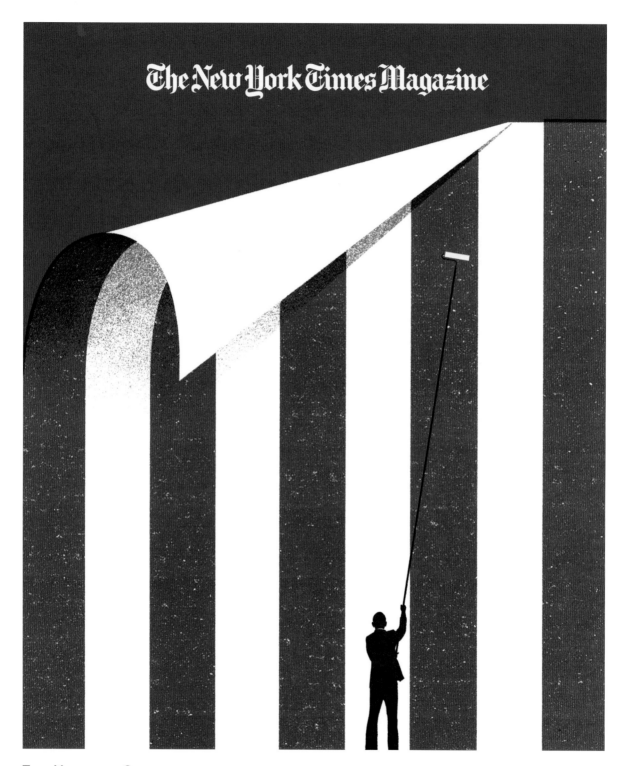

THE HEADS OF STATE
New York Times
Magazine cover about the Obama administration and the various tasks they undertake to repair America.

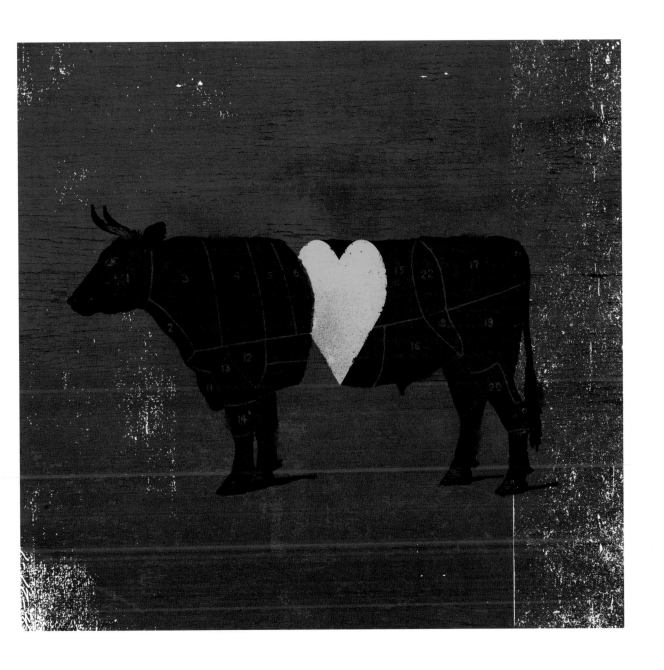

THE HEADS OF STATE
Audubon
How to rear happy and healthy livestock in a sustainable way.

BRAD HOLLAND
Madder Rose

JORDIN ISIP
The Banks Are Broken

Victor Juhasz
The Return of Rove
Karl Rove, a loathsome political puppet master. How better to portray him than as an evil Geppetto, attempting to do for John McCain what he had so successfully done for George W. Bush. This time it didn't work. For an article in *Rolling Stone* written by Matt Taibbi.

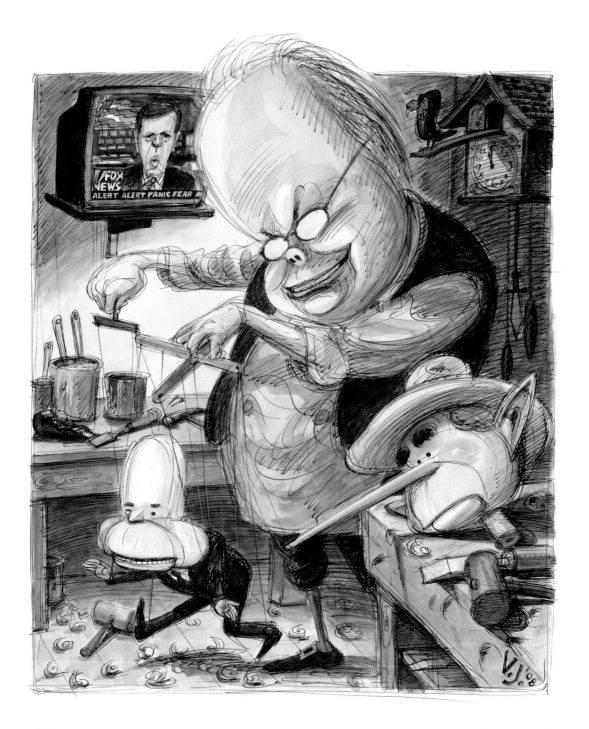

VICTOR JUHASZ

The Big Takeover–Hank Paulson

Illustration done for *Rolling Stone* magazine. The first of an ongoing series of dissections of the recent financial crisis, written by Matt Taibbi, examining how the very same people who so directly contributed to the disaster became the designated rescuers of the economy. My desire with the caricature of Paulson was to portray him as a barnyard animal focused on feeding his overstuffed litter of business types at the expense of many others.

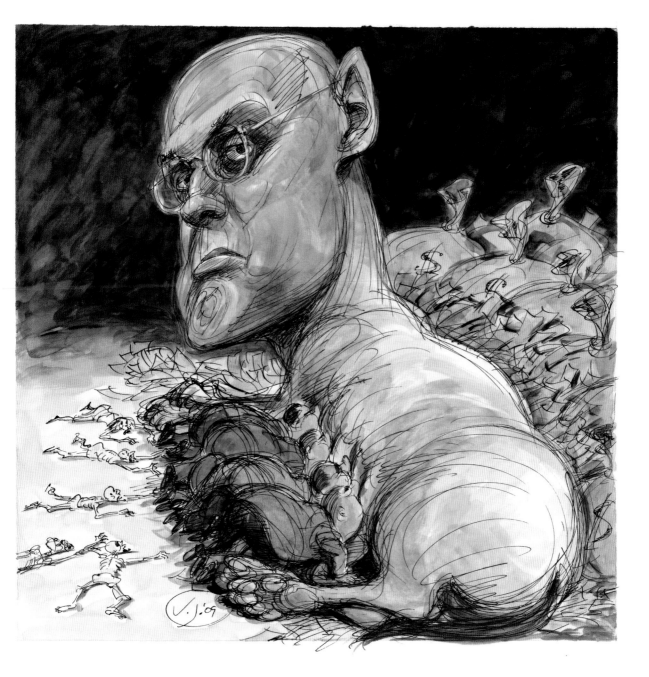

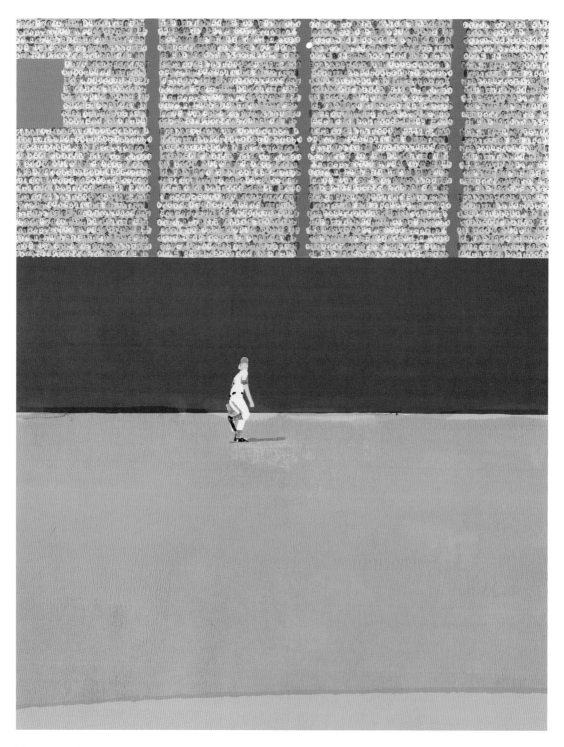

TATSURO KIUCHI
In the Ballpark
This was done for *Sports Graphic Number*, a magazine published by Bunshun in Japan. The article, "Kazuhiro Kiyohara, The Last Superstar," was written by Junji Yamagiwa. The piece was digitally created with Photoshop.

ANITA KUNZ
Isabella
This was a commission to paint a portrait of Isabella Rossellini. The idea was simply to make her as beautiful and porcelain-looking as possible.

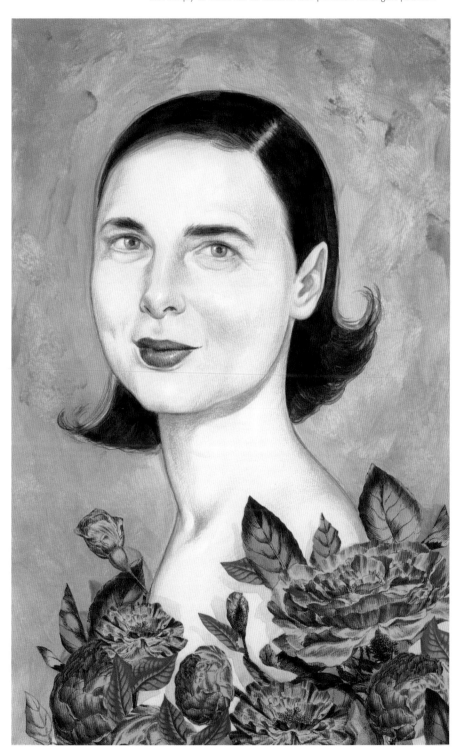

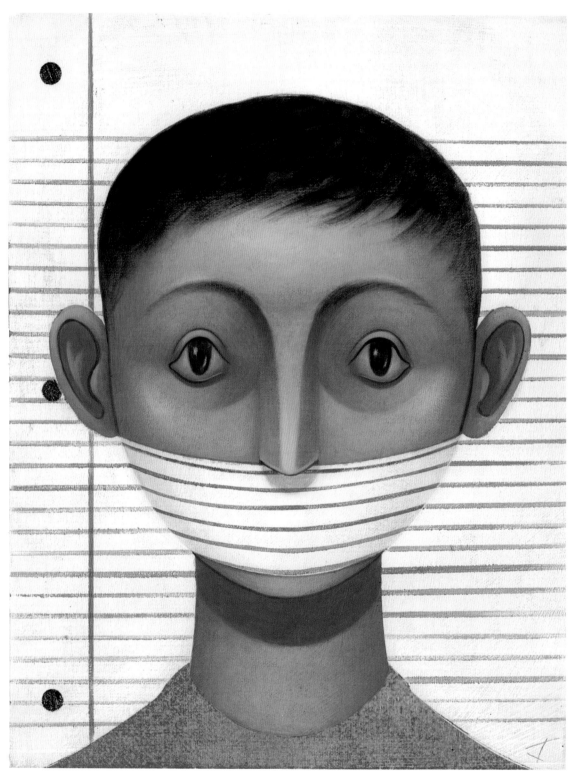

JON KRAUSE
Gagged

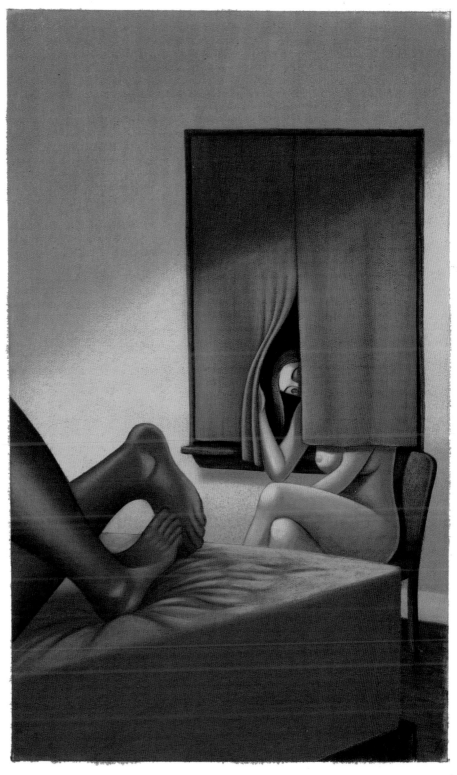

JON KRAUSE
3 Way

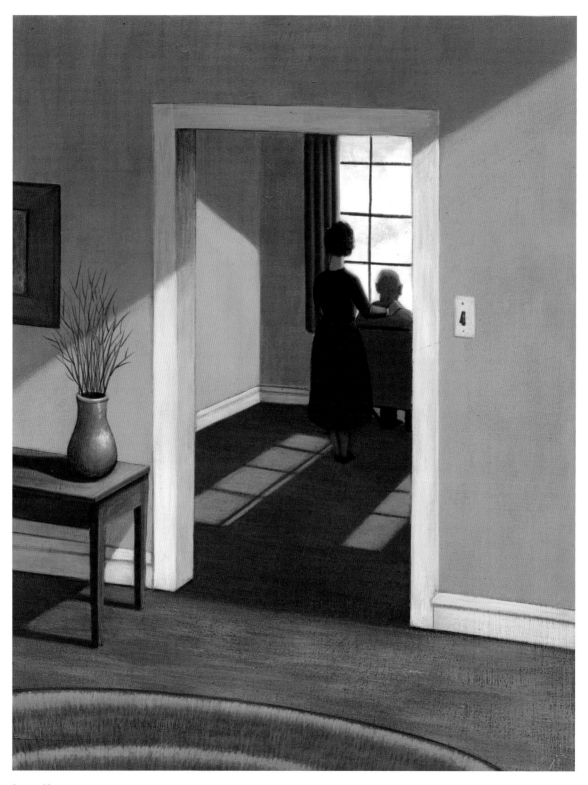

JON KRAUSE
Caring

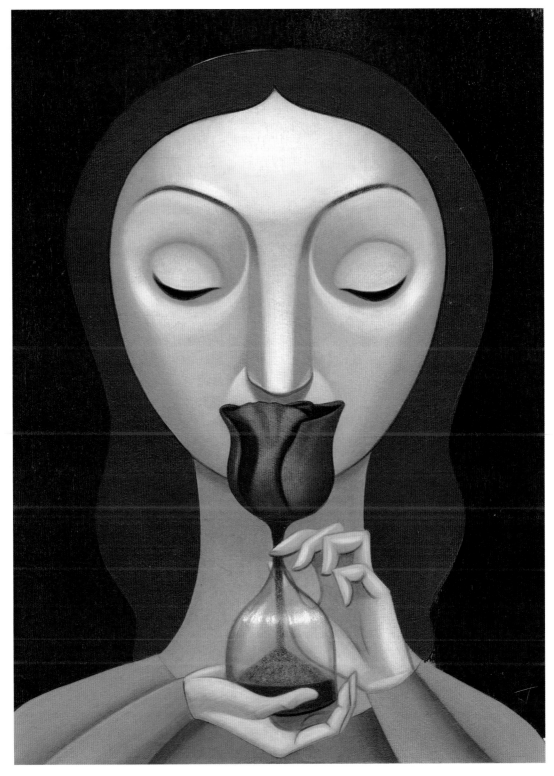

JON KRAUSE
Rose

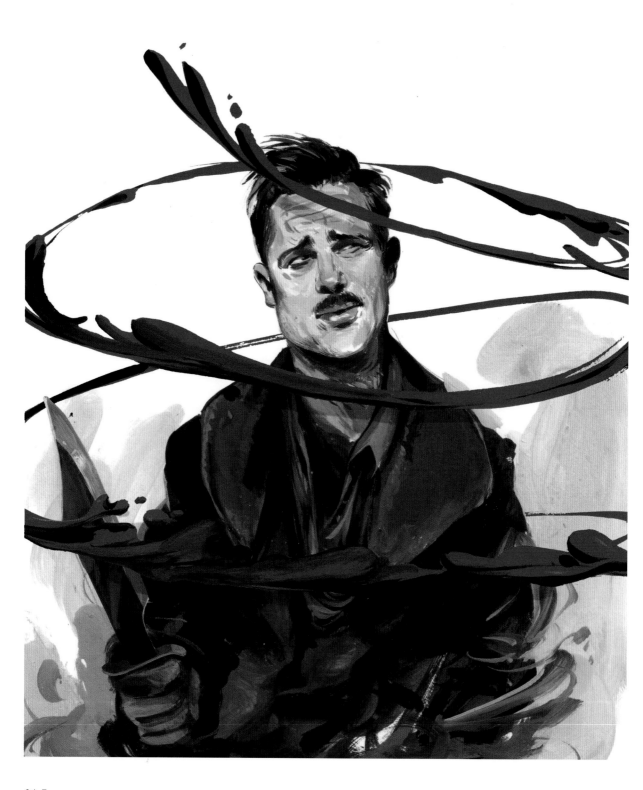

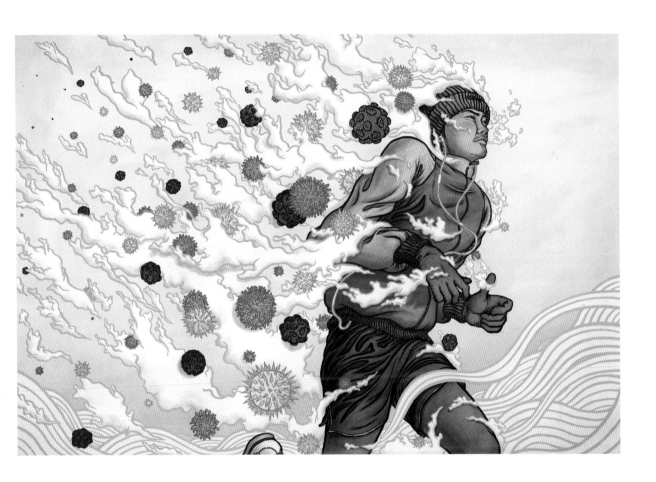

DONGYUN LEE

Is It Okay to Go for a Run When I Have a Cold?

Running when you have a cold is usually fine, unless you have a fever, in which case you should stay indoors. In fact, there's evidence that running can improve circulation and reduce stress, which boosts the immune system, so a run may help improve your symptoms. Take extra care to dress appropriately when you go out. Pay close attention to how the run affects your symptoms, and take a day or two off if they worsen, especially if you're feeling weak.

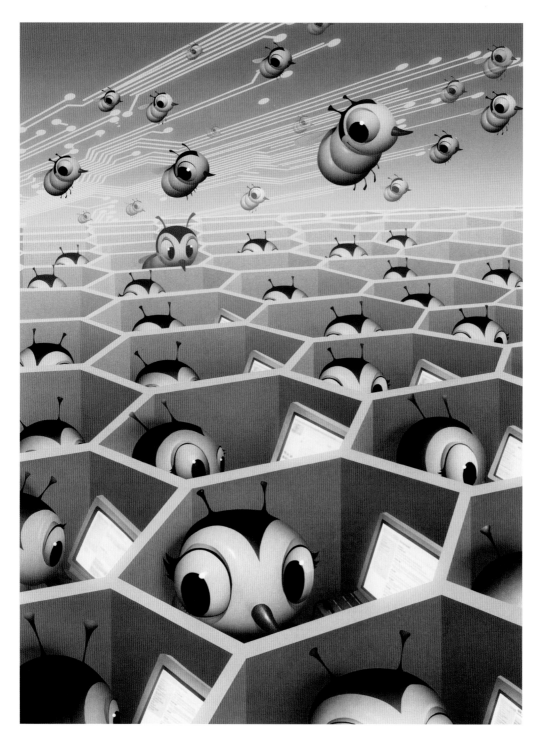

BILL MAYER
Buzzing With Productivity
This little illustration was for an article for *IBM Systems Magazine*. It seemed pretty obvious that when you're using beehives as an analogy for the workplace, why not put the bees in a honeycomb cubical. I added some little hi-tech jet trails to give it a little motion and a connection to technology.

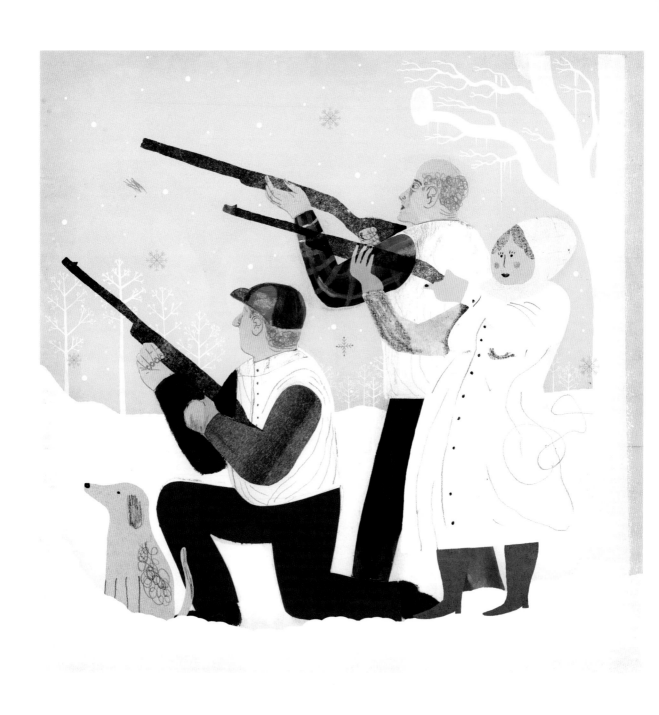

CHRIS SILAS NEAL
Hunters

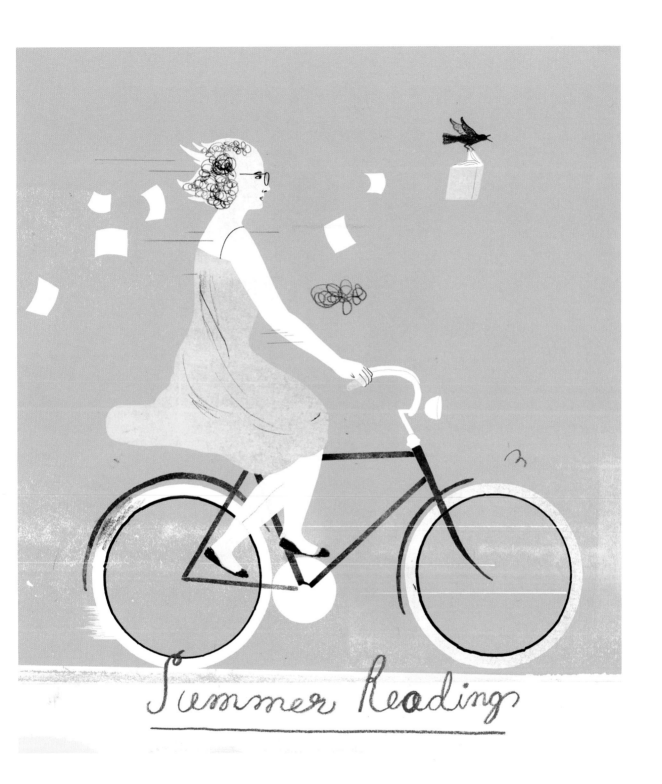

Summer Reading

CHRIS SILAS NEAL
Summer Reading

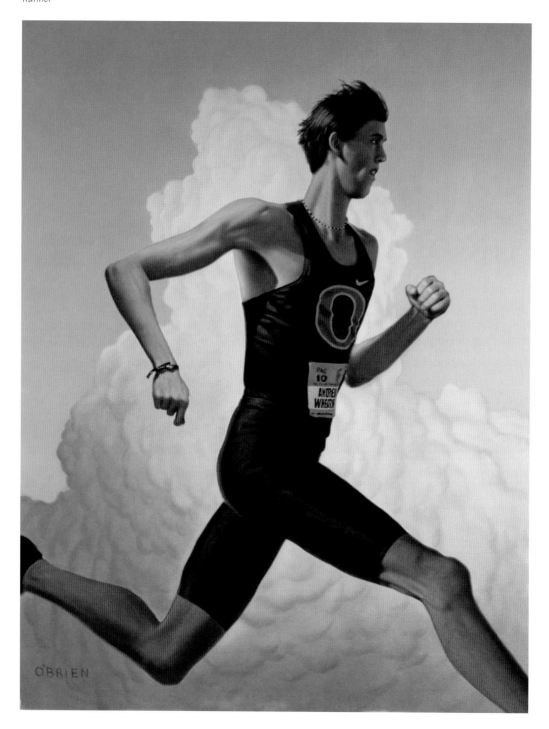

NANCY OHANIAN
The GOP
The drawing represents the antiquated image of the Republican Party. It was published during the 2008 U.S. presidential campaign.

Ken Orvidas

The Jungle

NoBrow Press asked 28 artists to contribute a piece based on the theme, the jungle. This could be taken literally, figuratively, or metaphorically. The project constraints included: the theme, three specific colors plus a tint of one of the given colors. The collective was published as a limited edition of 3,000 books.

CURTIS PARKER
Fathers

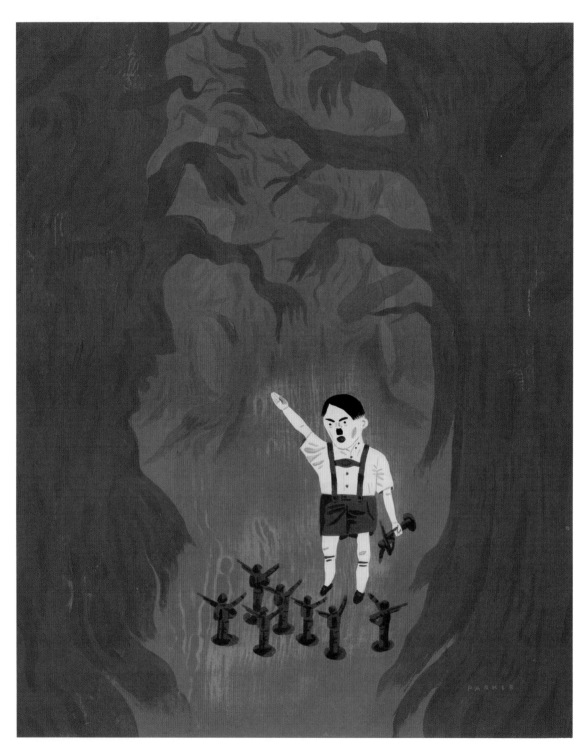

CURTIS PARKER
Castles in the Forest

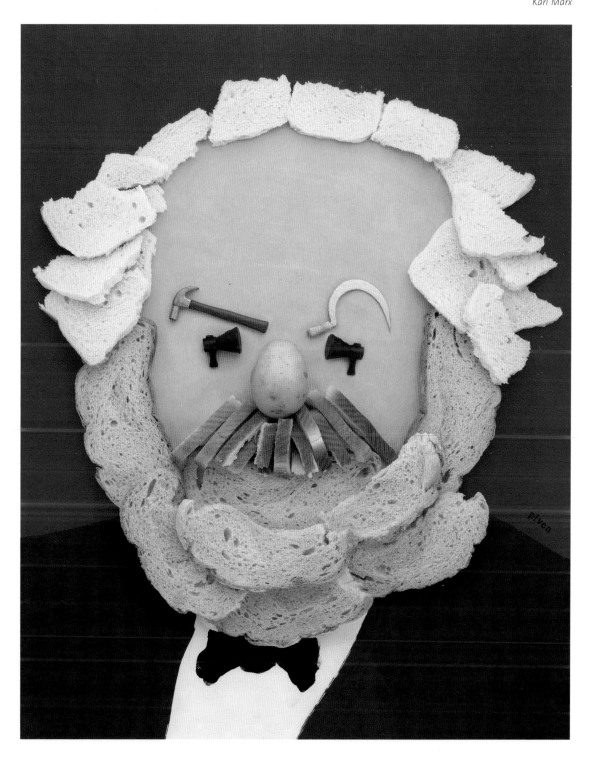

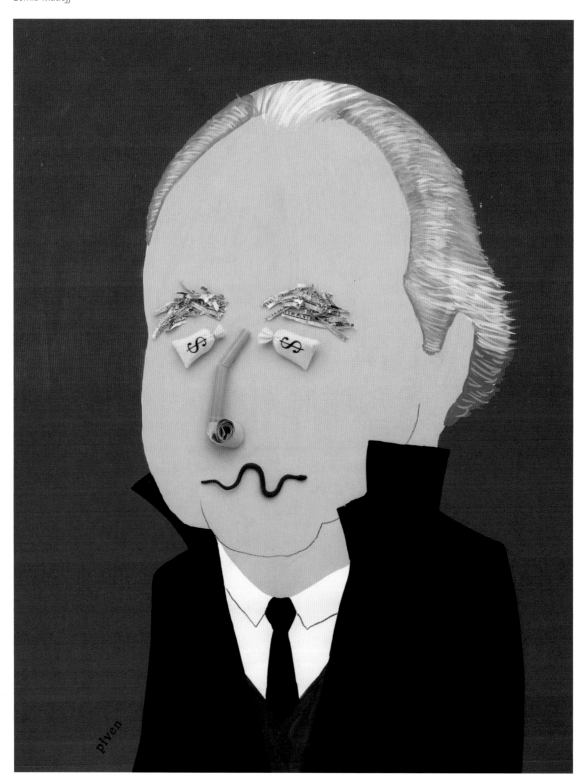

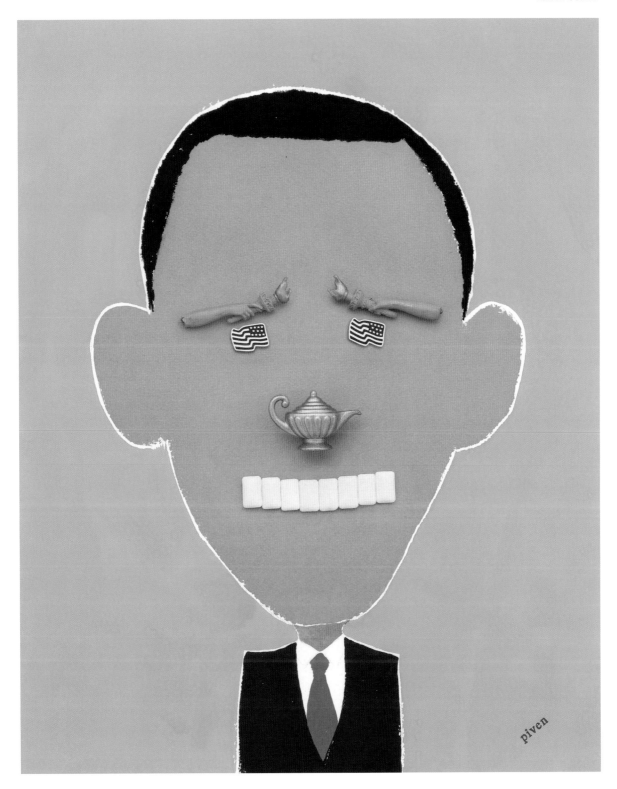

EMILIANO PONZI
Lark and Termite

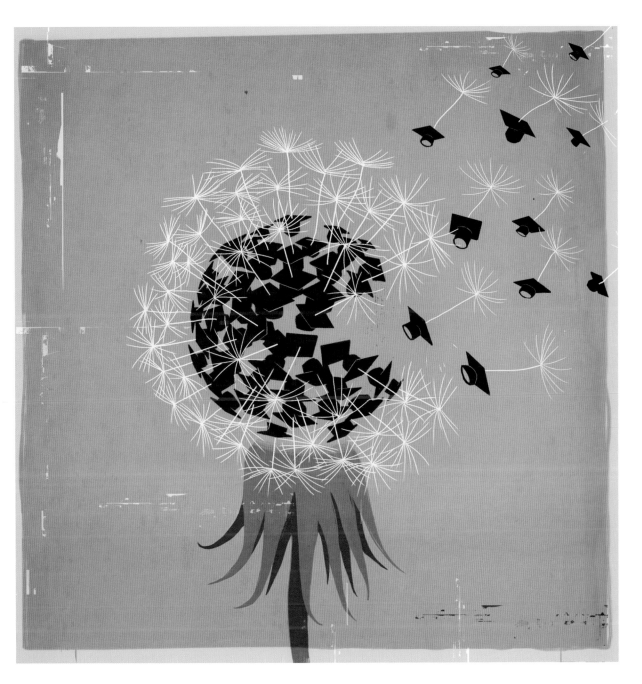

EMILIANO PONZI
Dandelion
This was created for an article in *Currents* magazine about
university drop-outs.

JON REINFURT

Three to One
This half-page illustration is for an article that evaluated the résumés of three composers, all of whom were competing for the same position in the Charlotte Symphony.

EDEL RODRIGUEZ

Free Speech?
This is a spread for a magazine titled *Liberty*. The story deals with the limits of free speech, and how words can sometimes go too far. Bryan Gray was the art director.

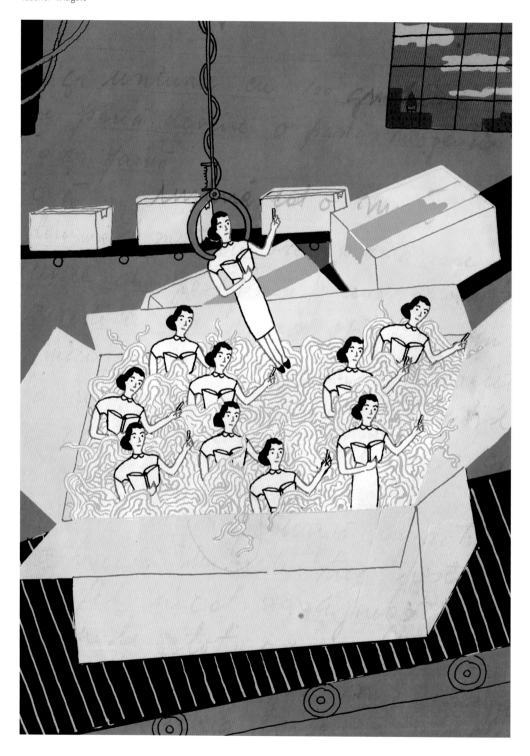

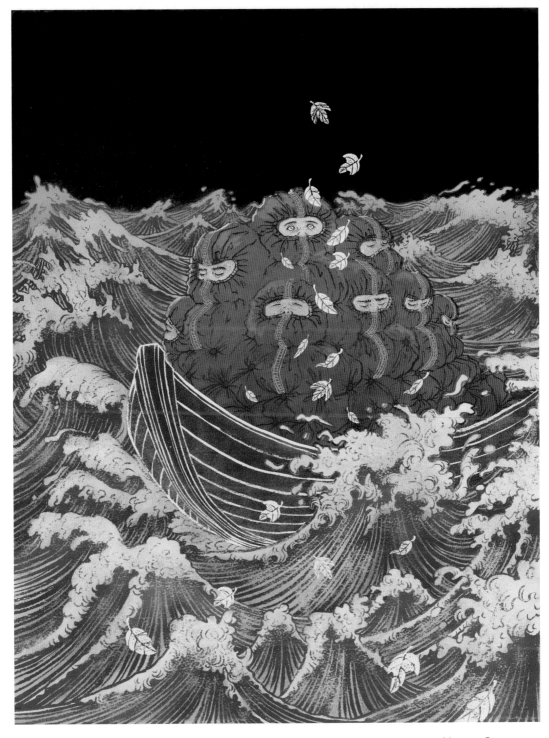

YUKO SHIMIZU
Life Boat

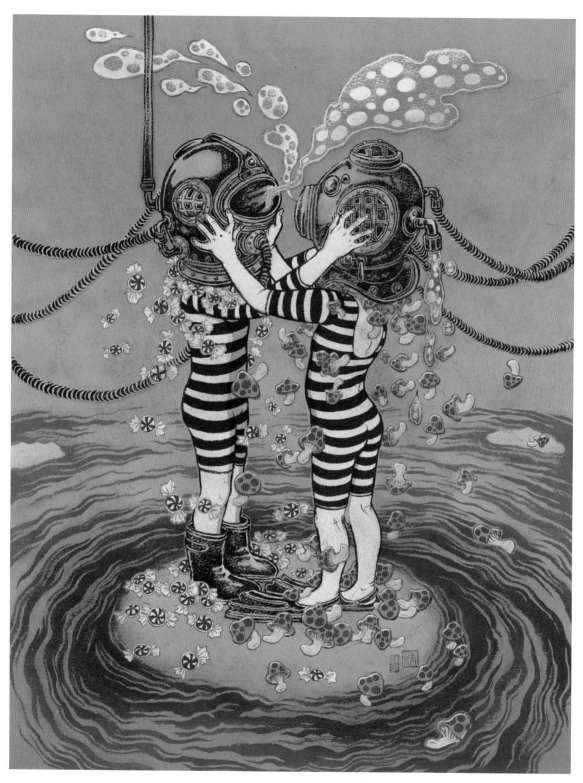

Yuko Shimizu
Diving Helmet

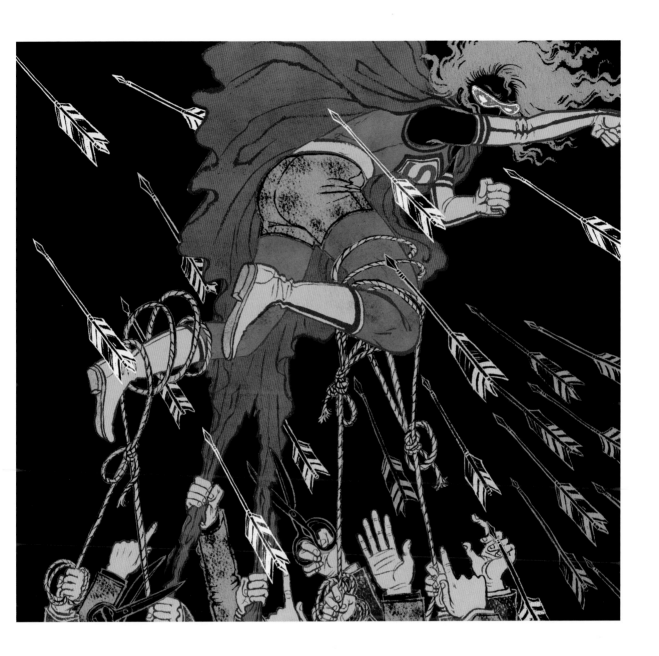

YUKO SHIMIZU
Fall of Superwoman

JASON SEILER
Frank McCourt

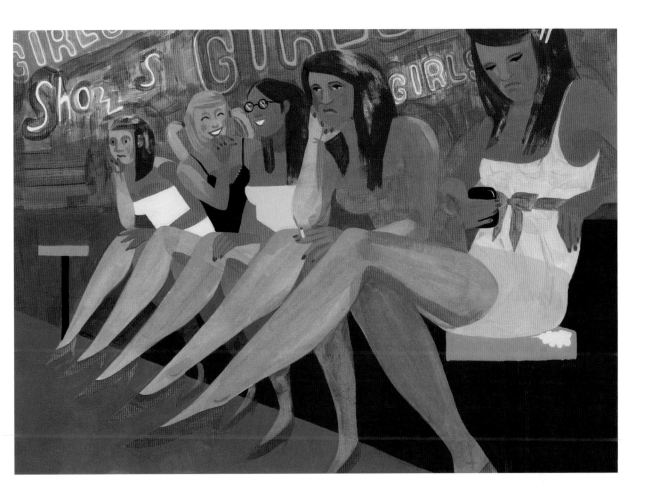

GENEVIEVE SIMMS
Bar Girls
This image was originally commissioned to accompany an article about the impact of the global recession on the so-called "bar girls" of Nana Plaza in Bangkok, Thailand. The composition pays homage to Toulouse Lautrec's can-can girls, with one important difference: In the absence of wealthy clients from overseas, despondency and boredom have replaced the party atmosphere. Executed in acrylic.

OWEN SMITH
California Dreamin'

Art Director Max Bode called me to illustrate a movie review of the Polish director Cristian Nemescu's first and last feature film. (Nemescu was killed in a car crash before the film editing was complete.) The story involves a stationmaster in a desolate town in Romania who halts a train that is shipping military supplies to Serbia. I wanted to show the tension between the devilish official and an American Marine Captain stuck fighting a battle of wills in the middle of nowhere.

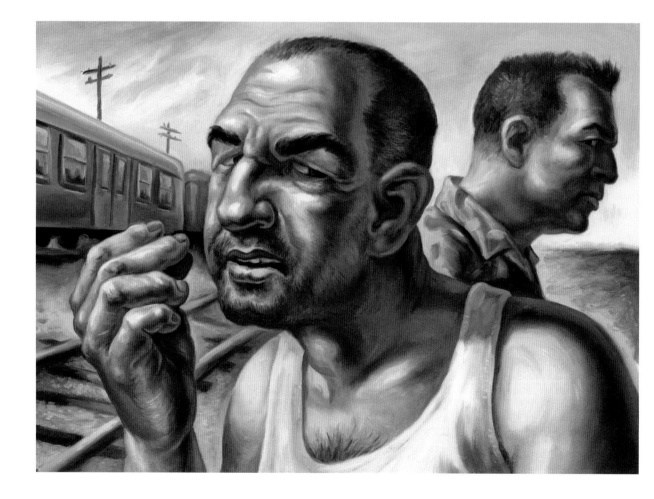

OTTO STEININGER
Scrabble Wars

BRIAN STAUFFER
Digital Killed the Papers
Feature art for a story about how digital revenues for *The New York Times*
are outpacing those of the print edition.

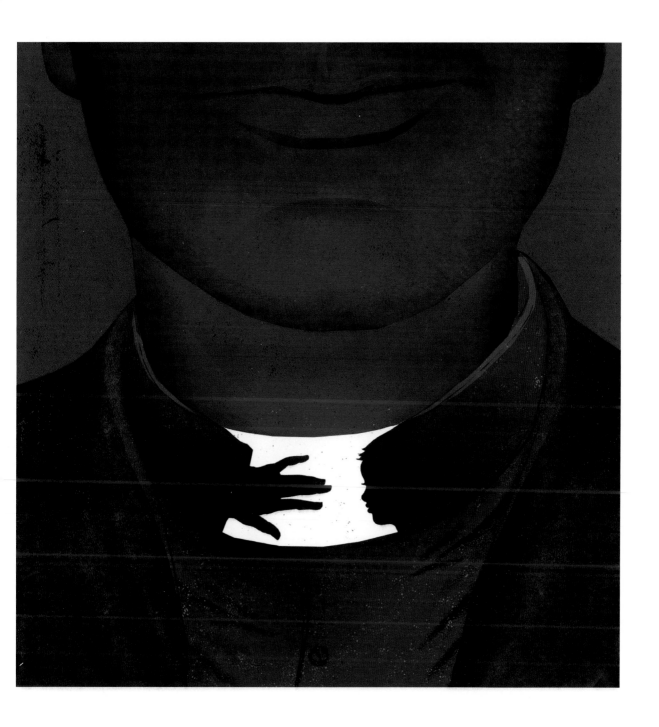

BRIAN STAUFFER
Pedophile Priest
Cover art for a profile of an infamous Bay Area pedophile priest.

BRIAN STAUFFER
Hazardous Cargo
Artwork for a feature about the dangers of transporting hazardous
materials by railroad.

SAM WEBER
The Crow Procedure
Aboriginal surgeons facilitate cosmetic transformations for a spiritually empty consumer class. This picture accompanied a short story in *The Walrus* and was painted in acrylic and finished digitally.

SAM WEBER
A Memory of Wind
Agamemnon sacrifices his daughter, Iphigenia, so that he may have wind to sail his warships to Troy. This short story had an ephemeral, lyrical quality to it, like that feeling you get at sunset after having been at the beach all day.

James Yang

Scary Tree

Illustration for an article originally titled, "It's 10 O'clock. Do You Know Where Your Advisor Is?" for *Plansponsor* magazine. Soojin Buzelli was the art director.

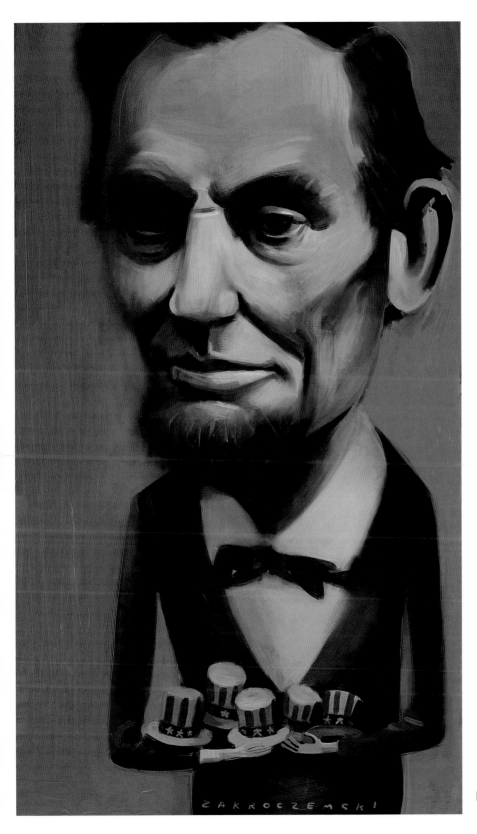

DANIEL ZAKROCZEMSKI
Lincoln Rivals

ADVERTISING/INSTITUTIONAL

 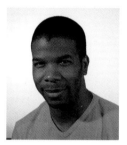

GAIL BICHLER
ART DIRECTOR,
THE NEW YORK TIMES MAGAZINE

Prior to her current position as art director at *The New York Times Magazine*, Gail Bichler worked at *T, The New York Times Style Magazine*; was an instructor at Minneapolis College of Art and Design and the principal of Gail Bichler Design; and worked in various capacities at studios in New York and Chicago including 2x4, Kate Spade, and studio blue. Gail's work is in the permanent collection of The Art Institute of Chicago and has been recognized by the AIGA, the Art Director's Club, the Type Director's Club, the Society of Publication Designers, *American Illustration*, *Print*, and *I.D.* magazine.

AMANDA SPIELMAN
GRAPHIC DESIGNER,
SPOTCO

Amanda Spielman is a graphic designer at SpotCo, a New York-based design studio and ad agency that specializes in creating artwork for Broadway theater. Prior to SpotCo, she spent seven years working in editorial design, including Time Inc Custom Publishing where she helped to launch *Proto*, a magazine for Massachusetts General Hospital. Her work has been featured in *The Design Entrepreneur*, *Fingerprint*, *Graphis*, *Step*, SPD, metropolismag.com, and the exhibition "Landscapes of Quarantine" held at Storefront for Art and Architecture in 2010. Amanda graduated from the MFA Design program at the School of Visual Arts, and holds a BA from Vassar College. She lives in Jackson Heights, Queens.

ESTHER PEARL WATSON
ILLUSTRATOR

Esther Pearl Watson grew up in the Dallas/Fort Worth area. Her family moved often, since her father's hobby of building huge flying saucers out of scrap metal and car engines didn't always sit well with the neighbors. Loosely based on a teenager's diary from the 1980s found in a gas-station bathroom, Esther's first graphic novel, *Unlovable*, details the sometimes ordinary, sometimes humiliating, often poignant, and frequently hilarious exploits of underdog Tammy Pierce. This remarkably touching and funny graphic novel tells the first-person account of Tammy's sophomore year.

STEFAN KIEFER
ART DIRECTOR,
DER SPIEGEL

Having joined *Der Spiegel* in 1996, Stefan Kiefer has been the art director of its cover department since 2000. After receiving a master's degree in illustration, he became known as a specialist of photorealistic illustrations. His clients were major ad agencies and publishing houses such as *Der Spiegel*, *Stern* magazine, Rowohlt, S. Fischer, and others. In 1991, Stefan joined an international design team based in the Netherlands to develop world-class theme parks under the guidance of magician Doug Henning. Later, he became the art director of an international manufacturer of health and spa products. At *Der Spiegel* Stefan has played a key role in increasing the use of illustration for the covers, mainly using talent from the United States.

WHITNEY SHERMAN
ILLUSTRATOR, DESIGNER, EDUCATOR

Whitney Sherman's recent projects include a line of limited edition ceramic ware under the name Pbody Dsign. Her illustration work is represented nationally by Gerald & Cullen Rapp, Inc., NY. Whitney's illustration work is included in the traveling group exhibition "Picturing Health" with Melinda Beck, Cathie Bleck, Guy Billout, Juliette Borda, Cora Lynn Deibler, Teresa Fasolino, Frances Jetter, Gregory Manchess, Peter de Sève, Elwood Smith, Mark Ulriksen, and Norman Rockwell. The exhibit originated at The Norman Rockwell Museum in Stockbridge, Massachusetts, and traveled to the El Paso Museum of Art. Along with her studio work, Sherman is the chair of illustration at the MICA, co-director of Dolphin Press & Print @ MICA, and serves as an advisor to the ICON6 Board.

STEPHEN SAVAGE
ILLUSTRATOR

Stephen Savage is known for his economical style of illustration that conveys complex ideas and emotions with simple lines and color. He does a wide range of work from children's books and household design to celebrity portraits and political icons. His books include the bestselling *Polar Bear Night* and a new Margaret Wise Brown picture book, *The Fathers Are Coming Home*. He created the animal faces on the Munchlers, whimsical lunch bags for kids made by BUILT NY. His editorial illustration has appeared in dozens of major newspapers and magazines and can be seen daily in the politics section on NYTimes.com. Stephen lives in Brooklyn with his wife and their baby daughter.

WHITNEY SHERMAN
ILLUSTRATOR, DESIGNER, EDUCATOR

Whitney Sherman's recent projects include a line of limited edition ceramic ware under the name Pbody Dsign. Her illustration work is represented nationally by Gerald & Cullen Rapp, Inc., NY. Whitney's illustration work is included in the traveling group exhibition "Picturing Health" with Melinda Beck, Cathie Bleck, Guy Billout, Juliette Borda, Cora Lynn Deibler, Teresa Fasolino, Frances Jetter, Gregory Manchess, Peter de Sève, Elwood Smith, Mark Ulriksen, and Norman Rockwell. The exhibit originated at The Norman Rockwell Museum in Stockbridge, Massachusetts, and traveled to the El Paso Museum of Art. Along with her studio work, Sherman is the chair of illustration at the MICA, co-director of Dolphin Press & Print @ MICA, and serves as an advisor to the ICON6 Board.

AMANDA SPIELMAN
GRAPHIC DESIGNER, SpotCo

Amanda Spielman is a graphic designer at SpotCo, a New York-based design studio and ad agency that specializes in creating artwork for Broadway theater. Prior to SpotCo, she spent seven years working in editorial design, including Time Inc Custom Publishing where she helped to launch *Proto*, a magazine for Massachusetts General Hospital. Her work has been featured in *The Design Entrepreneur*, *Fingerprint*, *Graphis*, *Step*, SPD, metropolismag.com, and the exhibition "Landscapes of Quarantine" held at Storefront for Art and Architecture in 2010. Amanda graduated from the MFA Design program at the School of Visual Arts, and holds a BA from Vassar College. She lives in Jackson Heights, Queens.

ESTHER PEARL WATSON
ILLUSTRATOR

Esther Pearl Watson grew up in the Dallas/Fort Worth area. Her family moved often, since her father's hobby of building huge flying saucers out of scrap metal and car engines didn't always sit well with the neighbors. Loosely based on a teenager's diary from the 1980s found in a gas-station bathroom, Esther's first graphic novel, *Unlovable*, details the sometimes ordinary, sometimes humiliating, often poignant, and frequently hilarious exploits of underdog Tammy Pierce. This remarkably touching and funny graphic novel tells the first-person account of Tammy's sophomore year.

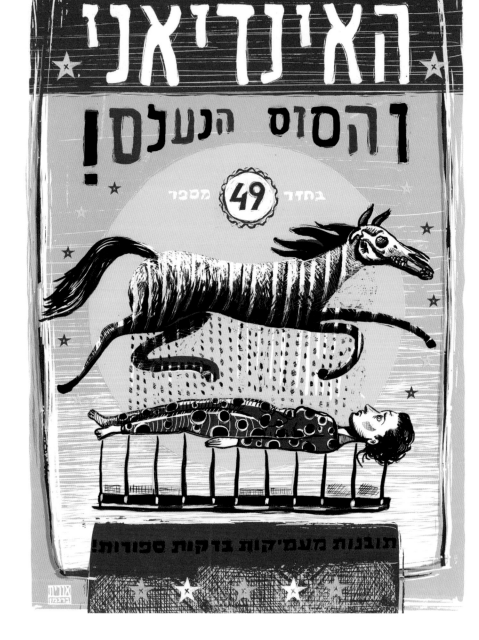

The Wish To Be An Indian
One of five posters created as part of the set design for *K.*, a site-specific performance inspired by short stories by Kafka, as part of the Israel Festival for Performing Arts, 2009.

A FIELD GUIDE TO NORTH AMERICAN CODERS.

GREAT GREY SLUG.
(*Lazimus maximus*)

KNOWN TO LEAVE A DISGUSTING TRAIL OF UNFINISHED BUSINESS IN ITS WAKE.

Great Grey Slug
Domenick Rella called me with an intriguing advertising assignment: draw a series of "heroic" animals, inspired by the work of John James Audubon for a company in the health insurance industry. The first creature for the tongue-in-cheek campaign was a Great Grey Slug. A heroic slug?—that was quite a challenge! This is the result.

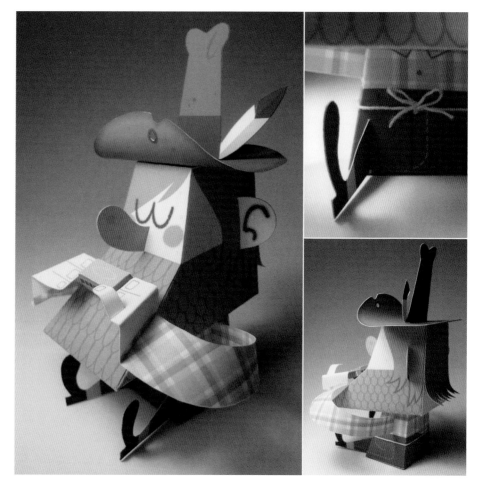

Buster
Paper toy created for the Urban
Paper Toy and Pop Out Show at
Pink Hobo Gallery, Minneapolis.

SILVER MEDAL WINNER
CURTIS PARKER

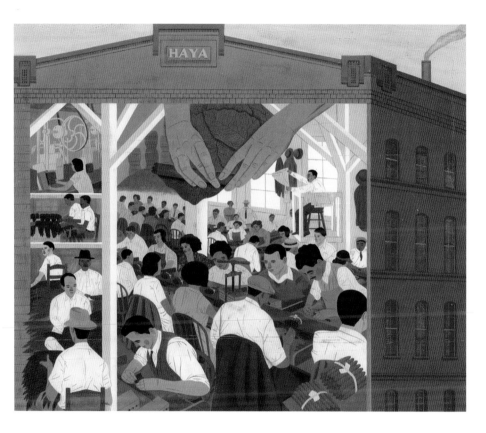

Cigar City Factory
This piece was one of four murals I painted for the new Tampa Bay History Center. The cigar industry in the '20s and '30s was big in Tampa and there were factories everywhere turning out hand-rolled cigars. I loved the idea that they had this guy sitting high up on the factory floor reading to the workers all day. I wanted this to have the feel of that time period, so I muted down the colors and kept the color range limited.

SILVER MEDAL WINNER
SAM WEBER

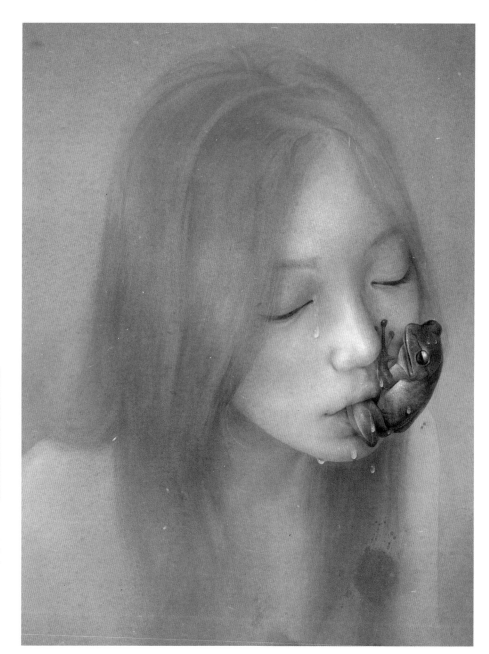

The Absinthe Drinker
Created for the annual Dellas Graphics Frog Folio. Artists are given free reign, as long as the image contains a frog.

ANA BENAROYA

WILCO Concert Poster

This piece evolved in my sketchbook and was ultimately pieced together on Photoshop. I loved working with the texture of hair and I knew that the colors had to be limited for a screen print, so this was the result!

I think this piece speaks about relationships and communication between people (or the lack thereof), which could also speak of the relationship music has to its listeners.

SERGE BLOCH

Nespresso City

For this campaign, Nespresso asked ten different artists to create images of European cities to then be printed on the coffee machines themselves. Serge tried to send a photo of himself but it was rejected, probably because he is less famous than George Clooney.

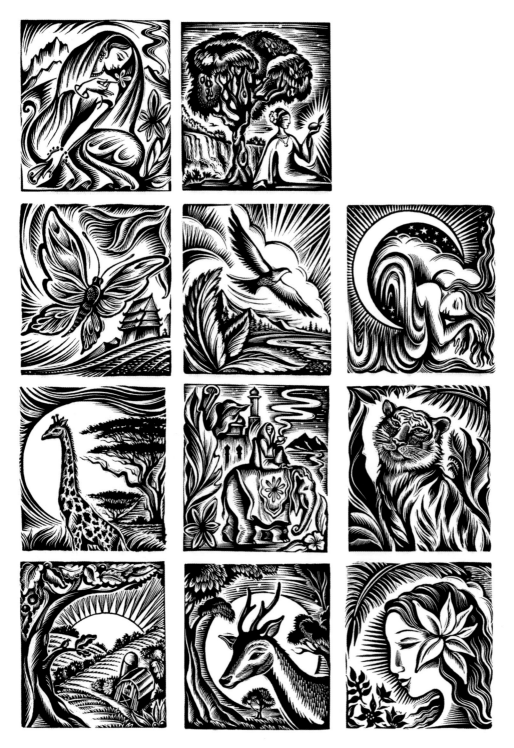

CATHIE BLECK
Good Earth Teas

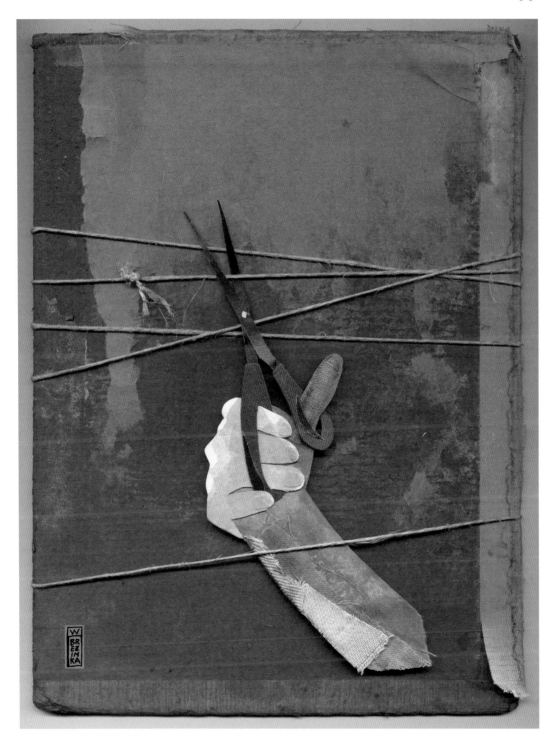

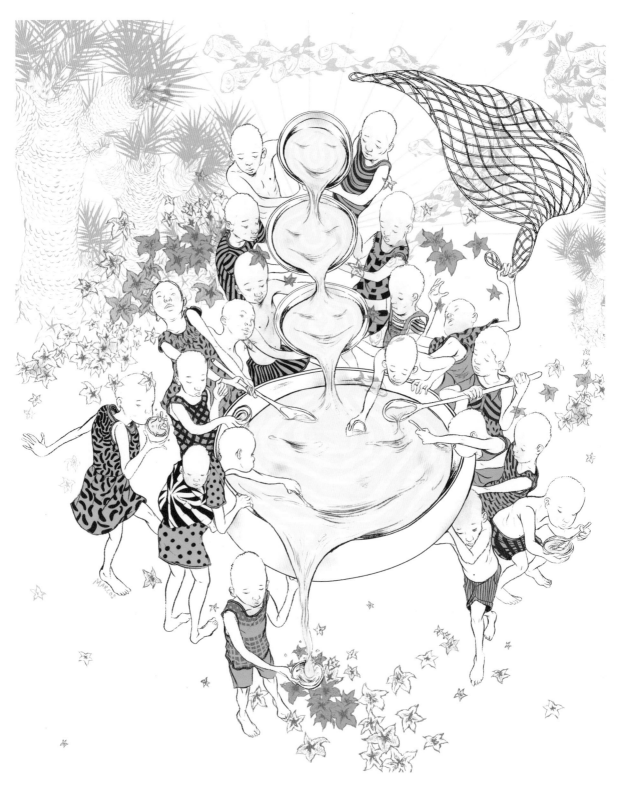

MARCOS CHIN
Untitled

JOSH COCHRAN
Wise Blood

I was given free reign as far as ideas go, and came up with a good variety of sketches. The idea that was chosen felt like a pivotal moment in the film and nicely summed everything up. Eric Skillman, the talented designer and art director at Criterion, told me to keep things loose and I took a more stripped down approach to the finish. I'm really happy with how things came together.

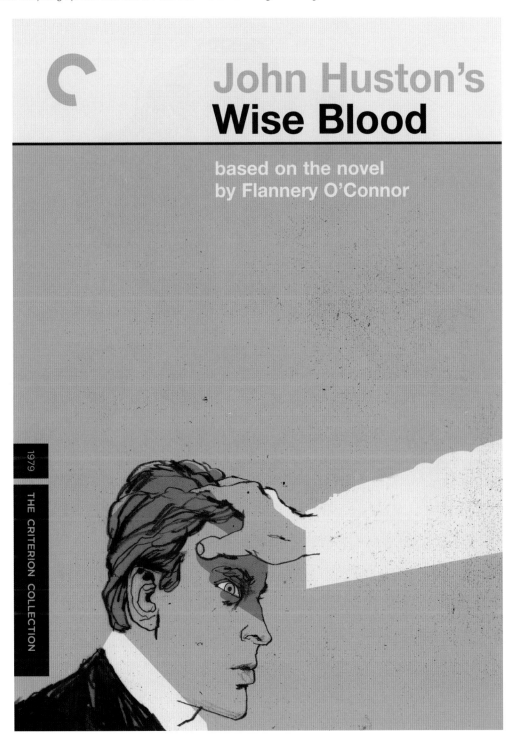

FERNANDA COHEN
(RED) Campaign 1
This drawing was inspired by a picture I took of myself for another project a few years back. When the Gap asked me to draw girls for a line of designer tees, I knew I had to use it. The art director gave me a lot of freedom, which I felt got the best out of me. The tees have my name and bio printed on their backs.

HUGH D'ANDRADE
Night of 1,000 Stars

CRANKYPRESSMAN.COM

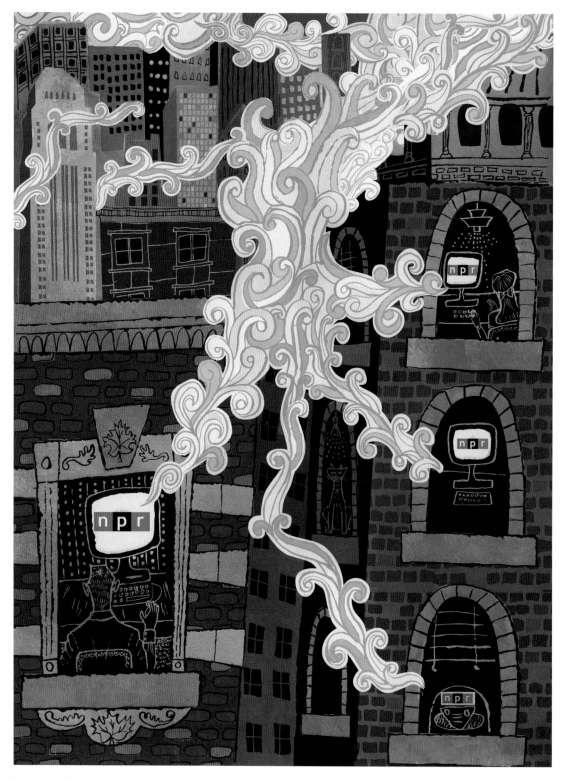

GILBERT FORD
National Public Radio Calendar Page (July)

MICHAEL GLENWOOD

Cherry Blossoms

This was done for an American Express promotional campaign. The artwork was for a customized window decal used by merchants accepting American Express in the Washington, D.C. area. Similar artwork was created for other large metropolitan areas, each decal featuring an iconic local landmark alongside the Amex logo. For each decal, the client chose a local illustrator who was familiar with that particular metropolitan area. Since the artwork would be used only regionally, it wasn't necessary that the landmark be a nationally known one. Because of the current political climate, I wanted to avoid any building that represented government, thus eliminating anything with columns, or a landmark that suggested a particular ideology or political party, which eliminated most memorials and monuments. The client and I narrowed the list of possible landmarks, for which I presented sketches. And while I favored going with something more esoteric (perhaps too esoteric for the client's needs), we settled on the cherry blossoms and Washington Monument. As with most of my work, it is hand drawn in Photoshop using a digital tablet and using none of Photoshop's filters or rendering tools.

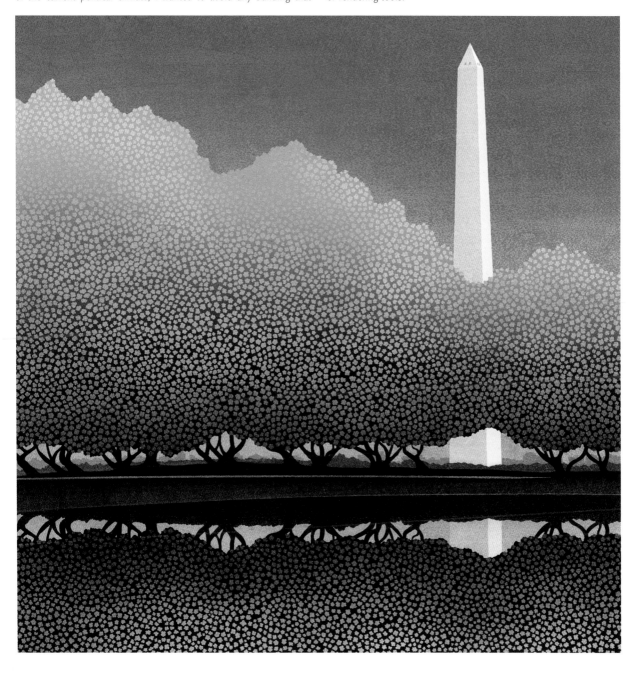

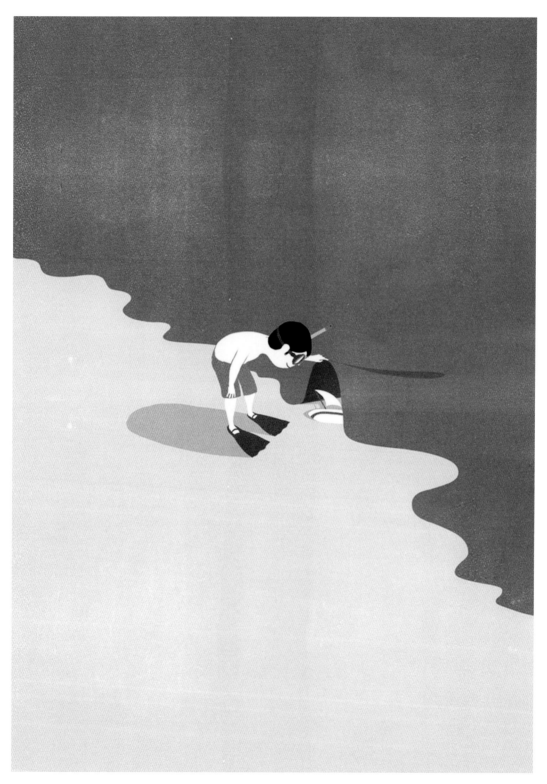

ALESSANDRO GOTTARDO
A New Discovery

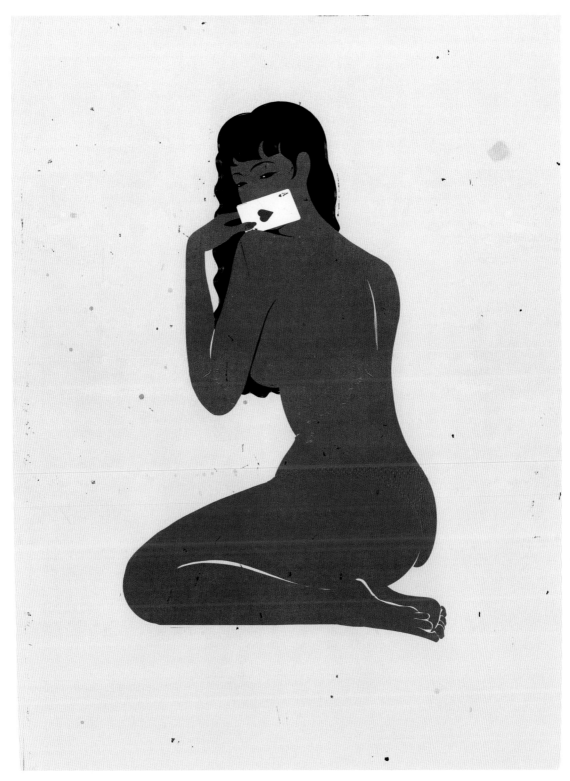

ALESSANDRO GOTTARDO
Heart On My Lips

TOMER HANUKA
Lust Collides

HENNIE HAWORTH

Teacups

I was asked by Habitat to create some posters for them. I was given the theme: collections. I chose teacups because of their decorative designs and the thought of drinking tea. To make the image I drew loads of cups and saucers, then scanned them in and arranged them on the computer. They were a great client to work with, very open to ideas.

JODY HEWGILL

St. Supéry Virtu

Portrait of a saint for St. Supéry wine label for Virtu 2009 label. I gave this saint a sexy, impish smile, and chose a background color palette to reflect the white wine.

BRAD HOLLAND
Cold Catch

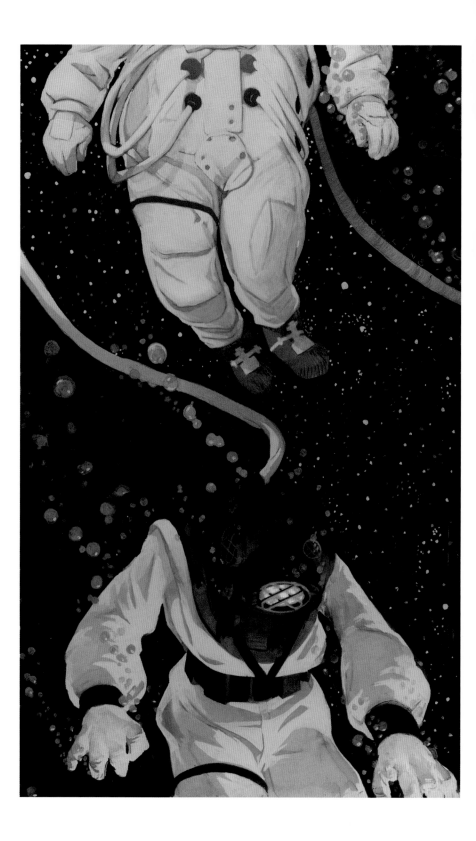

DONALD KILPATRICK III

Weeps

DONALD KILPATRICK III
Soul Birds

RENATA LIWSKA
Kawasaki Exit

JORGE MASCARENHAS

Bear Attack

This piece was for a Lürzer's Archive advertising campaign by various illustrators depicting bear attacks. The image of a grizzly "fishing" for humans came right into my mind. Helen O'Neill and Maggy Lynch Hartley were the art directors.

BILL MAYER
A Christmas Card
For years I have included slightly different increments of this drawing
when sending concepts to Hartford Stage. This time it made it to the top
of the heap. The original idea was scarier, with the ghosts woven into the
wrinkles of his face, but the client wanted to lighten it up a bit.

SCOTT McKOWEN
Twelfth Night

Elizabethan doublets on wardrobe stands represent the twins in Shakespeare's *Twelfth Night*. The inanimate garments are coming to life, animated by an irresistible attraction to each other. The costume details came from a portrait miniature painted in 1616 by Isaac Oliver, now in the Victoria and Albert Museum.

Scott McKowen

Pearl Theatre Company

The Pearl Theatre Company has been referred to as a little gem in the New York theatre community. This image was the season poster for the company's 25th anniversary in 2009. A pearl is small and rare and precious, and, as the light source for the illustration, created an interesting challenge: to render the translucency of an oyster shell in scratchboard.

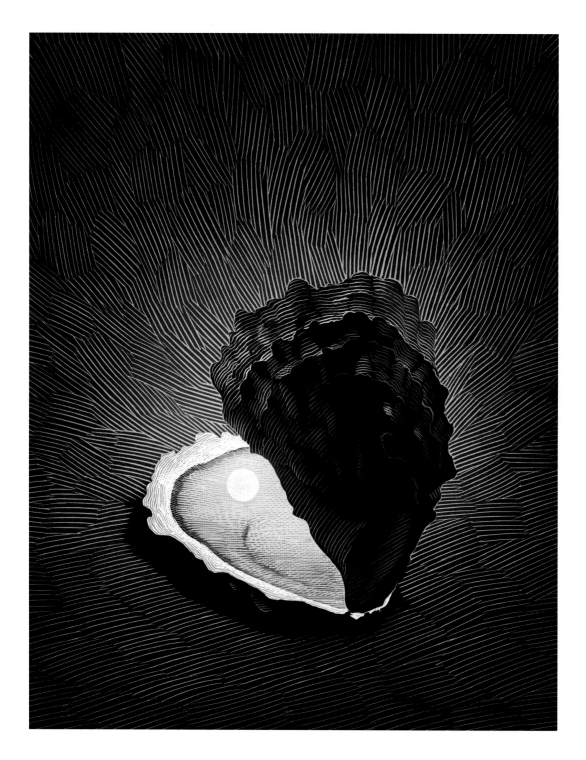

SCOTT McKOWEN

Tartuffe

Moliere's *Tartuffe* satirizes religious hypocrisy. It's a wickedly funny comedy, but the play has many darker complexities. When it first appeared, the play was well received by the public, and even by King Louis XIV, but the Archbishop of Paris threatened to excommunicate anyone who watched, performed in, or even read the play. I wanted the poster image to have some teeth. In Christian symbolism, the snake refers to Satan, the Tempter, enemy of God and the agent of the Fall.

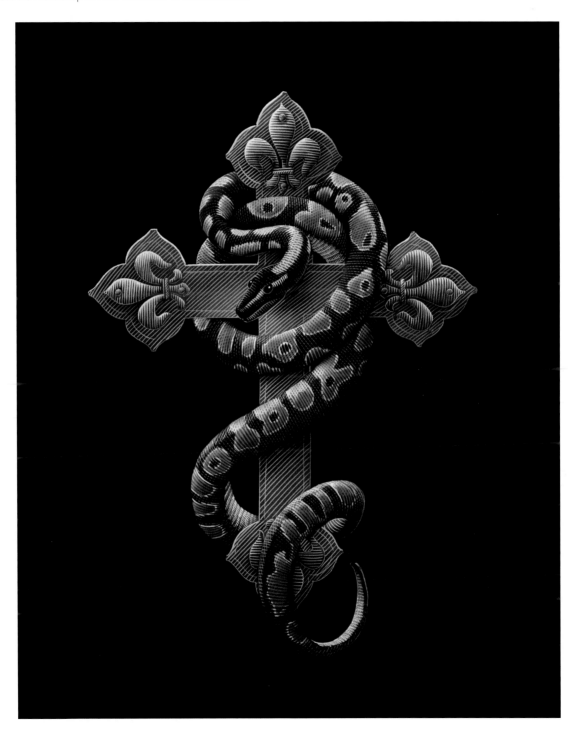

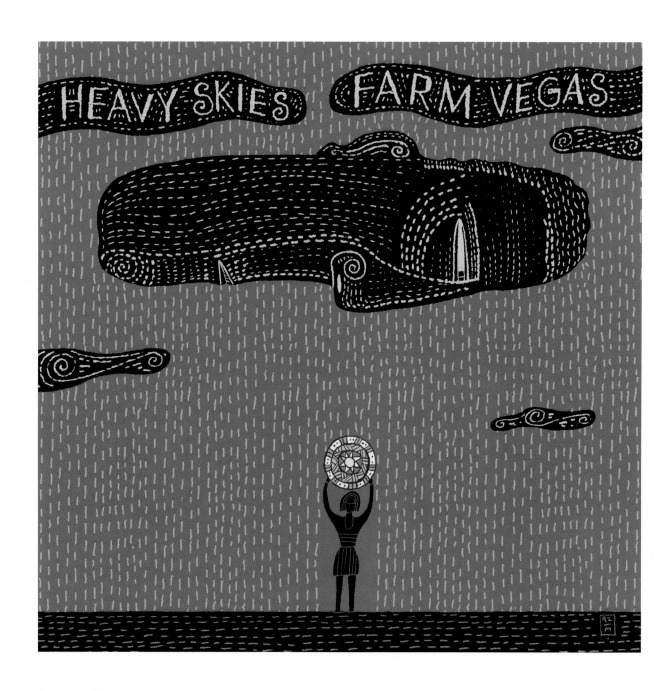

ROBERT MEGANCK
Heavy Skies

KADIR NELSON

Be Driven

I generally do one big ad job per year, which is enough for me. They're always fraught with numerous changes and nitpickings. This one in particular fit the bill. After delivering what I thought was the finish, the client requested several changes. They weren't big changes, but what made them particularly tough was the fact that I was on the road when they asked me to make them, which meant that I had to make the changes digitally. Fortunately, I had just purchased a new laptop fast and powerful enough to do the job. I made the changes in my hotel room and all was well. The client was happy and, hopefully, so was Lebron.

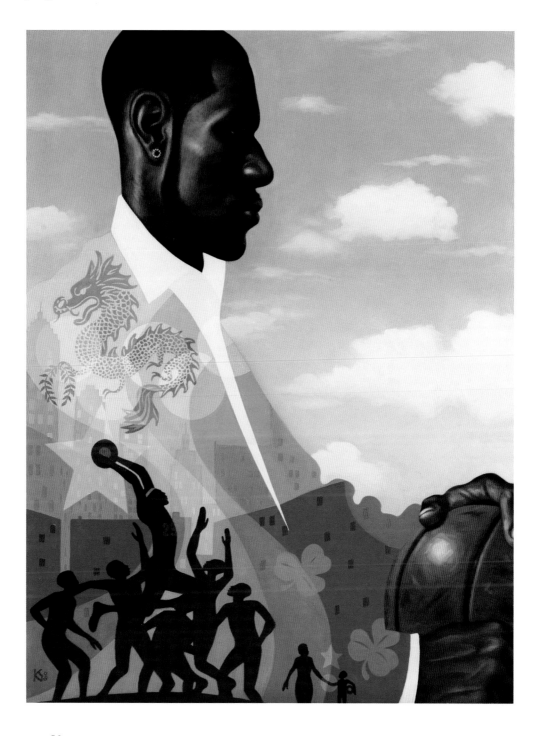

THE 14TH ANNUAL CROQUET BALL

BENEFITING THE PENFIELD CHILDREN'S CENTER

SEPTEMBER 12, 2009

Make an impact. Have an impact.

CHRIS SILAS NEAL
Penfield Poster

Chris Silas Neal
Lykke Li

Zachariah OHora
Monsters of Folk Poster

LORENZO PETRANTONI
Ragtime Musical

Curtis Parker

Collaboration

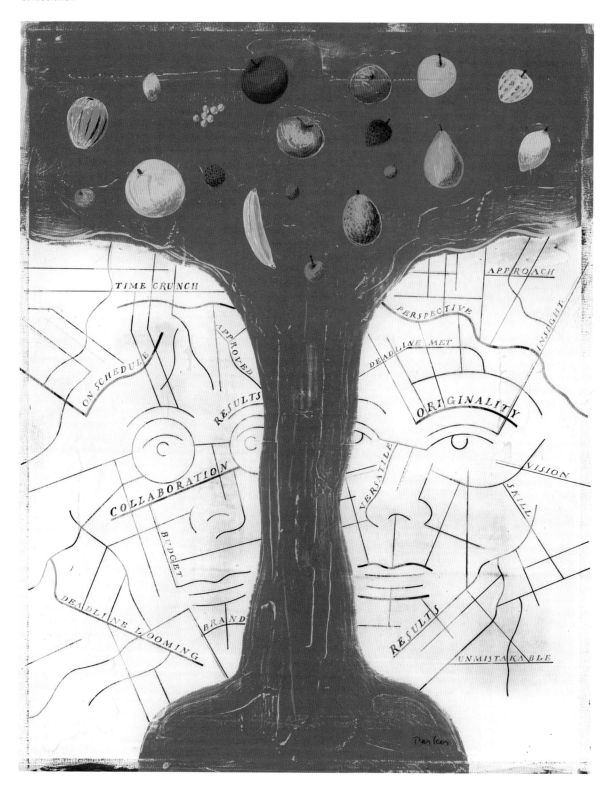

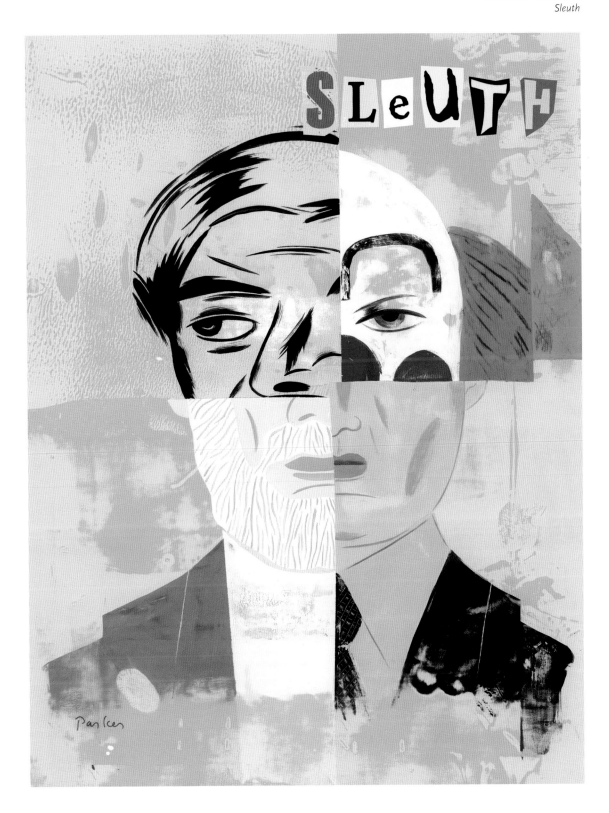

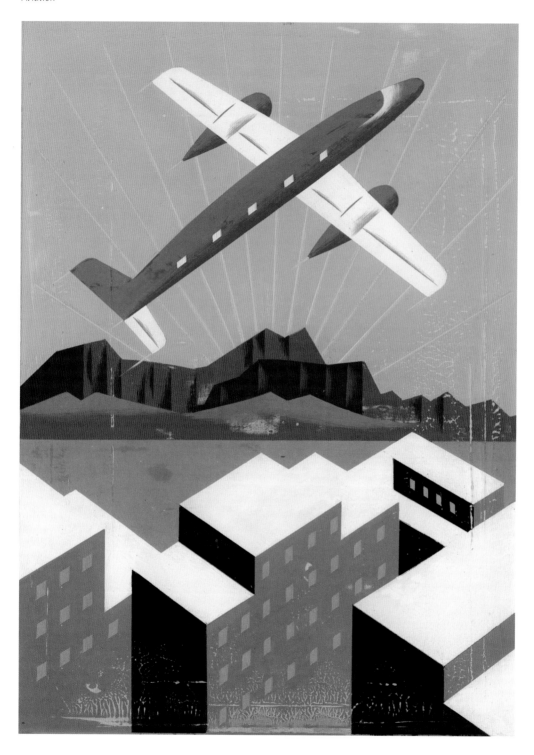

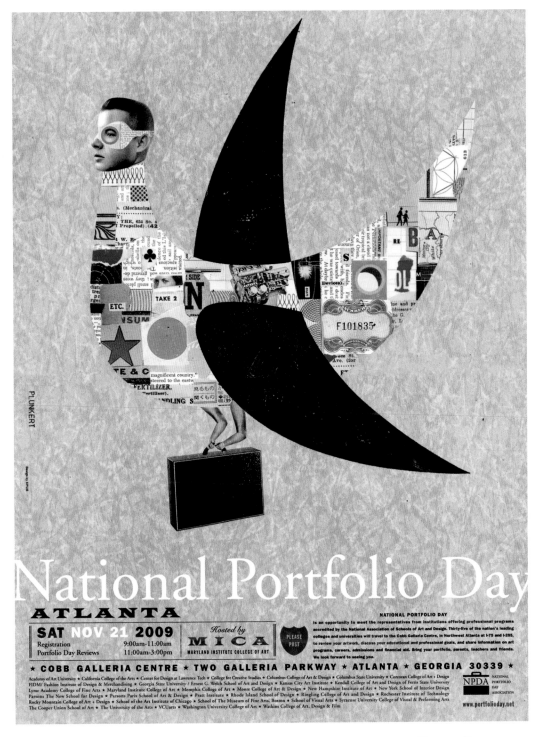

DAVID PLUNKERT
MICA National Portfolio Day in Atlanta

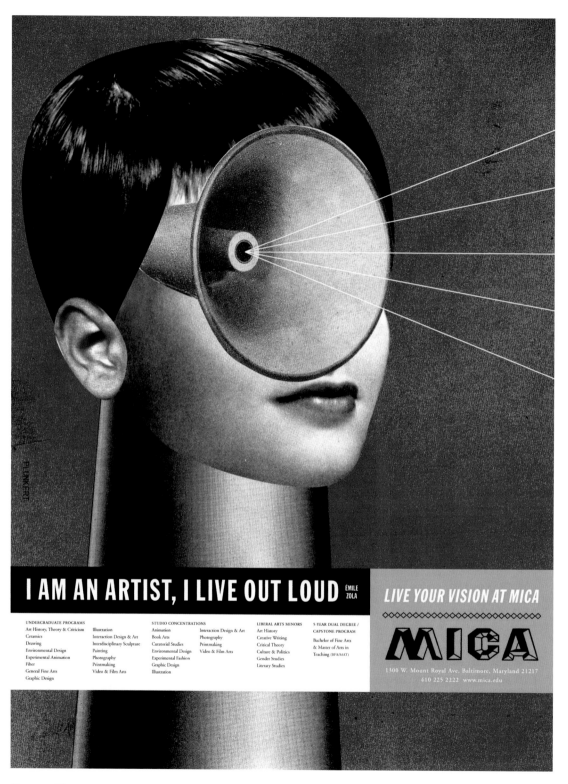

DAVID PLUNKERT
MICA Recruitment Poster

PAUL ROGERS

U.S. Open 2009

For this piece, the U.S. Open logo of a tennis ball with flames had to be included in the image. Although I was a little concerned about showing a flaming object flying over the New York skyline, the idea of turning the Brooklyn Bridge into a tennis net was too good to pass up.

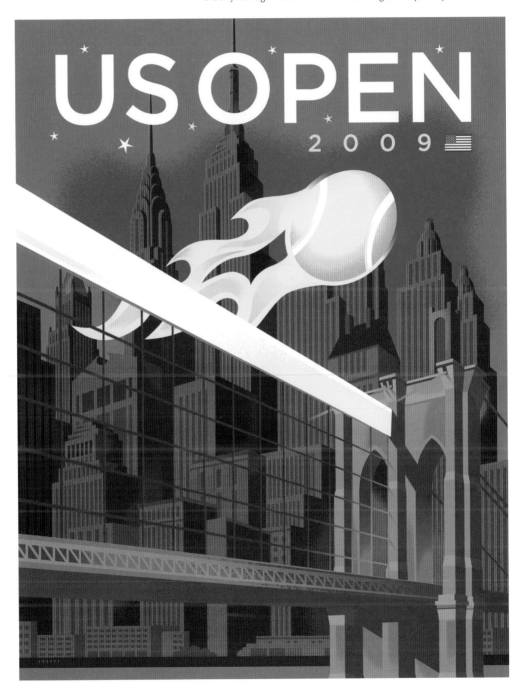

EDEL RODRIGUEZ
Rock and Roll

This painting was commissioned for the Rock and Roll Hall of Fame's 25th Anniversary Concerts. It was used in print advertising, billboards, t-shirts, posters, and on the concert program. I worked with *Rolling Stone* art director Joe Hutchinson and *Rolling Stone* editor Jann Wenner, one of the founders of the Hall of Fame.

EDEL RODRIGUEZ
Nixon in China
I was commissioned by the Vancouver Opera to create a series of four posters for its season's performances. This is *Nixon in China*, a contemporary take on Nixon's trip to the East in the 1970s. Doug Tuck was the art director and Annie Mack the designer.

FELIX SOCKWELL
Miles

JOHN SOLTIS
The Spirit

BRIAN STAUFFER
Death of a Salesman
Theater poster for the Soulpepper Theatre 2010 season production of
Arthur Miller's play.

BRIAN STAUFFER
Waiting for the Parade
Theater poster for the Soulpepper Theatre 2010 season production of
a play that explores the lives of five servicemen's wives waiting for their
husbands' return from WWII.

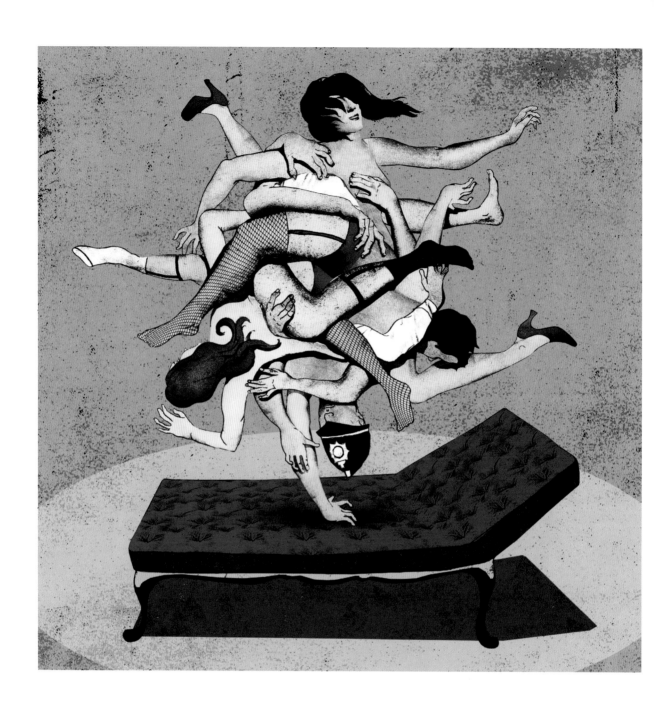

BRIAN STAUFFER
What the Butler Saw
Theater poster for the Soulpepper Theatre 2010 season production of a
sexually charged play about a psychiatrist who seduces just about anyone
who enters his office.

BRIAN STAUFFER
Vision Bomb
Promotional image for *The Directory of Illustration*.

THE HEADS OF STATE
NW Film Center
Poster for Portland's always clever International Film Festival.

The Heads of State

AC Newman
Show poster in support of A.C. Newman's "Get Guilty" tour.

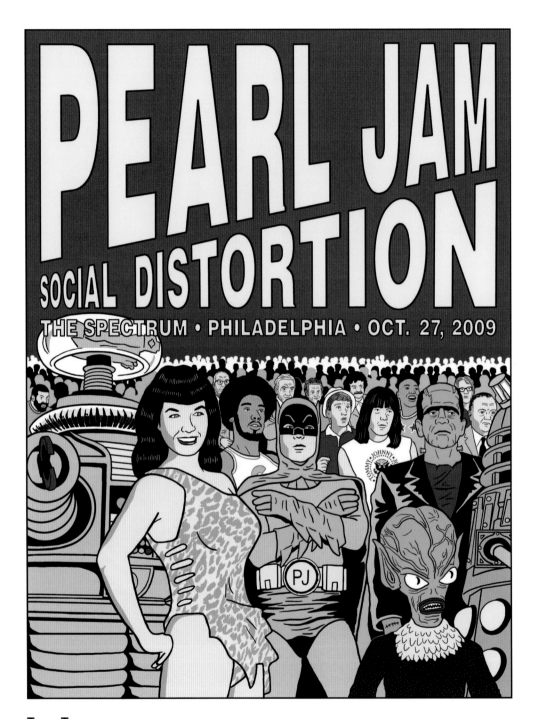

TOM TOMORROW
PJ Philly Night 1
Pearl Jam played the final four shows at the Spectrum in Philadelphia
before that venue was slated for destruction. This is the first of a series
of four posters I designed for those concerts.

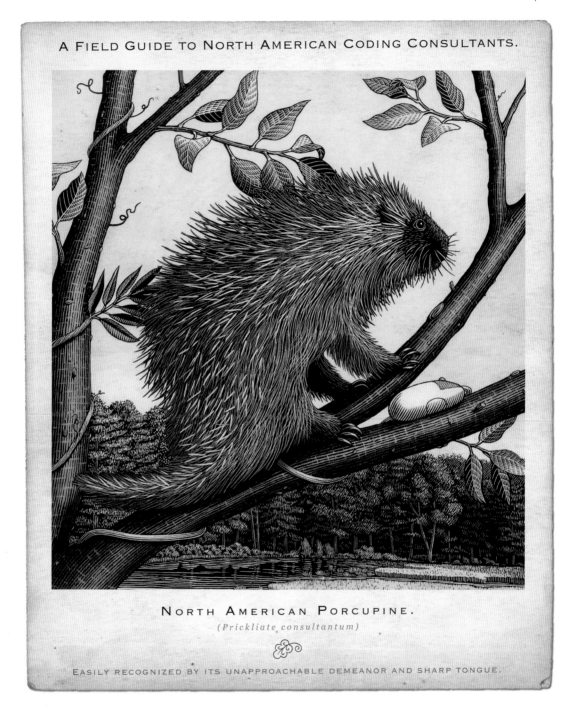

A FIELD GUIDE TO NORTH AMERICAN CODING CONSULTANTS.

NORTH AMERICAN PORCUPINE.
(Prickliate consultantum)

EASILY RECOGNIZED BY ITS UNAPPROACHABLE DEMEANOR AND SHARP TONGUE.

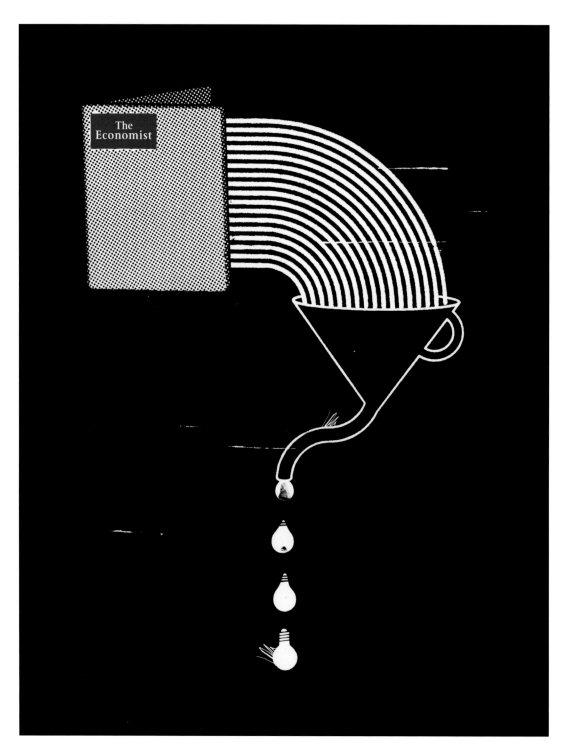

YAREK WASZUL
The Economist

MONIKA AICHELE
How To Make Snow

MONIKA AICHELE
I Don't Know

MONIKA AICHELE
Big Ears

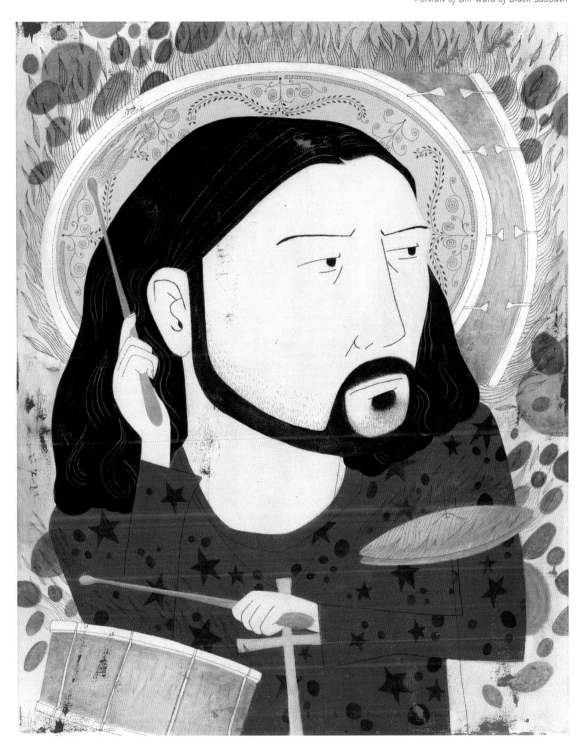

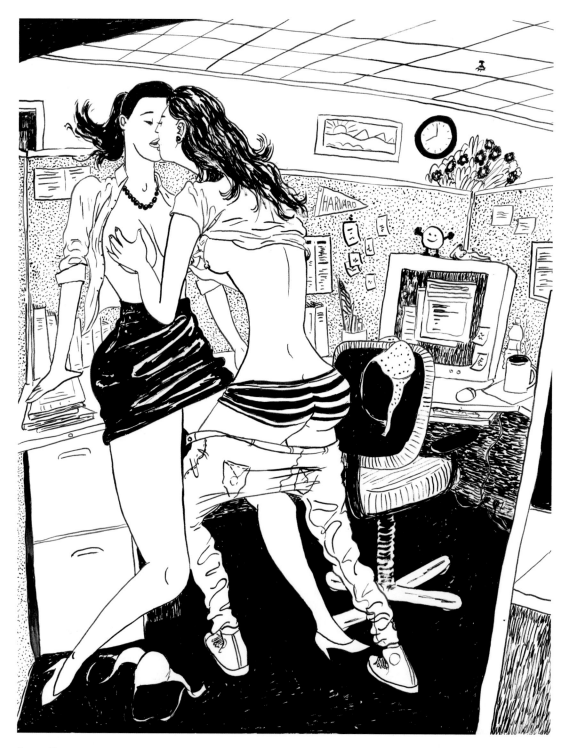

ANA BENAROYA

The Cubicle
This piece was commissioned for the exhibition PEEPSHOW, a collection
of different artists' interpretations of the theme: X-Rated Fantasy. And
there you have it.

MIKE BENNY

Nap Lajoie

This baseball portrait is from a project that Seraphein Beyn Advertising and I have been working on for 20 years. The unique challenge of this project has always been to create an interesting portrait even if you are not a baseball fan. Nap Lajoie was one of the great early ball players, who also happened to look a lot like a young Robert Deniro.

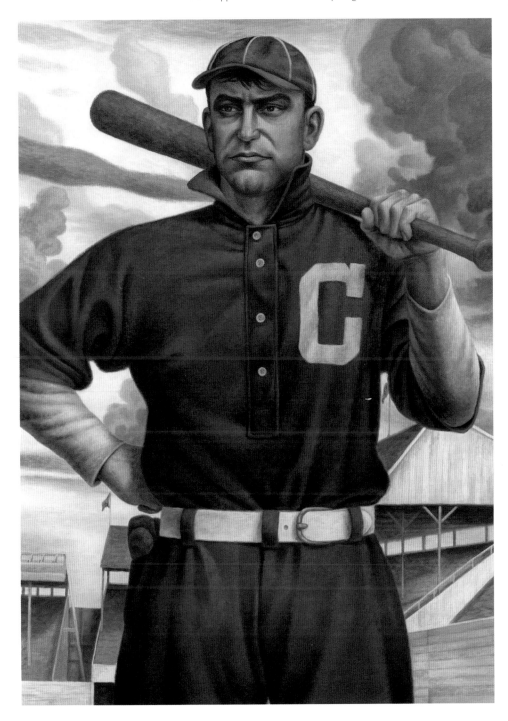

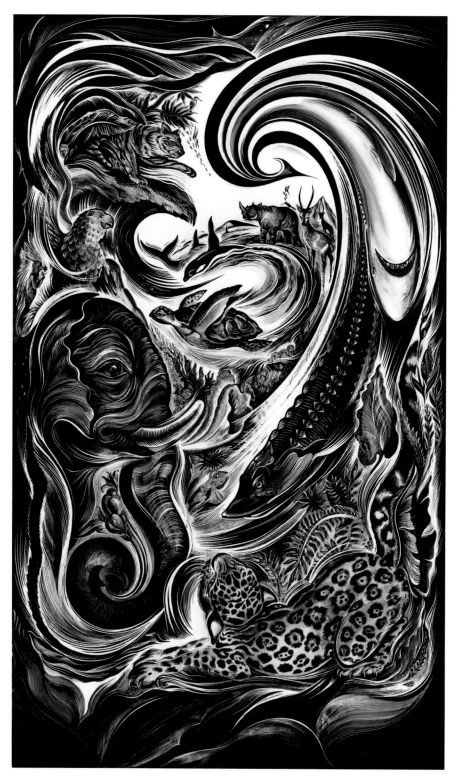

CATHIE BLECK
Nature's Myth 1

MARC BURCKHARDT

Custo Elvis
One of a series of pieces created for Custo Barcelona clothing in Spain that have been applied in various ways on their latest lines. The project had a fairly wide open brief, with the client providing random phrases that they asked me to illustrate. Fun stuff!

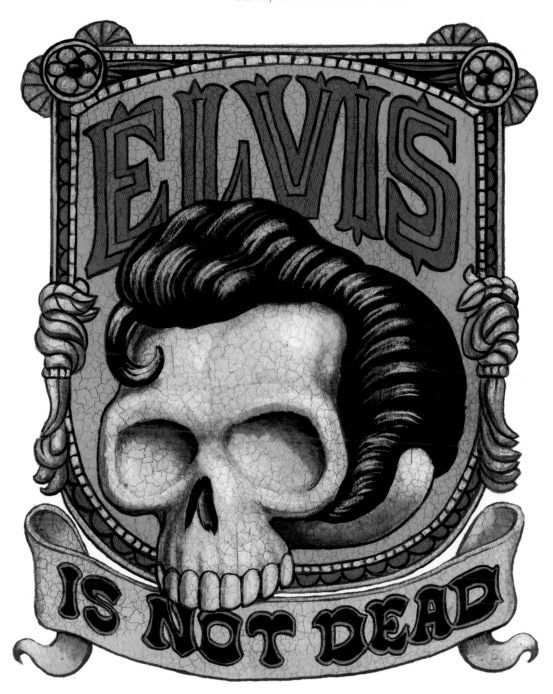

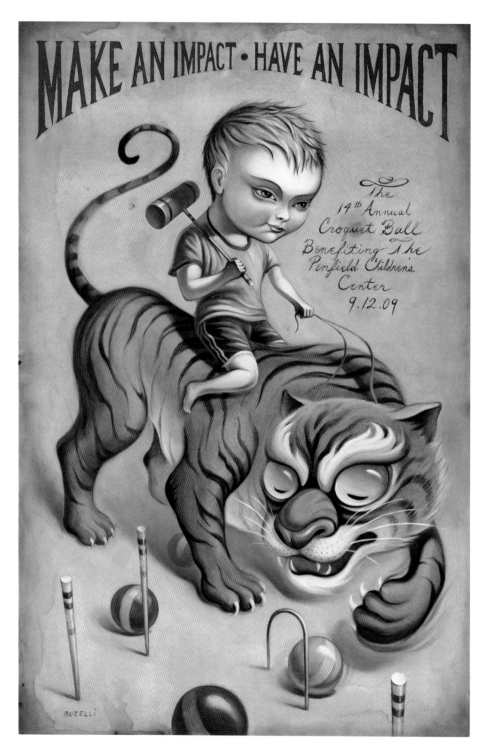

CHRIS BUZELLI
Penfield Poster

This poster was for the 14th Annual Croquet Ball benefitting the Penfield Children's Center in Milwaukee, Wisconsin. Some of my favorite illustrators have worked on a few of the past posters and set the bar very high. The only art direction was to include the title and text for the invite. I took advantage of this rare opportunity and hand-painted all the type.

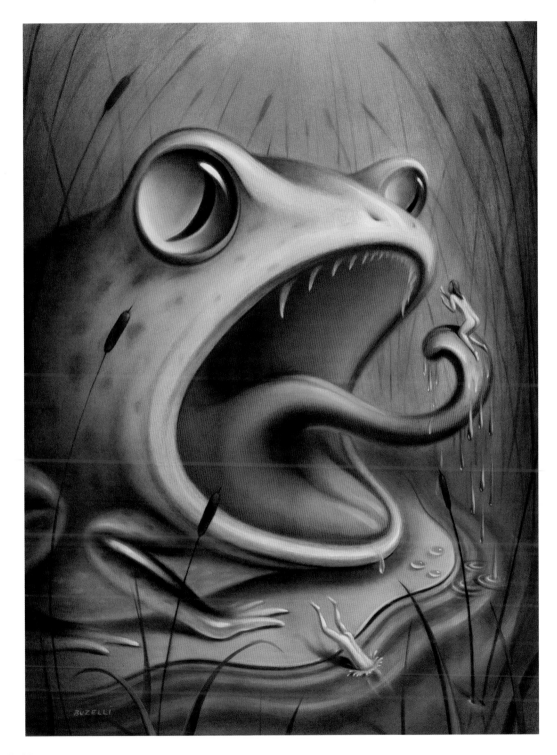

CHRIS BUZELLI
The Skinny Dippers
This painting was for the Dellas Graphics annual promotional calendar. The only requirement was to include their mascot/logo of a frog. I've seen many of the winning frogs in past Society annuals and was very excited when I got the call from the talented illustrator and art director, Jim Burke.

CHRIS BUZELLI
Ruiz
This portrait was part of a series for the Southwest Gas Annual report. I worked with art director Justin Keller on the same project last year and painted *Babe and the Big Blue Ox*. This time, he saw my recent graphite paintings and wanted something similar. I was given a small blurb and a snapshot of each employee.

HARRY CAMPBELL

Radio

Commissioned for the annual NPR calendar. We were asked to portray how we feel about NPR or how we listen. I've been listening to WNYC in New York for years via the Internet, no matter where I am. The piece shows the old and the new ways of listening.

Q. CASSETTI
Portrait of Jiri Harcuba, Masters of Studio Glass Show Identifier

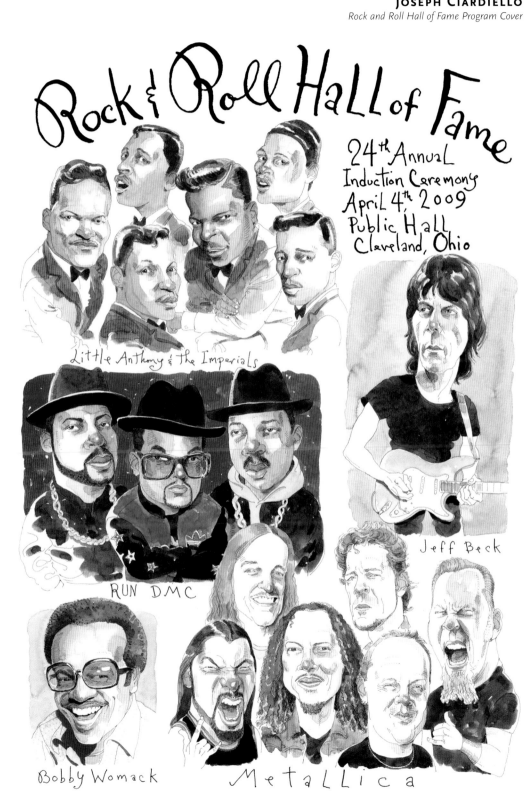

Rock & Roll Hall of Fame

24th Annual
Induction Ceremony
April 4th 2009
Public Hall
Cleveland, Ohio

Little Anthony & the Imperials

RUN DMC

Jeff Beck

Bobby Womack

Metallica

JOSH COCHRAN
Annual Report
This was used primarily for a website. I had to incorporate four different themes seamlessly into one long drawing. It also had to be an interactive piece that would scroll infinitely. I had a lot of fun drawing this. I worked with art director Jennifer Lee at VSA Partners.

TIMOTHY COOK
Charlie Watts
This portrait of the Rolling Stone's Charlie Watts was created for "Cut To The Drummer," portraits of 50 drummers by 50 artists. The exhibit/concert raised money for F.U.M.S. and the MS Society of Canada Scholarship Fund. The event was put together by The Bepo + Mimi Project, a Toronto-based organization that promotes the value of illustration as an art form.

CHRISTOPHER DARLING
A Book Show Invitation

ROGER DE MUTH

"Sementes De Pastos" Soares & Rebelo

I've been to Lisbon several times. It's a beautiful city, and a great place to visit. It's also a trip backwards in time. Lisbon reminds me of what cities were like in this country 50 years ago before malls ruled the roost. Some stores have remained in business for over a 100 years without changing the façades or the interiors. The seed store, Soares & Rebelo, is perhaps the prettiest store I've ever been in. It has remained unchanged over the years and for good reason—it's beautiful. Rows and rows of decorative seed packages line all the walls. On my last trip to Lisbon, I stopped in, made sure nothing had changed, then gave them a print of this painting. While they spoke no English, their eyes said "thank you" in Portuguese.

PETER DE SÈVE

Grand Central

MICHAEL DEAS
Edgar Allen Poe

Because of my research over the years, I was well acquainted with Poe's appearance before I started work on this stamp. In 1989, I published *The Portraits and Daguerreotypes of Edgar Allan Poe*, a comprehensive collection of images featuring authentic likenesses as well as derivative portraits. The portrait for the stamp was done in oils on a wooden panel.

BIL DONOVAN
Dior Café
An Artist-in-Residence for Christian Dior Beauty, Bil Donovan was commissioned to create a series of limited edition note cards that reflect the spirit, style, and sophistication of Dior. *Dior Café*, created for the series, was also selected to be printed on a Dior tote bag.

LEO ESPINOSA
The Poet
One of eight illustrations created for LaGuaka, an artists' collective from Colombia. Profits from the sale of artwork supports art programs for children of low income families.

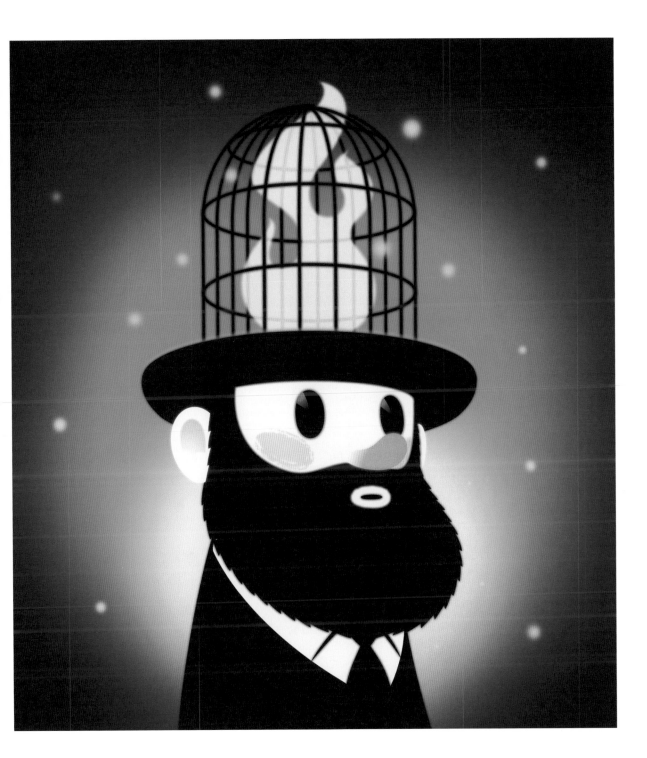

Leo Espinosa

Humans Are Yummy and Have Great Taste (in hats)
Custom wooden toy featured in Natural Resources, a traveling toy show
created by Bigshot Toyworks and Mike Burnett.

Sarajo Frieden
Annual Meeting of the Alarmed Bird Society

MICHAEL GLENWOOD

Oil Planet

This piece was created for a consulting company's analytical report detailing the current status of oil production in the so-called BRIC countries: Brazil, Russia, India, and China. It was a report filled with facts and statistics, charts and graphs, but not much of a plot line or vivid imagery. But that is one of the great things about being an illustrator: creating a fairly interesting picture while working from fairly uninteresting material. It's a challenge I find rewarding, and it's especially rewarding when the client has an appreciation for work that is not literal, which was the case here. Certain shapes lend themselves to use as metaphors and have a built-in graphic appeal—in this case, the form of the oil can is classic, and the round shape seemed tailor-made to be re-cast as the oil-containing Earth. And while my dad, a former cartographer, might raise an objection or two, I used a little artistic license to put Brazil, Russia, India, and China on the same side of the planet—a necessity in this case.

MICHAEL GLENWOOD

Tweets and Sharks

This was done for the University of Maryland—Baltimore, to illustrate a cover story about the potential repercussions of using social media sites like Twitter and Facebook. The article described how younger users, having grown up with technology that places a lower premium on privacy, unwittingly reveal personal information or post comments that can spread virally and later come back to haunt them. Because the story referred to the illusion of privacy that users feel when interacting on these sites—a sense that what is being shared is being shared only with a closed circle of friends—I wanted to convey the idea of illusion with an optical illusion as well as the notion of actions and consequences, hence the outgoing tweeting birds morphing into incoming sharks.

CHRIS GALL
In Flight

JEANNE GRECO
King and Queens of Hearts

The stamps make reference to two popular, classic icons but represent them in a simplified, modern style. I had wanted the statement to be strong but delicate. In the past, Love stamps had featured the usual vocabulary of hearts, flowers, cupids, etc. These stamps intend to depict a more mature, compassionate love and devotion between two people.

John Hendrix

AIGA 20 Twitter

The St. Louis chapter of the AIGA contacted me about creating a limited edition of 20 handmade prints to celebrate their 20th anniversary. The topic needed to address how our field has changed in the last two decades. I focused on the shift away from phone conversation to interaction on screens (very small screens). Perhaps being always reachable has made us more disconnected. Because these needed to be handmade prints, I worked a bit differently than usual. I created the figures in ink, then printed them with acetone transfers. On top of that I used rubber stamps, brayers, and block printing ink.

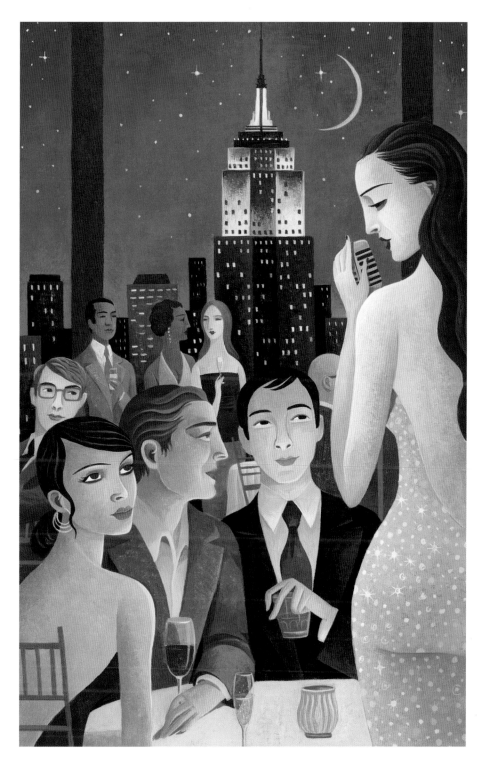

JODY HEWGILL
An Intimate Night
Invitation for a jazz/cabaret evening at the Rainbow Room for a winter fundraising benefit.

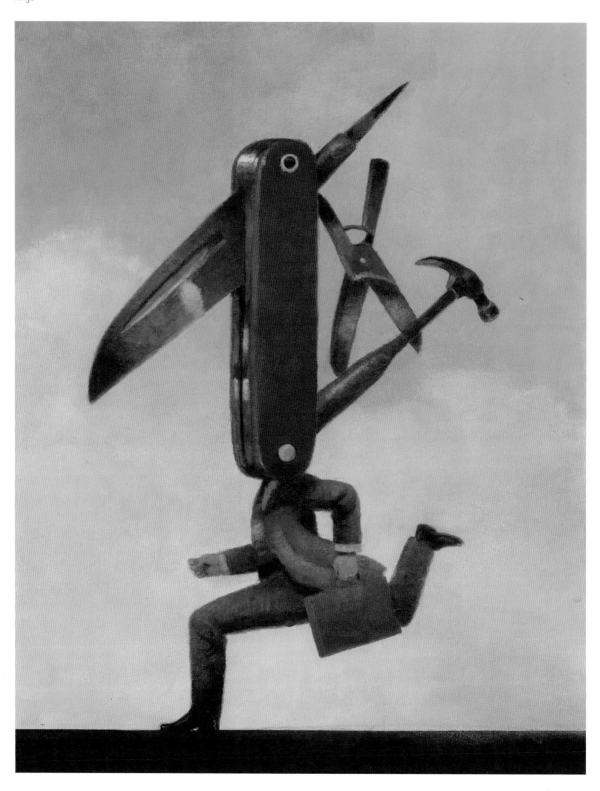

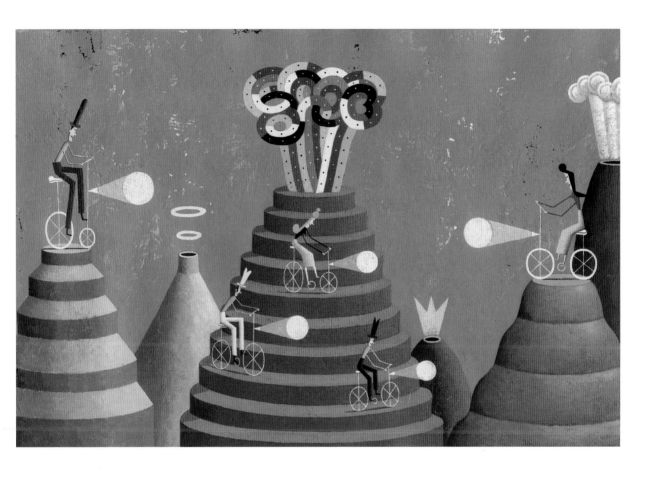

MARTIN JARRIE
Short Films Festival Poster
This was the poster for the 2009 International Clermont-Ferrant short film festival. Clermont-Ferrant is Auvergne's capital city, known for its (extinct!) volcanoes. The short film directors are as nuts as these fast-and-(screw)-loose projectionists. It is acrylic on paper.

TATSURO KIUCHI
Where is My Vote?
I was asked by photographer Morteza Majidi to do a protest poster for Iran. Protest posters done by many artists and designers around the globe were presented on the *Social Design Zine* website. The piece is digitally created with Photoshop.

ANITA KUNZ
Flesh and Blood/Snake
This was one of six paintings I produced entitled *Flesh and Blood*, having to do with human and animal symbiosis. I chose this one as a poster to promote a talk I did with Sam Weber at the Savannah College of Art and Design.

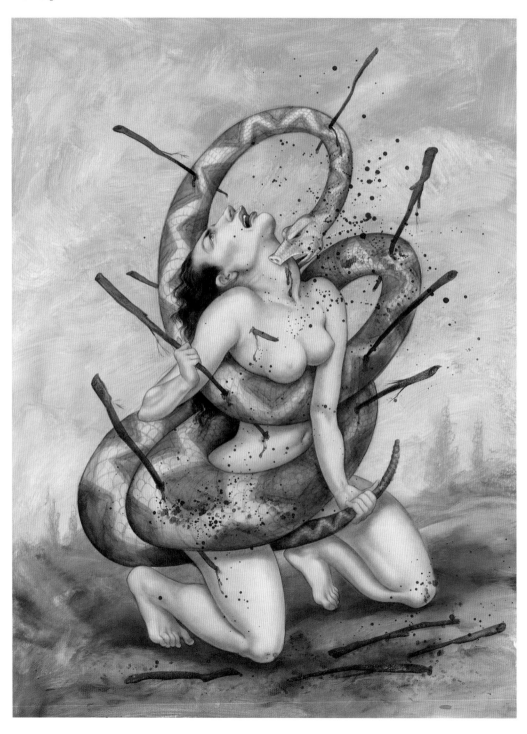

ANITA KUNZ

Charles Darwin

This painting was done as a demonstration for the students of The Illustration Academy. It was a filmed record of basically how I work, from idea generation and conception through the design of the image, and finally, it is a record of the painting from start to finish. I chose Darwin as a subject both because 2009 was his 200th birthday, and also because his ideas inform much of my personal work.

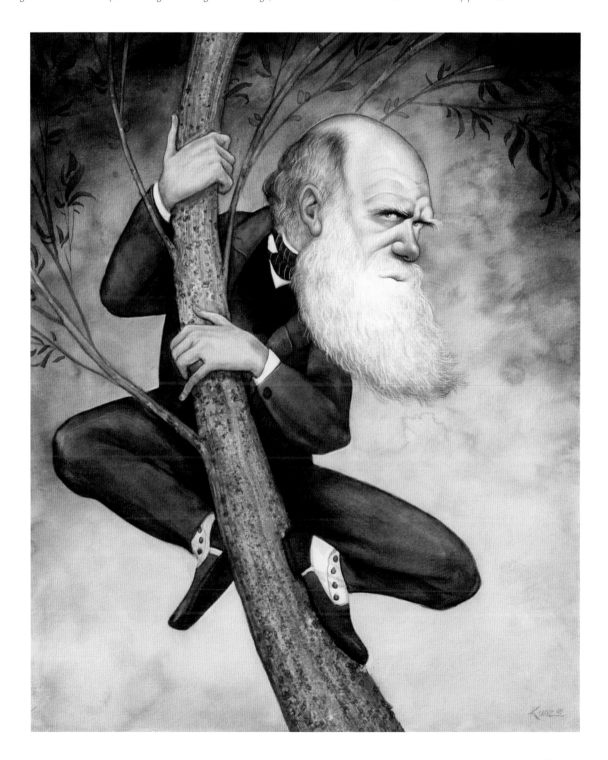

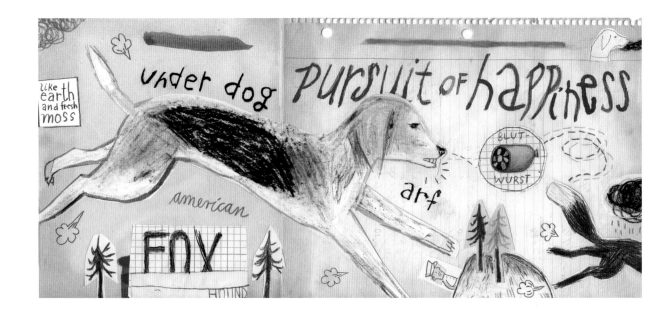

NORA KRUG
Pursuit
This piece was created for Wurst Gallery in Portland, Oregon, which commissioned me to create a drawing to support Dove Lewis dog hospital.

BILL MAYER

Traffic

The idea behind this illustration was that NPR was the oasis in a world of chaos. There were a bunch of these scenarios but the idea of the traffic came from my grandson, Forest. I was trying a limited color pallet to draw attention to the guy and his dog in the car.

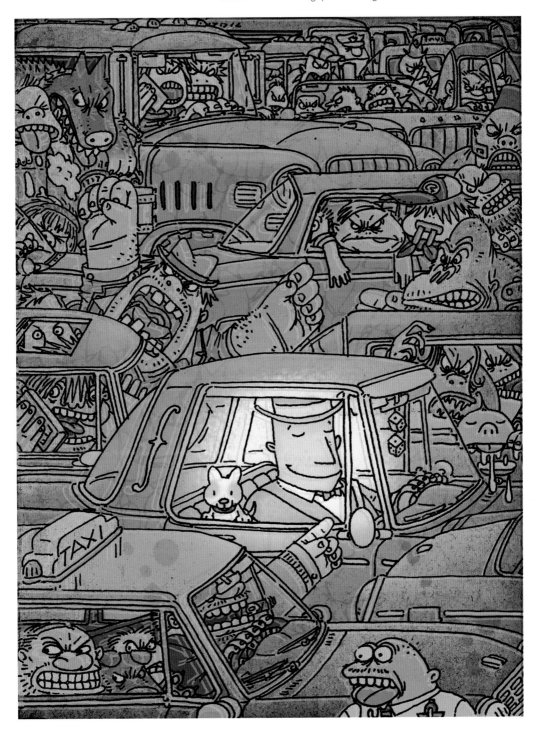

GRADY MCFERRIN
Ocelot

2009
Burgundy
Pinot Noir
Appellation
Bourgogne Controlée

Maître Renard
Produit de France

GRADY MCFERRIN
Maître Renard

GRADY MCFERRIN
The Driveway Moment

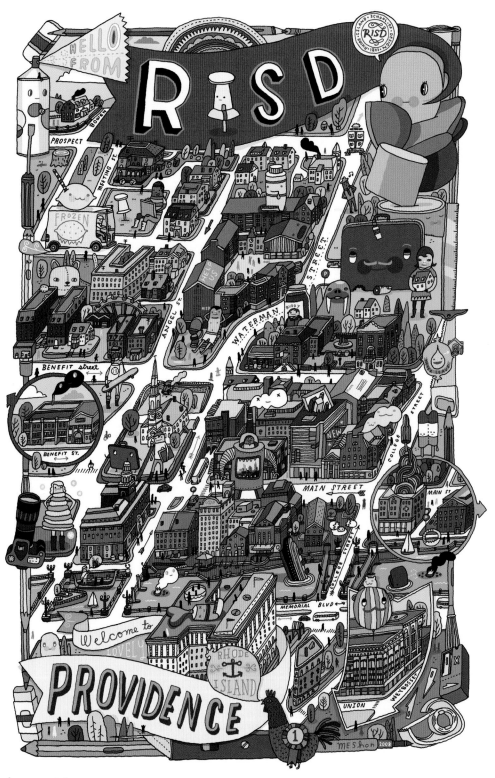

Aaron Meshon
Rhode Island School of Design

KADIR NELSON
Shirly Chisholm

This was one of those dream jobs I never really thought I'd get. Well, not until I was asked to submit a proposal to the U.S. House of Representatives for a painting of the first African American woman elected to Congress. After doing tons of sketches and wading through a very long approval process, I was given the green light to start painting. The curator and clerk really wanted the painting to show the character and spirit of Mrs. Chisholm. The raised finger turned out to be essential, and assured the approval of my last sketch. I really enjoyed painting her likeness, and had fun painting her coat and the matching deep blue sky. I hope I did justice to the proud and courageous pioneer whose passion for justice and equality for all people is sure to inspire a great many who pass through the halls of the Capitol Building and see her proud and forbidding gaze, finger raised and all.

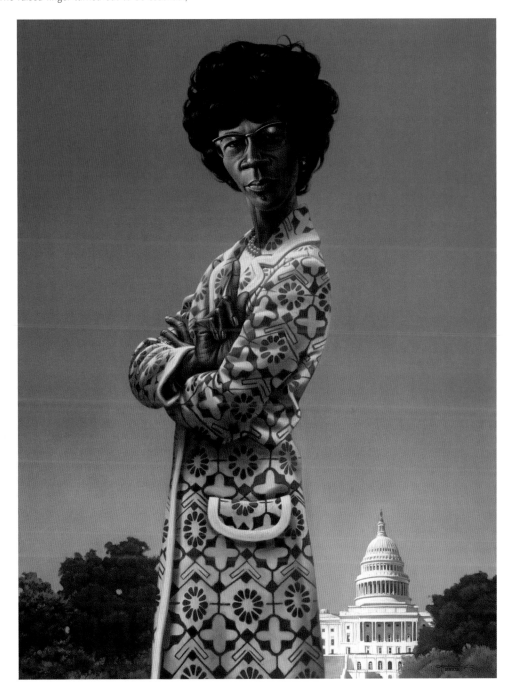

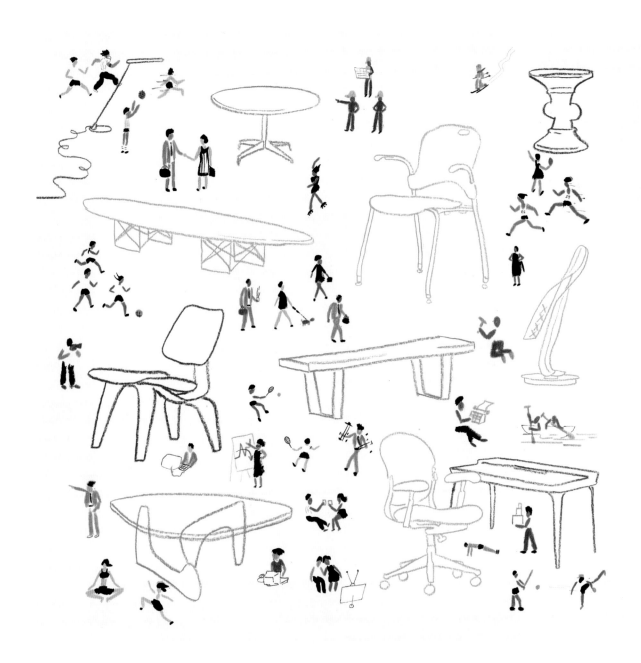

CHRIS SILAS NEAL
Herman Miller Piece

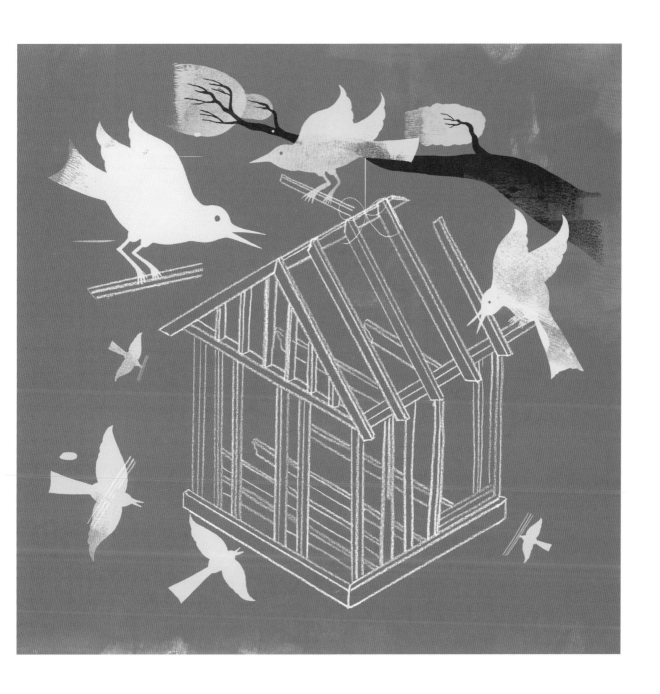

CHRIS SILAS NEAL
Herman Miller Bird House

Jillian Nickell

Alice's Sewing Basket

Originally I thought of this illustration while sewing a dress. I was reminded of just how much my pincushion looked like a hedgehog, and the other characters soon followed. The characters seemed to have come to me straight from a Lewis Carroll book. It was created using ink on Bristol board and was colored in Photoshop.

CHRISTOPHER NIELSEN
Gastroenterology

ZACHARIAH OHora
Don't Make Me Stop This Car!

MELANIE REIM
Hong Kong Harbor

EDEL RODRIGUEZ

Frog Prince
This is part of the Dellas Graphics frog calendar campaign in which each
month was illustrated by a different artist. The only direction was to cre-
ate an image that referenced a frog in some way.

EDEL RODRIGUEZ
Snowboards
The Vancouver Opera created a series of snowboards based on the art-
work I did for the season's four operas. The snowboards were auctioned
off to support the opera's educational programs.

PAUL ROGERS
Thanksgiving Day Parade
The challenge of fitting the complex scene of a Thanksgiving Day Parade onto four connecting postage stamps was complicated by the requirement that no recognizable licensed-character balloon appear in the design. It is always an honor to design postage stamps for the USPS and to work with the great art director Howard Paine.

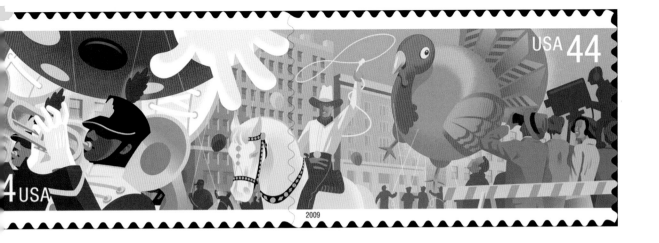

GUIDO SCARABOTTOLO
Year of the Tiger

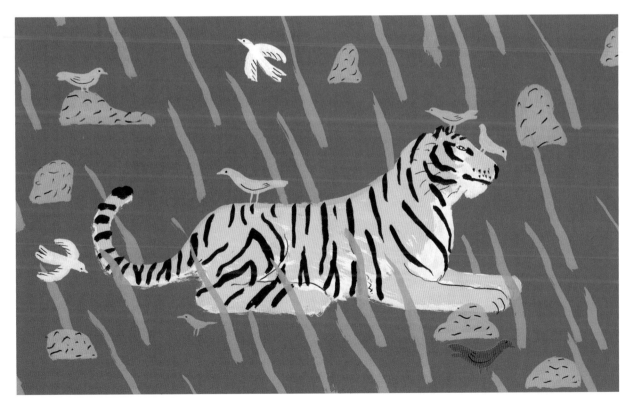

CHERIE SINNEN

Milkweed

This painting was created as a limited-edition Giclee print, signed and given to the Natural History Museum's patrons. This image was also composed with 17 other butterflies on a commemorative poster, and given to visitors on opening day of the museum's popular live-butterfly exhibit.

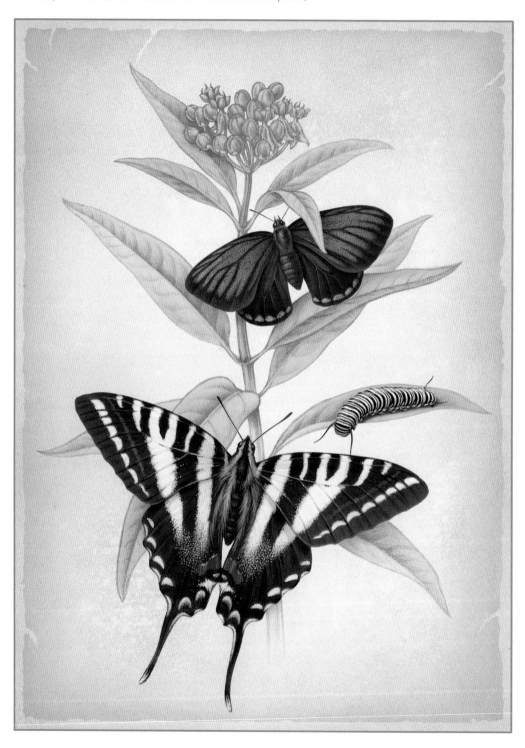

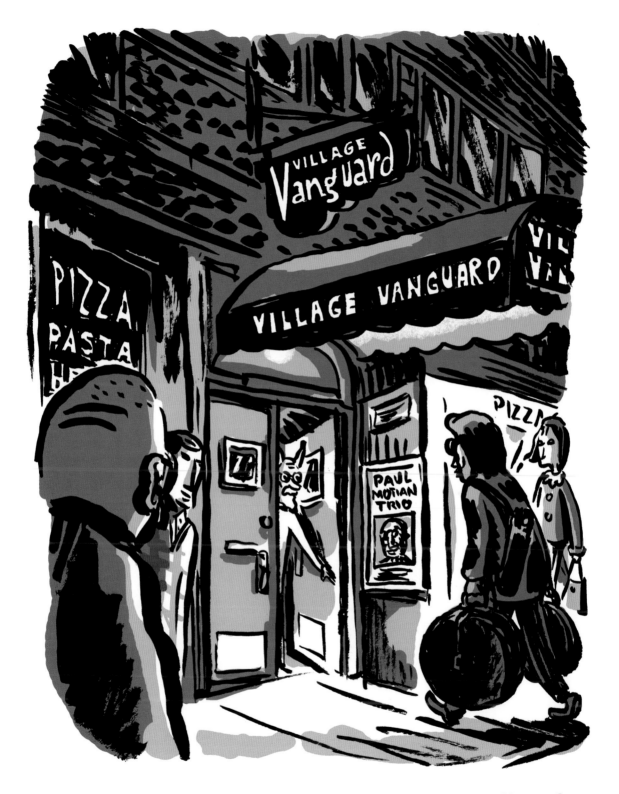

MICHEL SLOAN
Paul Motian Arrives at The Village Vanguard, NYC

LAURA SMITH
Wander Among the Wonders
The art was created as a call for entries for the American Marketing Association Crystal Awards held in Houston, Texas. The direction was to create something that evokes the feeling of an old travel poster or postcard. The image needed to incorporate one of the many man-made or natural wonders of the world, while symbolically representing them all.

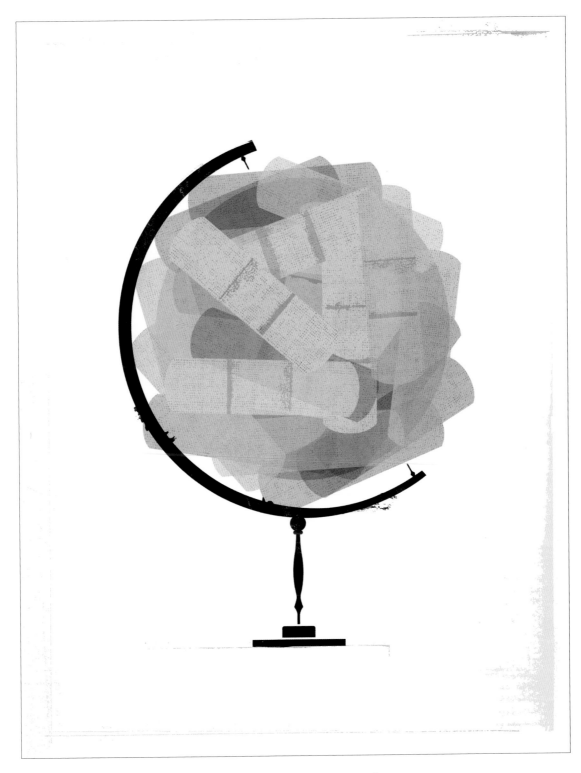

The Heads of State
McKinsey
The state of global healthcare.

HOUSTON TRUEBLOOD
Roots

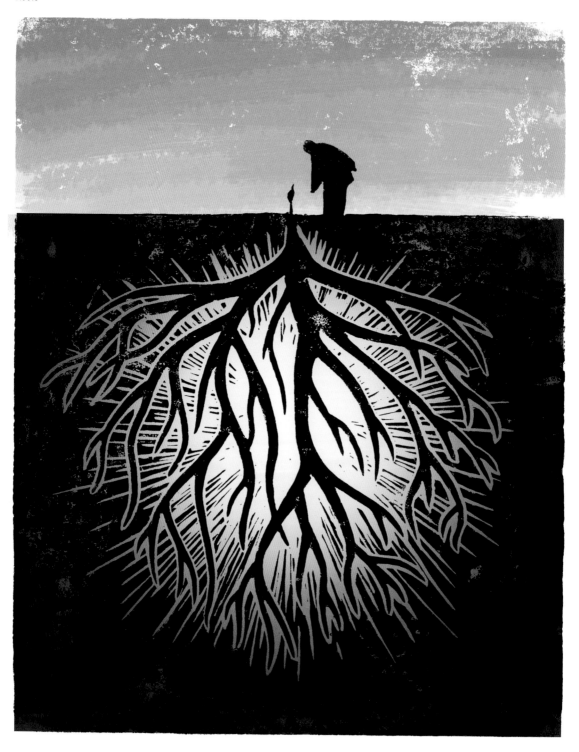

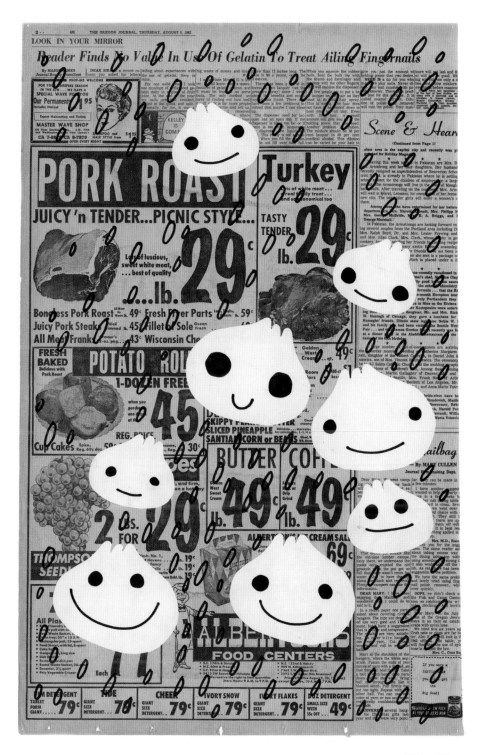

Nate Williams

Plant Hope

I created these hand-lettered covers for Ecojot Journals. I love hand lettering. It gives the text a tone. It tells the viewer how to interpret it on a subliminal level. Like a horror movie with music—if you didn't have the creepy music when someone walked into the basement, it wouldn't be scary.

JAMES YANG
Get Big
Fold-out poster for the *Directory of Illustration*. The mailer campaign was titled, "Get Big." David Plunkert of Spur Design was the art director.

JAMES YANG

Space Coin Bank

Space coin bank. Illustration for a wraparound image on a coin bank, which is sold to retailers. Cynthia Matthews at Mudpuppy Design was the art director.

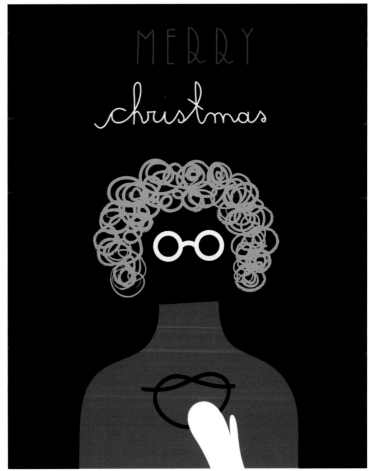

OLIMPIA ZAGNOLI
Merry Christmas
This is a Christmas greeting card I made for Corraini Publishing House. The girl in the picture actually looks like my mom.

BOOK

SEYMOUR CHWAST
DESIGNER, ILLUSTRATOR

Seymour Chwast's award-winning work has influenced two generations of designers and illustrators. He co-founded Push Pin Studios, which rapidly gained an international reputation for innovative design and illustration. Push Pin's visual language (which referenced culture and literature) arose from its passion for historical design movements and helped revolutionize the way people look at design. Seymour is a recipient of the AIGA Medal, was inducted into the Art Directors Hall of Fame, and has an honorary Ph.D in Fine Art from the Parsons School of Design. His work is in the collection of the Museum of Modern Art, the Metropolitan Museum of Art, and other major museums around the world. He has exhibited and lectured widely.

PIETRO CORRAINI
DESIGNER, EDUCATOR

Pietro Corraini was born in Mantova in 1981. He received a Masters degree in industrial design at Politecnico of Milano, developing a thesis on communication's noise. He lives in Milano, where he works in the field of book design and communication, heads the magazine *Un sedicesmiso*, is the art director for Edizioni Corraini, teaches visual communication at Cfp Bauer of Milano, and is assistant professor at Politecnico of Milano. He leads workshops in schools and museums all around the world, from the United States to Japan, is the author of *How to Break the Rules of Brand Design in 10+8 Easy Exercises*, and has just designed an agenda to aid in remembering new people. In general, he has fun putting together graphic projects.

JOHN GALL
V.P., ART DIRECTOR, VINTAGE AND ANCHOR BOOKS

John Gall's designs for Alfred A. Knopf, Grove Press, and Nonesuch Records have been recognized by the AIGA, Art Directors Club, *Print*, *Graphis*, and *I.D.* magazine, and are featured in the books *Next: The New Generation of Graphic Design*, *Less is More*, and *By Its Cover: Modern American Book Cover Design*. He is an instructor at the School of Visual Arts and currently serves on the board of AIGA/NY. He is the author, with Gary Engel, of *Sayonara Home Run: The Art of the Japanese Baseball Card*.

JESSICA HISCHE
TYPOGRAPHER, ILLUSTRATOR

After graduating from Tyler School of Art with a degree in Graphic Design, Jessica Hische took a position as senior designer at Louise Fili Ltd In 2009, she left Louise Fili Ltd to further pursue her freelance career. Her clients include Tiffany & Co., Chronicle Books, Samsung, Victoria's Secret, Target, and *The New York Times*, to name a few. Jessica has been featured in most major design and illustration publications, including *Communication Arts*, *Print*, *How*, *Graphis Design Annual*, *American Illustration*, and the *Society of Illustrators Annual*. She was featured as one of *Step*'s 25 Emerging Artists, *Communication Arts*' "Fresh," *Print*'s New Visual Artists 2009, and The Art Directors Club Young Guns. She works in Brooklyn, New York.

JASON KERNEVICH
THE HEADS OF STATE

Designer, illustrator, and educator, Jason Kernevich is a co-founder and creative director of The Heads of State, a design and illustration studio formed in 2002 with Dustin Summers. He has won many awards for the posters, book covers, and illustrations he's created for the likes of Wilco, R.E.M., *The New York Times*, Penguin, Random House, Starbucks, and *Wired*. A hell of a cook, Jason has lived, worked, and enjoyed many fine meals in Brooklyn, Rome, Los Angeles, and Philadelphia. He received his BFA from Tyler School of Art at Temple University, where he currently teaches. He works in a sunny office in old city Philadelphia surrounded by Ben Franklin impersonators and the sound of horses trotting on cobblestones.

LAURA LEVINE
VISUAL ARTIST

Laura Levine works in the mediums of illustration, painting, photography, animation, and film. Her work is in the permanent collections of the Museum of International Folk Art, the House of Blues, and the Galleria Comunale d'Arte Moderna e Contemporanea. It has been shown at the Brooklyn Museum, the Portland Museum of Art, La Luz de Jesus, Copro-Nason Gallery, Jen Bekman Gallery, Kunstmuseum Luzern, the Beach Museum of Art, and the Rock and Roll Hall of Fame and Museum, as well as in numerous one-person and group exhibits. Illustration clients include *The New Yorker, Rolling Stone,* and *The New York Times Magazine* as well as numerous books and CD covers. She's a regular contributor to *BLAB!* and has created several children's picture books.

PAUL MEISEL
ILLUSTRATOR

Paul Meisel received his BA from Wesleyan University where he majored in Fine Art. He spent his junior year at the Tyler School of Art in Rome and received an MFA in Graphic Design from Yale University. He began his illustration career working for such clients as *The New York Times, The Boston Globe, New York* magazine, and many others. He has illustrated more than 70 books for children and has worked for many publishers, including HarperCollins, Dutton Children's Books, Candlewick Press, and Holiday House. Among the books that he has illustrated are *Lunch Money and Other Poems About School, Go To Sleep, Groundhog!, The Three Bears' Christmas, What's So Bad About Gasoline?,* and *Harriet's Had Enough!* He has three sons and lives in Connecticut.

ANTHONY SWANEVELD
DESIGNER, SANDWICH CREATIVE

Toronto-based designer Anthony Swaneveld has been working in the industry since 2006. As art director for Soulpepper Theatre, he has had the pleasure of working with enviable illustration talent on several seasonal poster campaigns. Always on the lookout for more illustration projects, Anthony has curated two years of collaborative, giant, live, art mural pieces during an arts festival in Toronto. He has also pulled more illustrative talent into current branding projects. He recently helped launch a poster/print boutique that includes his own work and will showcase future collaborations with a multitude of artists and designers. Anthony currently works as design director for The Production Kitchen, as well as heading his own design company, Sandwich Creative.

CECILIA YUNG
ART DIRECTOR, V.P., PENGUIN BOOKS FOR YOUNG READERS

Cecilia Yung oversees illustration and design for two imprints, G. P. Putnam's Sons and Philomel Books. She is fortunate to have worked with some of the major illustrators of children's books, but the highlight of her work is to discover and develop new talent. She is on the board of advisors of SCBWI (Society of Children's Book Writers and Illustrators) where she plans many programs for picture book illustrators with other members of the Illustrators Committee.

GOLD MEDAL WINNER
Yuko Shimizu

The Beautiful and the Grotesque
This is the cover for *Ryunosuke Akutagawa Selected Short Stories.*

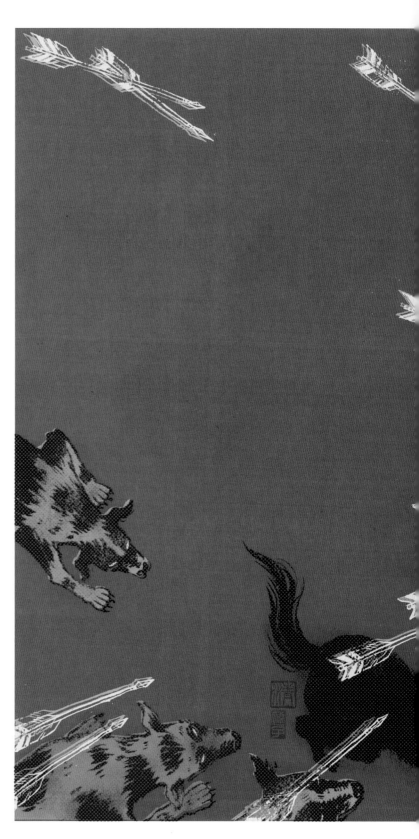

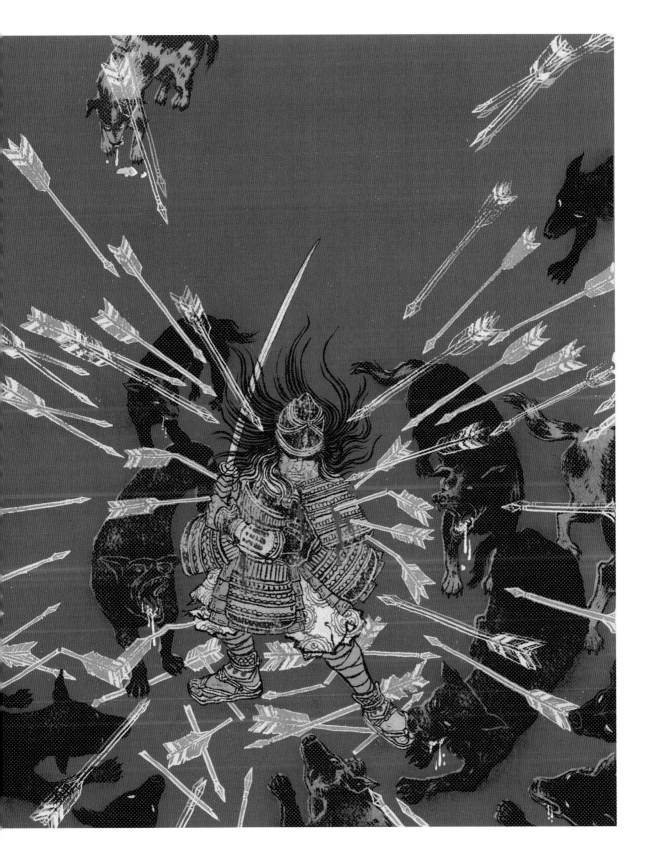

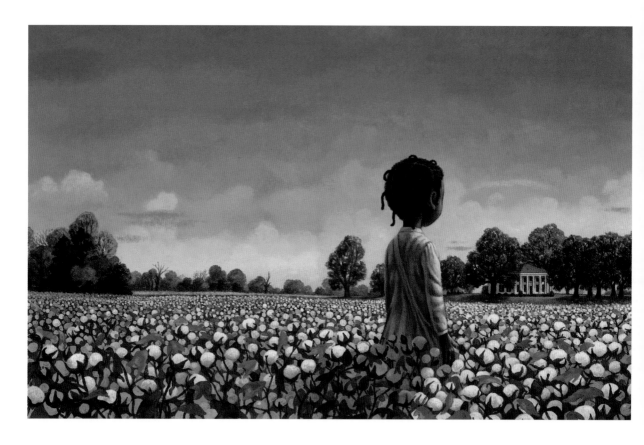

The Listeners Cover
The Listeners is a a story about slave children who were responsible for listening underneath the windows of the plantation owner's home at night. Their job was to gather information about the plantation and the world and bring it back to their families.

SILVER MEDAL WINNER
TATSURO KIUCHI

Rain Po Po Po
This is a jacket illustration for a children's picture book, *Rain Po Po Po*, written by Naoko Higashi. The book is for toddlers, so I had to use bright colors with simple, strong, and bold compositions. In order to make the book appeal to parents who have either boys or girls, I tried to depict the protagonist being indistinctive of gender by not showing his face fully. (Actually, he is a boy, but the child could be a girl, too.) The piece is digitally created with Photoshop.

A Week at the Airport
This piece was for the book of reflections by Alain de Botton, a Swiss philosopher and writer living in London, after he spent a week inside Heathrow as its Writer-in-Residence. I thought a sketchbook drawing of the people inside an airport could well represent the content of the book, not only as subject matter, but also through its style. As far as I am concerned, since I am also the art director of the covers that I illustrate, I have a very short time to consider and realize the covers—generally 10 to 15 days for 8 to 12 covers. During the six months between the realization of the cover and the publication of the book, there is a little bit of time for some adjustment, but maybe the amount of time at my disposal helps explain certain choices of style. On the other hand, I believe that to spend more than a few hours on the same drawing could bore me, and technical virtuosity has never been interesting for me. Anyhow, to be the art director of myself is quite amusing.

LINCOLN AGNEW
Harry and Horsie: Rocketboy

HANA AKIYAMA
"Ihatov" Farmers Song

PATRICK ARRASMITH

The Spook's Tale
This is a cover from the Last Apprentice series by Joseph Delaney. The image is of a moment in the story when the witch villain is hunting the protagonist in a forest, and using her magic to create fear in his heart.

I created the scratchboard line by hand, then digitized it and used Photoshop to color it.

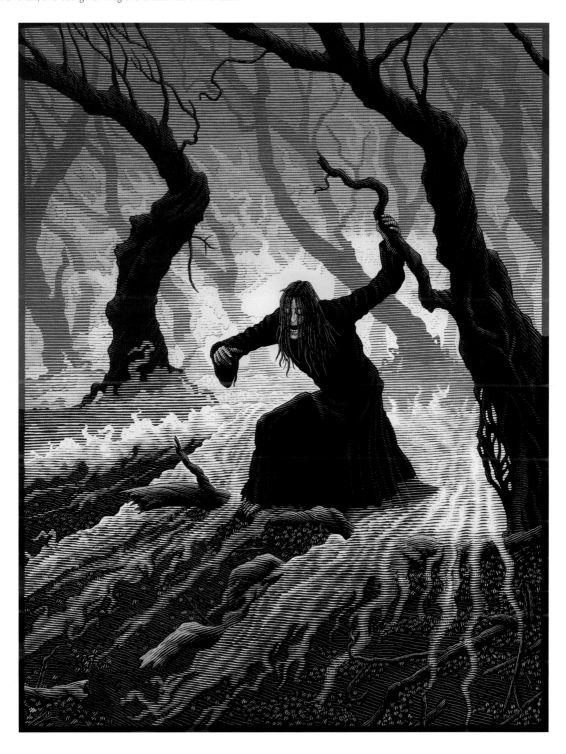

ANNA AND ELENA BALBUSSO

Meeting

This is one of a series of illustrations from the children's book *Indira Gandhi* by Paola Capriolo, Edizioni El Mondadori Group, Italy 2009. The book is about the life of the Prime Minister of the Republic of India for three consecutive terms, from 1966 to 1977, and for a fourth term from 1980 until her assassination in 1984. She was India's first and, to date, only female prime minister.

This image represents the Indira Gandhi's meeting, during the electoral campaign.

Before we began the project, we researched Indira's life, historically and iconographically. We studied the customs of Indian people, its architecture, and landscape to best capture its atmosphere. Inspired by its art, we didn't want to create images with an ethnic style, but rather to respect the richness of the colors and decoration of Indian art through our free interpretation in order to communicate the spirit and the soul of Indira through the colors, landscape, and nature. We use mixed media—our visible, acrylic brush strokes on Pakistan paper are hand made, then we used Photoshop.

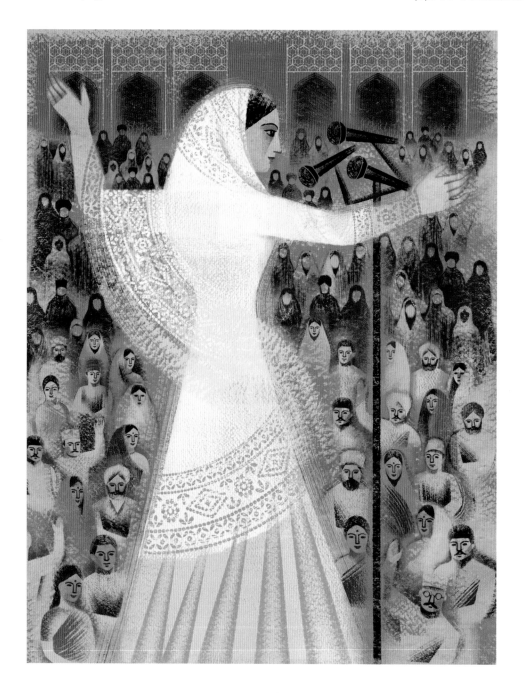

ANNA AND ELENA BALBUSSO
Wedding
This image, also from *Indira Gandhi*, represents the Hindu marriage ceremony of Indira and Feroze Khan Gandhi.

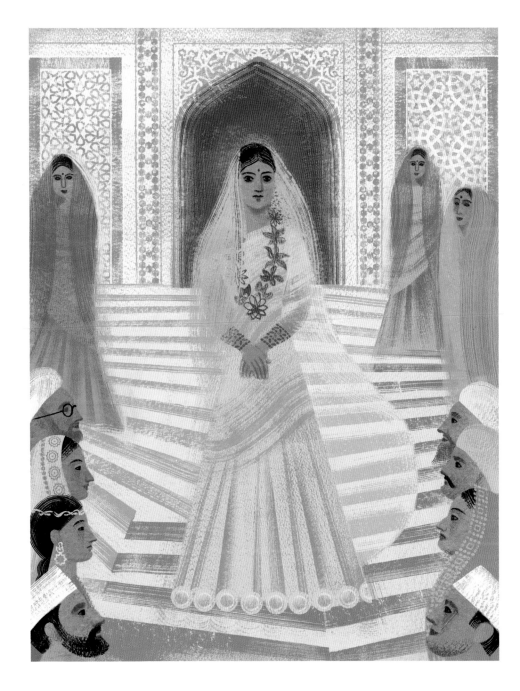

ANNA AND ELENA BALBUSSO
Poster
Also from *Indira Gandhi*, this represents the political success of Indira—
her image is on every poster in the city.

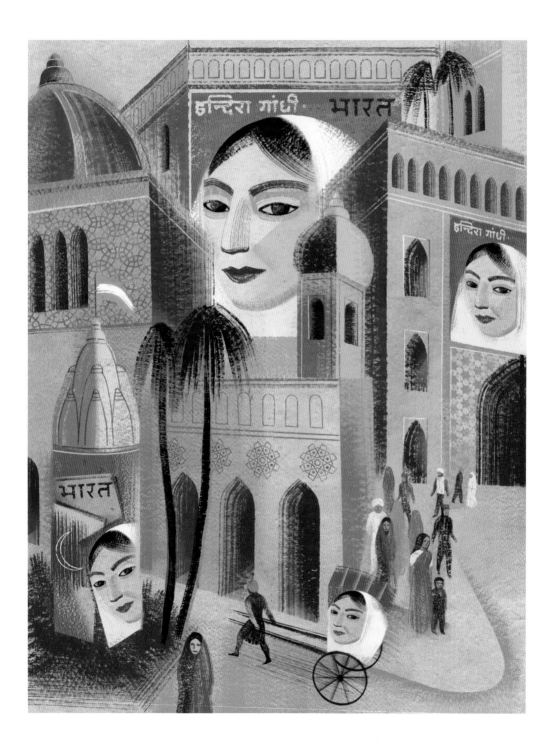

ANNA AND ELENA BALBUSSO
Autumn
This symbolic image, also from *Indira Gandhi*, represents Indira in a forest in autumn in Pakistan. The goddess Kali announces her death.

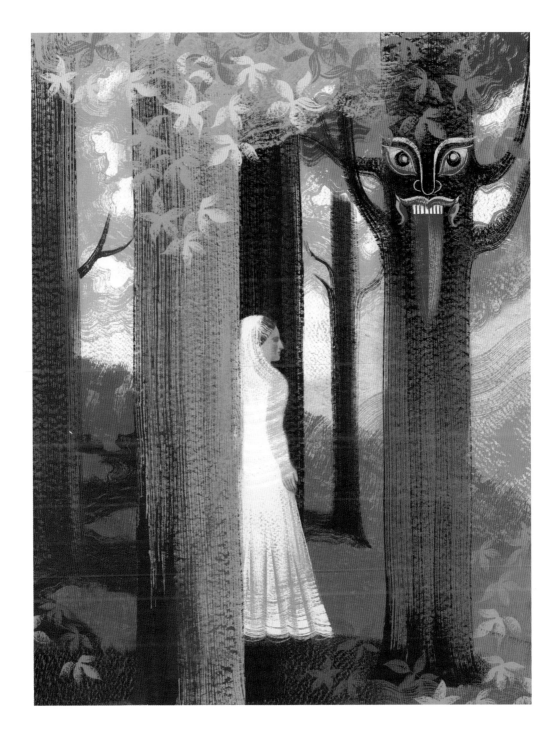

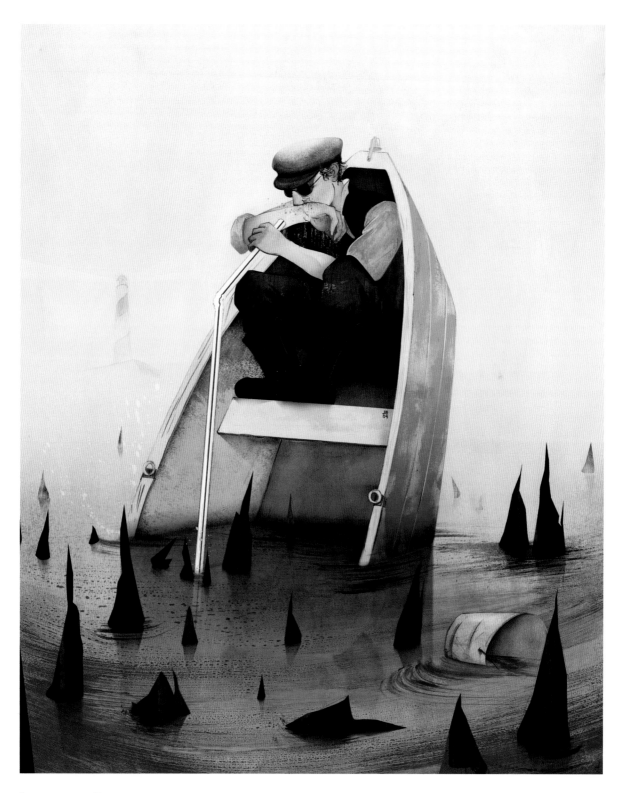

JONATHAN BARTLETT
Swallow Defeat

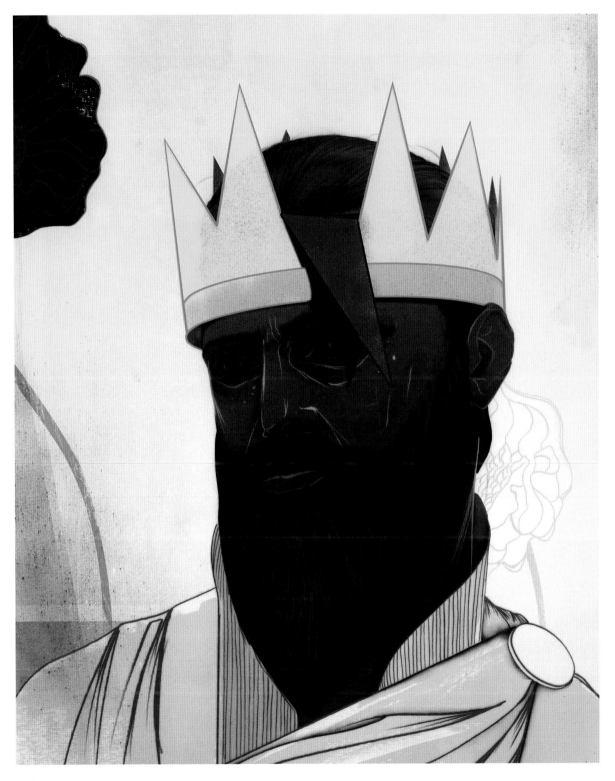

JONATHAN BARTLETT
The Failure

JONATHAN BARTLETT
Cheap Talk

JOSÉE BISAILLON
The Funambulist

MARC BURCKHARDT
These Children Who Come at You with Knives
Jacket art for a book of apocalyptic "fairy tales" by Jim Knipfel.

LOU BROOKS
A Fluent Platypus

Lou Brooks
Frankly, Frank Frankley

JOSH COCHRAN
Sleepwalker

This was a chapter opener for a young adult nonfiction book called *Mysteries Unwrapped: Medical Marvels*. I love drawing cityscapes and tried to contrast the geometric pattern of the buildings with the loose, simple line of the sleepwalker. The art director was Chrissy Kwasnik at Sterling Books.

GIANNI DE CONNO
Poems for the Moon

OLIVIER DAUMAS

The Tooth That Did Not Fail

My art is inspired by the dadaïste and surrealist artists. I use very old books, newspapers, and school childrens' notebooks, which I cut up and stick on a canvas. I prefer this part of my art because it still is abstracted. Then I paint with acrylic on this texture and erase the painting on certain areas so you can see background, old newspaper, letter titles, etc., after which I add figures, animals, and scenes. At the end, I digitize my art and work it with Photoshop. I need to work, not only digitally, but with raw material touching canvas, cutting paper, pasting old newspaper.

ETIENNE DELESSERT

The Mushrooms Ionesco Story No.4

The famous playwright gave me four absurd little stories in 1967. Because of a crooked American publisher, it took me forty years to paint the illustrations for the last two tales. It was quite a challenge to match, so many years later, the images of the four Silly Stories, since the characters and the situations are very similar. Absurd?

ETIENNE DELESSERT
Painting with Flowers Black, Moon Theater
Every night, as curtains of the evening part, a timeless production unfolds.
A young stagehand completes a host of preparations for the show.

1. ROOK 2. STARLING 3. PAINTED BUNTING

JEFFREY FISHER
Birds

TYLER GARRISON
Little Red Riding Hood

Working with Gavin Brammall and others from the *Guardian* was a real pleasure. It's always nice when a client has faith in you and enjoys your work enough to let you run free and have fun with a project. It also doesn't hurt that the subject matter involves fairy tales which are always full of fun and fantastic imagery.

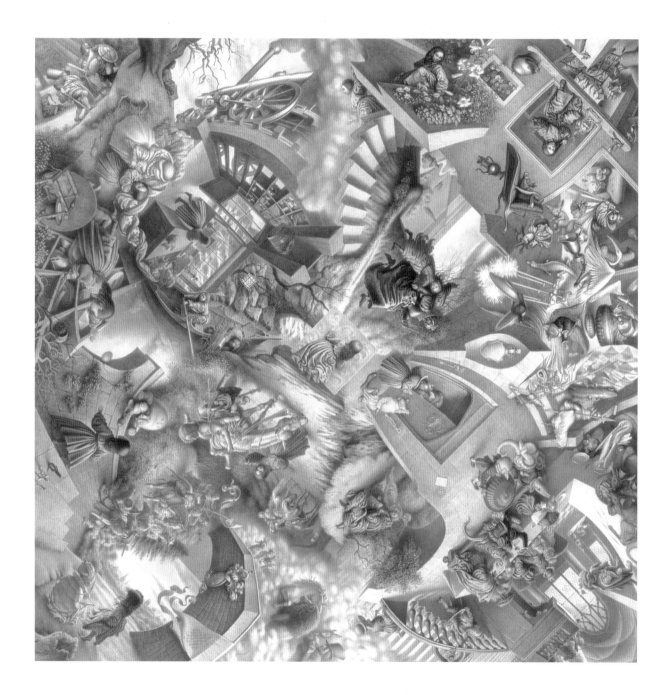

PIG'S SPLEEN

FIGURE 57-A

✳ IMPENDING WEALTH INDICATOR

YOU WILL SOON BE VISITED BY A STRANGER

TABLE 22A: SPLEENCAST

❶	DAMP	RAIN
❷	WIND	MELTING ICE CAPS
❸	CLOUDS	FAILED CROPS
❹	SUN	HUNGRY POLAR BEAR
❺	SHOWERS	FOOT RIOTS
❻	ICE	ICY, ICY COLD

BEN GIBSON
John Hodman's Pig Spleen

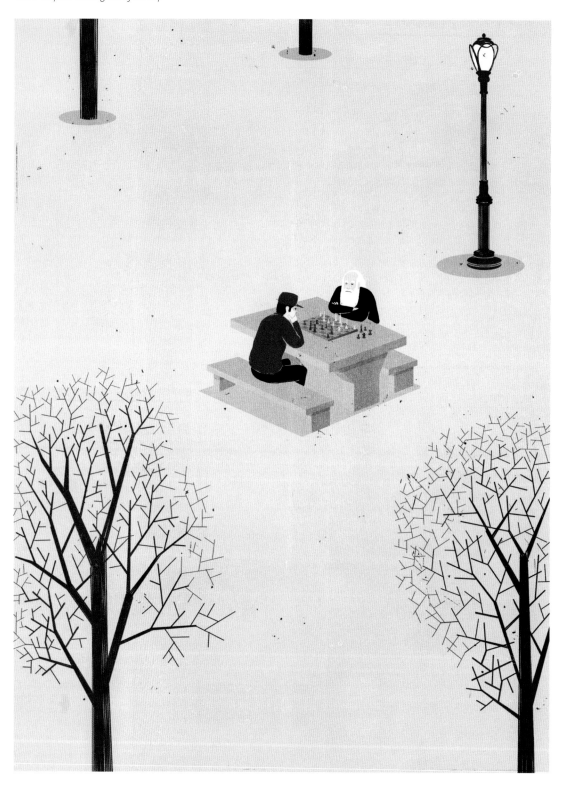

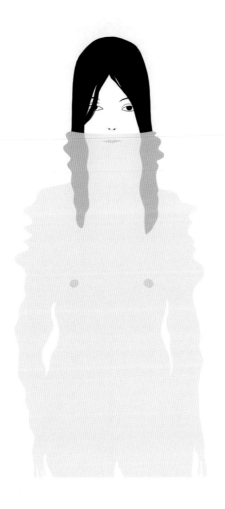

John Hendrix

AI-28 Haunted Lake

Mark Heflin and Matthew Lenning called me with a dream job: the cover of *American Illustration*. This is a massive and intimidating undertaking because there are none of the usual boundaries that define most illustration assignments. After many weeks of ideas, we settled on using a translucent sheet of red acetate for the book jacket, which would darkly display the book cover underneath. This image is the wrap-around jacket with flaps. My hope was that with both jacket and cover visible, it creates two interconnected visual narratives about our deepest anxieties and a longing for meaning in our life's work.

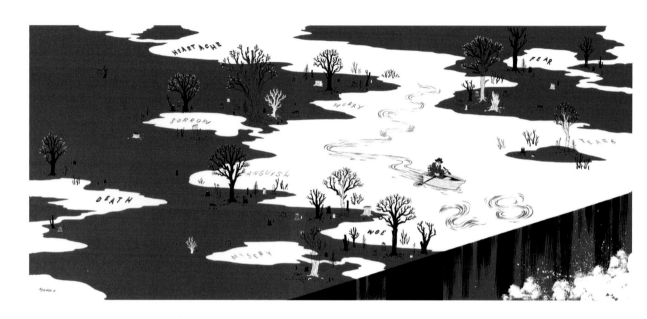

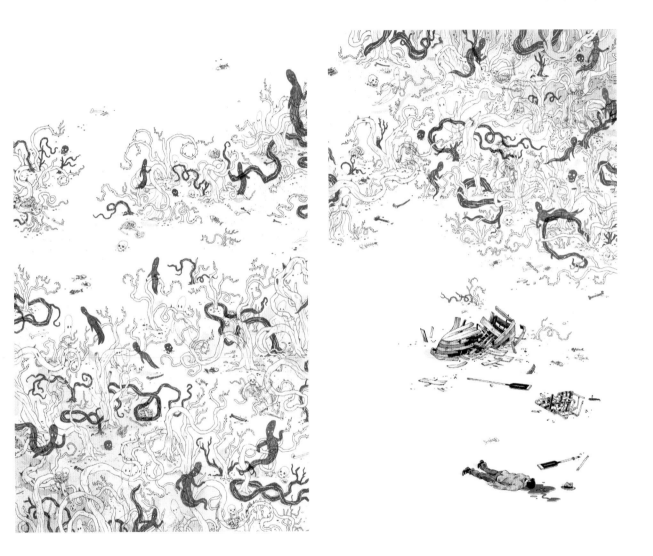

JOHN HENDRIX

Nebraska and Kansas

This image is from the book I wrote and illustrated, *John Brown: His Fight for Freedom*. The book describes the life of the fiery abolitionist from the mid-nineteenth century. Part of telling the story is illustrating some confusing and complicated legislation that plays a key part in the narrative. This drawing is about the Kansas-Nebraska Act, which divided the large prairies west of Missouri into two states that could vote for whether they were to enter the Union as a slave state or a free state. Passionate slave-owners from the South marshaled mercenaries to disrupt the voting and spread fear into the hearts of the "free-staters." These acts of terrorism set the stage for John Brown's defense of freedom in the state of Kansas.

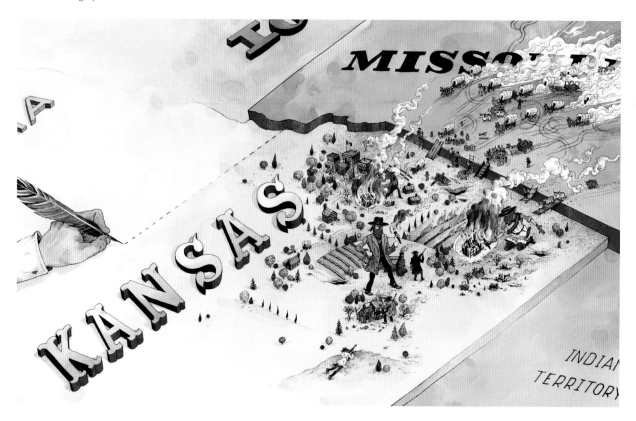

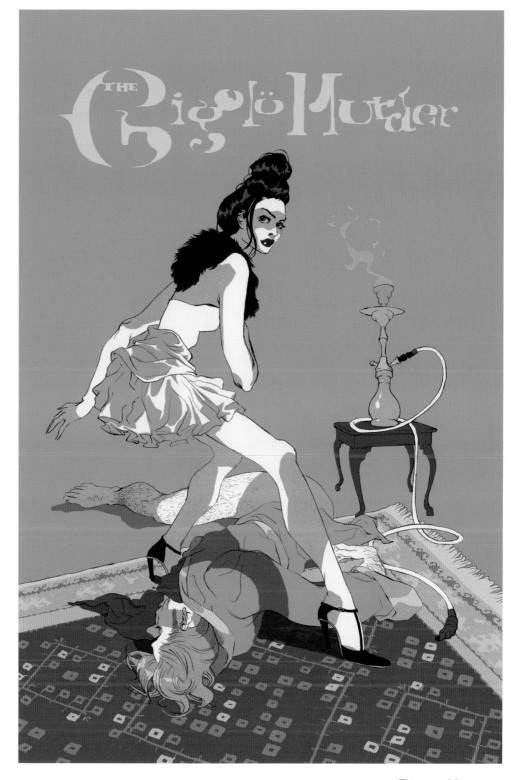

TOMER HANUKA
The Gigolo Murder

JESSICA HISCHE
Divinity of Second Chances
Cover illustration and typography.

BRAD HOLLAND
I Am the Messenger

HIROMICHI ITO

The Dogman Ship
This is an oil painting. The dog's name is Bo. He is two years old. He is so cute—my Shiba dog. I love him so much!

HIROMICHI ITO

Mt. Yummy

This digital illustration is the cover for *Mt. Yummy*, a book about *satoyama*, the Japanese mountain area which is now being treated very carefully by humans. This book is so nice—it makes you think about coexistence between nature and human beings.

HIROMICHI ITO

The Dog is Always Around Me
This digital piece is the cover for *The Dog is Always Around Me*. The leading character's dog always digs up pieces of stinky meat in the park when he goes for a walk. This book was considered for the prestigious Akutagawa Prize.

Hiromichi Ito

The Apartment

This digital illustration is the cover for *You Will Hear the Footstep Someday*, a story about family. There were a few solitary residents in the same apartment. Then, day by day, they became one family.

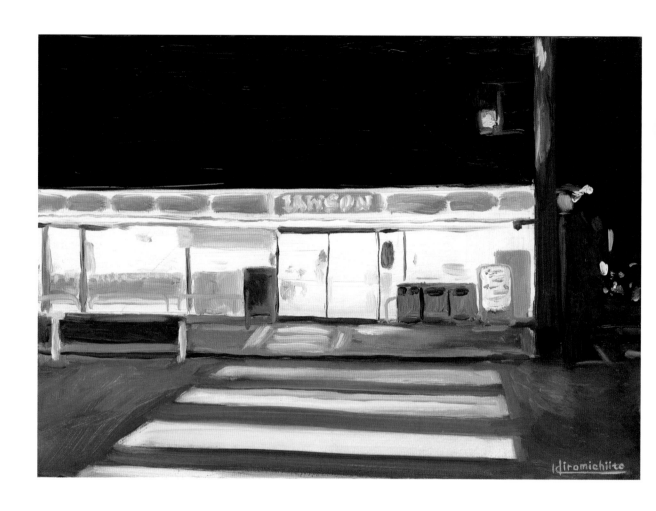

HIROMICHI ITO

Night Wanders
This is an oil painting. I wanted to paint something bright in the night.
So I chose a Japanese convenience store for a motif.

MARTIN JARRIE

A is for Araignee
This illustration, in acrylic, is from *Ménagerimes*, a children's book/CD for Didier Jeunesse publishing. *A comme Araignee* means "S is for Spider" The spider won't do tricks with no net!

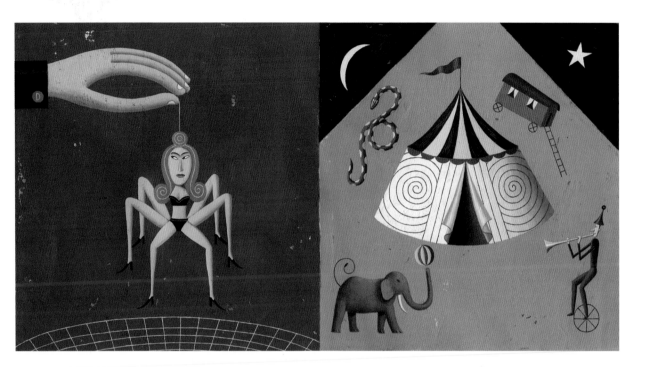

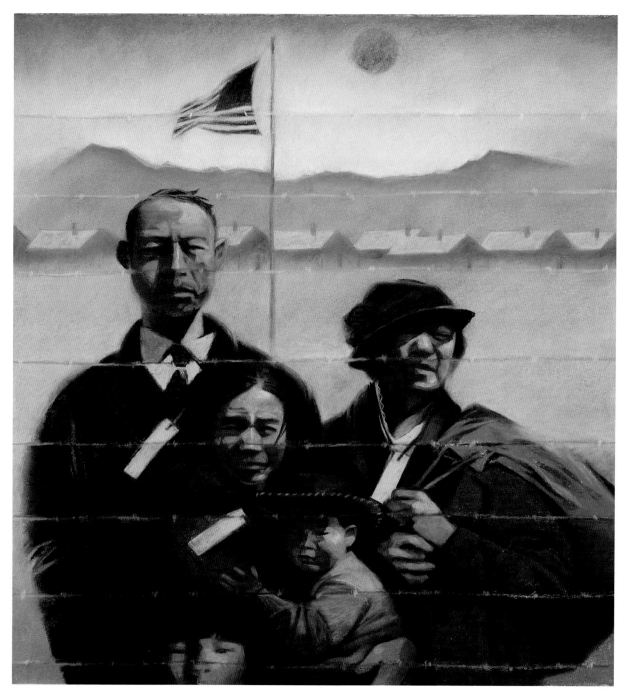

GARY KELLEY
Japanese-American Internment

TATSURO KIUCHI

Rain Po Po Po (cover)
As you might notice, I drew happy faces on each and every rain drop in the illustration so that kids could have fun looking at them. The piece is digitally created with Photoshop.

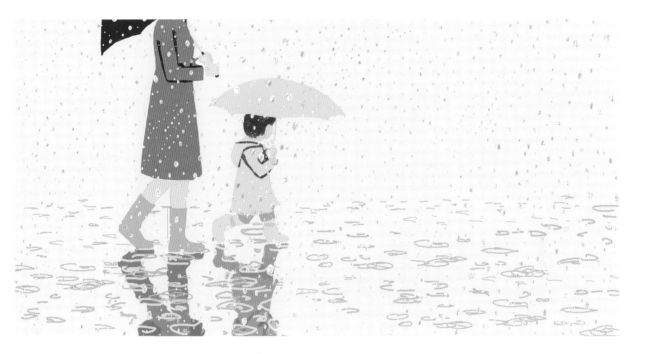

TATSURO KIUCHI
The Sea, the Sea
These are three of the nine interior color illustrations I did for the book
The Sea, the Sea by Iris Murdoch, published by The Folio Society in the
UK. They were digitally created with Photoshop.

Tatsuro Kiuchi
The Sea, the Sea

TRAVIS LAMPE
Armageddon Flub

GILES LAROCHE

Toledo

This is an illustration from the children's book *What's Inside? Fascinating Structures Around the World* published by Houghton Mifflin Harcourt in 2009. The bas-relief work was created with a variety of papers, acrylic, and gouache paint for the buildings, people, and animals, and pastels for the sky.

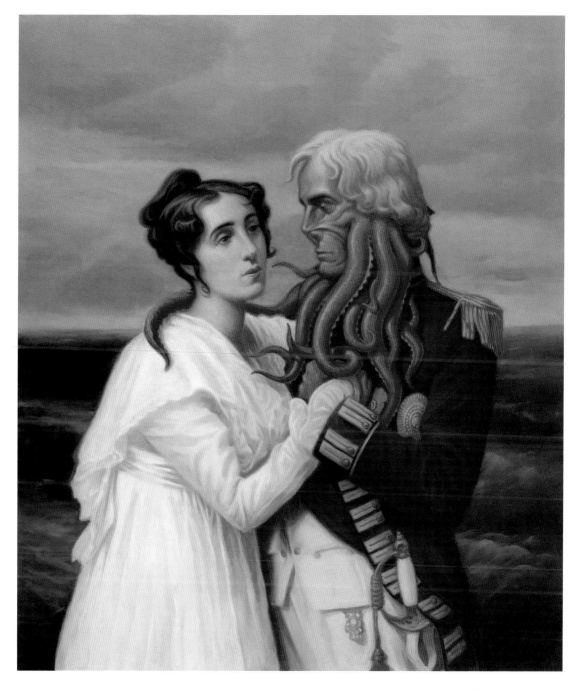

LARS LEETARU
Sense and Sensibility and Sea Monsters

VINTAGE **CHEEVER**

The Wapshot
Scandal

WITH A FOREWORD BY DAVE EGGERS

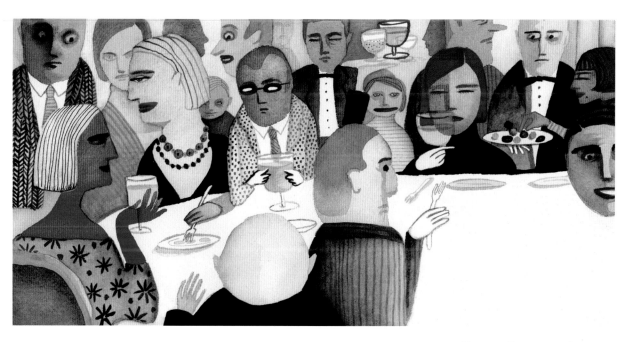

MARIA EUGENIA LONGO
Dinner Party

NICK LU

The Imaginary 20th Century Chapter 1, 2

These are two of the 12 illustrations I created for the historical science-fiction novel *The Imaginary 20th Century* by Norman Klein and Margo Bistis. The story involves the picaresque adventures of a woman who is seduced in 1901 by four suitors, each with their vision of the coming century. The book is also accompanied by a DVD with extensive illustration photography and film from the period.

MATT MAHURIN
Buck Fever

MATT MAHURIN
Green Witch

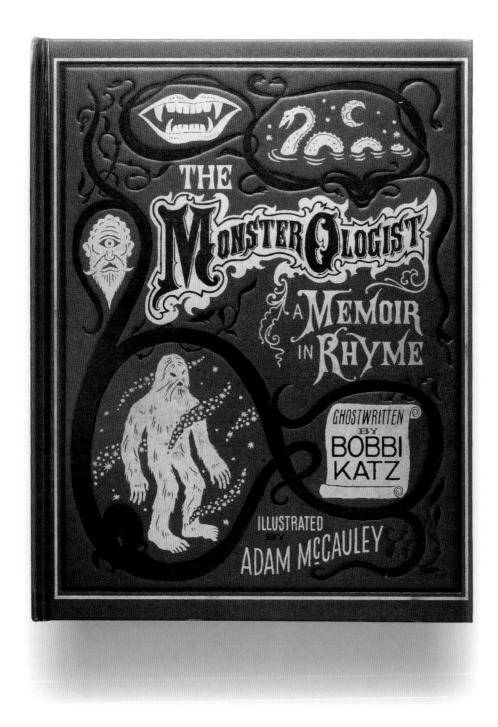

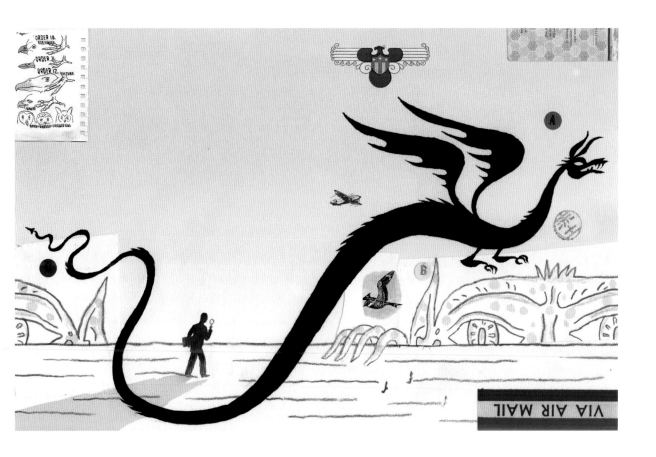

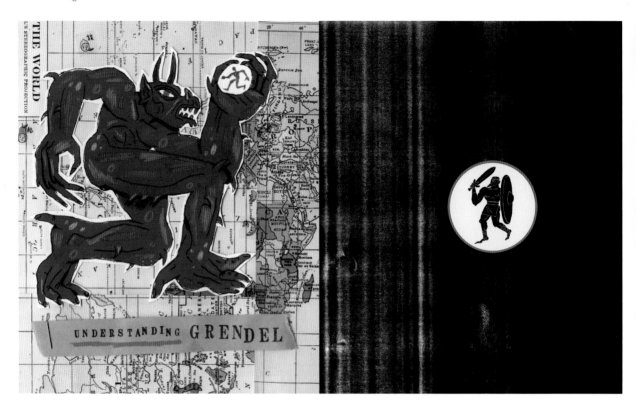

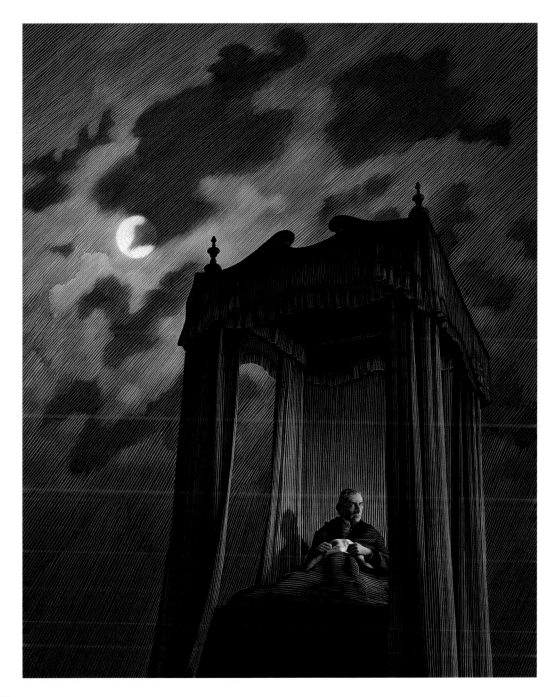

SCOTT McKOWEN
A Christmas Carol

For all its humanism, social conscience, and the hope it inspires of redressing the mistakes of your life, Charles Dickens's *A Christmas Carol* remains a really terrific ghost story, so I wanted my cover to be as spooky as possible. Scrooge is haunted in bed, the one place that he should feel most secure and safe. I like the idea of showing Scrooge's reaction to seeing a ghost, rather than the ghost itself. The walls of the room have dissolved away to reveal a moonlit sky, suggesting the breadth of Scrooge's supernatural journeys through time and space.

AARON MESHON
Directory of Illustration

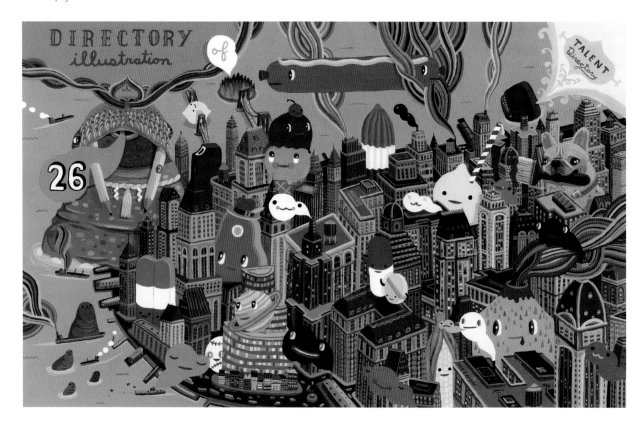

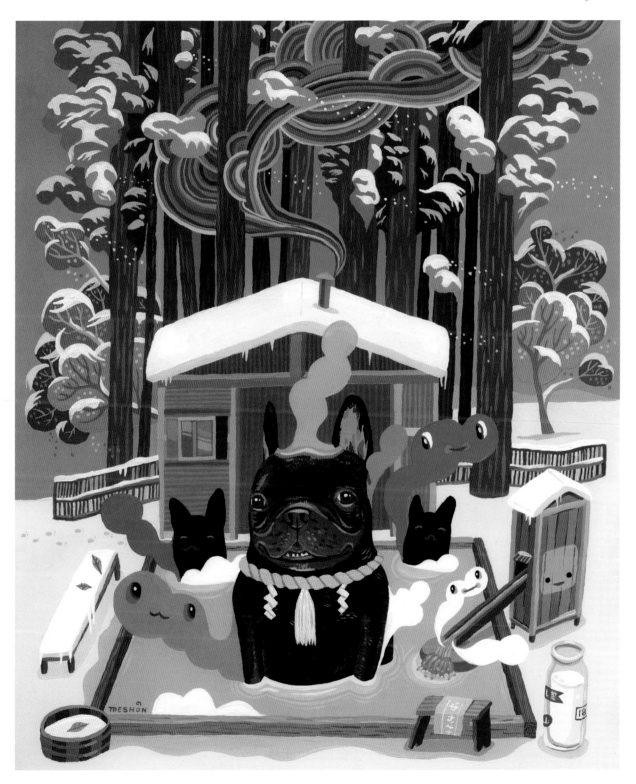

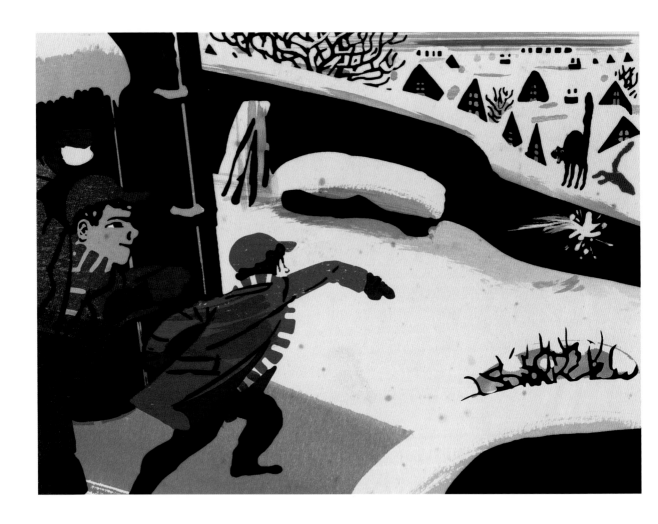

PEP MONTSERRAT

A Child's Christmas in Wales

Inspired on the traditional Japanese woodblock stampings and using a short palette, the art for this story about memories, snow, childhood, and Christmas in Wales, was done in a place which was quite the opposite—under the Spanish sun in August 2008, in the middle of an endless landscape of wheat-ripened fields in La Cardosa, in a house with remaining parts of a castle from the thirteenth century. The only thing story and place had in common was that both were expressing the worth of what we keep from past times. The book is the first Catalan translation, made by a Catalan poet, of the classical story by Dylan Thomas. The art for this book won the Junceda Award in 2009, sponsored by the Catalan Illustrators Association.

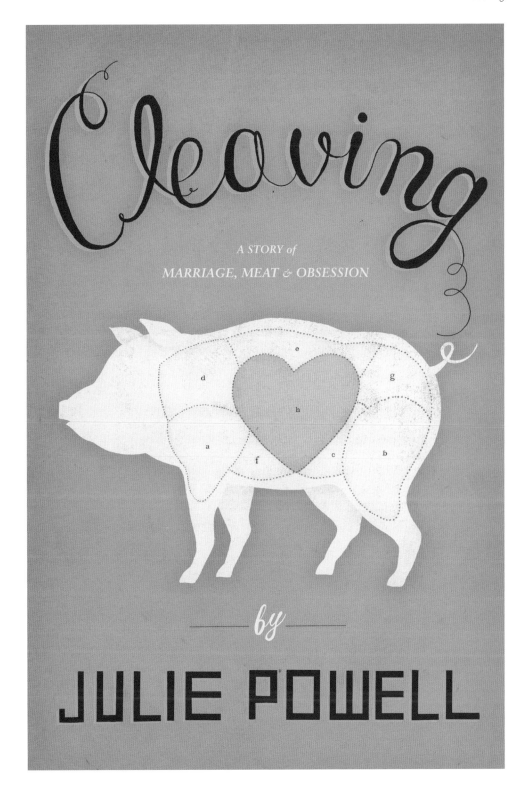

KADIR NELSON
Young Coretta
After reading Coretta's autobiography I found that I had a new appreciation for Mrs. King and her silent, but crucial role in the Civil Rights Movement of the 1960s. I felt compelled to pay a loving and poetic tribute to her through the paintings in the book. I love this portrait of Coretta as a young lady. She's beautiful, poised, and thoughtful, just as I imagined her to be in real life.

TIM O'BRIEN
Hunger Games

ZACHARIAH OHORA
Alligator Boogaloo

NAOKO OSHIMA
Falcon Flying Away

JOHN JUDE PALENCAR
Muse and Reverie

John Jude Palencar
Bitter Seeds

CURTIS PARKER
Snakehead

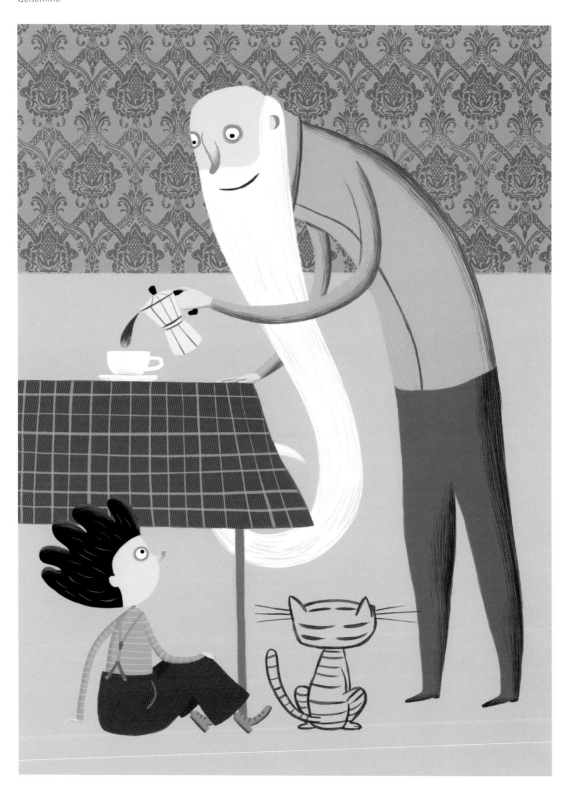

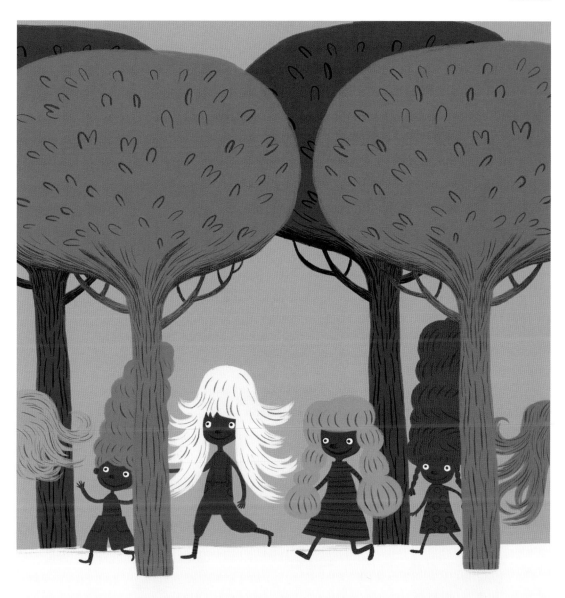

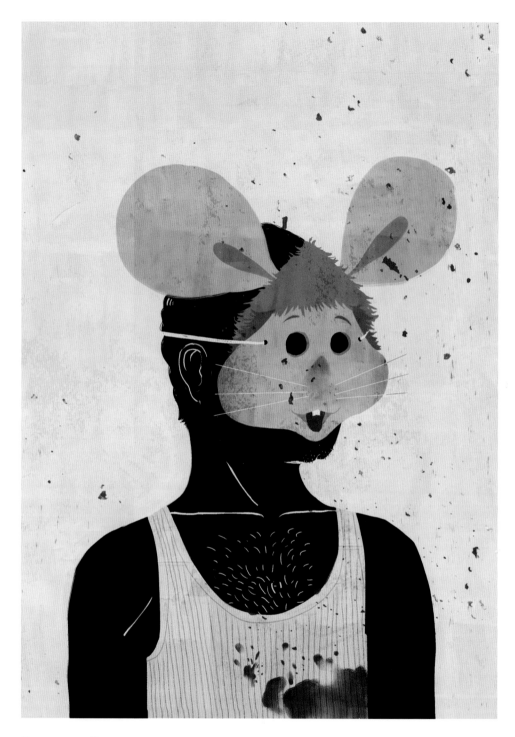

EMILIANO PONZI

Mouse

This was created for the cover of *La casa delle orbite vuote* by Alberto Levi Kessler. The book is a classic detective story about a serial killer who wears different masks. In this case it's *topo cigio*, an iconic character for children in Italy.

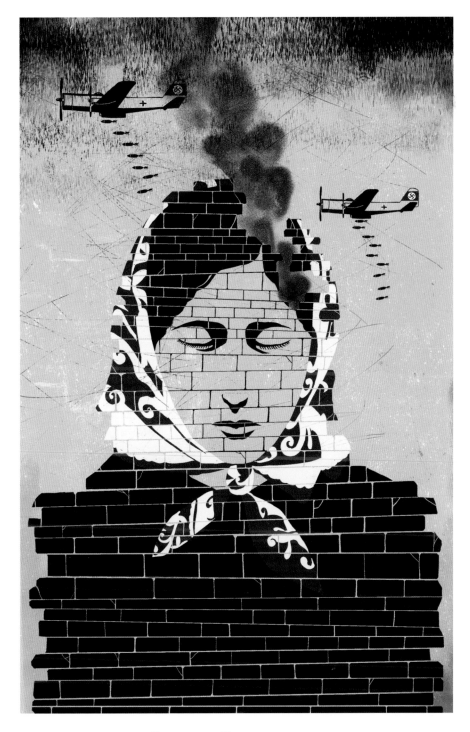

EMILIANO PONZI

La Madre

This was created for the cover of *La Madre* by Mauro Milesi. The book is about the strength and breaking point of a mother during the Second World War.

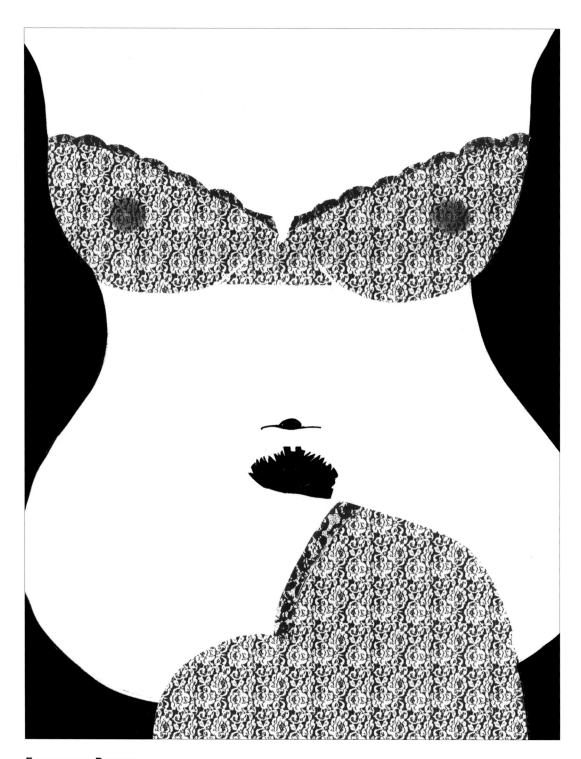

EMILIANO PONZI

Lingerie
This was created for the cover of *Gli asini volano alto* by Marco Archetti.
The book is about a priest who falls in love with a Spanish prostitute and
loses his religious path.

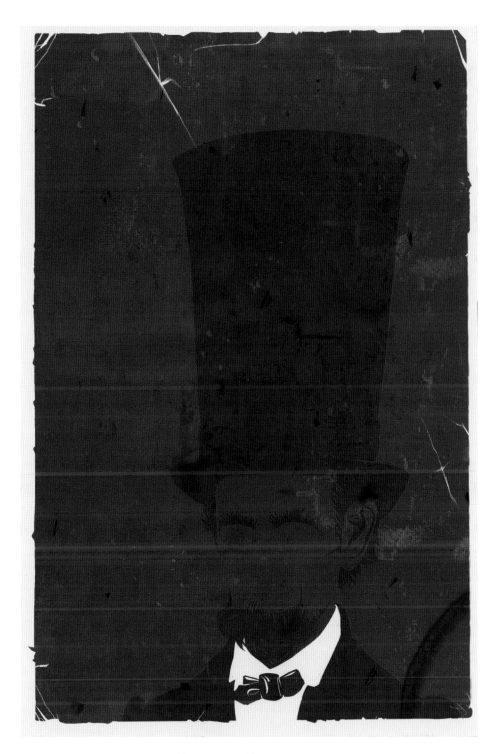

EMILIANO PONZI
Abraham Lincoln
This was created for the cover of *The Wit and Wisdom of Abraham Lincoln* by Alex Ayres. In this portrait of the president, he is depicted just by his hat and beard, two of his most recognizable features.

EDEL RODRIGUEZ

No Longer At Ease

I was commissioned to create a series of covers for books by the African author Chinua Achebe. This is a cover for his book titled *No Longer at Ease*. The story deals with personal and moral struggle— as well as turbulent social conflict—in the country of Nigeria. The publisher is Random House. I worked with art director John Gall and designer Helen Yentus.

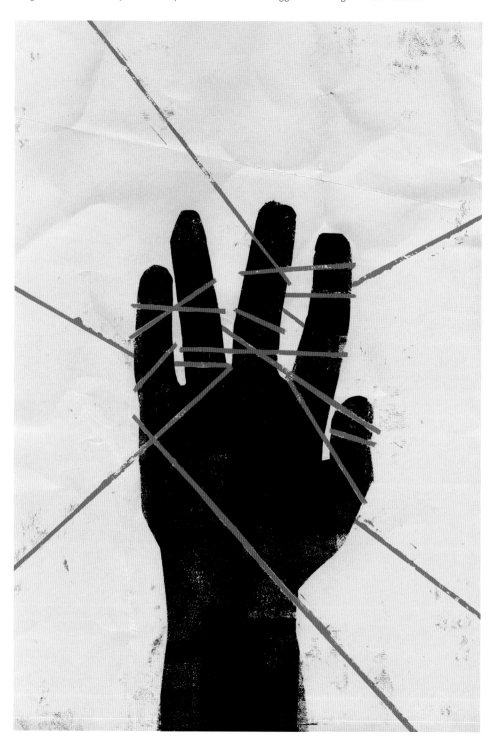

EDEL RODRIGUEZ
Girls At War
Girls at War is part of the Chinua Achebe series. The story deals with civil war and strife in Nigeria.

RED NOSE STUDIO
Here Comes the Garbage Barge

In the summer of 2007, I was contacted by Schwartz & Wade Books, a division of Random House, about the possibility of creating the illustrations for a new manuscript that was just being finished up. Anne Schwartz said she was familiar with my work and thought it would be perfect for a book about garbage. Although I was delighted she had called me, I wasn't sure how to take that statement. Was she implying that my work was garbage??? Not long after talking with her I realized she was very familiar with my work and how I use found objects and junk in my work. The book follows the true story of the infamous garbage barge from Islip Long Island in 1987 and the trials and tribulations of the tugboat captain Duffy St. Pierre.

CATELL RONCA
Solitude
This piece was first painted in my sketchbook using gouache colors, then arranged digitally. I really wanted to capture warm and intense colors that are typical of India. Working with Orion Books was a great experience and I also received some nice feedback from the author, which is unusual.

Jim Rugg
Afrodisiac: Vietnam 20,000 BC!

This piece is part of a book about a fictitious 1970s blaxploitation/comic book superhero named the Afrodisiac. The value of comic book artwork of that period was measured by its reproduction quality, as evidenced by the sloppy paste-ups, corrections, hand-written notes, and often poor condition of the originals that have survived.

GUIDO SCARABOTTOLO
Gli Scrittori Inutili
The title means: The unuseful writers.

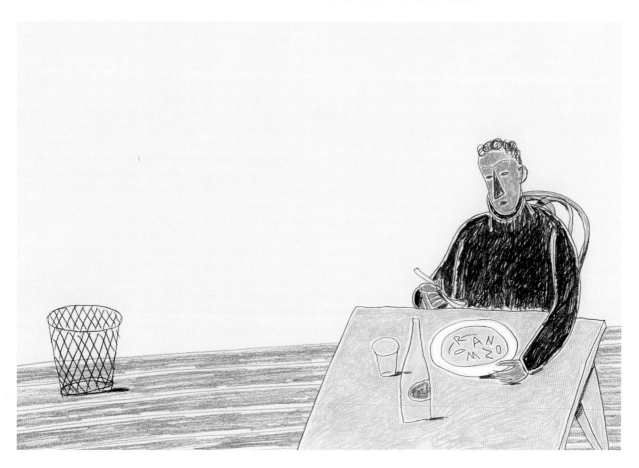

WARD SCHUMAKER

Eve & Snake

These illustrations are from the limited edition letterpress book *God's Femur*, which relates to an event in which the governor of Nebraska termed my work "pornography" and threatened me with prosecution unless I removed it from an exhibition in which it had won first prize.

DIRTY DEEDS

WARD SCHUMAKER
Dirty Deeds

ERIC SEAT
Kurt Vonnegut

When it comes to great authors of the last century, Vonnegut some-times gets forgotten when it comes to subjects who make great por-traits. With his wild hair and a thick mustache, Vonnegut is a wonderful subject for paintings and drawings. A special "thank you" goes out to the art director for the opportunity to have my humble art grace the cover of such a magnificent author's book.

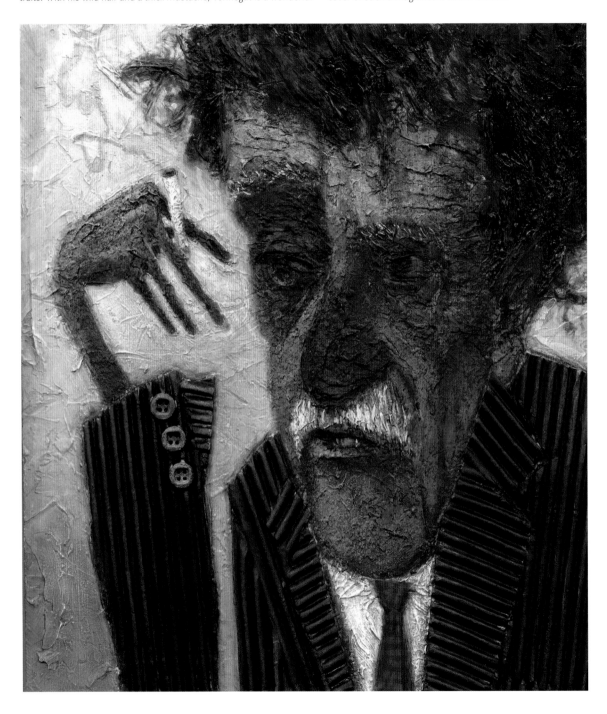

DOUGLAS SMITH
Topiary Lions, The Shining

YUKO SHIMIZU
The Unwritten Issue No.6 Cover

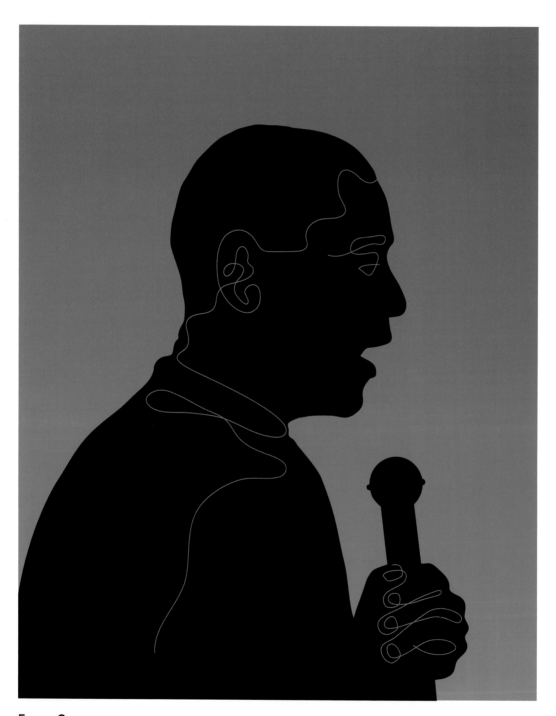

FELIX SOCKWELL
Obama

Steven Tabbutt

The Incident

I was commissioned to illustrate the cover of the comic anthology *Rabid Rabbit*, issue #10, using the theme Kitty Kitty. This piece is one of two versions I created.

JONATHAN TWINGLEY
The Badlands Saloon cover

JONATHAN TWINGLEY
Trailer Park Studio

JONATHAN TWINGLEY
Willie Beck Going Home

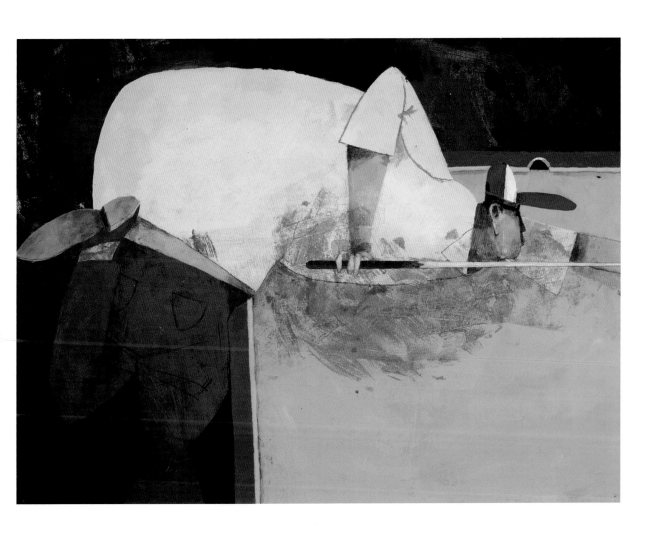

JONATHAN TWINGLEY
Shooter

RAYMOND VERDAGUER

Les Nations Obscures

A linoleum cut for the book cover of *Les Nations Obscures* (The Darker Nations) published by écosiété, Montreal, in 2009. *The Darker Nations: A People's History of the Third World*, by Vijay Prashad, was first published by The New Press, NY, in 2007. Montreal publisher écosié-té decided to release a French version and gave me the assignment. Because of the importance of the issue, I felt it was my responsibility to read the book very thoroughly in order to be clear about the author's views. The response was amazing—every single sketch was forcefully rejected. I sent back an impassioned defense of my concepts. To my surprise, two months later an email reply appeared asking if I would consider moving on with one of the rejected sketches.

Collaborating with anyone does not guarantee a Hollywood ending. Still, it is worth teaming up with others, as it could make a difference. Like light and dark—echoing the same dilemma I experience cutting linoleum blocks—there is the desire to take a chance, the hope of coming out with concrete and beneficial results. I highly recommend reading this book and supporting écosiété.

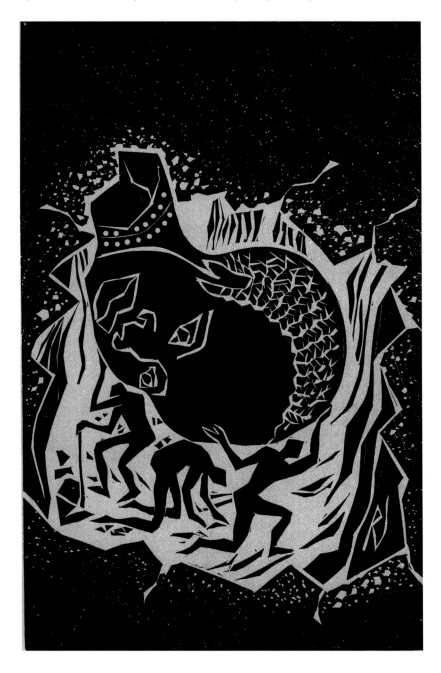

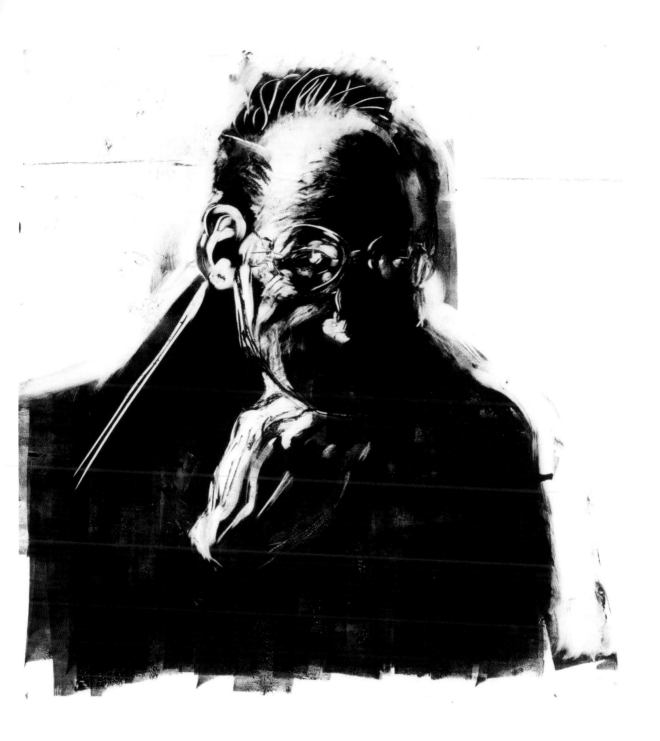

BRUCE WALDMAN
Gentleman in the Dark
This illustration was done for a book on the occult, and depicts a contemporary vampire. Working with Heather Zschock and Margaret Rubiano on this project was a rewarding and creative joint effort.

SAM WEBER
There Once Lived a Woman Who Tried to Kill Her Neighbor's Baby
A collection of Russian fairy tales for adults. Painted in watercolor and
acrylic, finished digitally.

SAM WEBER

Lord of the Flies

A new illustrated edition of William Golding's *Lord of the Flies*, published by The Folio Society. The cover is a one-color lithograph on red book cloth with white letterpress accents.

SAM WEBER

Prospero Lost

A book jacket for a contemporary fantasy novel cast with characters from Shakespeare's *The Tempest*. Painted in watercolor and acrylic, finished digitally.

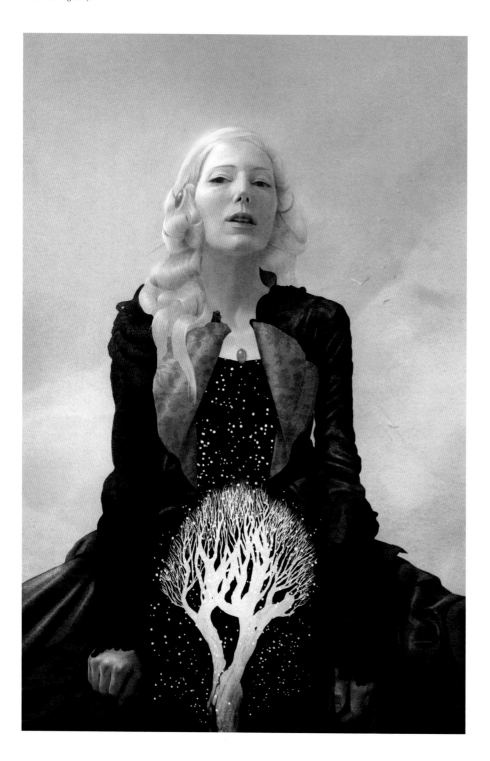

SAM WEBER

Painted Faces and Long Hair
For a new illustrated edition of *Lord of the Flies*. Depicting one of my favorite scenes, in which Jack paints his face with clay and charcoal, transforming his face into something inhuman. Painted in acrylic and finished digitally.

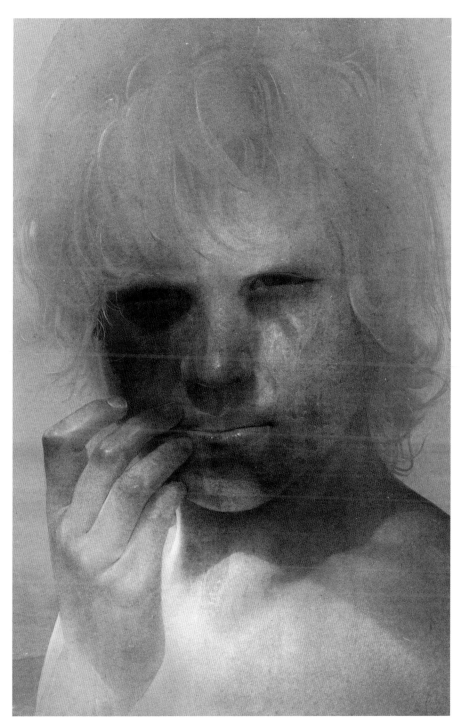

UNCOMMISSIONED

MELINDA BECK
ILLUSTRATOR, GRAPHIC DESIGNER, ANIMATOR

Melinda Beck received a BFA in Graphic Design from the Rhode Island School of Design in 1989. Her illustration and graphic design clients include Chronicle Books, *Fit Pregnancy, GQ, The New York Times, Rolling Stone,* Neiman Marcus, Nike, Target, and *Time.* Melinda also creates animated spots for Nickelodeon. Her work has received awards from and publication in annuals including *American Illustration,* The Art Directors Club, Society of Publication Designers, *Communication Arts, Print,* BDA, the Society of Illustrators, AIGA, and *I.D.* magazine. She works out of her studio in Brooklyn, New York.

JORDIN ISIP
ILLUSTRATOR

Jordin Isip is from Queens, New York, and has a BFA in Illustration from Rhode Island School of Design. His work has appeared in numerous publications, including *Atlantic Monthly, Business Week, GQ, Juxtapoz, McSweeney's, The New York Times, PlanSponsor, Rolling Stone,* and *Time,* as well as on book covers, posters, t-shirts, and CDs. Jordin has received recognition from *American Illustration,* The Art Directors Club, *Communication Arts, Print,* and the Society of Illustrators. His art has been exhibited throughout the United States and in Berlin, Kilkenny, London, Manila, Paris, and Rome. He has curated over a dozen group exhibitions, including "Mystery Meat" at Future Prospects (Philippines), "Scab On My Brain" at Space 1026 (Philadelphia), and "Panorama Project 3" at Jonathan LeVine Gallery (NYC). Jordin lives and works in Brooklyn and teaches at Parsons and Pratt.

AYA KAKEDA
ILLUSTRATOR

Aya Kakeda was born and raised in Tokyo. She earned a BFA from the Savannah College of Art and Design and an MFA in Illustration from the School of Visual Arts. Her illustrations often depict her imaginary ToTai Island and the creatures who live there. She was awarded a Silver medal from the Society of Illustrators of LA and a Bronze medal from *3x3 Illustration.* Her work appears in annuals such as *American Illustration,* the Society of Illustrators, and *Print.* She is currently working on a children's book, *The Hole in the Middle,* written by Kidrobot® founder Paul Budnitz, to be published by Disney–Hyperion Books. Aya has exhibited internationally, including exhibiting her illustrated embroidery pieces at the Musée International des Arts Modestes, Sète, France.

STEPHEN KRONINGER
ILLUSTRATOR, AUTHOR

The Wall Street Journal credits Stephen Kroninger with having "sowed the seeds of the collage renaissance." His editorial illustrations—both digital and on paper—have appeared in nearly every major newspaper and magazine in the United States, and in many publications around the world. Stephen's work was the subject of an exhibit at the Museum of Modern Art in New York City, the only time the museum devoted a one-person show to an illustrator. His work is in the permanent collection of MoMA, as well as in the National Portrait Gallery of the Smithsonian Institute in Washington, D.C. Stephen is also an award-winning author/illustrator of children's books. His animation projects include short films for Nickelodeon, HBO, CBS, and Noggin.

CHANG PARK
ILLUSTRATOR

Chang Park was born in Seoul, South Korea, and grew up in Los Angeles where he attended Art Center College of Design. Since relocating to New York City in the early 1990s to pursue a freelance career in illustration, he has created work for a diverse group of clients primarily in the editorial field. His clients include *Time, The New York Times, Business Week,* ESPN, *The Village Voice,* Asset International, Penguin Books, Warner Bros. Records, Elektra Records, and The Criterion Collection. He has also taught in numerous art institutions and is currently a faculty member at the Pratt Institute and Parsons The New School For Design in New York City.

DAVID PLUNKERT
ILLUSTRATOR, DESIGNER

Spur Design co-founder David Plunkert's illustrations have appeared on the covers of *Business Week*, *The New York Times Book Review*, and *The Wall Street Journal*, and on ad campaigns for Adidas, Gatorade, Motorola, and MTV. His work has been recognized by *Communication Arts*, *American Illustration*, and has appeared in numerous books, including *Masters of Poster Design* and *Graphic Design America 3*. He has received medals from the Society of Illustrators in New York as well as the Society of Illustrators LA, and his work has been collected by museums both nationally and abroad. He has taught graphic design and illustration at the Maryland Institute College of Art and at Shepherd University, and has lectured for various AIGA chapters across the country. A prolific poster designer, Plunkert received the best movie poster award at the South by Southwest Festival in 2009.

BRIAN REA
DESIGNER, ILLUSTRATOR

Los Angeles–based artist Brian Rea is the former art director for the Op-Ed page of *The New York Times*. He has produced drawings and designs for books, murals, posters, music videos, and magazines around the world. His work has appeared in *Playboy*, *The New York Times*, *Outside*, *Men's Journal*, and *Time*, among others. His design clients include Herman Miller, Kate Spade, Honda, Billabong, and MTV. Rea's work has been recognized by *Communication Arts Design*, *Photography*, and *Illustration* Annuals; AIGA's *50 Books 50 Covers*; *American Illustration*; the SPD annual; and *Print*. He has exhibited work in Barcelona, San Francisco, Los Angeles, New York, and Tokyo.

ANTHONY RUSSO
ILLUSTRATOR

Anthony Russo is a freelance illustrator living in Rhode Island. His clients include *The New York Times*, *The Washington Post*, *The Boston Globe*, *The New Yorker*, *Rolling Stone*, *Esquire*, Random House, HarperCollins, and others. His illustrations have brought him awards from *Communication Arts*, *American Illustration*, the Society of Illustrators, and *Graphis Annual*. Additionally, he has taught at the Rhode Island School of Design and Parsons in New York.

GINA TRIPLETT
ILLUSTRATOR

Gina Triplett has illustrated for clients that have included Converse, Whole Foods Market, Apple, Target, Chronicle Books, Little Brown, Penguin, *The New York Times*, and *Rolling Stone*. Her work has been featured on the pages of *American Illustration*, *Communication Arts Illustration Annual*, *Print's Regional Design Annual*, and the Society of Illustrators *Annual*. *Print* selected her for their New Visual Artist review, *Communication Arts* featured her in their Fresh column, and *Step* used her art on the cover for their Women in Illustration issue. She has been included in several illustration anthologies including *The Picture Book*, *Curvy*, and *Illustration Now*, which featured her art on the cover of the hardback edition.

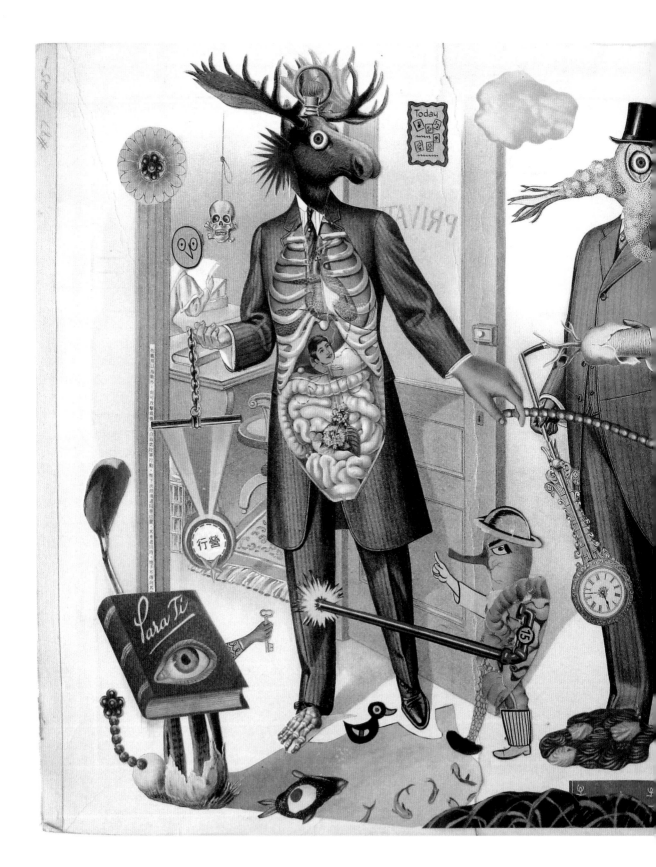

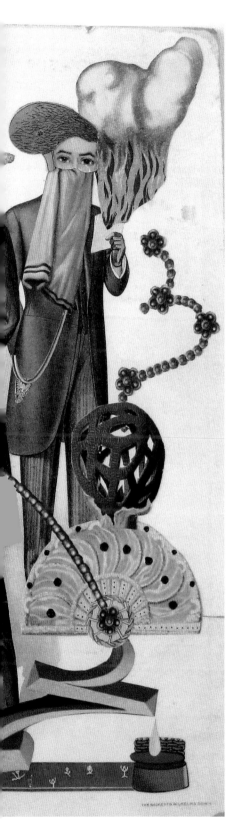

GOLD MEDAL WINNER
LOU BEACH

World of Men

This collage is one from a series of four called The World of Men (the other three can be viewed on my website, www.loubeach.com). They were created for an exhibit of my work at Billy Shire Fine Arts in L.A. The connective tissue in the series consists of symbolic images representing the internal workings of a man's psyche. They run the gamut from the obvious and mundane to the subconscious and incomprehensible, with occasional stops at the goofy.

SILVER MEDAL WINNER
MICHAEL SLOAN

*Professor Nimbus and the
Happy Valley Trolley*
This was inspired by a recent
trip to Hong Kong with my
family. I wanted to draw a
scene that reflected my affec-
tion for the city and that was
quintessentially Hong Kong,
showing the large neon signs
that overhang the teeming
streets, double-decker trolleys
and their overhead wires, and
dramatic weather and lights.
My three children are peer-
ing out of the top deck of the
trolley.

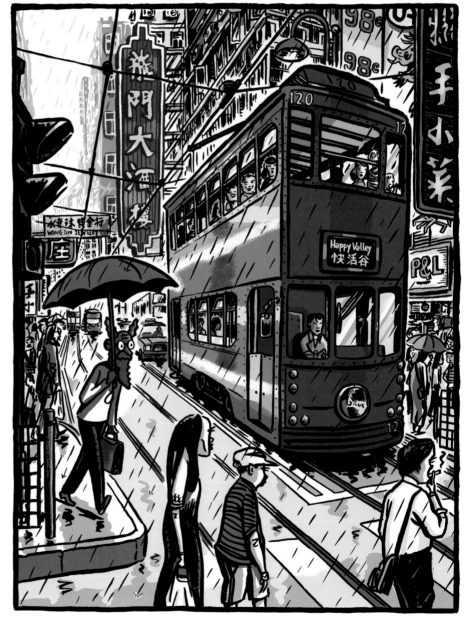

SILVER MEDAL WINNER
JILLIAN TAMAKI

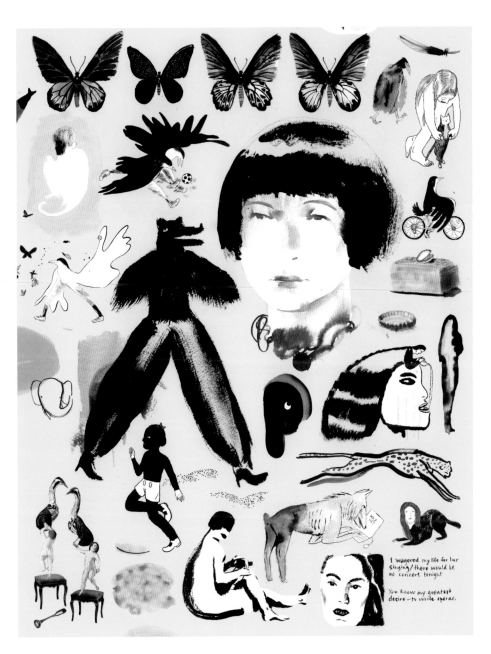

Newsprint
This image is a compilation of personal work culled mostly from sketchbooks. I am constantly trying to bring more of my personal, "rawer" work into my illustration, so I was particularly pleased that this experimental little piece was recognized by the Society. This piece appeared in a self-promotional newspaper for the Pencil Factory Studio. Thank-you to Jennifer Daniel and Josh Cochran for providing the original venue for it.

ELEFTHERIA ALEXANDRI
The Bottom of the Sea
Self-directed project providing an imaginative interpretation of the bottom of the sea. The artwork is a vector illustration.

Deforestation

This painting started with an idea I had been thinking about for a while: a horizon line and cut tree trunk tangent. I've always been conscious of the environment and do things to help preserve the earth in the little ways I can. I find it so surprising that there are some people who are very ambivalent or outright against trying to preserve what we have. While painting this image, I thought about Mother Nature having issues of the environment unabashedly in her face—being mocked but also being helpless to defend herself.

ANDREW BANNECKER
Tears of Hope

ANDREW BANNECKER
Barney and Friend

LOU BEACH
Big C

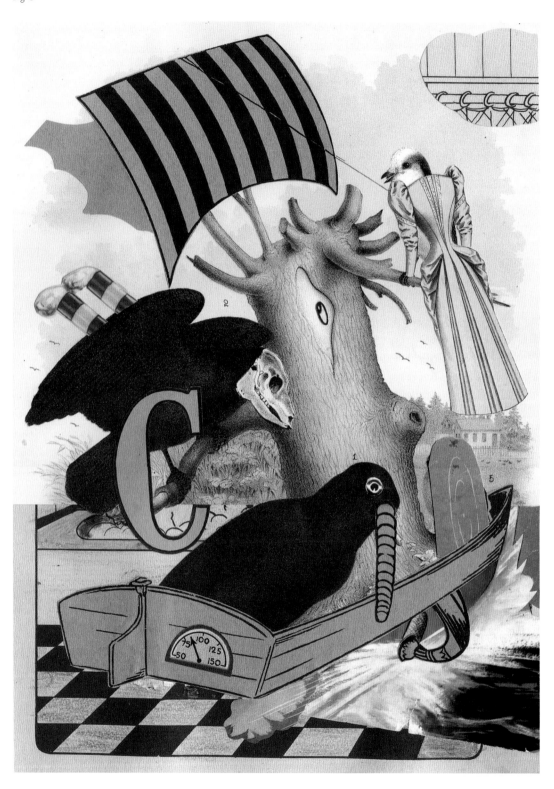

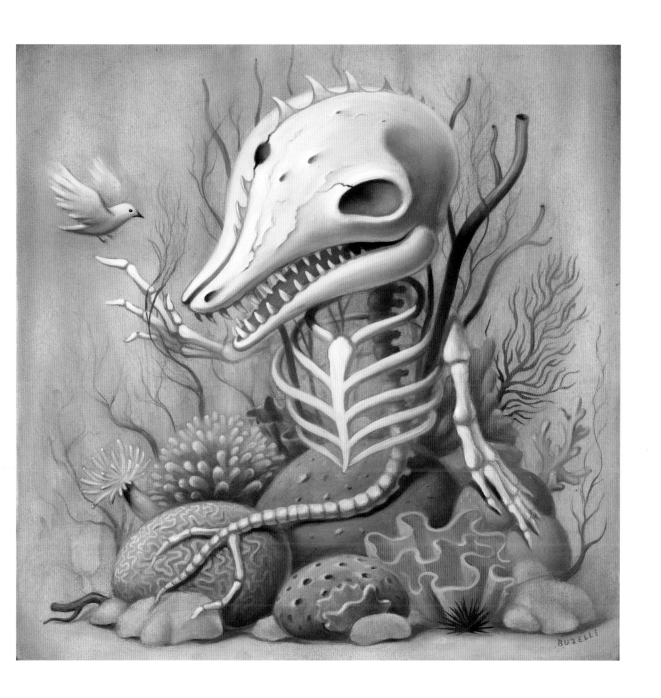

CHRIS BUZELLI
Harbinger
Sea serpents, childhood memories, relationships between sons and fathers, and the bleak future—some of the ideas swirling in my head during this process. This 10- x 10-inch oil painting was for Mark Murphy's Know Show at Art Basel, Miami.

Marc Burckhardt

Affliction
One in a series of images for a gallery exhibition at Blank Space Gallery
in New York City.

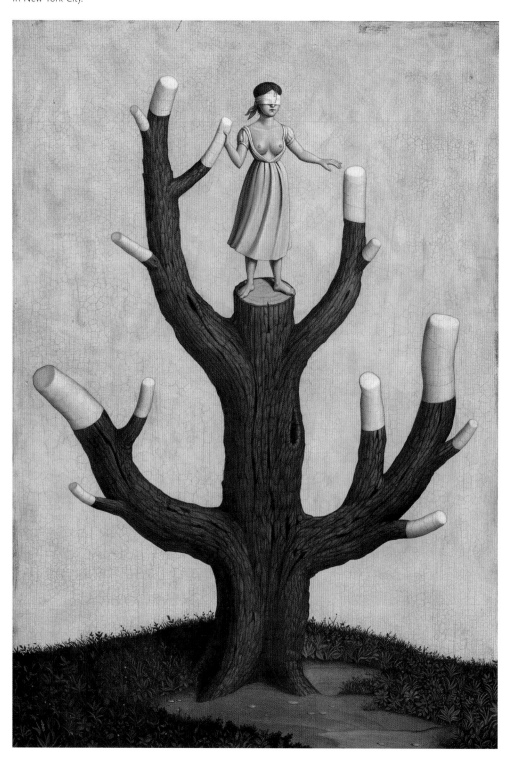

MARC BURCKHARDT

Snakehandler
One in a series of images for a gallery exhibition at Blank Space Gallery in New York City.

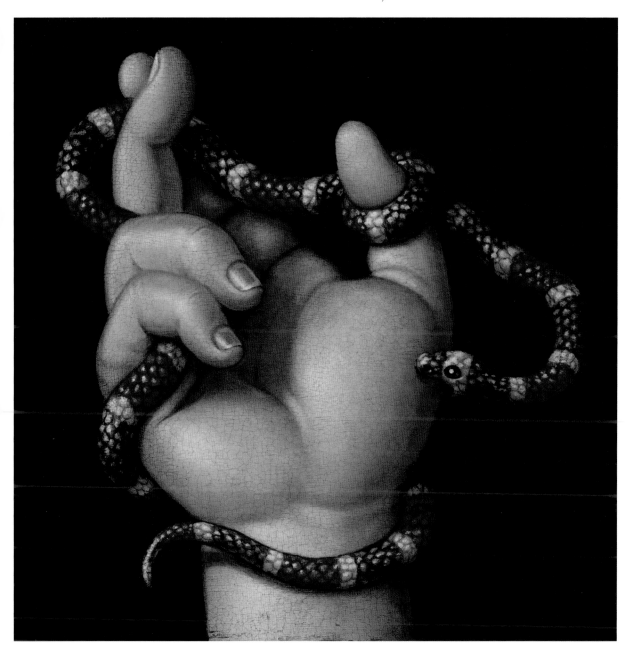

HARRY CAMPBELL
Hand
This was done as a personal piece. Simply exploring different ways of working. Much of my work is very technical, with circuitry, wires, and mechanical imagery. This is one of many exercises to expand how I work.

HARRY CAMPBELL
Waterboarding
This was done as a personal piece, though my approach was much like how I would handle a *New York Times* Op-Ed piece, but without the approval process. I don't find it particularly hard to come up with images for topics like this—it's all there, already in my head.

JOSEPH CIARDIELLO
Les Paul

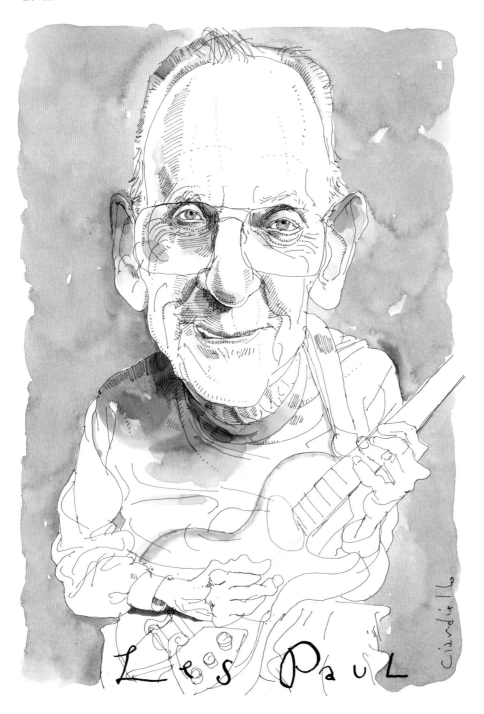

GREG CLARKE
El Gato Oscuro
This poster, the title of which translates as *The Obscure Cat*, is for a fictitious tapas bar in Spain created as a self-promo. It seemed like a nice vehicle for two colors in a quasi-vintage poster style.

ANDREW DeGRAFF

Playing Away

ANDREW DeGRAFF
Marvel Superheroes

RICHARD DOWNS

Red Titi Monkey
The Red Titi Monkey lives in the lower canopy of the Yasuní National
Park. He resides in the "Zona Intangible," the untouchable zone.

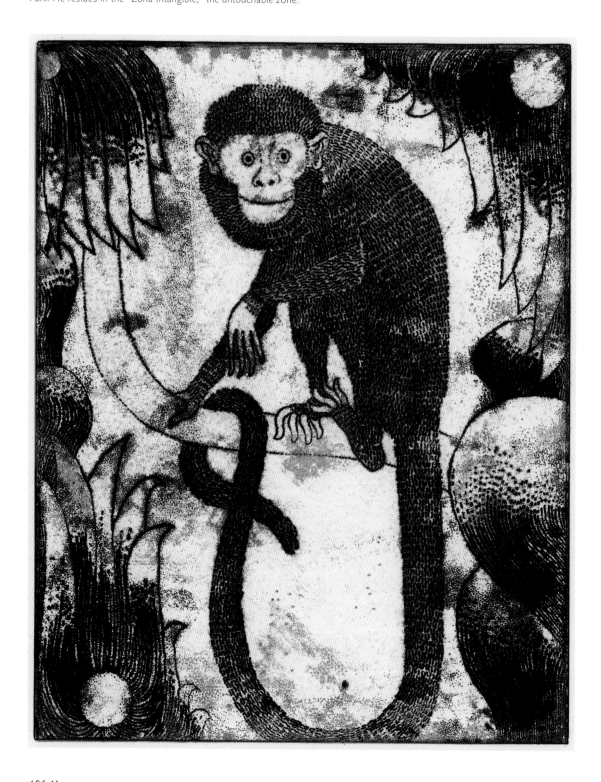

RICHARD DOWNS

Pretty Polly
My interpretation of the Appalachian folk song "Pretty Polly." The song is a murder ballad about a young woman lured into the forest where she is killed and buried in a shallow grave.

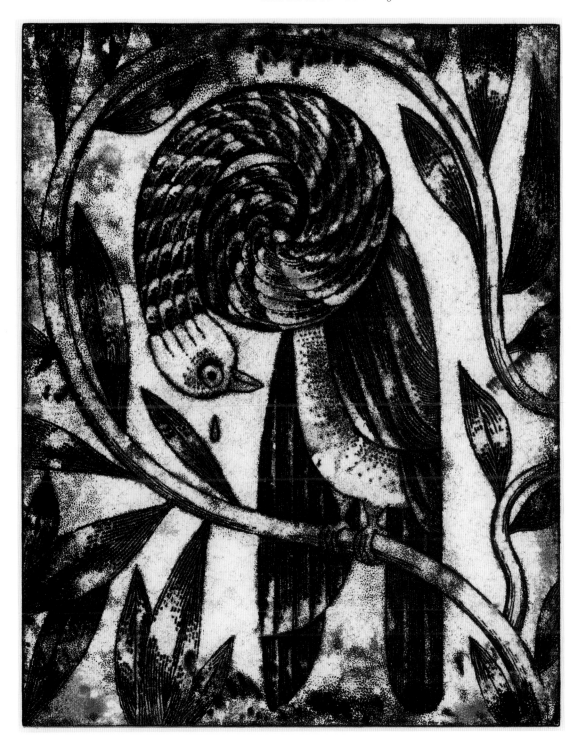

RICHARD DOWNS

Amazing Grace

My interpretation of the hymn "Amazing Grace," written by English poet
John Newton and published in 1779. It's message is that forgiveness and
redemption is possible, regardless of the sins people commit.

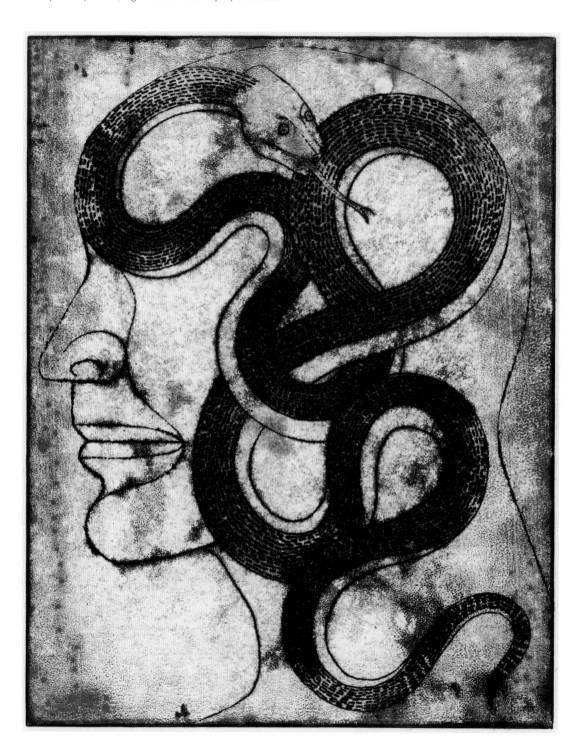

RICHARD DOWNS
Max, the Crystal Skull
Max is one of 13 ancient crystal skulls in the world. Max was found in Guatemala in 1925 and is considered to have been used by Mayan priests for healing and prayer. Those who touch Max experience expanded psychic abilities.

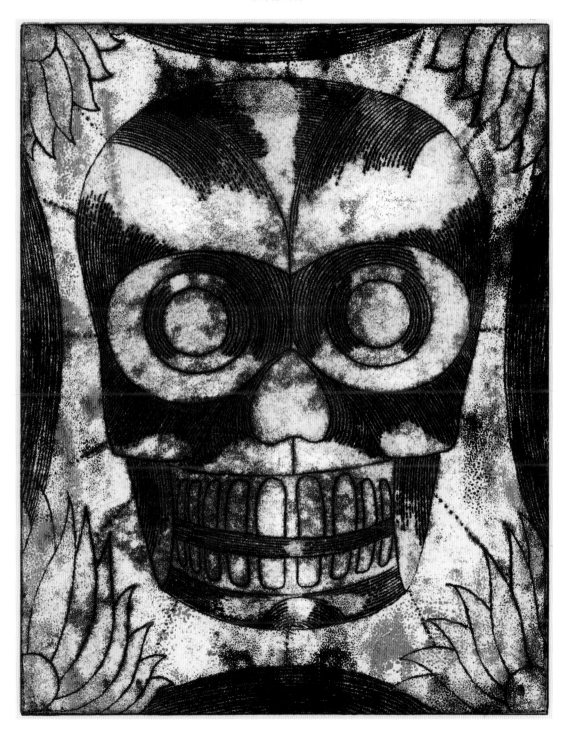

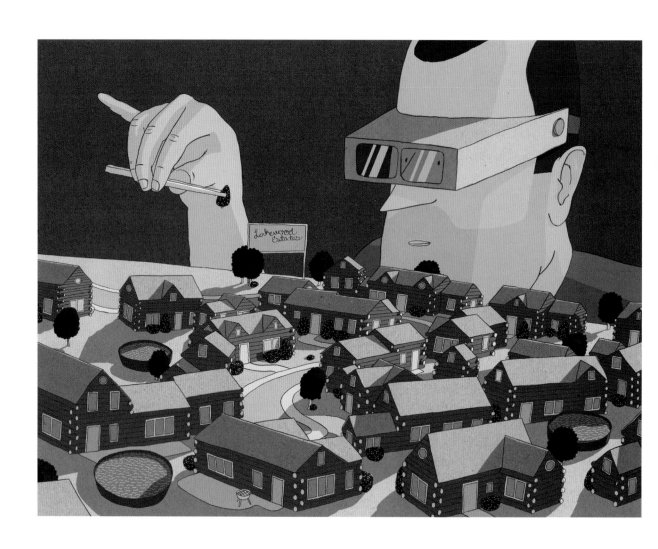

DAVID ERCOLINI
Model Town

BRECHT EVENS

Subway

Ecoline (transparent ink) allows for strong color while leaving the image light and free. In these pieces, characters and spaces are often more suggested than shown full-on. Figures are often drawn as no more than *a pars pro toto* (a hat, eyes, shoes, a movement). The reader fills in the blanks. The images become more like memory: you went somewhere, you remember different rooms, you remember a hat but not the person wearing it, you remember a dance move but not the person dancing.

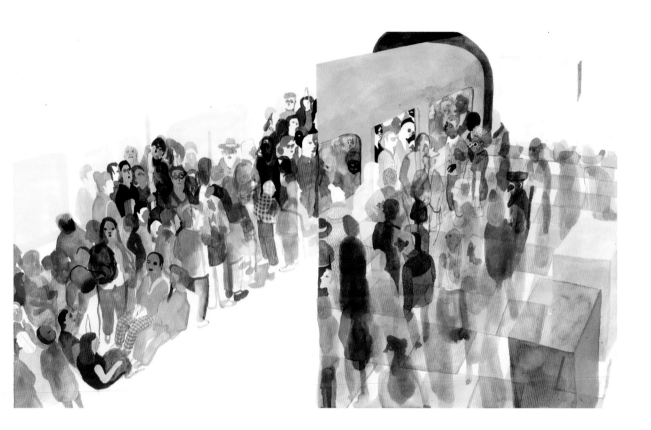

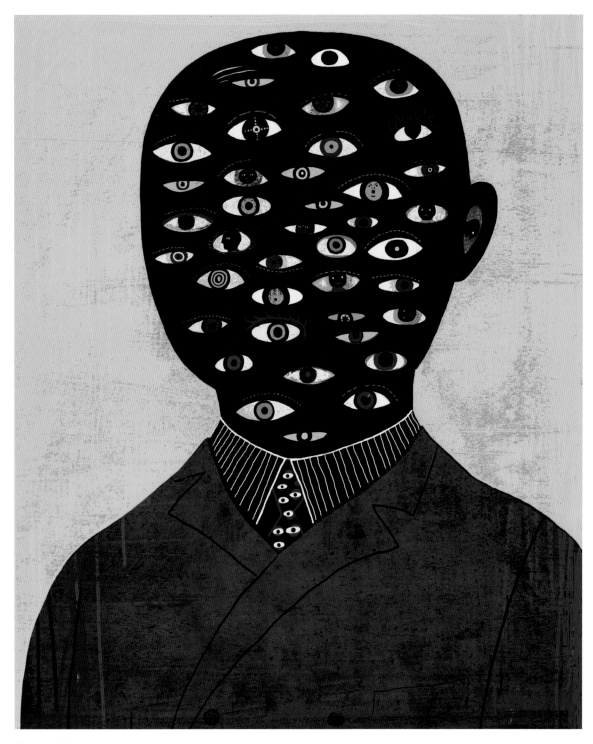

BEPPE GIACOBBE
Psicosi Collecttiva

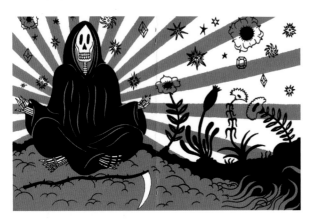
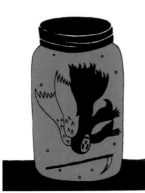
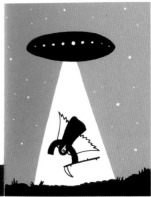
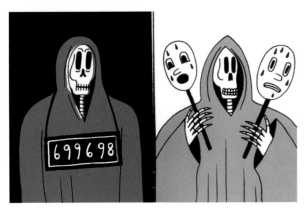

PETER HAMLIN
The Little Book of Death
This piece was an outlet for my thoughts about mortality. It was time to
turn the tables on the Grim Reaper.

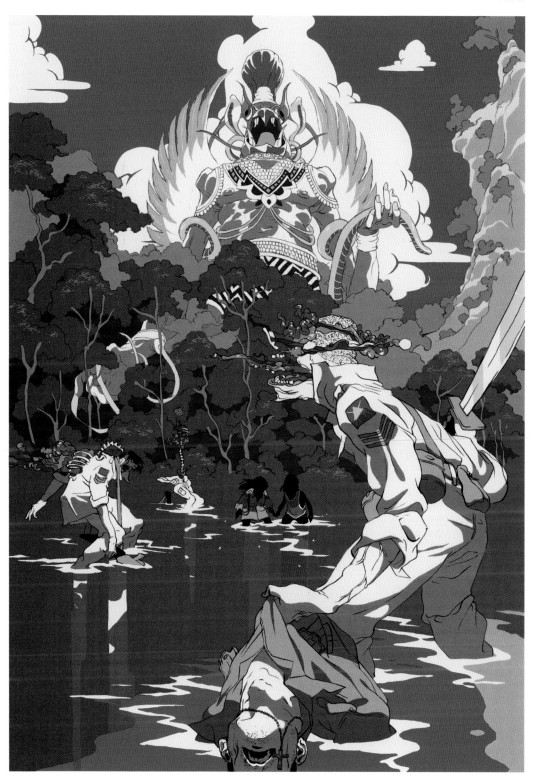

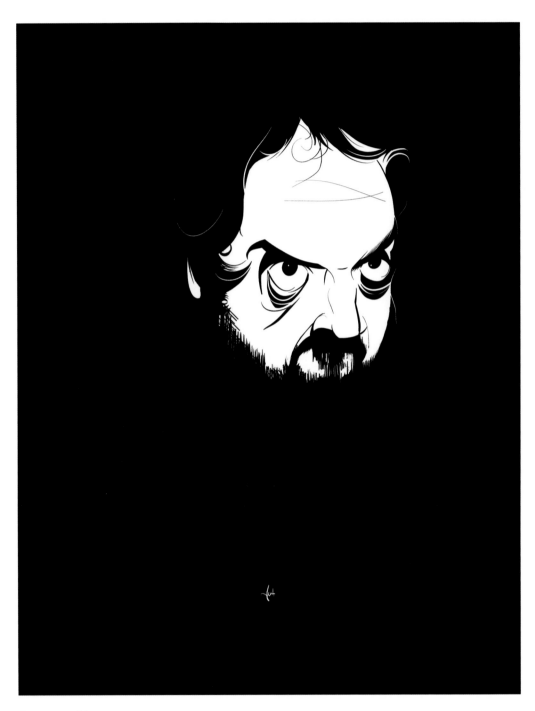

ANTONY HARE
Stanley Black

While working with vector brush strokes, I began to see my work bordering on sculpture. Focusing on the third dimension while stripping down the art to its core shape was the driving force behind *Stanley* *Black*. This, coupled with seeing the way more black ink made my work easier on the eyes, both on computer screens and printed on paper.

JESSICA HISCHE
Say it with Flowers
Personal work

Aya Kakeda

Alchemists Creating 24th Season

This is a painting from my series called 24th Season. In ToTai Island, every 100 years they create a new kind of creature to represent their island. Now it's their 24th season, when the alchemists are infusing the cave seal with poisonous flowers. Will the new creature be good? The answer is, "not really." The 24th season will turn bad and start poisoning and distorting the island, but it's a long story...

AYA KAKEDA
Looking for Friends

MICHAEL KLEIN
Pants Guy

NORA KRUG
Alter Ego
This etching was based on a dream I had: I returned to my hometown, and, just as I was trying to enter the house in which I'd grown up, a small, white figure and a white duck fell from the sky. As I picked them up from the ground, I realized that they were dead.

ANITA KUNZ

Birth of Venus

I've been working on a series of paintings that have to do with re-thinking iconic images. This is the first of three images concerning the birth and death of Venus, redux.

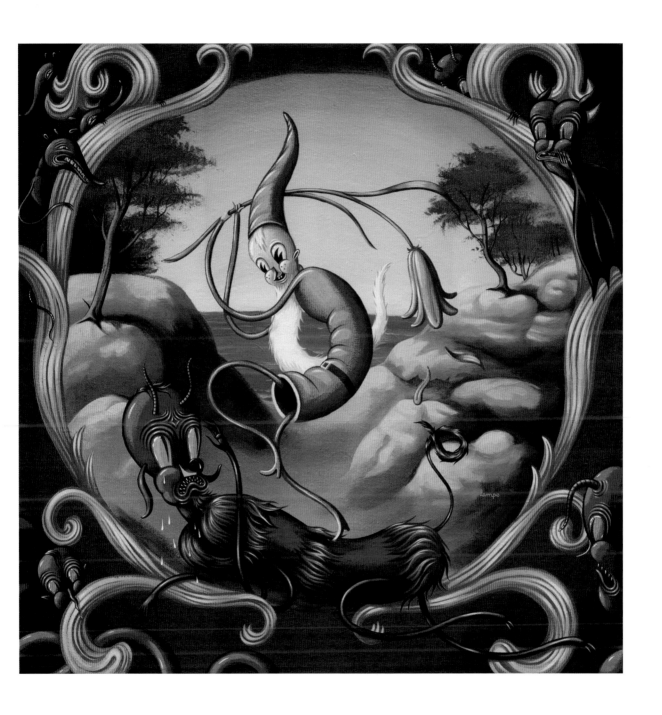

TRAVIS LAMPE
Vim Smackdown

LORI ANN LEVY-HOLM

Classes on Buses

This piece is a gouache illustration for a story I wrote about the 1951 student-led strike that took place at R.R. Moton High School in Farmville, Virginia, to protest the inequities of the black schools. The students thought they were walking out to ensure a new school for themselves, but instead, their walk-out empowered the adults in that community to fight for desegregation.

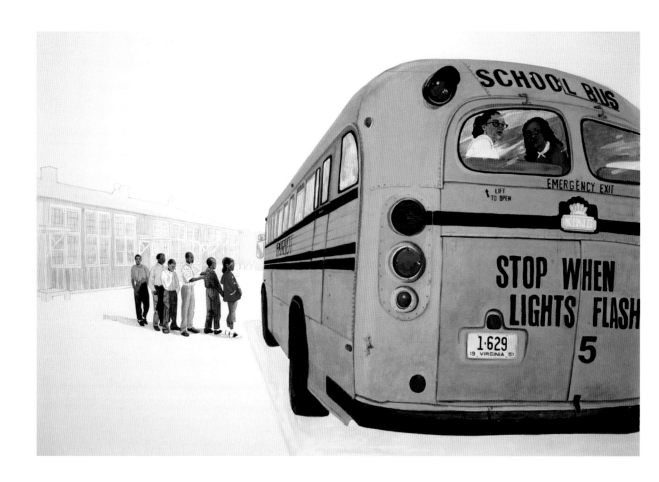

·LET THE RIGHT ONE IN·

" Vampires can't just go inside someone's place...
They have to be INVITED!"

"Sshhh, she whispers as her finger touches my lips"...
"It will be worth it!" Her sensual voice says...
"I'll do things with you no one has EVER done!"
"Have you ever tasted BLOOD?"
"Blood tastes.... DANGEROUS."
"It's sweet and thick... but I won't go!"
"Why are you here?"
"Because you think you're not AFRAID?"
"Because you need to know?"
"Know who I am?"
Let ME IN!

JORGE MASCARENHAS
Let the Right One In
Sketchbook painting based on the Swedish movie.

ADAM McCAULEY
Napili Bay, October 2009

AARON MESHON

Sakana

BEE MURPHY
Carrots and Mint

TIM O'BRIEN

Chuck Brown

In the middle of 2009 I was asked to contribute a piece to a show at CoproGallery in Santa Monica. The show was titled MONSTERS! I decided to make something cute/realistic. After much sketching, I decided that poor Charlie Brown had some odd features and proportions. This image went viral last summer and now it's worldwide.

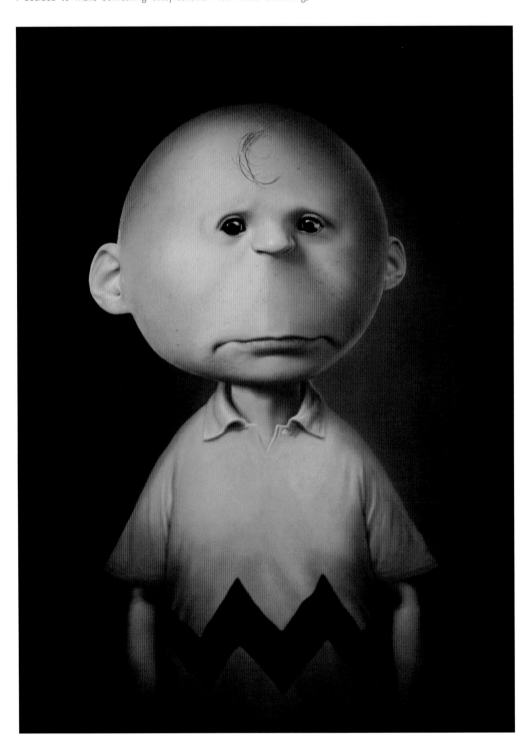

VALERIA PETRONE
Up the Tree

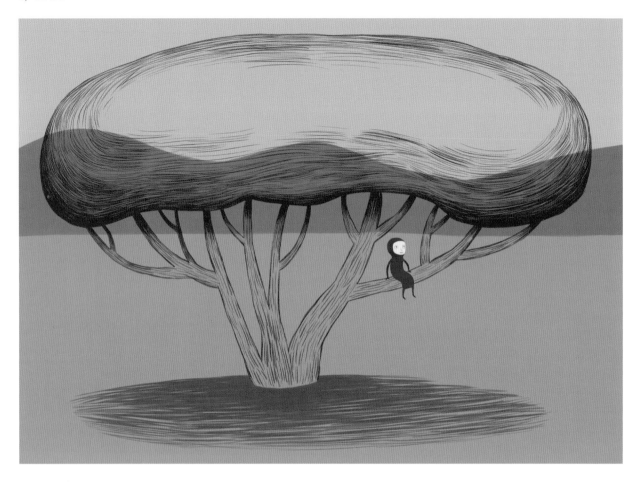

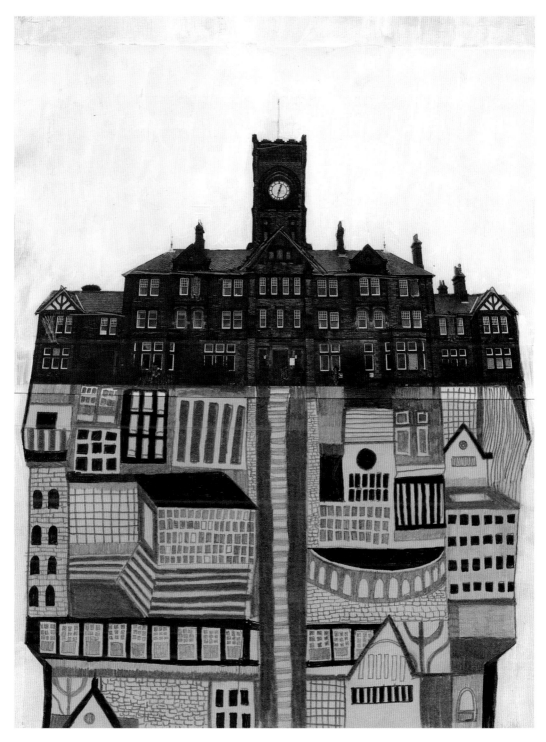

GARRETT PRUTER
Asylum 3

Peter Ra

Lincoln and Kennedy

I am fascinated by almost everything iconic within present day America. After researching the amazing historical facts, I was inspired by the links between these two presidents. I felt compelled to create the duality of their unique bond, in a pop surrealist style.

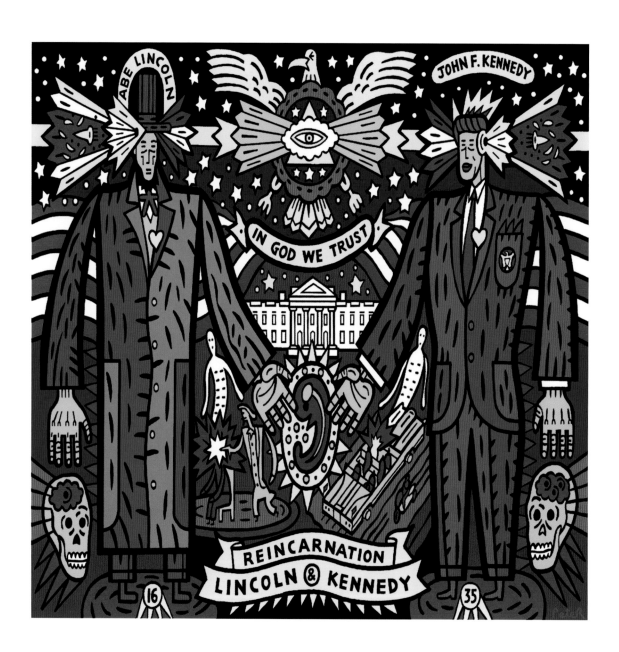

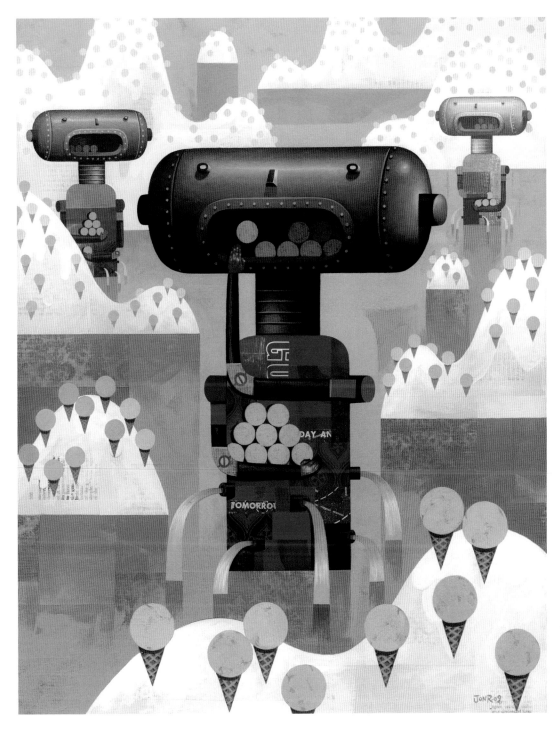

JON REINFURT
Strawberry Meltdown
Part of a series of paintings that uses robots and ice cream to explore the theme of industrial evolution through the consumption of natural resources. Originally for a gallery exhibition, this image is now available as a limited edition print for sale on my website.

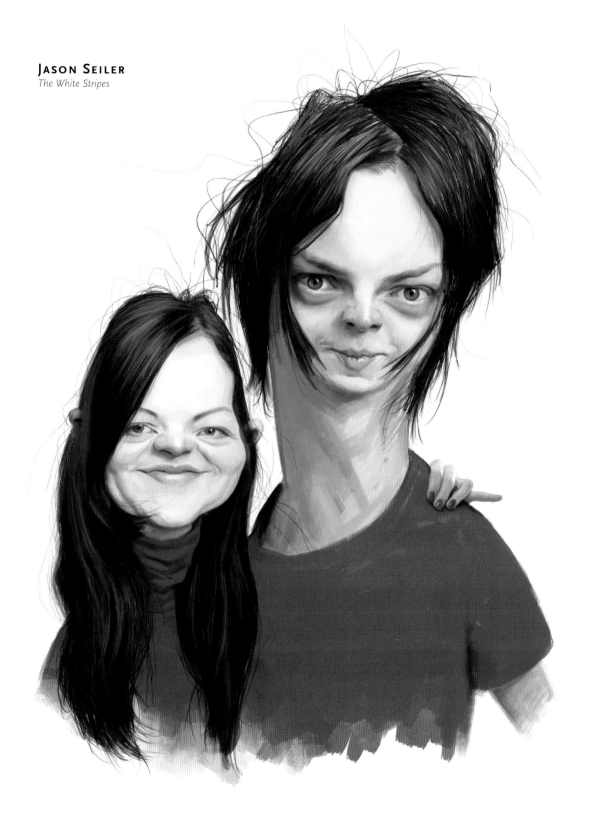

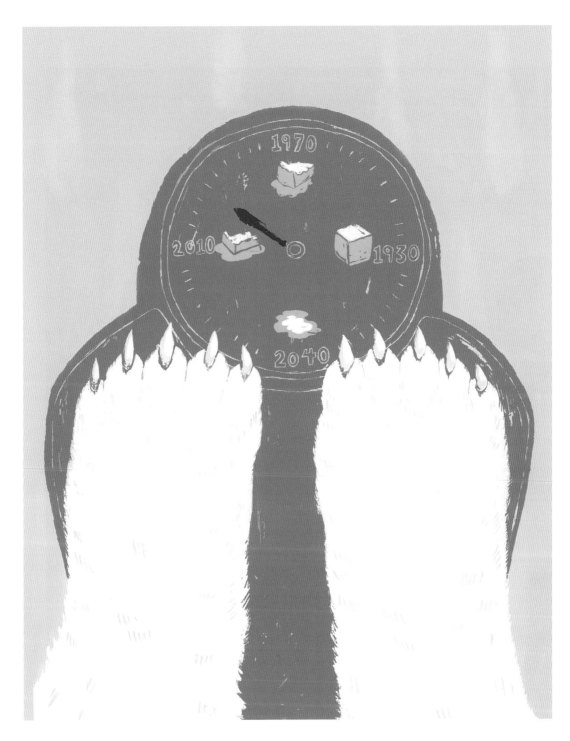

SIMONE SHIN

Melting

This is a piece about the effects of global warming on the population of polar bears and their eventual path to extinction. It is within a series of environmentally conscious works I made using silkscreen, acrylic paint, and digital techniques.

BECCA STADTLANDER
The Thinker
This image was inspired by a scene in Sherwood Anderson's *Winesburg, Ohio*. It is a personal piece painted with gouache on Indian cotton rag paper.

RALPH STEADMAN
1st Woman Jockey

OTTO STEININGER
Dymaxion Taxi

MARK ULRIKSEN
Waylon and Willie

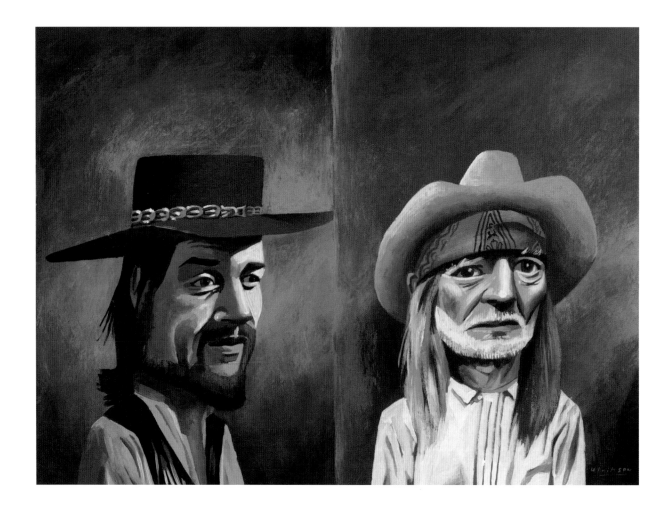

GORDON WIEBE
The Last Fish
A mixed media piece depicting the imaginary harvesting of our oceans' very last fish. It was done for an imaginary atlas published by The Lifted Brow.

LULU WOLF
Astronomy Parachute

OLIMPIA ZAGNOLI
Ulysses and Penelope
This poster represents a modern version of Ulysses coming back home
to Penelope.

SEQUENTIAL

GABRIELLE BELL
COMIC BOOK ARTIST

Gabrielle Bell has contributed to many acclaimed comic anthologies, including *Mome*, *Kramer's Ergot*, and *The Drawn & Quarterly Showcase*, as well as *McSweeneys*, *The Believer*, *Vice Magazine* and *BookForum*. Her work has been selected for the 2007, 2009, and 2010 *Houghton-Mifflin Best American Comics* and the *Yale Anthology of Graphic Fiction*, and she's the recipient of two Ignatz awards. Her books include *When I'm Old and Other Stories* (Alternative Comics) and *Lucky* (Drawn & Quarterly). The title story of Bell's latest book, *Cecil and Jordan in New York*, has been adapted for the film anthology *Tôkyô!* by Michel Gondry. She lives in Brooklyn, New York, and is working on a second volume of *Lucky*, which she serializes on her blog.

MONTE BEAUCHAMP
BLAB!

Monte Beauchamp is the founder, editor, and designer of *BLAB!*, an anthology of painting, illustration, print-making, and sequential art. His work has appeared in *Communication Arts*, *American Illustration*, *Print*, *Graphis*, and the SPD Annual. He has served as a juror for *American Illustration* and has received numerous advertising awards, including five New York Festival Awards for excellence in print and television communications. His books include: *The Life and Times of R. Crumb* (St. Martin's Press), *Striking Images: Vintage Matchbook Cover Art* (Chronicle), *New & Used BLAB!* (Chronicle), and *The Devil in Design* (Fantagraphics). He is founder of the *BLAB!* Picto-Novelettes series, whose titles include: *Sheep of Fools* by Sue Coe, *Old Jewish Comedians* by Drew Friedman, and *The Magic Bottle* by Camille Rose Garcia.

CHRIS CAPUOZZO
ILLUSTRATOR, DESIGNER

In 2000, the Cooper-Hewitt National Design Museum exhibited a sketchbook of Chris Capuozzo's drawings in the National Design Triennial. In 2008 Chris and his wife, Denise, started a design studio: Intergalactico. Their projects include illustrations for a children's book, *A Flake Like Mike*, which were the basis for Sak's Fifth Avenue's 2009 holiday windows display; the design of *Mascots & Mugs*, about NYC subway graffiti characters and cartoons; and works for Stussy, the street wear company. In 2004 his solo show, The Launching of the Dream Weapon, was held at the Sandra Gering Gallery. A founding member of Funny Garbage, he helped invent its original and sophisticated aesthetic, combining elements from high and low culture. Among Chris's awards are three Webby awards.

BILL KARTALOPOULOS
EDUCATOR/CRITIC

Bill Kartalopoulos teaches classes about comics and illustration at Parsons The New School for Design. He regularly writes about comics for *Print* magazine, where he is a contributing editor, and reviews comics for *Publishers Weekly*. He is a frequent public speaker and has given presentations and moderated public discussions about comics at NYU, the New York Center for Independent Publishing, Fordham University, and the School of the Art Institute of Chicago. He is the programming coordinator for SPX: The Small Press Expo, and for the Brooklyn Comics and Graphics Festival. He has worked as a publishing associate at RAW Books and Graphics, and in 2008 he curated Kim Deitch: A Retrospective at the Museum of Comic and Cartoon Art in New York City.

DOMINIE MAHL
CREATIVE DIRECTOR, CURIOUS PICTURES

As Creative Director at one of the largest East Coast animation studios, Dominie works with almost all aspects of the development and creative process, leading teams for TV and feature projects as well as game development and select commercials. Working with both clients and talent, she produces and directs through all stages of the creative process. Dominie began her animation career at MTV Animation Studio. Starting as an artist in the storyboard department on *Beavis and Butt-Head*, she moved up the ranks and was promoted to Production Supervisor, where she oversaw a number of MTV properties, including *Daria*, *The Head*, *The Maxx*, and *Aeon Flux*. As a freelancer, she has also art directed and done visual development for products, promotional materials, CD packaging, books, games, and clothing.

MOTOMICHI NAKAMURA
ILLUSTRATOR, ANIMATOR

Born in Tokyo, Japan, Motomichi Nakamura graduated from Parsons School of Design in 1996. Motomichi seeks to capture the intense fear, sadness, and anger that we experience subconsciously as nightmares. These emotions are represented abstractly, or as monsters that have a humorous quality which renders them as innocent and child-like depictions of darkness. His digital animation work has been exhibited at the New Museum of Contemporary Art in New York City and the Moscow Contemporary Art Center. He has performed as a VJ at MoMA, at the Centraal Museum in Utrecht, and has participated in film festival screening at Sundance and Onedotzero. He has worked on animation, design, and illustration projects for clients such as EA, MTV, and Zune, and produced music video for the Swedish band, The Knife.

VICTORIA ROBERTS
CARTOONIST, PERFORMER

Victoria Roberts is an internationally-renowned cartoonist and performer. Born in Manhattan, Victoria grew up in Mexico City and Sydney. Under contract to *The New Yorker* since 1988, her work has also appeared in *The Australian*, *Uno Mas Uno* (Mexico), and *Vrij Nederland* (Holland). She has written and illustrated six books, illustrated 14 books, and received several grants, awards, and residencies, including an Australian Bicentennial grant for "Australia Felix" published by Chatto & Windus. Since 2004, she has appeared on stage as her cartoon character Nona Appleby (née Molesworth). Nona is a kimono-clad Australian octogenarian. Her first solo show, *Nona*, opened at the National Museum for Women in Washington D.C. in 2005, and went on to a season at Urban Stages in New York City. Nona was a guest of the In Good Company Festival in London, Ontario, in 2006 with a second solo show that incorporates Nona on film.

RIA SCHULPEN
PUBLISHER, BRIES

When she was in her early twenties, Ria Schulpen discontinued studying translation and interpretation. She then worked briefly as dishwasher, cab driver, and for a newspaper (pre-distribution section), before she got a steady job at the public library in her hometown, Antwerp. In 1999, while still working in the public library, she started Bries, her publishing company specializing in fine comics, graphic novels, and art books. In 2006 she exchanged her job at the public library for a job with Beeld Beeld, organizing retrospectives of internationally renowned and critically acclaimed comics artists (José Muñoz, Ever Meulen). In 2009 she decided to focus on publishing, and quit her job with Beeld Beeld. She lives in Antwerp with her cat Briesje.

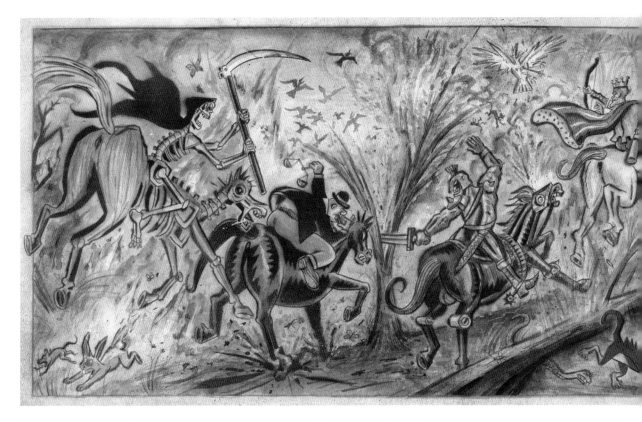

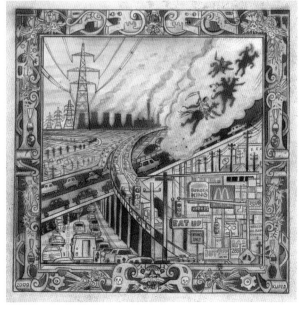

The Four Horsemen

BLAB! editor, Monte Beauchamp, loosely suggested the theme: "Apocalypse." This subject was usually a favorite, especially during the cold, dark George W. Bush reign. However, I had spent a few years in Mexico in a warm, sunny climate and was trying to bring more light into my work. I decided to look back at the historic roots of the concept and was reminded about the Four Horsemen of the Apocalypse: Conquest, War, Famine and Death. It was curious to discover absolutely conflicting ideas about what the various horsemen represented. The white horse rider, the Conqueror, was variously considered to be Christ, or the Antichrist, or the Holy Spirit, or none of the above, depending upon whom you asked. It's a wonder we can agree on anything! My darker tendencies got the better of me, which lead to this *Apocalypse Now* interpretation. Still, hope springs eternal that next year's submissions will be more upbeat. I for one don't love the smell of napalm in the morning.

SILVER MEDAL WINNER
GREG CLARKE

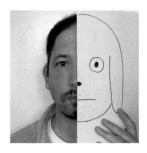

The Neurotic Art Collector
I wanted to create a character engaged in a single-minded pursuit bordering on religious fervor. His need to accumulate and surround himself with beautiful objects is a subconscious bid to deny his own impermanence. Paradoxically, his unhealthy obsession results in hastening his demise.

THE NEUROTIC ART COLLECTOR

By Greg Clarke

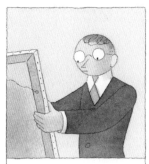

For Ed, art was a portal to something unknowable and more powerful than himself. So he collected it.

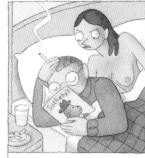

His obsession had a corrosive affect on his personal life and his health.

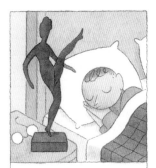

His wife left when an Elie Nadelman moved in.

He forsook his only child to spend more time with his only Morandi.

His cat suffered from chronic anxiety disorder triggered by the unsettling presence of an Albert Pinkham Ryder painting.

SILVER MEDAL WINNER
JUNGYEON ROH

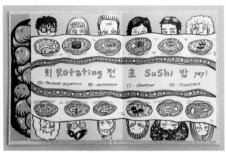

Today is Sushi Day
Sisters who are sushi masters went to a rotating sushi restaurant and taught American people how to be master sushi eaters.

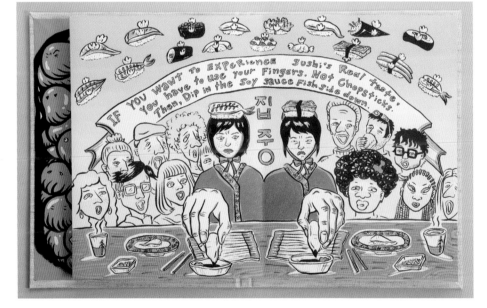

SILVER MEDAL WINNER
Esther Pearl Watson

Unlovable Vol.1
Based on a real diary that the author found in a gas station bathroom in 1995, this episodic collection is an alternately hilarious and exhausting trip through the inner monologue and outer turmoil of overweight high school sophomore Tammy Pierce.

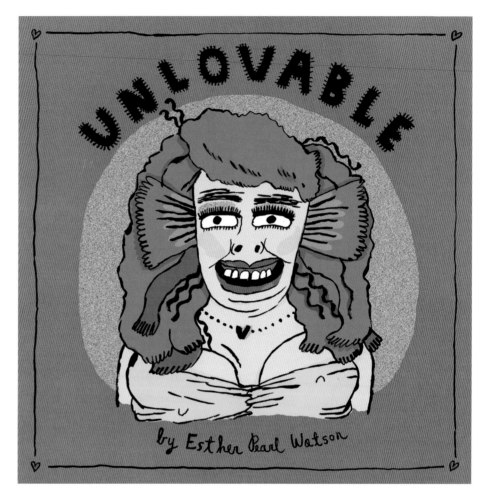

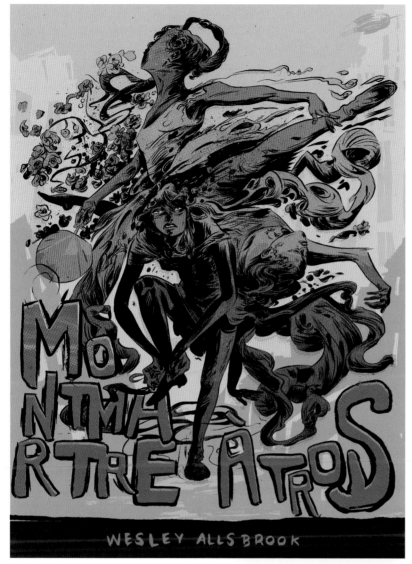

LAUREN SIMKIN BERKE
Excerpts

The exclamation point has yet another panic attack.

The question mark finds life utterly bewildering.

The comma feels entitled to a break.

ANDREA D'AQUINO
A Modern Guide to Punctuation

All typography is expressive, but punctuation marks in particular seem to come with their own set of personality quirks and neurosis, which I explore in this series. Always asked to describe a thought, yet never to be the subjects themselves—that seemed unfair. All images start with drawings, paint, cut paper, then a small degree of digital refinements.

BRECHT EVENS

Les Noceurs

Ecoline (transparent ink) allows for strong color while leaving the image light and free. In these pieces, characters and spaces are often more suggested than shown full-on. Figures are often drawn as no more than a *pars pro toto* (a hat, eyes, shoes, a movement). The reader fills in the blanks. The images become more like memory: you went somewhere, you remember different rooms, you remember a hat but not the person wearing it, you remember a dance move but not the person dancing.

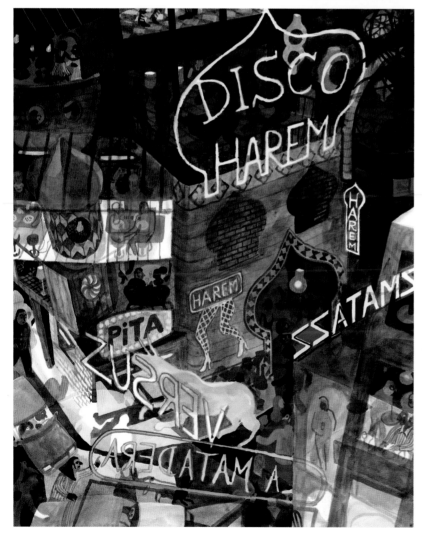

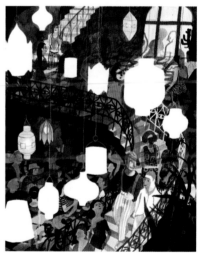

ERIK T. JOHNSON
Kirby Machine

VICTOR KERLOW
Subway Buskers of New York

These drawings were all done on location, in the subway systems of New York City, for the comics anthology *Syncopated* from Villard/Random House Books. Some drawings were done during rush hour, others later in the evening, and a couple were done in the early hours of the morning. Most of the subway buskers are familiar with one another, so during the course of drawing one person, others I had previously drawn would come up in conversation, as well as a few that I would go on to draw later. Brendan Burford was a great art director to work with, and it is always wonderful to be able to incorporate on-location drawing into an assignment.

MICHAEL KLEIN
Phonic Tonic Coasters

Nora Krug

Snow Season

This 10-page visual narrative was created for *Spring*, a German magazine published annually by a group of women comic artists. This year's theme was "crime," and I created a story about a man who murdered his wife and hid her body inside a snowman.

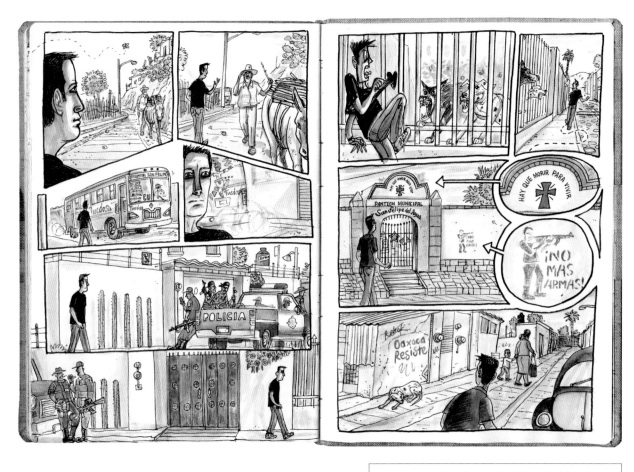

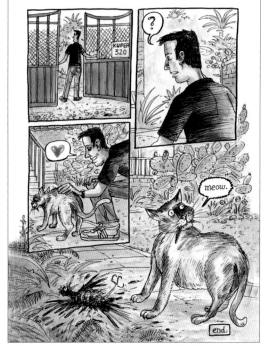

Peter Kuper

Walk in Mexico

From 2006 to 2008 I lived in Oaxaca, Mexico, and almost everyday I took a walk in my neighborhood. This comic, done in the final pages of my sketchbook, was an attempt to capture my experiences throughout that time. I had no idea how to end the story but found a conclusion when I came to the very last page of the book. Later, it was also published in *Diario de Oaxaca*, which collected all the work I had done during those two years.

BILL MAYER

Bebo

Bebo was a little series I did, desperately trying to get noticed in *3x3* directory. They were originally written in badly translated French. Which made them even funnier than I could ever be on purpose. Sex, fishnet hose, Penguins—what more could you want?

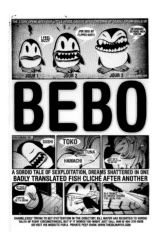

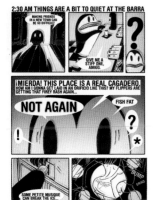

GARY MUSGRAVE
The Pearl

ANDREA OFFERMANN

Mate

I sent sketches for the complete story, along with several pages of finished drawings, to Kazu Kibuishi, the editor of *Flight*, who decided whether or not the story would be suitable for the book. His reply was positive and he gave me free reign to finish the story as I liked. I finished drawing the pages in pen and ink on paper and then decided to work with digital coloring for the background and the mechanical birds. I hand painted the animals that the birds change into in order to emphasize this change, as well as to show that the animals are the real thing, not the mechanical birds in which they were hidden.

PHILIPPE PETIT-ROULET
Chairs

Sea of Birds

Performed by
WHITE BOX THEATER

○ Comedy ○ Drama ● Dance ● Multimedia ● Music

THEATRE
BALTIMORE ■ AMERICA
PROJECT

Jan 25 *to* Feb 7

2009-2010 SEASON

3 of 6

45 West Preston Street Baltimore MD 410.752.8558 www.theatreproject.org

Bad Weather Ballads

THEATRE
PROJECT

Performed by
SANDGLASS THEATER
Mar 1 *to* 14

45 West Preston Street Baltimore MD 410.752.8558 www.theatreproject.org

The
Grandmother Project

THEATRE
PROJECT

Performed by
VT DANCE
Mar 15 *to* 28

45 West Preston Street Baltimore MD 410.752.8558 www.theatreproject.org

Crumbs:
a possibly true story

THEATRE
PROJECT

Performed by
AL LETSON
May 10 *to* 23

45 West Preston Street Baltimore MD 410.752.8558 www.theatreproject.org

EMILIANO PONZI
Love

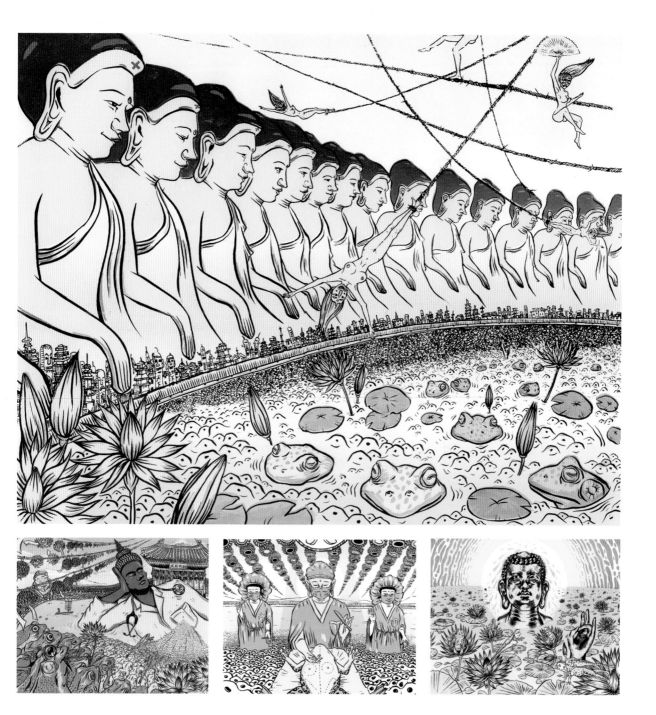

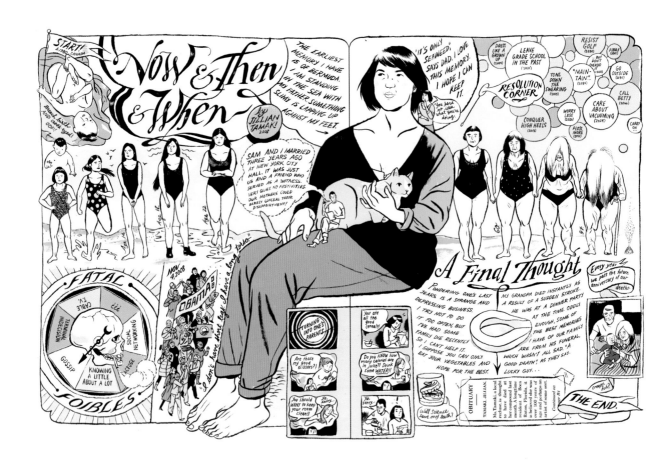

JILLIAN TAMAKI
Now & Then & When

AI TATEBAYASHI
What She Reminds Me Of...
This series is my personal project that was inspired by my admiration for nicely aged ladies whom I witness in my everyday life. Sometimes their fashions and looks remind me of something else, as you see here.

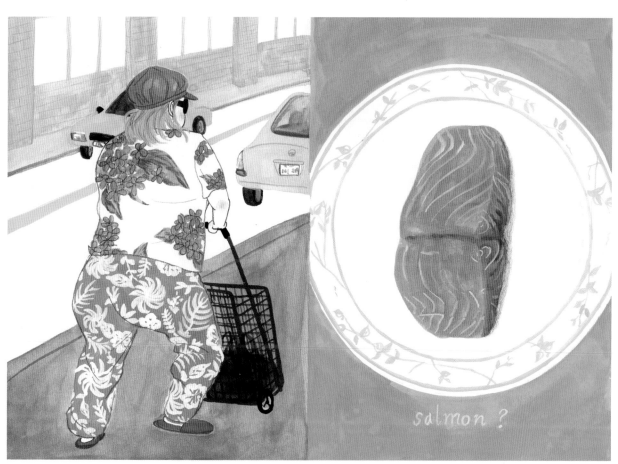

salmon ?

tomato ?

bean sprouts ?

JEAN TRIPIER
Bad News

RICH TU

Let There Be Stuff
This series stems from 12 years of Catholic school combined with an
overwhelming desire to never work in a shopping mall again.

STUDENT SCHOLARSHIP
AND
DISTINGUISHED EDUCATORS IN THE ARTS

The Society of Illustrators fulfills its education mission through its museum exhibitions, library, archives, permanent collection, and, most proudly, through the Student Scholarship Competition.

The following pages present a sampling of the 241 works selected from 6,205 entries submitted by college-level students nationwide. The selections were made by a prestigious jury of professional illustrators and art directors.

Scott Bakal chairs this program and major financial support is given by the Society of Illustrators as well as various other generous private and corporate donors, including Blick Art Materials, Delmar Cengage Learning, The Art Department, the Master Class Program, the late Arthur Zankel, and the late Joyce Rogers Kitchell, and other bequests established in memory of family and colleagues.

An endowment from bequests and corporate support makes possible over $55,000 in awards to the students.

Distinguished Educator in the Arts is an annual award selected by a distinguished group of illustrator/educators from a large pool of candidates.

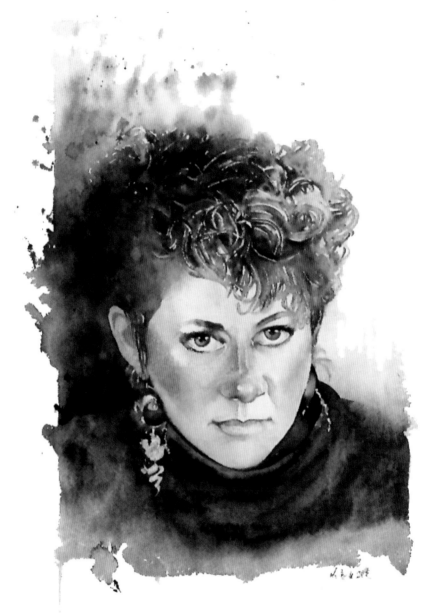

The Society of Illustrators is dedicated to preserving the memory of Joyce Rogers Kitchell, a nationally reknowned watercolorist whose illustrations were sought for both private collections and commercial advertising.

We are committed to honoring her legacy and fostering her spirit of kindness and generosity.

Illustration by Joyce Rogers Kitchell, 1989

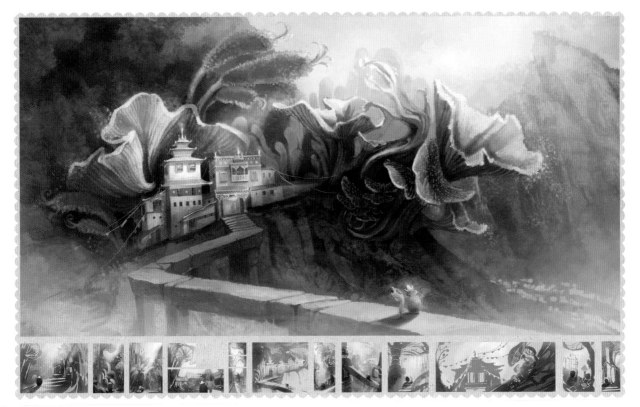

PRISCILLA WONG
Dance for the Winter Worm
San Jose State University
Zankel Scholarship

Zankel nominees: JooHee Yoon from Rhode Island School of Design, Mando Vere from Rhode Island School of Design, and Priscilla Wong. 2010 Jury: Charles Hively, James Yang, Martha Rich, Laura Tallardy, Richard Borge

The Society of Illustrators proudly presents the Zankel Scholar named in memory of Arthur Zankel, whose generous bequest has made this scholarship possible. Mr. Zankel was a firm advocate for higher education. This is the fourth year the Society has been honored to seek, in his name, the best of the junior class and to financially support his or her senior year of college.

Zankel Scholar winner
Priscilla Wong (right)

ROBERT BARRETT

In the 28 years since Robert Barrett faced his first class of students at Brigham Young University, illustrators have retooled for the digital age. They have switched mediums, experimented with software, and explored alternative outlets for their work. Illustrators who are educators have struggled to accommodate these changes. Through this uncertainty, Robert Barrett's touchstone has remained constant. In his own work and in his classroom, drawing is paramount. When Barrett started college, critic Clement Greenburg's essays denigrating realism had convinced many educators that drawing was irrelevant. Fortunately, at the University of Utah, portrait painter Alvin Gittins braved the derision of his colleagues to teach drawing fundamentals. Barrett found this curriculum liberating and honed Gittins's lessons during his graduate studies at the University of Iowa and his post-graduate work in Germany. Drawing has been the foundation of Robert Barrett's success as an award-winning illustrator, muralist, painter, and author whose clients include Random House, McGraw Hill, HarperCollins, and *McCall's* magazine. He has exhibited his work nationally and has had one-man shows in Utah, Idaho, New York, and Berlin, Germany. He has shared this success with his students by teaching them the skill that made it possible—both in his classroom and through his book, *Life Drawing: How to Portray the Figure With Accuracy and Expression*. "Bob Barrett is truly a great educator," writes illustrator and author Brett Helquist. "I began my illustration career as an unhappy engineering student with marginal drawing skills. Bob patiently taught me the craft of making pictures. More than anything Bob helped me understand illustration as a serious discipline worthy of serious study."

"There appears to be no substitute for shaping natural abilities through discipline," Barrett writes. Nevertheless, as his students struggle to meet uncompromisingly high standards, they have a sympathetic mentor. Current student Ty Carter, who just completed his internship at PIXAR writes, "He is a teacher consistently motivated by the success of his students, whose classroom is a preface to brilliance and hope." Carter works digitally and is headed towards a career that bares little resemblance to the opportunities available 28 years ago. Even so, Barrett's example will guide him through his first years as an illustrator. "Robert is the epitome of a teacher, he is a living example of inspiration," Carter explains. "To me, Robert Barrett confirms that you are only as good an artist as you are a man."

ALICE "BUNNY" CARTER

DONALD IVAN PUNCHATZ

[1936 –2009]

Steven Heller called him a "skilled hyperrealist with a penchant for the absurd." Don is probably best known for his science fiction illustrations, satirical work for *National Lampoon*, and a long list of fiction illustration for the likes of *Playboy*, *Esquire*, and *Rolling Stone*. Not to mention his *Time* magazine covers. His teaching career began long before he ever entered a classroom as a professor. His business, Sketchpad Studio, was modeled after that of a Renaissance Master. As the boss, main talent, and guru, he took in fledgling illustrators and assigned them a job depending on their level of skill. Thus, in the process of producing an enormous volume of work, Don taught, nurtured, and mentored some of the biggest and most well-known talents in the business today. Not content to simply earn a living, Don commuted once a week to Texas Christian University, nearly every semester, for over 37 years. There he taught a never-ending stream of standing-room-only classes. As a professor, he went far beyond technique, and challenged his students to truly understand the communication problems they were dealing with, and to solve them in the most effective and creative way possible.

Don would frequently bring his professional projects to class in order to demonstrate method. In a subtle way this also helped to foster a better understanding of what the students could learn from the Maestro—and they became more attentive and harder working because of it. Besides his routine teaching at TCU, Don was also a regular visiting Professor for the Masters in Illustration program at Syracuse University. It is difficult to find a successful illustrator in the Dallas/Austin/Houston markets who was not one of his Sketchpad "elves" or students at some point. Murray Tinkelman has called Don "The Godfather of Dallas Illustration." Being a humble man, Don was annoyed by this moniker, but never was a title more well-deserved. Don Punchatz was an amazingly talented Illustrator; a caring teacher; an intellectual giant; a loving husband and father; and a sweet and gentle soul.

LEWIS GLASER

"[Don Punchatz's] ability to touch men with acrylic and melt them into beasts, or touch beasts with oil and ink—and voila! they are senators or brokers—is endlessly amazing" — **RAY BRADBURY**

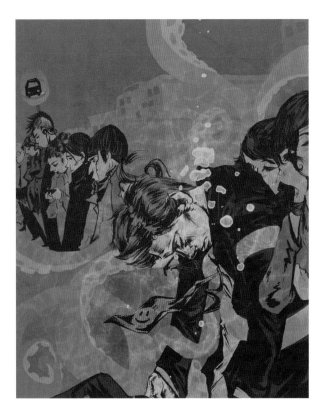

COURTNEY BILLADEAU
Drowning In Work
Digital
Minneapolis College of Art and Design
Tom Garrett, Instructor
$5,000 In Memory of Arthur Zankel
Art Department Scholarship in Honor
of Mark English

DARIEN MCCOY
Mamá También
Savannah College of Art and Design
Mohamed Danawi, Instructor
$5,000 in Memory of Joyce Rogers Kitchell

JIM TIERNEY
Azaz
The University of the Arts
Robert Byrd, Instructor
$4,000 Nancy Lee Rhodes Roberts
Scholarship Award

VICTO NGAI
The New Standard
Mixed media and digital
Rhode Island School of Design
Chris Buzelli, Instructor
$4,000 Nancy Lee Rhodes Roberts
Scholarship Award
2011 Call for Entries Poster

ANNA TOPURIYA
Dick Meets Ed
Art Center College of Design
Paul Rogers, Instructor
$3,000 in Memory of Albert Dorne

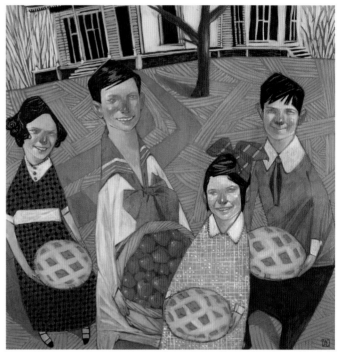

DAN SCHWARTZ
Apple Fest
Acrylic
Syracuse University
Yvonne Buchanan, Instructor
$2,500 Nancy Lee Rhodes Roberts
Scholarship Award

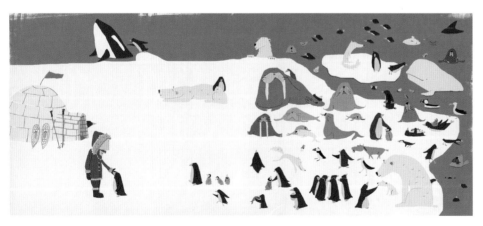

KATRIN WIEHLE
Pipapo Ice Scene
Digital
Savannah College of Art and
Design, Atlanta
Rick Lovell, Instructor
$2,500 Nancy Lee Rhodes
Roberts Scholarship Award

CHRISTINA ELLIS
Yuki-onna
Digital
Ringling College of Art and Design
Joe Thiel, Instructor
$2,500 MicroVisions Award
Master Class Program Scholarship

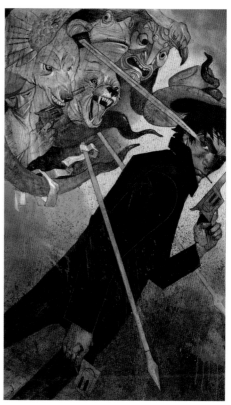

PATRICK RICHARDSON
Last Stand
Digital
Ringling College of Art and Design
Don Brandes, Instructor
$2,000 MicroVisions Award

ALIJA CRAYCROFT
Character Design of a Japanese Kappa
California College of the Arts
Dugald Stermer, Instructor
$2,000 in Memory of Warren Rogers

KEITH ALVARADO
?uest
Monotype
Ringling College of Art and Design
Don Brandes, Instructor
$2,000 in Memory of Verdon Flory

<div align="right">

RACHEL PONTIOUS
Antigone
Acrylic and ink
School of Visual Arts
Thomas Woodruff, Instructor
$2,000 Nancy Lee Rhodes Roberts
Scholarship Award

</div>

ALEX UYENO
Two Rows of People Use Skype
Ink and Photoshop
Maryland Institute College of Art
Whitney Sherman, Instructor
$2,000 in Memory of Bernie Fuchs

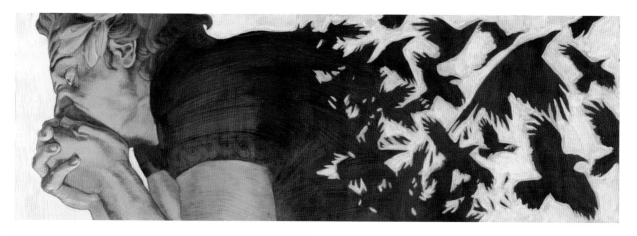

YOUNG NAM HELLER
Oedipus Rex
Acrylic
School of Visual Arts
Thomas Woodruff, Instructor
$1,500 in Memory of Cora Grayer

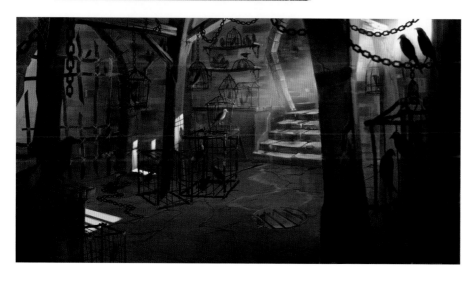

YELENA BRYKSENKOVA
Georges Perec
Pen and watercolor on paper
Maryland Institute College of Art
Deanna Staffo, Instructor
$1,500 in Memory of Helen Wohlberg Lambert
and Herman Lambert

MILES DULAY
Birdcage
Digital
San Jose State University
Nino Navarra, Instructor
$1,000 The Cengage Learning
Drawing Inspiration Student
Scholarship Award

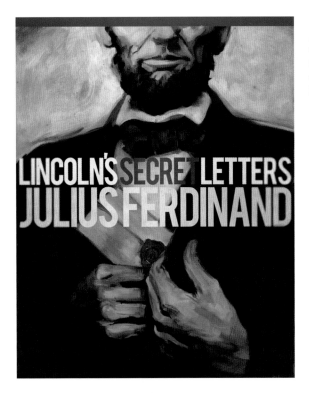

MIKE PUNCEKAR
Lincoln's Secret Letters
Oil and digital
Columbus College of Art and Design
C.F. Payne, Instructor
$1,000 The Cengage Learning Drawing
Inspiration Student Scholarship Award

TARA JACOBY
Little Red Riding Hood
Acrylic
Fashion Institute of Technology
Sal Catalano, Instructor
$1,000 in Memory of Effie Bowie

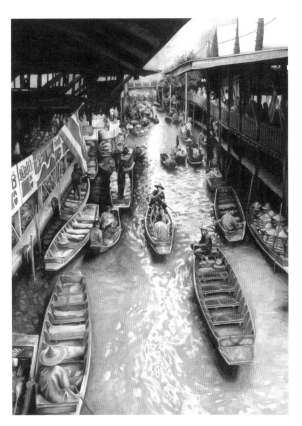

LISA AMBROSE
Thai Trade on the Khlong Damnoen Saduak
Watercolor
Kendall College of Art and Design
Jon McDonald, Instructor
$1,000 in Memory of Harry Rosenbaum

TREY BRYAN
Polo #2-7
Acrylic
Ringling College of Art and Design
George Pratt, Instructor
$1,000 John Klammer Award

MARIAN DILAN
Will We Clone a Dinosaur?
California College of the Arts
Dugald Stermer, Instructor
$1,000 Dan Adel Award

JONGMEE KIM
Blind
Digital
College for Creative Studies
Don Kilpatrick III, Instructor
$1,000 in Memory of Bill Charmatz

INDEX

DANIEL ADEL
292 Main St.
Cold Spring, NY 10516
danieladel@mindspring.com
www.danialadel.com

P. 50
ART DIRECTOR:
Scott Anderson
CLIENT: Playboy
MEDIUM:
Oil on canvas

P. 51
ART DIRECTOR:
Jason Treat
CLIENT: The Atlantic
MEDIUM:
Oil on canvas

P. 52
ART DIRECTOR:
Jason Treat
CLIENT: The Atlantic
MEDIUM:
Oil on canvas

LINCOLN AGNEW
602-2520 Palliser Dr. SW
Calgary T2V4S9, Canada
403-238-2448
info@lincolnagnew.com
www.lincolnagnew.com

P. 275
ART DIRECTOR:
Martha Rago
CLIENT: HarperCollins
MEDIUM:
Pen & ink, digital

P. 276
ART DIRECTOR:
Martha Rago
MEDIUM:
Pen & ink, digital

MONIKA AICHELE
Schoenere Welt
Gotzinger Str. 52 A
Munich 81371, Germany
212-496-3706
mail@monikaaichele.com
monikaaichele.com

P. 198
CLIENT: Eiga Design
MEDIUM: Serigraphy

P. 199
CLIENT:
Inga Lorenz-Debor
MEDIUM: Serigraphy

P. 200
CLIENT:
Mareike Dittmer
MEDIUM: Serigraphy

P. 277
ART DIRECTOR:
Friederike Gauss-Girst
CLIENT: Friederike
Girst/Dumont Verlag
MEDIUM: Mixed

HANA AKIYAMA
3-14-35 Shimo-ochiai, Shinjyuku-ku
Tokyo 161-0033, Japan
81-90-2941-3061
akiyama@jagda.org
www.hanaakiyama.com

P. 278
ART DIRECTOR:
Fumikazu Ohara
CLIENT: Plancton

ELEFTHERIA ALEXANDRI
Spetses Island 18050, Greece
+003 069-446-92650
e_a@ilikeyellow.com
http://www.ilikeyellow.com

P. 390
MEDIUM: Digital

WESLEY ALLSBROOK
99 Franklin St. #2L
Brooklyn, NY 11222
401-256-0255
wallsbro@gmail.com

P. 457
Art Directors:
Liz Gorinsky
Gina Gagliano
MEDIUM:
Brush, ink, digital

RAQUEL APARICIO
c/o Magnet Reps
1783 S. Crescent Heights Blvd.
Los Angeles, CA 90035
866-390-5656
art@magnetreps.com
www.magnetreps.com

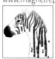
P. 49
ART DIRECTOR:
Antonio Ares
CLIENT:
Viajar Magazine
MEDIUM:
Indian ink, digital

PATRICK ARRASMITH
162 16th St. #8E
Brooklyn, NY 11215
718-499-4101
patrickarrasmith@earthlink.net
www.patrickarrasmith.com

P. 279
ART DIRECTOR:
Paul Zakris
CLIENT:
Greenwillow Books
MEDIUM:
Scratchboard, digital

SCOTT BAKAL
PO Box 320638
West Roxbury, MA 02132
631-525-2309
info@scottbakal.com
www.scottbakal.com

P. 53
ART DIRECTOR:
Bryan Gray
CLIENT:
Liberty Magazine
MEDIUM: Acrylic, ink

P. 201
ART DIRECTOR:
Scott Bakal
CLIENT:
Cut to the Drummer
MEDIUM: Acrylic, ink

P. 391
MEDIUM: Acrylic, ink

**ANNA AND
ELENA BALBUSSO**
via Ciro Menotti 15
Milano 20129, Italy
0039-027-010-8739
balbusso.twins@gmail.com
www.balbusso.com

P. 280
ART DIRECTOR:
Orietta Fatucci
CLIENT: Edizioni El
Mondadori Group
MEDIUM:
Acrylic, digital

P. 281
ART DIRECTOR:
Orietta Fatucci
CLIENT: Edizioni El
Mondadori Group
MEDIUM:
Acrylic, digital

P. 282
ART DIRECTOR:
Orietta Fatucci
CLIENT: Edizioni El
Mondadori Group
MEDIUM:
Acrylic, digital

P. 283
ART DIRECTOR:
Orietta Fatucci
CLIENT: Edizioni El
Mondadori Group
MEDIUM:
Acrylic, digital

ANDREW BANNECKER
804 Aaron Ct.
Great Falls, VA 22066
917-209-3462
abannecker@gmail.com
www.andrewbannecker.com

P. 392

P. 393

JONATHAN BARTLETT
336-345-0369
jb@seejbdraw.com
www.seejbdraw.com

P. 284
ART DIRECTOR:
Marshall Arisman

P. 285
ART DIRECTOR:
Marshall Arisman
MEDIUM: Mixed

P. 286
ART DIRECTOR:
Marshall Arisman
MEDIUM: Mixed

LOU BEACH
900 S. Tremaine Ave.
Los Angeles, CA 90019
323-934-7335
lou@loubeach.com
www.loubeach.com

GOLD
P. 386
MEDIUM: Collage

P. 394
MEDIUM: Collage

ANA BENAROYA
23 Peach Orchard Dr.
East Brunswick, NJ 08816
732-407-4113
ana.benaroya@gmail.com
www.anabenaroya.com

P. 139
ART DIRECTOR:
Emily Rosenblum
CLIENT: Wilco
MEDIUM: Screenprint

P. 202
ART DIRECTOR: BrenB
CLIENT: The Small
Press/Offset 2009
MEDIUM: India ink,
Photoshop

MIKE BENNY
11703 Uplands Ridge Dr.
Austin, TX 78738
512-263-5490
mbenny@austin.rr.com
http://mikebenny.com

P. 203
ART DIRECTOR:
Bob Beyn
CLIENT:
Seraphein Beyn
MEDIUM: Acrylic, oil

SILVER
P. 272
ART DIRECTOR:
Jennifer Bacheller
CLIENT:
Sleeping Bear Press
MEDIUM: Acrylic

P. 287
ART DIRECTOR:
Jennifer Bacheller
CLIENT:
Sleeping Bear Press
MEDIUM: Acrylic

ORIT BERGMAN
Karem Maharal
Hof Hakarmel 30840, Israel
+972-524-681-496
orit.bergman@gmail.com
www.oritbergman.com

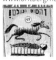
SILVER
P. 134
ART DIRECTOR:
Idit Herman
CLIENT: Clipa Theater
for Performing Art
MEDIUM:
Scratchboard, digital

LAUREN SIMKIN BERKE
c/o Riley Illustration
PO Box 92
New Paltz, NY 12561
845-255-3309
teresa@rileyillustration.com
www.rileyillustration.com

P. 458
MEDIUM: Mixed

GUY BILLOUT
274 Shoreham Village Dr.
Fairfield, CT 06824
guy@guybillout.com

P. 56
ART DIRECTOR:
Pete Sucheski
CLIENT: Fortune

JOSÉE BISAILLON
4705 Pelletier St.
St-Hubert J3Y 2H7, Canada
450-904-2563
info@joseebisaillon.com
www.joseebisaillon.com

P. 288
ART DIRECTOR:
Andrée Lauzon
CLIENT: Les 400 Coups
MEDIUM: Mixed

CATHIE BLECK
2270 Chatfield Dr.
Cleveland Heights, OH 44106
cb@cathiebleck.com
www.cathiebleck.com

P. 142

P. 204
ART DIRECTOR:
Diane Woolverton
CLIENT:
U.S. State Department
MEDIUM: Ink, kaolin
pigment on clay board

SERGE BLOCH
c/o Marlena Agency
322 Ewing Street
Princeton, NJ 08540
609-252-9405
marlena@marlenaagency.com
www.marlenaagency.com

P. 54
MEDIUM: Ink, collage

P. 55
MEDIUM: Ink, collage

P. 140

P. 141

FRANCESCO BONGIORNI
Via Dall'Occo 9, Cormano
Milan 20032, Italy
0039-333-713-0534
mail@francescobongiorni.com
www.francescobongiorni.com

P. 57
ART DIRECTOR: Max Bode
CLIENT: The New Yorker
MEDIUM: Digital

JULIA BRECKENREID
82 Oakvale Ave.
Toronto M4J 1J1, Canada
416-513-0017
julia@breckenreid.com
www.breckenreid.com

GOLD
P. 40
ART DIRECTOR:
Faith Cochran
CLIENT:
More Magazine, Canada
MEDIUM: Acrylic on
paper, digital

WAYNE BREZINKA
1300 Overton St.
Old Hickory, TN 37138
615-497-2549
wayne@brezinkadesign.com
brezinkadesign.com

P. 143
CLIENT: Shane Lamb
MEDIUM:
Collage, montage

STEVE BRODNER
100 Cooper St. #6G
New York, NY 10034
917-596-2938
www.stevebrodner.com

P. 58
ART DIRECTOR:
Amid Capeci
CLIENT: Newsweek
MEDIUM: Watercolor

LOU BROOKS
PO Box 753
Redwood Valley, CA 95470
707-485-0800
lou@loubrooks.com
www.loubrooks.com

P. 290
ART DIRECTOR:
Netta Rabin
CLIENT:
Workman Publishing
MEDIUM: Digital

P. 291
ART DIRECTOR:
Netta Rabin
CLIENT:
Workman Publishing
MEDIUM: Digital

NIGEL BUCHANAN
51/61 Marlborough St.
Surry Hills 2010, Australia
612-9699-3694
nigel@nigelbuchanan.com
www.nigelbuchanan.com

P. 59
ART DIRECTOR:
Soojin Buzelli
CLIENT: Plansponsor
MEDIUM: Digital

MARC BURCKHARDT
1111 W. 7th St.
Austin, TX 78703
512-458-1690
marc@marcart.net
www.marcart.net

SILVER
P. 46
ART DIRECTOR:
Jason Treat
CLIENT: Atlantic Monthly
MEDIUM:
Acrylic, oil on wood panel

P. 60
ART DIRECTOR:
Joe Kimberling
CLIENT: LA Magazine
MEDIUM:
Acrylic, oil on board

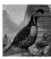
P. 61
ART DIRECTOR:
Joe Kimberling
CLIENT: LA Magazine
MEDIUM:
Acrylic, oil on board

P. 205
ART DIRECTOR:
Mikiharu Yabe
CLIENT: Custo Barcelona
MEDIUM: Acrylic,
oil on board

P. 289
ART DIRECTOR:
Michael Accordino
CLIENT:
Simon & Schuster
MEDIUM:
Acrylic, oil on board

P. 396
MEDIUM: Acrylic,
oil on wood panel

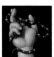
P. 397
MEDIUM: Acrylic,
oil on wood panel

PHILIP BURKE
1948 Juron Dr.
Niagara Falls, NY 14304
716-478-5915
burke.philipburke@gmail.com

P. 62
ART DIRECTOR:
Sarah Garcea
CLIENT: INC.
MEDIUM: Oil on canvas

P. 63
Illustration Editor:
Christine Curry
CLIENT: The New Yorker
MEDIUM: Oil on canvas

P. 64
ART DIRECTOR:
Nancy Butkus
CLIENT:
The New York Observer
MEDIUM: Oil on canvas

CHRIS BUZELLI
125 E. 4th St. #22
New York, NY 10003
212-614-8111
cb@chrisbuzelli.com
www.chrisbuzelli.com

P. 65
ART DIRECTOR:
Lee Caulfield
CLIENT: Technology
Review Magazine
MEDIUM: Oil

P. 206
Art Directors:
Karen Kirsch
Jim Root
CLIENT:
Penfield Children's Center
MEDIUM: Oil

P. 207
ART DIRECTOR: Jim Burke
CLIENT: Dellas Graphics
MEDIUM: Oil

P. 208
ART DIRECTOR:
Justin Keller
CLIENT: SouthWest Gas
MEDIUM: Graphite, oil

P. 395
MEDIUM: Oil on panel

SCOTT CAMPBELL
533 E. 5th St. #21
New York, NY 10009
415-215-9101
Scottlava@gmail.com
Scott-c.blogspot.com

P. 459
ART DIRECTOR:
Nicholas Gazin
CLIENT: Vice Magazine
MEDIUM: Pen, digital

HARRY CAMPBELL
6302 Pinehurst Rd.
Baltimore, MD 21212
410-371-0270
harry@harrycampbell.net
www.harrycampbell.net

P. 66
ART DIRECTOR:
Domenica Genovese
CLIENT: Johns Hopkins
MEDIUM: Digital

P. 209
ART DIRECTOR:
Katie Burk
CLIENT: NPR
MEDIUM: Digital

P. 398
MEDIUM: Digital

P. 399
MEDIUM: Digital

Q. CASSETTI
Two Camp St.
Trumansburg, NY 14886
607-387-5424
q@theluckystone.com
www.qcassetti.com

P. 210
ART DIRECTOR:
Robert Cassetti
CLIENT:
Corning Museum of Glass
MEDIUM: Digital

MARCOS CHIN
16 Manhattan Ave. #4H
Brooklyn, NY 11206
646-416-0936
marcos@marcoschin.com
ww.marcoschin.com

P. 144

JOAN CHIVERTON
203 W. 90th St. #5B
New York, NY 10024
917-494-1110
joan@joanchiverton.com
www.joanchiverton.com

P. 212
ART DIRECTOR: Julie Levin
CLIENT:
Society of Illustrators
MEDIUM: Pen & ink

P. 213
ART DIRECTOR:
Julie Levin
CLIENT:
Society of Illustrators
MEDIUM: Pen & ink

JOSEPH CIARDIELLO
35 Little York, Mt. Pleasant Rd.
Milford, NJ 08848
908-996-4392
joe@joeciardiello.com
www.joeciardiello.com

P. 67
ART DIRECTOR:
Nicholas Blechman
CLIENT: The New York
Times Book Review
MEDIUM: Pen & ink

P. 211
ART DIRECTOR:
Ellen Nygaard
CLIENT:
Rock & Roll Hall of Fame
MEDIUM: Pen, watercolor

P. 400
MEDIUM: Pen, watercolor

GREG CLARKE
214 Twin Falls Court
Newbury, CA 91320
805-499-8823
greg@gregclarke.com
www.gregclarke.com

P. 401

SILVER
P. 454
ART DIRECTOR:
Monte Beauchamp
CLIENT: BLAB!
MEDIUM: Ink, watercolor

DAN CLOWES
The New Yorker
4 Times Square
New York, NY 10036

P. 70
Art Director of Covers:
Françoise Mouly
CLIENT: The New Yorker
MEDIUM: India ink,
colored in Illustrator

JOSH COCHRAN
61 Greenpoint Ave. #515
Brooklyn, NY 11222
626-354-7407
mail@joshcochran.net
www.joshcochran.net

P. 145

P. 214
ART DIRECTOR:
Jennifer Lee
CLIENT: VSA Partners
MEDIUM: Digital

P. 292
ART DIRECTOR:
Lauren Rille
CLIENT:
Sterling Publishing
MEDIUM: Digital

FERNANDA COHEN
917-673-3447
info@fernandacohen.com
www.fernadacohen.com

P. 146
CLIENT: The Gap
MEDIUM: Ink, marker

TIMOTHY COOK
10701 Drumm Ave.
Kensington, MD 20895
301-949-5002
tim@timothycook.com
www.timothycook.com

P. 147
CLIENT: Teen Tones
MEDIUM: Ink, relief print,
digital collage

P. 215
ART DIRECTOR:
Sandra Dionisi
CLIENT:
The Bepo + Mimi Project
MEDIUM: Ink, relief print,
digital collage

JOHN CUNEO
69 Speare Rd.
Woodstock, NY 12498
845-679-7973
john@johncuneo.com
www.johncuneo.com

SILVER
P. 47
ART DIRECTOR:
David Curcurito
CLIENT: Esquire
MEDIUM: Ink, watercolor

P. 68
ART DIRECTOR:
David Curcurito
CLIENT: Esquire
MEDIUM: Ink, watercolor

P. 402
MEDIUM: Inks, watercolor

P. 403
MEDIUM: Roller ball pen,
whiteout, watercolor

HUGH D'ANDRADE
Mati McDonough
2498 Harrison St.
San Francisco, CA 94110
415-513-3444
hugh@hughillustration.com
www.hughillustration.com
www.Matirose.com

P. 148
ART DIRECTOR:
Renee Harcourt
CLIENT: Blame Sally
MEDIUM: Digital

ANDREA D'AQUINO
75 Bank St. #5J
New York, NY 10014
212-741-7487
andreadaquino@mac.com
www.andreadaquino.com

P. 460
MEDIUM:
Paint, collage, digital

CHRISTOPHER DARLING
500 Riverside Dr.
New York, NY 10027
269-599-9216
mail@christopherdarling.com
www.christopherdarling.com

P. 216
ART DIRECTOR:
Marshall Arisman
CLIENT:
School of Visual Arts
MEDIUM: Acrylic, ink,
pencil, tracing paper,
digital color

OLIVIER DAUMAS
c/o Wilkinson Studios
1121 E. Main St. #310
St. Charles, IL 60174
630-549-0504
chris@wilkinsonstudios.com
http://www.wilkinsonstudios.com

P. 294
CLIENT: Scarabèa Edition
MEDIUM: Acrylic on
canvas, collage, digital

P. 295
CLIENT: Scarabèa Edition
MEDIUM: Acrylic on
canvas, collage, digital

GIANNI DE CONNO
c/o Marlena Agency
322 Ewing Street
Princeton, NJ 08540
609-252-9405
marlena@marlenaagency.com
www.marlenaagency.com

P. 293

ROGER DE MUTH
59 Chenango St.
Cazenovia, NY 13035
315-655-8599
rdemuth@syr.edu
www.demuthdesign.com

P. 217
ART DIRECTOR:
Naomi De Muth
CLIENT:
Chameleon Gallery
MEDIUM:
Ink, watercolor, digital

PETER DE SÈVE
25 Park Place
Brooklyn, NY 11217
718-398-8099
peter.deseve@verizon.net
www.peterdeseve.com

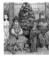
P. 218
Art Directors:
Arnold Fenner
Cathy Fenner
CLIENT: Spectrum
MEDIUM: Watercolor, ink

P. 298
MEDIUM: Watercolor, ink

MICHAEL DEAS
c/o William Gicker
New Orleans, LA
www.michaeldeas.com

P. 219
ART DIRECTOR:
Carl T. Herman
CLIENT:
U.S. Postal Service

ANDREW DEGRAFF
471 Vanderbilt Ave. #2B
Brooklyn, NY 11238
718-408-0881
andrewdegraff@andrewdegraff.com
www.andrewdegraff.com

P. 404
MEDIUM: Gouache

P. 405
MEDIUM: Gouache

ETIENNE DELESSERT
PO Box 1689
#5 Lakeview Ave.
Lakeville, CT 06039
860-435-0061
edelessert@snet.net
www.etiennedelessert.com

P. 296
ART DIRECTOR:
Rita Marshall
CLIENT:
Delessert & Marshall
MEDIUM:
Watercolor, pencils

P. 297

BIL DONOVAN
58 St. Marks Place
New York, NY 10003
212-228-3754
dukedonovan@earthlink.net
www.bildonovan.com

P. 220
ART DIRECTOR:
Amanda Baldwin
CLIENT:
Christian Dior Beauty
MEDIUM: Ink, digital

RICHARD DOWNS
15394 Wet Hill Rd.
Nevada City, CA 95959
530-470-0435
r_downs@sbcglobal.net
www.downs-art.com

P. 71
ART DIRECTOR:
SooJin Buzelli
CLIENT: Plansponsor
MEDIUM: Monotype

P. 406
MEDIUM: Monotype

P. 407
MEDIUM: Monotype

P. 408
MEDIUM: Monotype

P. 409
MEDIUM: Monotype

SVEN SMITAL EBOY
Der Spiegel Magazine
104 West 70th St. #PH4
New York, NY 10023

P. 72
ART DIRECTOR:
Stefan Kiefer
CLIENT: Der Spiegel
MEDIUM: Digital

GÜRBÜZ DOĞAN EKŞIOĞLU
Osman Zeki Ungor Sk.
1/14 Moda 34710, Turkey
+90 216-345 3367
gdeksi@gmail.com
www.gurbuz-de.com

P. 73
Art Director of Covers:
Françoise Mouly
CLIENT: The New Yorker
MEDIUM:
Color ink, airbrush

DAVID ERCOLINI
461 Sackett St. #2
Brooklyn, NY 11231
508-801-6878
davidercolini@gmail.com
www.davidercolini.com

P. 410
MEDIUM: Mixed, digital

LEO ESPINOSA
11 Wright St.
Cambridge, MA 02138
617-441-7773
leo@studioespinosa.com
www.studioespinosa.com

SILVER
P. 136
ART DIRECTOR:
Shad Petosky
CLIENT:
Pink Hobo Gallery
MEDIUM: Digital on
sculpted paper

P. 221
ART DIRECTOR:
Juan Marin
CLIENT: La Guaka
MEDIUM: Digital

P. 222
ART DIRECTOR:
Klim Kozinevich
CLIENT: Bigshot Toyworks
MEDIUM:
Acrylics on wood

BRECHT EVENS
c/o Magnet Reps
1783 S. Crescent Heights Blvd.
Los Angeles, CA 90035
866-390-5656
art@magnetreps.com
www.magnetreps.com

P. 411
MEDIUM:
Ecoline, gouache

P. 461
MEDIUM:
Ecoline, gouache

JEFFREY FISHER
c/o Riley Illustration
PO Box 92
New Paltz NY 12561
845-255-3309
teresa@rileyillustration.com
www.rileyillustration.com

P. 299
ART DIRECTOR:
Gretchen Scoble
CLIENT: Chronicle Books
MEDIUM: Acrylic

DAVID FLAHERTY
475 FDR Dr. #2107 L
New York, NY 10002
212-529-3151
david@artarea.com
www.artarea.com

P. 149
ART DIRECTOR:
Jamie Berger
CLIENT: The Cranky
Pressman Printers
MEDIUM:
Digital, letterpress

P. 300
ART DIRECTOR:
David Flaherty
CLIENT: The Fuchs Book
MEDIUM: Digital

VIVIENNE FLESHER
630 Pennsylvania Ave.
San Francisco, CA 94107
415-648-3794
vivienne@warddraw.com
www.warddraw.com

P. 74
ART DIRECTOR:
Hansen Smith
CLIENT: LA Times
MEDIUM: Mixed

P. 75
ART DIRECTOR:
Leanne Shapton
CLIENT:
The New York Times
MEDIUM: Mixed

GILBERT FORD
61 Greenpoint Ave. #400
Brooklyn, NY 11222
347-452-4098
info@gilbertford.com
www.gilbertford.com

P. 150
ART DIRECTOR:
Katie Burk
CLIENT: NPR
MEDIUM:
Mixed, digital

SARAJO FRIEDEN
1910 N. Serrano Ave.
Los Angeles, CA 90027
323-462-5045
sarajo@sarajofrieden.com
www.sarajofrieden.com

P. 223
CLIENT:
Home+Human
Fashion LTD
MEDIUM:
Gouache, cut paper

CHRIS GALL
4421 N. Camino del Santo
Tucson, AZ 85718
520-299-4454
chris@chrisgall.com
www.chrisgall.com

P. 226
ART DIRECTOR:
Sandra Bloodworth
CLIENT:
MTA Arts for Transit
MEDIUM: Digital

TYLER GARRISON
34-20 32nd st. #5c
Astoria, NY 1106
205-529-3922
tyler@fizzlepopstudio.com
www.fizzlepopstudio.com

P. 301
ART DIRECTOR:
Gavin Brammall
CLIENT: The Guardian
MEDIUM: Digital

LASSEN GHIUSELEV
Kniaz Boris 58
Sofia 1463, Bulgaria
359 2 852 46 31
mail@iassen.com
www.iassen.com

P. 302
ART DIRECTOR:
Dimiter Savoff
CLIENT:
Simply Read Books
MEDIUM: Gouache,
digital watercolor

BEPPE GIACOBBE
Via Leone Pancaldo, 6
Milano 20129, Italy
+39 258-303-031
bgiacobbe@me.com
www.beppegiacobbe.com

P. 80
CLIENT:
Corriere della sera
MEDIUM: Digital

P. 412

BEN GIBSON
911 Union St. #3
Brooklyn, NY 11215
646-335-5962
ben@ben-gibson.com
www.ben-gibson.com

P. 303
ART DIRECTOR:
Sean McDonald
CLIENT:
Riverhead Books
MEDIUM:
Mixed, digital

MICHAEL GLENWOOD
2344 N. Taylor St.
Arlington, VA 22207
888-818-9811
michael@mglenwood.com
www.mglenwood.com

P. 151
ART DIRECTOR:
Thomas Grillo
CLIENT:
American Express
MEDIUM: Digital

P. 224
ART DIRECTOR:
Gary Callahan
CLIENT: Boston
Consulting Group
MEDIUM: Digital

P. 225
ART DIRECTOR:
Erin Ouslander
CLIENT:
University of Maryland
MEDIUM: Digital

ALESSANDRO GOTTARDO
Arto Design
Via Stradella 13
Milan 20129, Italy
+39 335-704-9862
conceptualillustration@gmail.com
http://illoz.com/shout/

P. 76
ART DIRECTOR:
Christine Carr
CLIENT:
The New Republic
MEDIUM: Digital

P. 77
ART DIRECTOR:
Gina Toole
CLIENT: AARP
Segunda Juventud
MEDIUM: Digital

P. 78
ART DIRECTOR:
Nicholas Blechman
CLIENT: The New York
Times Book Review
MEDIUM: Digital

P. 79
ART DIRECTOR:
Cathy Gilmore Barnes
CLIENT:
The New York Times
MEDIUM: Digital

P. 152
ART DIRECTOR:
Antonella Bandoli
CLIENT: Seac
MEDIUM: Digital

P. 153
ART DIRECTOR:
Alessandro Gottardo
CLIENT: Brema
MEDIUM: Digital

P. 304
ART DIRECTOR:
Riccardo Falcinelli
CLIENT:
Minimum Fax Edition
MEDIUM: Digital

P. 305
ART DIRECTOR:
Riccardo Falcinelli
CLIENT: Minimum Fax
MEDIUM: Digital

ALEXA GRACE
Old Manor Farm
5791 Route 209
Kerhonkson, NY 12446
917-678-5957
ARTxfacts@aol.com
alexagrace.com

P. 413
MEDIUM:
Collage: paper, wire,
thread

JEANNE GRECO
c/o William Gicker
New York, NY 10012
www.caffegrecodesign.com

P. 227
ART DIRECTOR:
Derry Noyes
CLIENT:
U.S. Postal Service

PETER HAMLIN
508 3rd St. #1
Brooklyn, NY 11215
347-385-4508
phamlin@hambot.com

P. 414
MEDIUM: Silkscreen

TOMER HANUKA
156 2nd Ave. #5F
New York, NY 10003
917-749-6267
tomer@thanuka.com
www.thanuka.com

P. 154
ART DIRECTOR:
Col McBryde
CLIENT: Some Young
Punks Wine Makers
MEDIUM: Mixed

P. 309
ART DIRECTOR:
Roseanne Serra
CLIENT:
Penguin Books
MEDIUM: Mixed

P. 415
MEDIUM: Mixed

ANTONY HARE
844 Dufferin Ave.
London N5W 3K1, Canada
226-688-6082
antony@siteway.com
www.siteway.com

P. 416
MEDIUM: Vector art

HENNIE HAWORTH
c/o Magnet Reps
1783 S. Crescent Heights Blvd.
Los Angeles, CA 90035
866-390-5656
art@magnetreps.com
www.magnetreps.com

P. 155
ART DIRECTOR:
Katy Elliot,
The Art Group
CLIENT: Habitat
MEDIUM: Mixed

JOHN HENDRIX
1145 Ursula Ave.
St. Louis, MO 63130
314-802-7326
mail@johnhendrix.com
www.johnhendrix.com

P. 228
ART DIRECTOR:
Karin Soukup
CLIENT:
AIGA St. Louis
MEDIUM: Acetone
transfer, rubber
stamps, block
printing ink

P. 306
ART DIRECTOR:
Matthew Lenning
CLIENT:
American Illustration
MEDIUM: Pen & ink

P. 307

P. 308
ART DIRECTOR:
Chad Beckerman
CLIENT:
Abrams Books for
Young Readers
MEDIUM: Pen & ink,
acrylic washes

JOYCE HESSELBERTH
3504 Ash St.
Baltimore, MD 21211
410-235-7803
contact@spurdesign.com
joycehesselberth.com

P. 417
MEDIUM: Digital

JODY HEWGILL
260 Brunswick Ave.
Toronto M5S 2M7, Canada
416-924-4200
jody@jodyhewgill.com
www.jodyhewgill.com

P. 156

P. 229
ART DIRECTOR:
Greg Coleman
CLIENT:
Manhattan Theatre
Club/Winter Benefit
MEDIUM: Acrylic on
gessoed board

JAKOB HINRICHS
Friedelstr. 40
Berlin 12047, Germany
+49 176-9636-5532
mail@jakobhinrichs.com
www.jakobhinrichs.com

P. 81
ART DIRECTOR:
Martin Colyer
CLIENT:
Reader's Digest UK

JESSICA HISCHE
c/o Frank Sturges
142 W. Winter St.
Delaware, OH 43015
740-369-9702
frank@sturgesreps.com
www.sturgesreps.com

P. 310
ART DIRECTOR:
Alice Laurent
CLIENT: Hodder &
Stoughton UK
MEDIUM: Digital

P. 311
ART DIRECTOR:
Jennifer Wang
CLIENT: Penguin
MEDIUM: Digital

P. 418

BRAD HOLLAND
96 Greene St.
New York, NY 10012
212-226-3675
brad-holland@rcn.com
www.bradholland.net

P. 84
ART DIRECTOR:
Irene Gallo
CLIENT:
Tor Online Magazine
MEDIUM:
Acrylic on board

P. 157
ART DIRECTOR:
Brad Holland
CLIENT:
Harrah's Entertain-
ment, Rio Casino
MEDIUM:
Acrylic on board

P. 230
ART DIRECTOR:
Dennis Benoit
CLIENT:
Entergy Corporation
MEDIUM:
Acrylic on board

P. 312
ART DIRECTOR:
Isabel Warren Lynch
CLIENT:
Random House
MEDIUM:
Acrylic on board

JEREMY HOLMES
616 Roberts Ave.
Glenside, PA 19038
215-533-6971
jholmes@muttink.com

P. 313
ART DIRECTOR:
Kristine Brogno
CLIENT:
Chronicle Books
MEDIUM:
Digital collage

STERLING HUNDLEY
14361 Old Bond St.
Chesterfield, VA 23832
sterling@sterlinghundley.com
www.sterlinghundley.com

P. 158

JORDIN ISIP
PO Box 320638
West Roxbury, MA 02132
631-525-2309
jordin@jordinisip.com
www.scottbakal.com

P. 85
ART DIRECTOR:
Christine Silver
CLIENT:
Business Week
MEDIUM:
Mixed, on panel

P. 419
MEDIUM:
Mixed, on panel

HIROMICHI ITO
Pen Still Writes 3-6-8 3rd Fl. Takaban
Meguro-Ku, Tokyo 152-0004, Japan
81-3-3710-5634
hello@hiromichiito.com

P. 314
ART DIRECTOR:
Jiromaru
CLIENT: Nihon Jido
Bungakusha Kyokai
MEDIUM: Oil

P. 315
ART DIRECTOR: Tomo-
ko Fujita
CLIENT: Kadokawa
Haruki Jimusho
MEDIUM: Digital

P. 316

P. 317

P. 318

MARTIN JARRIE
c/o Marlena Agency
322 Ewing St.
Princeton, NJ 08540
609-252-9405
marlena@marlenaagency.com
www.marlenaagency.com

P. 231
ART DIRECTOR:
Antoine Lopez
CLIENT: Festival du
Court Metrage de
Clermont Ferrand
MEDIUM: Oil

P. 319
ART DIRECTOR:
Vincent Etienne
CLIENT: Didier
Jeunesse Publisher
MEDIUM: Oil

ERIK T. JOHNSON
PO Box 582061
Minneapolis, MN 55458-2061
612-743-1989
erik@erikjohnson.us

P. 462
ART DIRECTOR:
Erik T. Johnson
CLIENT: Edward
McGowen
MEDIUM: Split
fountain silk screen

VICTOR JUHASZ
515 Horse Heaven Rd.
Averill Park, NY 12018
518-794-0881
juhasz@taconic.net
www.victorjuhasz.com

SILVER

P. 48
ART DIRECTOR:
Steven Charny
CLIENT: Rolling Stone
MEDIUM:
Pen, ink, watercolor

P. 86
ART DIRECTOR:
Steven Charny
CLIENT: Rolling Stone
MEDIUM:
Pen, ink, watercolor

P. 87
ART DIRECTOR:
Steven Charny
CLIENT: Rolling Stone
MEDIUM:
Pen, ink, watercolor

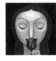

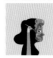
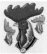

TIM O'BRIEN
310 Marlborough Rd.
Brooklyn, NY 11226
718-282-2821
tonka1964@aol.com
www.obrienillustration.com

P. 102
ART DIRECTOR:
Kory Kennedy
CLIENT:
Runner's World
MEDIUM: Oil on panel

P. 248
ART DIRECTOR:
Felix Sockwell
MEDIUM:
Oil on panel, digital

P. 344

P. 432
MEDIUM: Oil on panel

ANDREA OFFERMANN
Horner Weg 199
Hamburg 22111, Germany
+49 170 819 4243
andreaoffermann@gmail.com
www.andreaoffermann.com

P. 469
ART DIRECTOR:
Kazu Kibuishi
CLIENT:
Flight Comics,
Villard Publishing
MEDIUM: Pen & ink,
acrylic, digital

NANCY OHANIAN
250 Night Hawk Circle
West Deptford, NJ 08086
856-384-2774
ohanian@rowan.edu
www.nancyohanian.com

P. 103
ART DIRECTOR:
Nancy Ohanian
CLIENT: Trouble
Media Services
MEDIUM: Digital

ZACHARIAH OHORA
225 Dudley Ave.
Narberth, PA19072
347-204-5211
zach@zohora.com
www.zohora.com

P. 172
CLIENT:
Monsters of Folk
MEDIUM: Silkscreen

P. 249
ART DIRECTOR:
Mitch Nash
CLIENT: BlueQ
MEDIUM:
Acrylic on wood

P. 345
ART DIRECTOR:
Patrick Collins
CLIENT:
Henry Holt Books for
Young Readers
MEDIUM: Acrylic on
Stonehenge paper

KEN ORVIDAS
16724 NE 138th Court
Woodinville, WA 98072
425-867-3072
ken@orvidas.com
www.orvidas.com

P. 104
ART DIRECTOR:
Alex Spiro
CLIENT: NoBrow
Illustration Journal
MEDIUM: Digital

NAOKO OSHIMA
4500 Broadway #6C
New York, NY 10040
646-436-2276
n.oshima99@gmail.com
www.naokooshima.com

P. 346
ART DIRECTOR:
Azita Shahidi
CLIENT: Tuti Design
MEDIUM:
Watercolor, collage

JOHN JUDE PALENCAR
3435 Hamlin Rd.
Medina, OH 44256
330-725-5292
ninestandingstones@yahoo.com

P. 347
ART DIRECTOR:
Irene Gallo
CLIENT: Tor Books
MEDIUM: Acrylic

P. 348
ART DIRECTOR:
Irene Gallo
CLIENT: Tor Books
MEDIUM: Acrylic

SUNGKYUNG PARK
318 N. Harrison St. #4
Richmond, VA 23220
804-878-2080
parkillustration@gmail.com

P. 433

CURTIS PARKER
1946 E. Palomino Dr.
Tempe, AZ 85284
480-820-6015
cparker@curtisparker.com
www.curtisparker.com

P. 105
ART DIRECTOR:
Lisa Sergi
CLIENT:
Brown University
MEDIUM:
Acrylic on canvas

P. 106
ART DIRECTOR:
Carol Kaufman
CLIENT: LA Times
Book Review
MEDIUM:
Acrylic on canvas

SILVER
P. 137
ART DIRECTOR:
Jeff Stammen
CLIENT: Tampa Bay
History Center
MEDIUM:
Acrylic on canvas

P. 174
CLIENT:
Scott Hull Associates
MEDIUM:
Acrylic on canvas

P. 175
ART DIRECTOR:
Jay Jung
CLIENT: Triad Stage
MEDIUM:
Acrylic on canvas

P. 176
ART DIRECTOR:
Art Lofgreen
CLIENT: City of Mesa
MEDIUM:
Acrylic on canvas

P. 349
ART DIRECTOR:
Marci Senders
CLIENT:
Random House
MEDIUM:
Acrylic on canvas

PHILIPPE PETIT-ROULET
c/o Riley Illustration
PO Box 92
New Paltz, NY 12561
teresa@rileyillustration.com
www.rileyillustration.com

P. 470
Illustration Editor:
Christine Curry
CLIENT:
The New Yorker
MEDIUM: Pen & ink

LORENZO PETRANTONI
c/o Marlena Agency
322 Ewing Street
Princeton, NJ 08540
609-252-9405
marlena@marlenaagency.com
www.marlenaagency.com

P. 173

VALERIA PETRONE
Via altaguardia 15
Milano 20135, Italy
+39 02-583-0777-1
valeria@valeriapetrone.com
www.valeriapetrone.com

P. 350

P. 351
CLIENT:
Edizioni El Mondadori
MEDIUM: Digital

P. 434
CLIENT:
Edizioni El Mondadori
MEDIUM: Digital

HANOCH PIVEN
Asturies 16, 2-2 ext.
Barcelona 08012, Spain
054-463-5438
hanoch@pivenworld.com
www.pivenworld.com

P. 107
ART DIRECTOR:
Bryan Erickson
CLIENT:
FP Foreign Policy
MEDIUM: Collage

P. 108
ART DIRECTOR:
Chrissy Dunleavy
CLIENT: TIME
MEDIUM: Collage

P. 109
ART DIRECTOR:
David McKendrick
CLIENT: Esquire UK
MEDIUM: Collage

DAVID PLUNKERT
3504 Ash St.
Baltimore, MD 21211
410-235-7803
info@spurdesign.com
www.spurdesign.com

P. 177
CLIENT:
Maryland Institute
College of Art
MEDIUM: digital

P. 178
CLIENT:
Maryland Institute
College of Art
MEDIUM: Digital

P. 471
CLIENT: Anne Fulwiler
MEDIUM: Digital

EMILIANO PONZI
c/o Magnet Reps
1783 S. Crescent Heights Blvd.
Los Angeles, CA 90035
866-390-5656
art@magnetreps.com
www.magnetreps.com

P. 110
ART DIRECTOR:
Beth Broadwater
CLIENT:
Washington Post
MEDIUM: Digital

P. 111
Art Directors: Angela
Carpenter Gildner
David Herbick
CLIENT: Currents
MEDIUM: Digital

P. 352
ART DIRECTOR:
Alessandra Graziani
CLIENT: Zines
MEDIUM: Digital

P. 353
ART DIRECTOR:
Alessandra Graziani
CLIENT: Zines
MEDIUM: Digital

P. 354
ART DIRECTOR:
Christiano Guerri
CLIENT: Feltrinelli
MEDIUM: Digital

P. 355
ART DIRECTOR:
Lucia Kim
CLIENT: Plume
MEDIUM: Digital

P. 472
ART DIRECTOR:
Fabio Novembre
CLIENT: Electa
MEDIUM: Digital

GARRETT PRUTER

P. 435
MEDIUM: Collage,
graphite, ink, acrylic

PETER RA
39 Webb St.
Melbourne, Coburg 3058, Australia
011-61-3-9354-7026
plexus6@iinet.net.au

P. 436
MEDIUM: Digital

RED NOSE STUDIO
c/o Magnet Reps
1783 S. Crescent Heights Blvd.
Los Angeles, CA 90035
(866) 390-5656
art@magnetreps.com
www.magnetreps.com

P. 358
Art Directors:
Anne Schwartz
Lee Wade
CLIENT:
Schwartz & Wade
MEDIUM: 3D

MELANIE REIM
214 Riverside Dr. #601
New York, NY 10025
212-749-0177
melanie_reim@nyc.rr.com
wwww.melaniereim.com

P. 250
CLIENT:
Fashion Inst. of Tech.,
Pamela Ellsworth
MEDIUM:
Pen & ink, digital

P. 251
CLIENT:
Fashion Inst. of Tech.
Pamela Ellsworth
MEDIUM: Pen & ink

JON REINFURT
413 Hoffman St.
Philadelphia, PA 19148
973-271-9608
jon@reinfurt.com
www.reinfurt.com

P. 112
ART DIRECTOR:
Carrie S. Campbell
CLIENT:
Charlotte Magazine
MEDIUM: Mixed

P. 437
MEDIUM: Mixed

EDEL RODRIGUEZ
16 Ridgewood Ave., PO Box 102
Mt. Tabor, NJ 07878
973-983-7776
edelrodriguez@aol.com

P. 113
ART DIRECTOR:
Bryan Erickson
CLIENT:
Liberty Magazine

P. 180

P. 181

P. 182

P. 252
ART DIRECTOR:
Jim Burke
CLIENT:
Dellas Graphics
MEDIUM:
Acrylic, ink on paper

P. 253
ART DIRECTOR:
Annie Mack
CLIENT:
The Vancouver Opera
MEDIUM:
Acrylic, ink on paper

P. 356
ART DIRECTOR:
Helen Yentus
CLIENT:
Random House
MEDIUM:
Acrylic, ink on paper

P. 357

PAUL ROGERS
12 S. Fair Oaks Ave. #208
Pasadena, CA 91105
626-564-8728
paulrogers@attglobal.net
www.paulrogersstudio.com

P. 179

P. 254
ART DIRECTOR:
Howard E. Paine
CLIENT:
U.S. Postal Service

JUNGYEON ROH
165 E.. 89th St. #2C
New York, NY 10128
646-896-4600
jungyeon@jungyeonroh.com
www.jungyeonroh.com

SILVER
P. 455
ART DIRECTOR:
David Sandlin
MEDIUM: Silkscreen

P. 473
ART DIRECTOR:
Tomer Hanuka
MEDIUM: Silkscreen

CATELL RONCA
c/o Magnet Reps
1783 S. Crescent Heights Blvd.
Los Angeles, CA 90035
866-390-5656
art@magnetreps.com
www.magnetreps.com

P. 359
ART DIRECTOR:
Steve Marking
CLIENT:
Orion Books UK
MEDIUM:
Gouache, digital

MARC ROSENTHAL
39 Cliffwood St.
Lenox, MA 01240
413-446-7831
vze2c9cu@verizon.net
www.marc-rosenthal.com

P. 114
ART DIRECTOR:
Heather Hartshorn
CLIENT: hk Design
MEDIUM: Ink, digital

JIM RUGG
113 Amherst Pl.
Glenshaw, PA 15116
412-213-0242
jimrugg@hotmail.com
www.jimrugg.com

P. 360
ART DIRECTOR:
Chris Pitzer
CLIENT:
Adhouse Books
MEDIUM:
Pen & ink, digital

GUIDO SCARABOTTOLO
Via Custodi 16
Milano 20136, Italy
+39 025-810-2263
guido@scarabottolo.com
www.scarabottolo.com

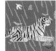
P. 255
ART DIRECTOR:
Guido Scarabottolo
CLIENT:
Cherry Terrace Tokyo
MEDIUM:
Brush, digital

SILVER
P. 274
ART DIRECTOR:
Guido Scarabottolo
CLIENT:
Guanda Publishing
MEDIUM:
Pencil, computer

P. 361
ART DIRECTOR:
Guido Scarabottolo
CLIENT:
Guanda Publishing
MEDIUM:
Pencil, computer

P. 362
ART DIRECTOR:
Giudo Scarabottolo
CLIENT:
Guanda Publishing
MEDIUM:
Pencil, computer

P. 363
ART DIRECTOR:
Guido Scarabottolo
CLIENT:
Guanda Publishing
MEDIUM:
Pencil, computer

WARD SCHUMAKER
630 Pennsylvania Ave.
San Francisco, CA 94107-2916
415-648-8058
ward@warddraw.com
www.warddraw.com

P. 364
CLIENT: San Francisco
Center for the Book
MEDIUM: Ink on
paper, Photoshop

P. 365
CLIENT: San Francisco
Center for the Book
MEDIUM: Ink on
paper, Photoshop

ERIC SEAT
1206 Sunset Dr.
Columbia, MO 65203
703-727-5372
ericseat@gmail.com

P. 366
ART DIRECTOR:
György Tibor Szántó
CLIENT: Maecenas
Publishing House
MEDIUM: Mixed

JASON SEILER
c/o Richard Solomon Artists
Representative
149 Madison Ave. #708
New York, NY 10016-6713
212-223-9545
richard@richardsolomon.com
www.richardsolomon.com

P. 118
ART DIRECTOR:
Philip Chalk
CLIENT:
The Weekly Standard
MEDIUM: Digital

P. 438
MEDIUM: Digital

YUKO SHIMIZU
Shy Studio
225 W. 36th St. #502
New York, NY 10018
917-379-2636
yuko@yukoart.com
www.yukoart.com

P. 115
ART DIRECTOR:
SooJin Buzelli
CLIENT:
Asset International
MEDIUM:
Drawing, digital color

P. 116
ART DIRECTOR:
SooJin Buzelli
CLIENT:
Asset International
MEDIUM:
Drawing, digital color

P. 117
ART DIRECTOR:
Antje Klein
CLIENT:
Der Spiegel Special
MEDIUM:
Drawing, digital color

P. 184
ART DIRECTOR:
Jonathan Sellers
CLIENT: The Word
MEDIUM:
Drawing, digital color

P. 185
ART DIRECTOR:
Jonathan Sellers
CLIENT: The Word
MEDIUM:
Drawing, digital color

GOLD
P. 271
Art Directors:
Albert Tang
Rodrigo Corral
CLIENT: W.W. Norton
MEDIUM:
Drawing, digital color

P. 368
Art Directors:
Karen Berger
Pornsak Pichetshote
CLIENT:
DC Comics Vertigo
MEDIUM:
Drawing, digital color

P. 369
Art Directors:
Karen Berger
Pornsak Pichetshote
CLIENT:
DC Comics Vertigo
MEDIUM:
Drawing, digital color

SIMONE SHIN
PO Box 1084
South Pasadena, CA 91031
626-755-7420
sjaeshin@yahoo.com
www.simoneshin.com

P. 439
MEDIUM:
Silkscreen, acrylic,
digital

GENEVIEVE SIMMS
9604 74 Ave. NW
Edmonton T6E 1E6, Canada
780-436-1374
genevieve.simms@gmail.com
www.genevievesimms.com

P. 119
ART DIRECTOR:
Danae Thompson
CLIENT: The Calgary
Herald, Swerve
Magazine
MEDIUM: Acrylic

CHERIE SINNEN
2217 Canyon Dr.
Los Angeles, CA 90068
323-463-6291
cherie@cheriesinnen.com
www.cheriesinnen.com

P. 256
ART DIRECTOR:
Cherie Sinnen
CLIENT: Julia Rivera
MEDIUM:
Acrylic, digital

MICHAEL SLOAN
203-887-1243
michaelsloan@earthlink.net
www.michaelsloan.net

P. 257
ART DIRECTOR:
Sandra Dionisi
CLIENT:
The Bepo + Mimi
Project
MEDIUM:
Brush, ink, digital

SILVER
P. 388
MEDIUM:
Brush, ink, digital

P. 440
MEDIUM:
Brush, ink, digital

OWEN SMITH
1608 Fernside Blvd.
Alameda, CA 94501
510-865-1911
owensmithart@att.net

P. 120
ART DIRECTOR:
Max Bode
CLIENT:
The New Yorker
MEDIUM:
Oil on board

LAURA SMITH
6545 Cahuenga Terrace
Hollywood, CA 90068
323-467-1700
Laura@LauraSmithArt.com
http://LauraSmithArt.com

P. 258
Art Directors:
Jonathan Fisher
Dann Snapp
CLIENT: BrandExtract
MEDIUM: Acrylic

DOUGLAS SMITH
c/o Richard Solomon Artists
Representative
149 Madison Ave. #708
New York, NY 10016
212-223-9545
richard@richardsolomon.com
http://www.richardsolomon.com/
P. 367

RICH TU
973-868-9342
richtu@richtu.com
www.richtu.com

P. 477
CLIENT: Carrier Pigeon
Anthology
MEDIUM: Ink, brush,
pen, digital

P. 478
MEDIUM: Ink, brush,
pen, digital

JONATHAN TWINGLEY
615 W. 172nd St. #53
New York, NY 10032
917-613-2144
twingley@verizon.net
www.twingley.com

P. 372
CLIENT: Scribner
MEDIUM:
Acrylic on paper

P. 373
CLIENT: Scribner
MEDIUM:
Acrylic on canvas

P. 374
CLIENT: Scribner
MEDIUM:
Acrylic on canvas

P. 375
CLIENT: Scribner
MEDIUM:
Acrylic on canvas

MARK ULRIKSEN
841 Shrader St.
San Francisco, CA 94117
415-387-0170
mark@markulriksen.com
www.markulriksen.com

P. 444
MEDIUM:
Acrylic on board

ANDRÉS VERA MARTÍNEZ
254 Pelton Ave. #2
Staten Island, NY 10310
512-964-5141
andres@andresvera.com
www.andresvera.com

P. 479
ART DIRECTOR:
Carroll Burrell
CLIENT:
Graphic Universe,
Lerner Publishing
Group
MEDIUM: Ink, digital

RAYMOND VERDAGUER
337 E. 9th St. #8
New York, NY 10003
212-674-2953
rv@rverdaguer.com

P. 376

BRUCE WALDMAN
18 Westbrook Rd.
Westfield, NJ 07090
908-232-2840
swgraphics@comcast.net

P. 377
ART DIRECTOR:
Heather Zschock
CLIENT:
Peter Pauper Press
MEDIUM: Monoprint

YAREK WASZUL
61-109 Niagara St.
Toronto M5V 1C3, Canada
416-533-0000
yarek@yarekwaszul.com
yarekwaszul.com

P. 196
ART DIRECTOR:
Dave Dye
CLIENT:
The Economist
MEDIUM: Digital

ESTHER PEARL WATSON
325 N. Adams St.
Sierra Madre, CA 91024
626-836-2210
funchicken@verizon.net
funchicken.com

SILVER
P. 456
ART DIRECTOR:
Eric Reynolds
CLIENT:
Fantagraphics Books
MEDIUM: Ink, digital

SAM WEBER
573 Leonard St. #3
Brooklyn, NY 11222
917-374-3373
sam@sampaints.com
www.sampaints.com

P. 126
ART DIRECTOR:
Brian Morgan
CLIENT: The Walrus
MEDIUM: Watercolor,
acrylic. digital

P. 127
ART DIRECTOR:
Irene Gallo
CLIENT: Tor.com
MEDIUM:
Acrylic, digital

SILVER
P. 138
ART DIRECTOR:
Jim Burke
CLIENT:
Dellas Graphics
MEDIUM: Watercolor,
acrylic, digital

P. 378
ART DIRECTOR:
Roseanne Serra
CLIENT:
Penguin Books
MEDIUM: Watercolor,
acrylic, digital

P. 379
ART DIRECTOR:
Sher Gee
CLIENT:
The Folio Society
MEDIUM: Ink

P. 380
ART DIRECTOR:
Irene Gallo
CLIENT: Tor Books
MEDIUM: Watercolor,
acrylic, digital

P. 381

WEI WEI
c/o Studio J
19 NW 5th Ave.
Portland, OR 97210
503-928-4436
stephen@studioj-pdx.com

P. 261
Art Directors:
John C. Jay
Stephen Giem
CLIENT: Studio J

GORDON WIEBE
c/o Magnet Reps
1783 S. Crescent Heights Blvd.
Los Angeles, CA 90035
866-390-5656
art@magnetreps.com
www.magnetreps.com

P. 445
MEDIUM: Mixed

NATE WILLIAMS
c/o Magnet Reps
1783 S. Crescent Heights Blvd.
Los Angeles, CA 90035
866-390-5656
art@magnetreps.com
www.magnetreps.com

P. 262
ART DIRECTOR:
Carolyn Gavin
CLIENT: Ecojot
MEDIUM: Mixed

LULU WOLF

P. 446
MEDIUM: Watercolor,
collage, pencil

TED WRIGHT
4237 Hansard Ln.
Hillsboro, MO 63050
314-607-9901
twrightart@aol.com
www.tedwright.com

P. 197
ART DIRECTOR:
Frank Steiner
CLIENT:
Miracle Recreational
Equipment Company
MEDIUM:
Pen & ink, digital

JAMES YANG
509 12th St, #2D
Brooklyn, NY 11215
347-721-3666
james@jamesyang.com
www.jamesyang.com

P. 128
ART DIRECTOR:
SooJin Buzelli
CLIENT: Plansponsor
MEDIUM: Digital

P. 263
ART DIRECTOR:
Dave Plunkert
CLIENT: Directory of
Illustration
MEDIUM: Digital

P. 264
ART DIRECTOR:
Cynthia Matthews
CLIENT:
Mudpuppy Design
MEDIUM: Digital

OLIMPIA ZAGNOLI
Viale Coni Zugna 34
Milan 20144, Italy
0039-347-715-4986
olimpia.zagnoli@gmail.com
www.olimpiazagnoli.com

P. 265
ART DIRECTOR:
Pietro Corraini
CLIENT:
Corraini Edizioni
MEDIUM: Digital

P. 447
MEDIUM: Digital

DANIEL ZAKROCZEMSKI
168 Olean St.
East Aurora, NY 14052
716-849-4168
dzakroczemski@buffnews.com

P. 129
ART DIRECTOR:
John Davis
CLIENT:
The Buffalo News
MEDIUM: Digital

Client Index

ART DIRECTORS

PROFESSIONAL STATEMENTS

PARSONS BFA IN ILLUSTRATION

A pioneer in the field of illustration since 1898,
Parsons The New School for Design continues
to set the pace in the world of visual communication.

Illustration by Stella Lee, Class of 2010

More information about the program, including examples of
student work, can be found at www.newschool.edu/illustration

PARSONS THE NEW SCHOOL FOR DESIGN

THEN & NOW

6

Ringling College of Art + Design

Department of Illustration

Destroying the myth of the starving artist.

www.ringling.edu

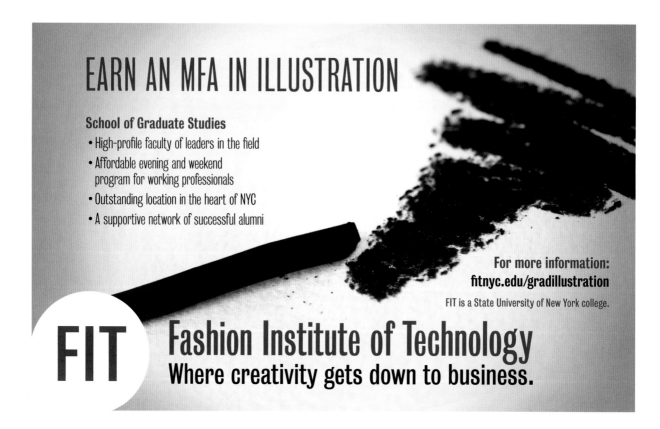

Joseph Adolphe

Brian Ajhar

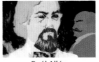
Raúl Allén

Shino Arihara

Stuart Briers

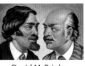
David M. Brinley

Nigel Buchanan

Lonnie Busch

Harry Campbell

Jonathan Carlson

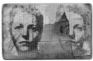
Stephanie Dalton Cowan

Robert de Michiell

John S. Dykes

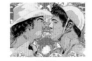
EAMO

Jan Feindt

Matthieu Forichon

Phil Foster

Anthony Freda

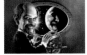
Mark Fredrickson

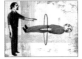
Arthur E. Giron

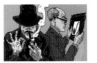
Asaf Hanuka

Peter Horjus

Peter Horvath

Celia Johnson

Douglas B. Jones

Federico Jordán

James Kaczman

J.D. King

Laszlo Kubinyi

Jerome Lagarrigue

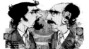
PJ Loughran

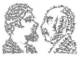
Bernard Maisner

Hal Mayforth

Sean McCabe

Richard Mia

Bruce Morser

Shaw Nielsen

James O'Brien

Yuta Onoda

Dan Page

Cara Petrus

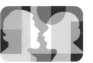
John Pirman

Jean-Francois Podevin

Jon Reinfurt

Rafael Ricoy

Marc Rosenthal

Alison Seiffer

Seth

Whitney Sherman

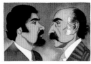
Jeffrey Smith

Ryan Snook

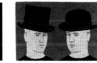
James Steinberg

Sharon Tancredi

Elizabeth Traynor

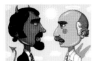
Andy Ward

Anders Wenngren

Michael Witte

Noah Woods

Phil Wrigglesworth

Brad Yeo

GERALD AND CULLEN RAPP

www.rappart.com

420 Lexington Ave Penthouse New York, NY 10170 Ph 212.889.3337 Fx 212.889.3341 info@rappart.com

WE ALL START OFF *LOVING* ART.

WHO CAN FORGET HOW WE LIKED GETTING OUR FINGERS *DIRTY* IN KINDERGARTEN

WITH COLORED *CHALK* OR *CRAYONS* OR POSTER *PAINT*.

WE MUSHED TOGETHER *CLAY* TO MAKE ASHTRAYS FOR OUR PARENTS. WE *PASTED*

TOGETHER POPSICLE STICKS TO MAKE A JEWELRY BOX.

WE *EXPLORED* DRAWING FIGURES: SELF-PORTRAITS, MOM, DAD, SIBLINGS. HOUSES.

TREES. CELEBRATIONS. VACATIONS. *CRUDE* THOUGH THEY WERE THEY HAD

REAL MEANING TO US AND EVEN TODAY LOOKING BACK THEY STILL DO.

THEY ARE *MEMORIES* WE CAPTURED IN OUR OWN UNIQUE WAY.

MOST OF US MOVED AWAY FROM ART AS OUR EDUCATION CONTINUED; SOME BECAME

ENAMORED WITH SCIENCE OR MATH OR HISTORY AND *ART* FADED FROM OUR LIVES.

BUT THERE WERE ALWAYS AT LEAST A COUPLE OF KIDS IN OUR CLASSROOM

THAT SOMEHOW WE KNEW WOULD ALWAYS BE *ARTISTS*.

AND THEY *ARE*, SOME ARE FINE ARTISTS, OTHERS ARE *ILLUSTRATORS* AND A GROWING

NUMBER ARE BOTH. ILLUSTRATORS CAPTURE THE *ESSENCE* OF OUR TIMES

THROUGH *PAINT* OR *PIXEL*. THE STYLE OF OUR TIMES IS EVIDENT

IN THE ILLUSTRATIONS THAT APPEAR IN TODAY'S MAGAZINES, NEWSPAPERS,

BOOKS, BILLBOARDS AND ON SCREENS LARGE AND SMALL.

THEY RECORD EVENTS, PERSONALITIES, IDEAS—POLITICAL OR OTHERWISE, PATHOS,

LOVE, THE ZEITGEIST IN A MUCH *DEEPER* AND MORE *MEANINGFUL* WAY

THAN WE CAN OURSELVES OR THAT AN ORDINARY PHOTOGRAPH PROVIDES.

THE IMAGE IS IMBUED WITH THE *HAND* AND *EYE* OF THE ARTIST,

IT *SPEAKS* TO US IN A TRULY UNIQUE WAY. AND JUST LIKE OUR EARLY CRUDE STICK

FIGURES, IT MAKES A LASTING *IMPRESSION*.

IN THIS ANNUAL AND OUR OWN WE LOOK AT THE *ART* OF ILLUSTRATION TODAY.

AND FORESEE *MEMORIES* OF TOMORROW. ENJOY.

3 x 3

The Magazine of Contemporary Illustration

Our magazine and juried annuals have been recognized countlessss times by The Society of Publication Designers, Applied Arts, Communication Arts and HOW International Design Annual.

WWW.3X3MAG.COM

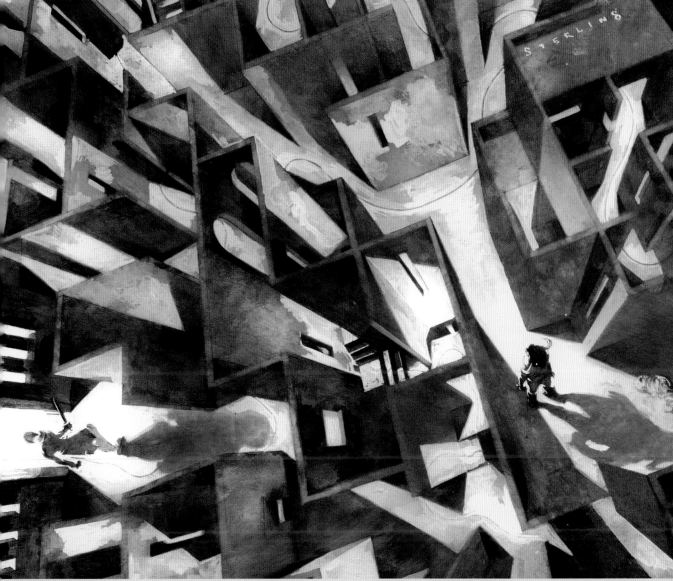

UNLEASH YOUR
CREATIVE VOICE
MFA
MASTER OF FINE ARTS
LIMITED RESIDENCY IN ILLUSTRATION
HARTFORD
ART SCHOOL

IMAGINE being surrounded by incredibly talented and motivated illustrators from all over the country.
IMAGINE being surrounded by this group of practicing professionals who have checked their egos at the door and have the courage to allow themselves to be exposed to life altering experiences.
IMAGINE all the possibilities; our students do.

Murray Tinkelman:
Director
Carol Tinkelman:
Program Administrator
tinkelman@hartford.edu
914-737-5961
www.hartfordillustrationmfa.org
Our blog: www.hartfordillustration.com

UNIVERSITY OF HARTFORD
200 Bloomfield Avenue, West Hartford, CT 06117

Barbara Tyler

Fashion Illustration

www.fashionillustrationandmore.com

WWW.
TARAJACOBY
.COM

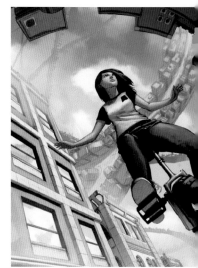

the illustration site

PORTFOLIO STOCK WHAT'S NEW ART TALK ABOUT

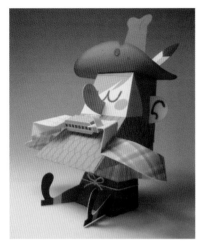

Leo Espinosa
Silver Medal,
Institutional

Guido Scarabottolo
Silver Medal, Book

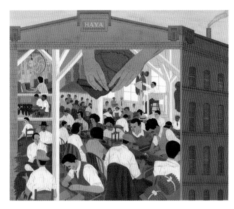

Curtis Parker
Silver Medal,
Institutional

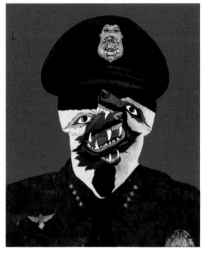

Brian Stauffer
Gold Medal,
Editorial

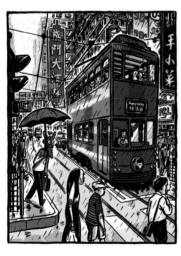

Michael Sloan
Silver Medal,
Uncommissioned

Elizabeth Traynor
Silver Medal,
Advertising